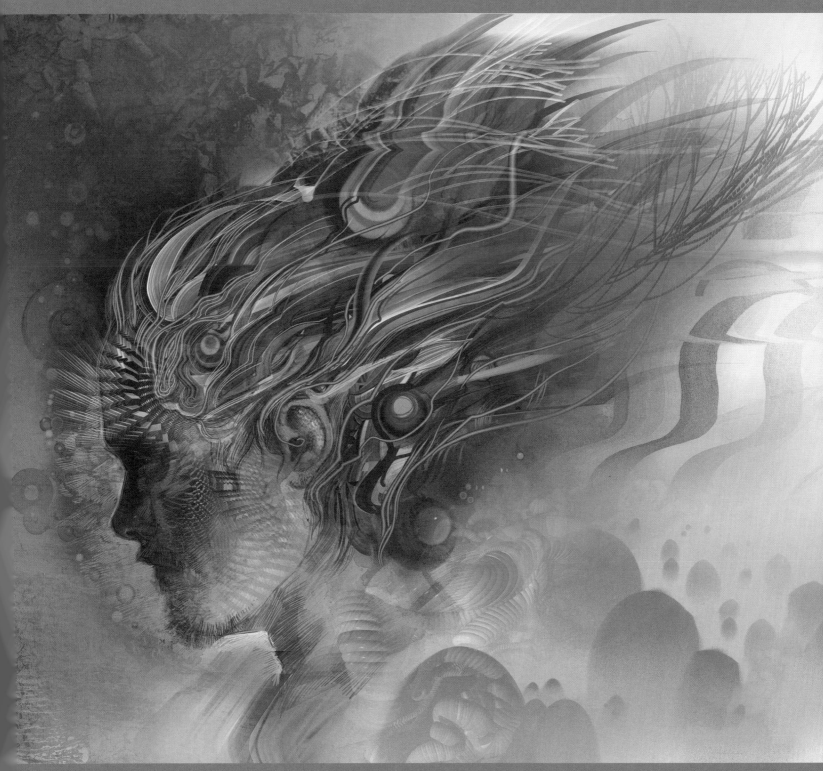

Art by Android Jones, androidjones.com

SPECTRUM 21
THE BEST IN CONTEMPORARY FANTASTIC ART

FEATURING OVER 250 ARTISTS INCLUDING

yoann lossel justin gerard anna & elena BaLBusso

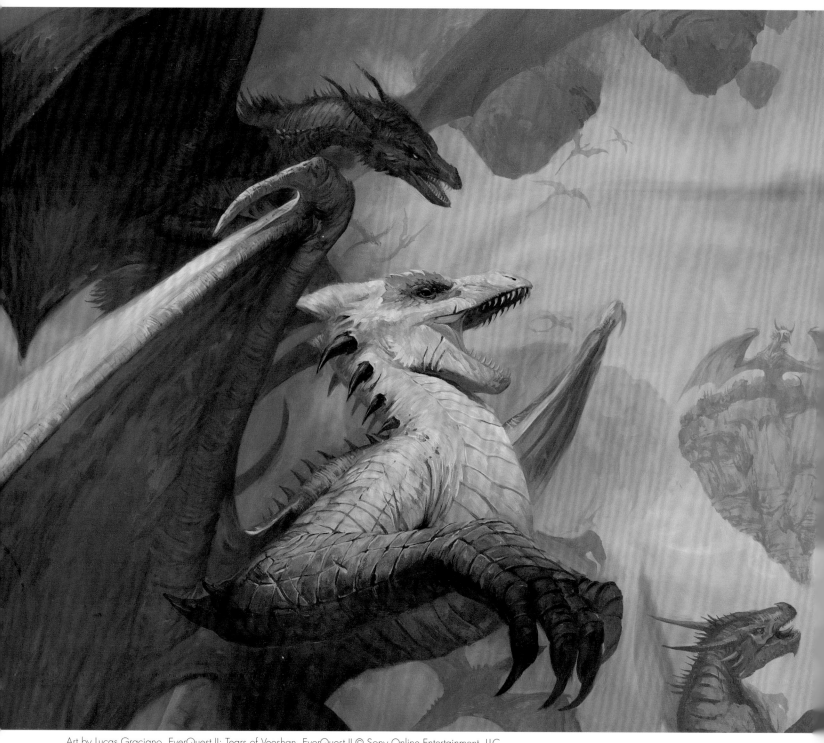

Art by Lucas Graciano. EverQuest II: Tears of Veeshan. EverQuest II © Sony Online Entertainment, LLC

FLESK

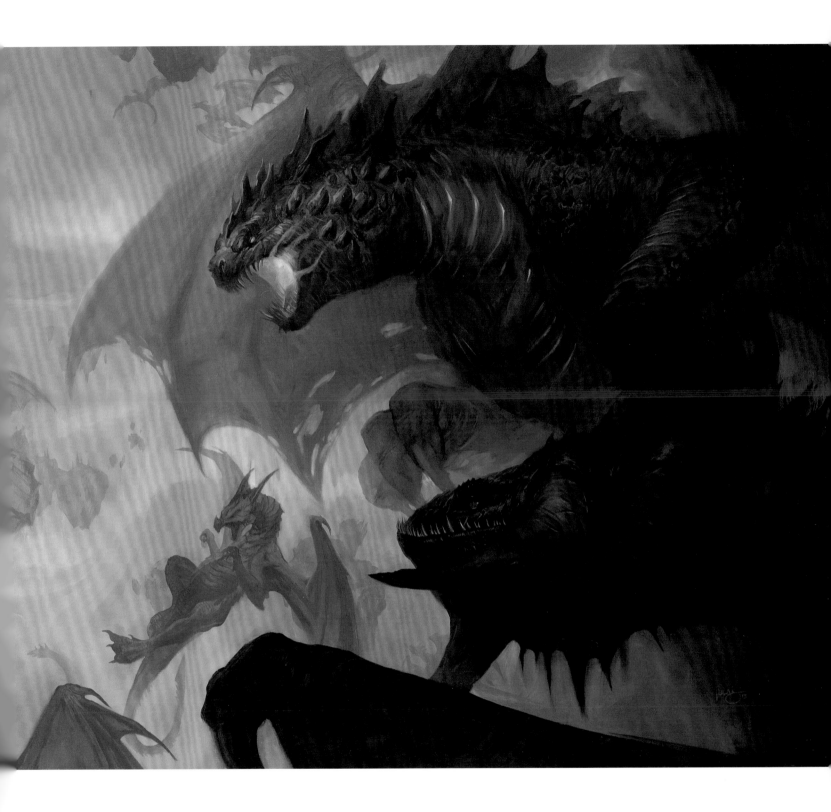

SPECTRUM 21

THE BEST IN CONTEMPORARY FANTASTIC ART

EDITED BY JOHN FLESKES

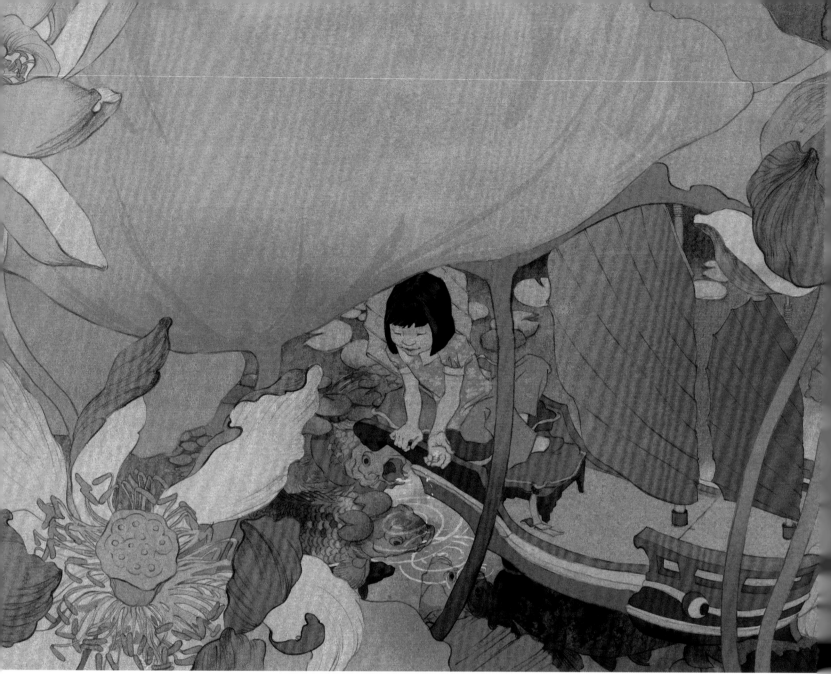

Art by Kirsti Wakelin. "Lilies, Koi and Chang Kuo-lao" from Dream Boats.

Spectrum Advisory Board: Brom, Alice A. Carter, Mark Chiarello, James Gurney, Charles Kochman and Iain McCaig. Honorary Spectrum Advisory Board members: Harlan Ellison, Arnie and Cathy Fenner, and Tim Underwood.

Edited and designed by John Fleskes. Copy edited by Martin Timins. Additional copy edits by Cathy and Arnie Fenner. Production assistance by Keith Silva.

First Printing, November 2014. Printed in Hong Kong.
Paperback edition ISBN: 978-1-933865-57-7
Hardcover edition ISBN: 978-1-933865-58-4

Artists, art directors and publishers interested in receiving entry information for the next Spectrum competition can visit spectrumfantasticart.com for details. Printable entry forms are available. Call for Entries posters (which contain complete rules, lists of fees and forms for participation) are mailed in October each year.

fleskpublications.com
spectrumfantasticart.com
spectrumfantasticartlive.com

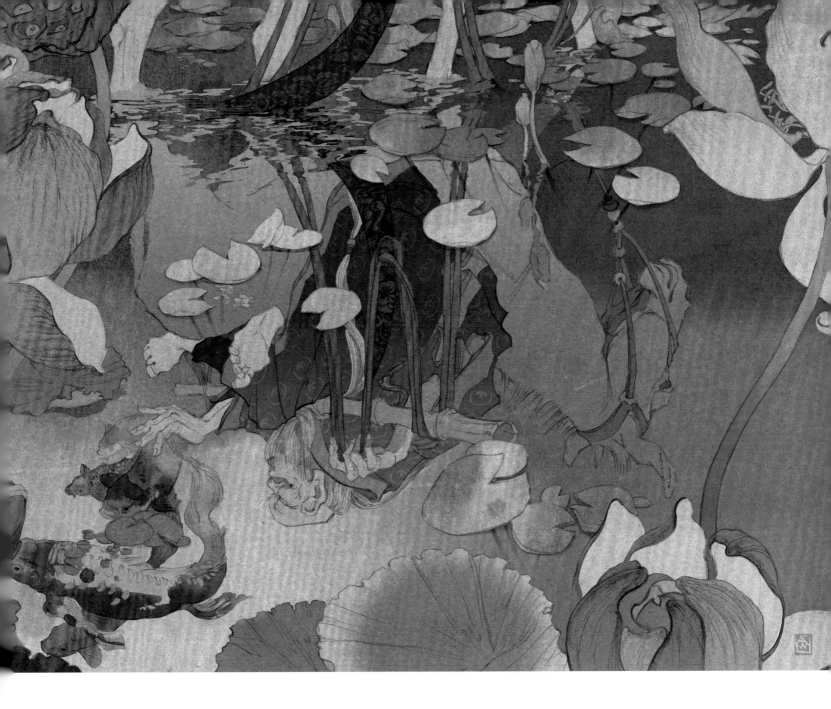

CONTENTS

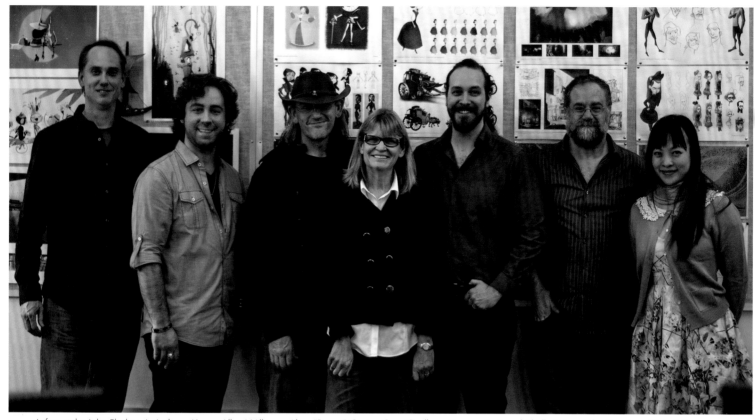

Left to right: John Fleskes, J. Anthony Kosar, Allen Williams, Alice "Bunny" Carter, Cory Godbey, George Pratt and Shelly Wan at the Spectrum 21 judging event.

SPECTRUM 21 JUDGING EVENT

The judging event for *Spectrum 21* was held on Saturday, March 1, 2014, at San Jose State University's Animation/Illustration program building in San Jose, California. Through the generosity of the program coordinators—Alice "Bunny" Carter, Courtney Granner and David Chai—plus nearly twenty student volunteers, the day was an enjoyable mixture of judging and visiting with the students. The Animation/Illustration program is consistently ranked as one of the premier university programs in the nation. It is committed to providing a world-class education at an affordable price, preparing students for careers in feature-film animation, games, television and any other media that uses animation and storytelling as a core communication tool. The environment proved perfect for a day of stimulation and for viewing artwork.

With the event being private to maintain the integrity of the judging process, we wanted to develop a method to share the process with the public. With this in mind, we invited our friends at Helpful Bear Productions to document the day through photographs, films and interviews with the jury members. The footage was used to post our progress on the Spectrum Fantastic Art website (*spectrumfantasticart.com*) during the course of the day and following weeks.

The five-member jury consisted of an esteemed group of artists: Cory Godbey, George Pratt, J. Anthony Kosar, Shelly Wan and Allen Williams. They were selected based on their reputations within the professional community and their passion for art. Each is a superb artist with an open mind regarding the styles, approaches and tools that are found in *Spectrum* submissions. They also constantly give back by serving to guide and support others.

A *Spectrum* submission is included within these pages if it has received a majority of votes. This is done if three or more judges selected a piece of art as being exceptional. We pay close attention to the process to guarantee its fairness. The jury members are discouraged from talking to one another during the selection process. The judges are excluded from considering their own work for an award, and each individual may not vote upon his or her own work. No submissions are prescreened. Every submission is shown to each member. We would like to thank them for taking the time to be a part of *Spectrum*. Now, let's meet the jury.

Photo by Greg Preston for Spectrum Fantastic Art

CORY GODBEY

Cory Godbey lives in South Carolina with his wife, Erin, and their many cats. He creates fanciful illustrations for picture books, covers, comics, advertising, animated shorts and films. Godbey's work has been featured in a variety of esteemed annuals, publications and galleries. Some of his favorite past projects include working with The Jim Henson Co. and Archaia Entertainment on *Fraggle Rock* and *Labryinth* comics, as well as creating the art and animation for the award-winning documentary film *The Last Flight of Petr Ginz*. He shares his creative process and experience with emerging artists through online classes, workshops and mentorships.

GEORGE
PRATT

George Pratt is an award-winning painter, writer and photographer. His work is in numerous private collections worldwide. Among the many awards he has received are the Eisner Award for his graphic novels, a Spectrum Gold Medal and Best Feature Documentary at the New York International Independent Film Festival for the documentary *See You In Hell, Blind Boy*. Pratt teaches full-time at the Ringling College of Art and Design in Sarasota, Florida, and summers at the Illustration Academy in Kansas City, Missouri.

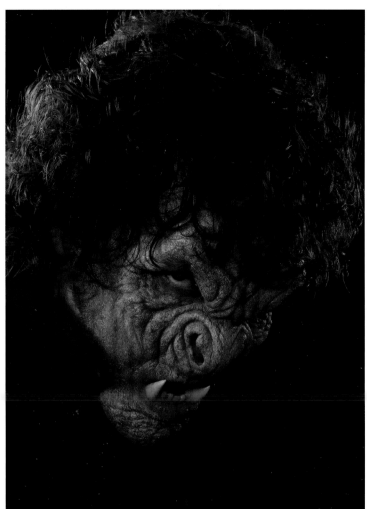

J. ANTHONY KOSAR

Award-winning artist and *Face-Off* season 4 champion, J. Anthony Kosar specializes in fine art, illustration, sculpture and special effects through his company, Kosart Effects Studios, LLC. In 2007, he interned at the legendary Stan Winston Studio, creating effects for *Indiana Jones and the Kingdom of the Crystal Skull* and James Cameron's *Avatar*. Kosar creates special effects for theater, film and commercials, and teaches the art of FX through his studio in Westmont, Illinois. Besides FX, Kosar designs and sculpts Halloween masks, prototypes for toys, collectibles and medical anatomical models. He also illustrates for novels and comic books, curates art gallery exhibitions and creates his own fine-art paintings and sculptures. His paintings have appeared in *Watercolor Artist Magazine* and *Splash: Best of Watercolor*, and his sculptures have appeared in *Spectrum: The Best in Contemporary Fantastic Art*.

SHELLY
WAN

Shelly Wan is originally from Guangzhou in southern China. After graduating from the attached school of the Guangzhou Academy of Fine Arts, she came to California to attend the Art Center College of Design in Pasadena and interned at Walt Disney Imagineering during school. After graduating in December of 2004, she went to work for Rockstar Games as a concept artist on the titles "Bully" and "Red Dead Redemption." In 2007 Wan went to work at Imagi Animation Studios as a visual-development artist on "Astroboy." She started at Pixar as a sketch/color artist in 2010 to begin work on *Monsters University*. She has also done art for multiple book and comic covers and "Magic: The Gathering." Wan was awarded "Best in Show" at the Beverly Hills Summer Art Show 2008 and also was awarded the Jack Gaughan Award for Best Emerging Artist in the same year. She has been featured in multiple exhibits at the American Museum of Illustration.

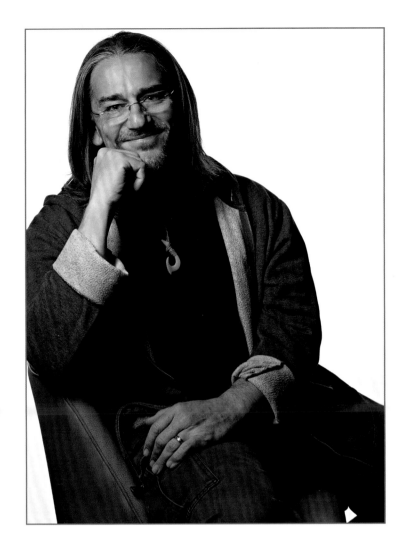

ALLEN WILLIAMS

"I've always loved drawing for as long as I can remember," says Williams. "I have pictures of monsters that I did at the age of three, and I feel most at home with a pencil in my hand. I also work in acrylics, oils and occasionally digital… but everything always starts with drawing. I went to college for a few years but left when I started doing more illustration than actual homework assignments. I became a professional freelance artist in 1988 and have worked on many publications, games and projects since then. Beginning with TSR, *Dragon* magazine and later progressing into CCGs such as 'Magic The Gathering' and 'Rage.' Most recently I have worked for Paramount [Noah], Lionsgate and Legendary [Pacific Rim]."

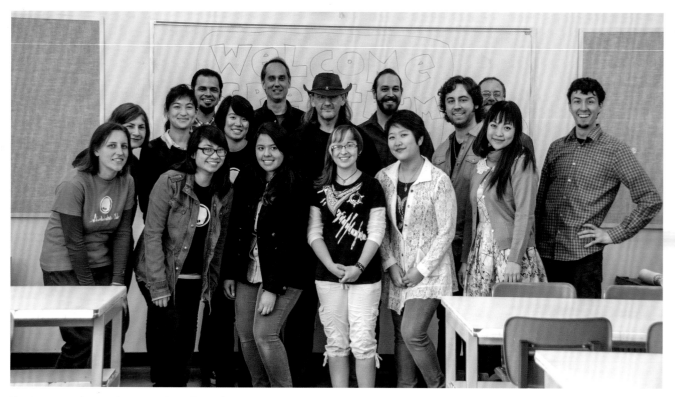

The Spectrum judging volunteers and jury, from left to right: Kathy McNeal, Elyssa Pahn, Danielle Case, Gary Velo, Grace Chen, Sydney Sun, Anna Corrales, John Fleskes, Allen Williams, Karlee Ludvik, Cory Godbey, Da-Hee Im, J. Anthony Kosar, George Pratt, Shelly Wan and Keith Silva.

Student volunteers—the afternoon shift, from left to right: Claudia Law, Colleen Peck, Jessica Tong, Lancing Chen, Dharitha "Dee" Pathirana, Catharina Sukiman, Ting-Yu Chen and Nicole Chen.

ACKNOWLEDGMENTS

This book is the result of the effort by a team of dedicated and passionate individuals who realize that Spectrum is larger than any one person. We understand that by working together—and having fun in the process—we can achieve something that can benefit and entertain an entire community.

My thanks begins with the Spectrum founders, Cathy and Arnie Fenner, who had the vision to turn Spectrum into an international phenomenon over the last twenty years. Tim Underwood deserves accolades for his faith in the Fenners and for taking the chance to herald Spectrum and publish its annual collection for two decades through Underwood Books. I would especially like to express my gratitude to Cathy and Arnie, and to Tim, for their trust in me to continue the legacy of Spectrum for the coming years.

I would also like to thank Terri Windling for her masterful Grand Master essay on Iain McCaig. And to William Stout for his touching remembrance of Ray Harryhausen.

The transition to Flesk Publications has been five years in the making, as I worked in the background with Cathy and Arnie to gain an intimate knowledge of how Spectrum operates. Once here in the Flesk line, I have been grateful to my loyal crew, who have so eagerly assisted in the future of Spectrum. These people include: Joshua Ford, Keith Silva, Martin Timins, Gary Velo, James Walker and Stanley Yeung. I would also like to point out the support of Helpful Bear Productions, Greg Preston and Sampsel Preston Photography, and Alice "Bunny" Carter, Courtney Granner and David Chai at San Jose State University.

It continues to be an honor to carry the Spectrum torch—which we in the Flesk crew are privileged to be a part of. I would like to wrap this up with our heartfelt gratitude to the contributing artists and to those who support us through the purchase of this book. Thank you!

JOHN FLESKES

Left to right: Omar Rayyan receiving his gold award in the Unpublished category at the Spectrum 21 awards ceremony. Backstage with Tran Nguyen after receiving her gold award in the Editorial category. Arnie and Cathy Fenner celebrate with Iain McCaig upon his being honored with the Spectrum Grand Master Award.

Left to right: At the Spectrum/Flesk booth at Spectrum Fantastic Art Live with J. Anthony Kosar, Justin Sweet, Cory Godbey, Vance Kovacs, Camillia d'Errico, Jackson Robinson, Steve Rude, Allen Williams, Mark Schultz, Frank Cho, Bill Carman, Dave Palumbo, Annie Stegg-Gerard, Justin Gerard, Arnie Fenner, John Fleskes, Android Jones, Craig Elliott and Terry Dodson.

Left to right: At Spectrum Fantastic Art Live where Paul Bonner signs a book for an attendee. Virginie Ropars contributes to the group piece during the ongoing Sculpt-O-Rama. Artist and art director Marc Scheff (who along with Orbit's art director, Lauren Panepinto) gives the first of three hands-on presentations to help artists achieve their potential with their careers. Vance Kovacs works on his latest piece for all to observe. The show and awards ceremony are open to the public.

SPECTRUM FANTASTIC ART LIVE

Spectrum Fantastic Art Live (SFAL) is a fantasy-focused art fair in which creators can display, share and sell originals, prints, sculpture, crafts, toys and more to an audience of fans and peers. There is something for everyone, including presentations, panels, displays, portfolio reviews, workshops and educational opportunities. Our goal is to honor the artists and put on a fantasy-art convention that anyone is welcome to attend and enjoy. SFAL is *the* event that celebrates fantastic art and its creators. Over two hundred artists arrived for the three-day gathering which ran May 9-11, 2014, in Kansas City, Missouri.

Held in conjunction with the event was the Spectrum 21 awards ceremony. This year's awards were presented on May 10 at a gala ceremony held at the historic Midland Theatre. Industry greats were on hand to present the winners in each category, including Anne and Tim Bruckner, Frank Cho, John English, Cathy and Arnie Fenner, Irene Gallo, Gregory Manchess, Lauren Panepinto, Bob Self and Paul Tobin. A special thanks to our Spectrum 21 jury, who made the selections: Cory Godbey, George Pratt, J. Anthony Kosar, Shelly Wan and Allen Williams.

To learn how to be a part of SFAL in 2015, please visit *spectrumfantasticartlive.com*.

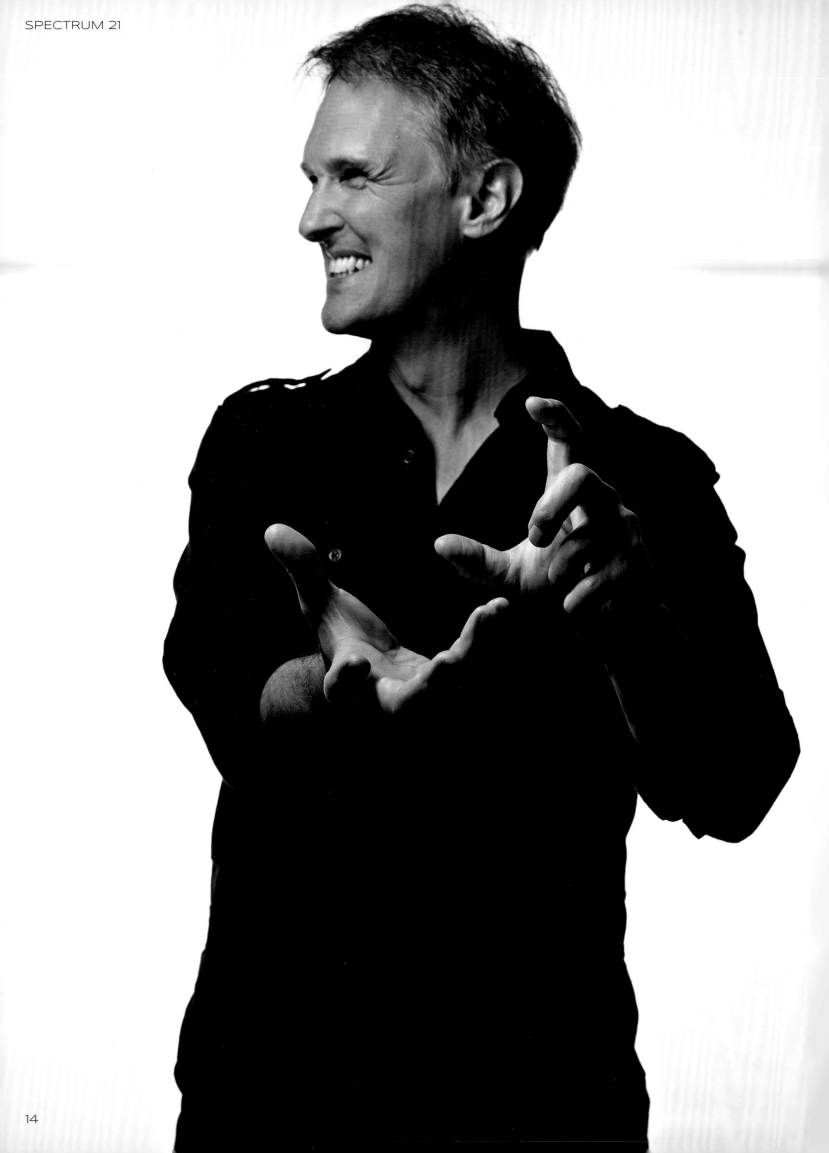

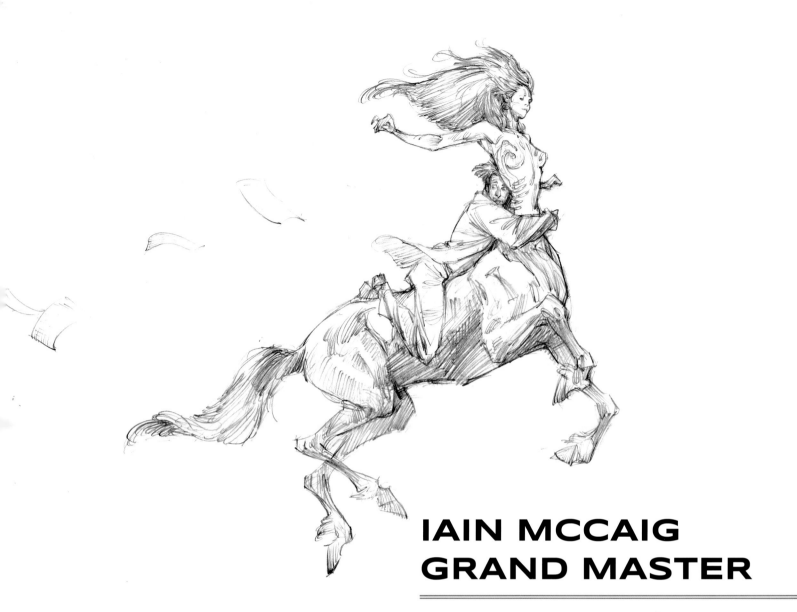

IAIN MCCAIG
GRAND MASTER

BY TERRI WINDLING

A Grand Master, as Arnie Fenner has explained, is an artist who has worked for at least twenty years at a consistently high level of quality; who has influenced and inspired other artists; and who has left his or her mark on our field as a whole. "Craft alone," he writes, "is not sufficient to receive the honor: There are many skilled painters who produce solid, profession work. But (and this is key) it fails to resonate. It is admired in the moment and immediately forgotten. A Grand Master's art, on the other hand, gets stuck in the viewer's heart and memory."

By this measure, it is easy to see why Iain McCaig has been chosen as this year's recipient of the honor. In a career spanning thirty-five years (with no sign of waning), he has created wonders for clients who range from publishers, record labels and game companies to major film directors, while also producing films and fine art of his own and inspiring generations of younger artists through lectures, workshops, and instructional DVDs. Among his peers, Iain is admired for his technical brilliance and beloved for his generosity of spirit. Through works as varied as the album art for Jethro Tull's *Broadsword and the Beast* to conceptual designs for the *Star Wars* films, his visions have entered the dreams—and the nightmares—of millions the whole world over.

The man himself is a bit of Trickster, in the classic mythic sense: both straight forward and elusive, down-to-earth and otherworldly. No one could be more honest, open and engaged when you meet him face-

to-face, yet beneath his openness are layers that can take many years of friendship to penetrate, with further layers beneath where only the artist himself may roam. Articles about him don't even agree on whether he's American, Canadian or Scottish, and the truth is that he is all these things, holding passports to all three countries. He currently lives in a house high in the trees of Victoria, British Columbia, with his wife Leonor. They have two grown children, Mishi and Inigo, both of them artists themselves.

Iain was born in California in 1957 but spent most of his childhood in Canada. At 14, when his family moved back to the States, Iain persuaded his parents to let him stay behind in Canada to finish his schooling—and it was then, left alone in a big family house with a film camera and time on his hands, that he began to make his first films. He had planned to be a writer, not a visual artist or filmmaker, but now a new path unfolded before him, leading in a whole new direction. When high school ended, Iain moved to Scotland to study art at the historic Glasgow School of Art, best known for its association with Charles Rennie Mackintosh and the Scottish Art Nouveau movement. Upon completion of his studies, he moved to London, spending seventeen years in Europe in total—focused on illustration while casting sidelong glances at the world of film.

Iain's first foray into film was a summer job working on Sesame Street cartoons and the trailer for an animated feature called *Twice Upon a Time*. But it was a decade later, when he moved from London

to California, that his film career took off in earnest and brought him to where he is today: recognized as one of the leading conceptual designers in the feature-film industry. He's best known for his work as a principal designer for the first three films in the *Star Wars* saga, where he created landmark designs for Darth Maul, Queen Amidala and many other characters. The long list of other films he has worked on includes James Cameron's *Terminator II*, Steven Spielberg's *Hook*, Francis Ford Coppola's *Dracula*, Neil Jordan's *Interview With the Vampire*, Sony/Revolution/Universal's *Peter Pan*, Warner Brothers' *Harry Potter and the Goblet of Fire*, and both the Paramount Pictures' and Disney/Pixar's versions of *John Carter of Mars*.

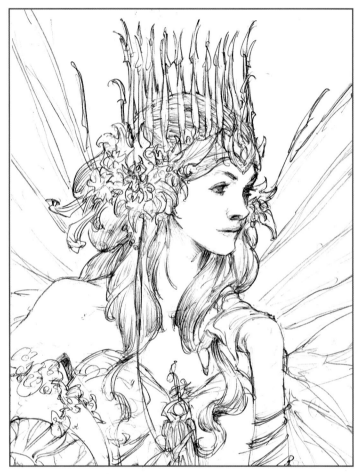

He was also co-producer and concept design director on *Outlander*, the science-fiction epic from Ascendant Pictures. He made his directorial debut with a children's film, *The Face*, which won the gold medal for Best Family Film at the Houston International Film Festival and a Year 2000 Notable Video award from the American Library Institute. Iain wrote and designed his first CG feature film, *The Pied Piper*, for Imax/Mainframe in 2001. And in 2005, he founded Ninth Ray Studios, a freelance design group that has handled development and preproduction work for a number of major motion pictures, including *The Spiderwick Chronicles*. At the same time, he has continued to illustrate books and to teach and lecture widely. His art has been exhibited at the Smithsonian and in galleries around the world.

As can be seen from this list, Iain is a man with huge reserves of creative energy, drive and passion. One rarely sees him tired, overwhelmed or discouraged. Embattled, yes, as he wrestles with deadlines or labors to move a project forward against opposition. But discouraged, no. Nor is there a drop of cynicism in his entire makeup. Iain doesn't define himself as an artist but as a "visual storyteller," which explains why he shifts so easily and so happily between many mediums. Whether painting, writing or directing a film, he is always focused on *telling a story*. Stories bubble out of him constantly, surrounding him in a silvery aura and trailing behind him wherever he goes. With every job he approaches, every idea he explores, his gaze is locked on the story at its core, whether he's bringing another writer's story to life or creating one of his own. "My higher calling is to serve the story," I have often heard him say. "I never just make images. The images are there to tell stories."

Despite the lightness of his own spirit, Iain also relishes nightmares, monsters and tales of the dark. "Darkness," he says, "is one of my favorite places...perhaps because I am so opposite. I had a ridiculously happy childhood. My parents stayed together until I was grown. Everyone seemed to love me. I had a lot of friends. It was very hard when I first tried to write fiction, because I didn't have any dark experiences to draw on. I had to *imagine* my evil. I had to imagine all the bad things that *could* have happened to me but didn't. And yet, imaginary fears can be just as strong as the real ones...in fact, maybe even stronger. The imagination turns the threat you can't see into exactly the thing you are afraid of most. I don't think dark stories are bad for us. I think we need them and we love them, because of the contrast they make with the rest of our lives. They make the good moments better and brighter."

There's a famous story about the time George Lucas delivered his script for *Star Wars Episode One* to the art department at Skywalker Ranch. It contained a new Sith Lord named Darth Maul, described as *"a vision from your worst nightmare."*

"That was all I needed," says Iain. "I sat down and drew my worst nightmare: an unseen presence watching me from the shadows, with glittering eyes and metallic teeth and red ribbons falling over its dead white flesh like rivulets of blood. I put the picture inside a folder and, at our next meeting, slid it over to George. He took one horrified look, slapped the folder closed and slid it back to me.

"'Okay,' he said, 'give me your second worst nightmare.'"

In 2008, Insight Editions released *Shadowline: The Art of Iain McCaig*, an astonishing art book covering twenty-eight years of Iain's commercial and personal artwork—from *Star Wars* and other film concept art to dinosaurs, otters, monsters, fairies and Alice in Wonderland. The text by Iain is a story, of course, a fictional journey to his studio in the magical world of the Shadowline. The Shadowline, he writes, "is the place where things meet. Light and shadow. Hope and despair. Good and evil. It's a universal watering hole. Ideas gather there. So do artists."

The book covers all the different facets of his career, including his dedication to the fine art of teaching. It is Iain's contention that art is a *language*, and as such it's one that each one of us can learn. We might never become as fluent as Michelangelo (or, indeed, as Iain himself), but we *can* all learn to tell visual stories through the regular practice of some basic techniques. Iain shares his approach to the drawing board through popular classes, workshops, DVDs ... and also one-on-one with virtually everyone he meets through his work and his travels. You can often find him bent over a page showing someone that, yes, they too can draw—both for their own pleasure and to better understand the visual world all around them. "We are wired to tell stories," he says, "visually, verbally, any way we can. The more stories, the more tellers, the more points of view, the better for all of us."

So if, as Arnie Fenner states, Grand Masters can be recognized by the influence they have on others and the number of people they have inspired, then Iain McCaig is very grand indeed. I should know, for he has inspired me and sharpened my vision for over two decades. And he's still going strong, trailing stories wherever he goes.

Catch one if you can.

Terri Windling
Chagford, Devon, England
June 2014

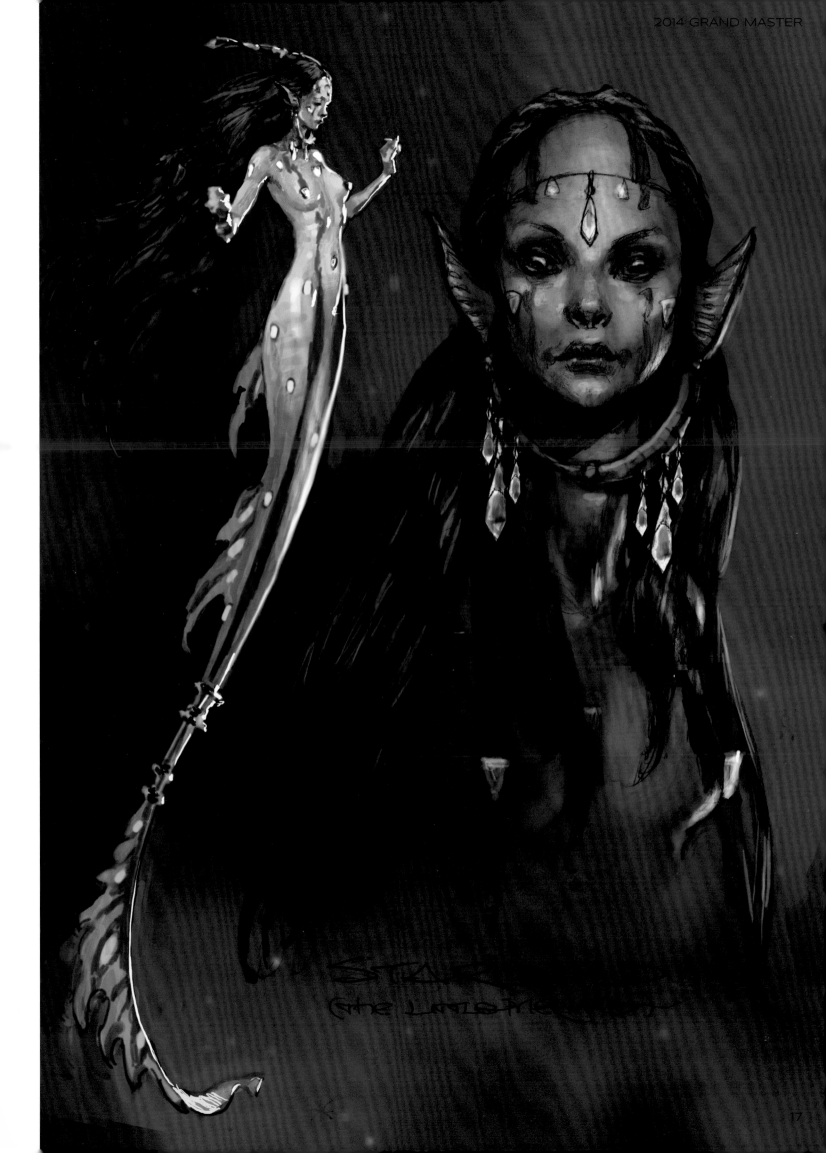

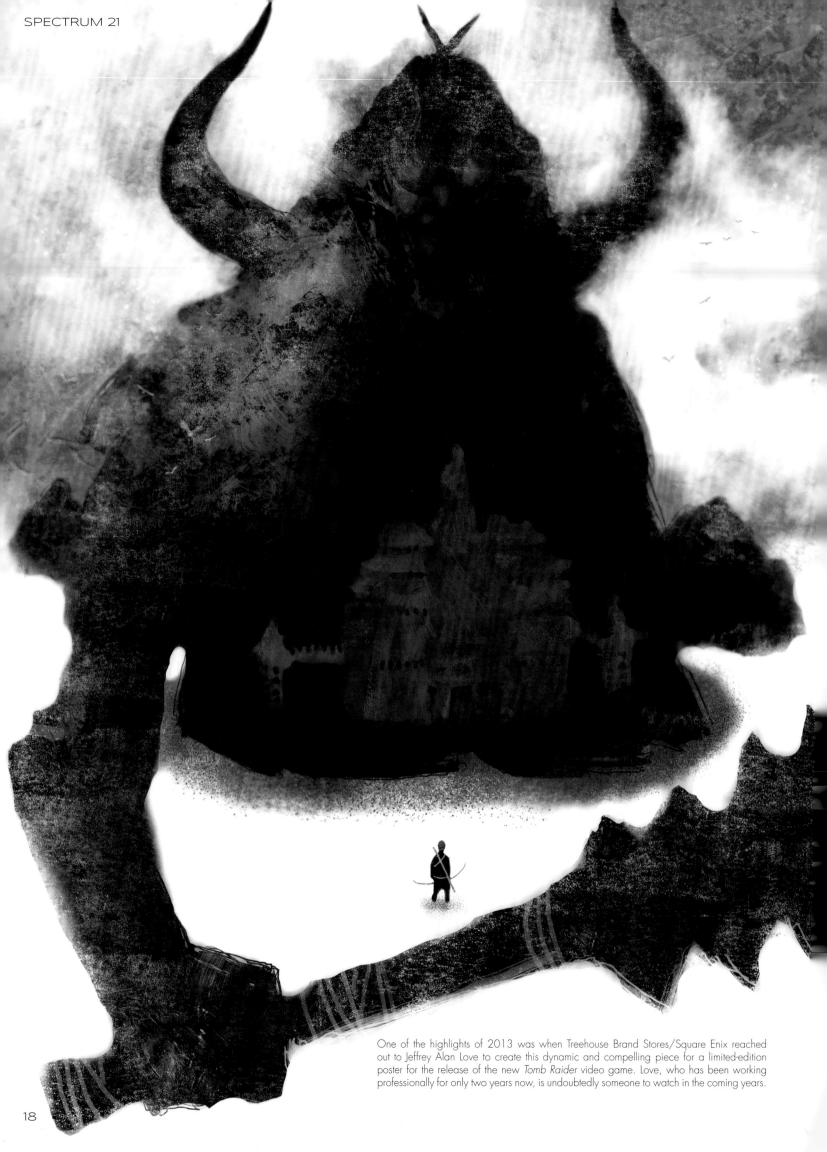

One of the highlights of 2013 was when Treehouse Brand Stores/Square Enix reached out to Jeffrey Alan Love to create this dynamic and compelling piece for a limited-edition poster for the release of the new *Tomb Raider* video game. Love, who has been working professionally for only two years now, is undoubtedly someone to watch in the coming years.

Photo by Greg Preston for Spectrum Fantastic Art

YEAR IN REVIEW

BY JOHN FLESKES

Artists make the best company. Their passion is contagious and their creativity boundless. Spending time with artists will enrich your mind through their constant inquisitiveness and in the way they redefine the real world into an imaginative one. They express their ideas through the bold use of a wide variety of mediums and styles. These visionaries create moments that would not otherwise be possible. They do this by spending countless hours in seclusion, laboring over their craft. They pour their emotions into imagery that they then present as a gift to the world. Spectrum was born out of the desire to provide a singular home for the best in contemporary fantastic art. We will continue to leave the door unlocked where all can enter.

The beauty of Spectrum is that not any one style, genre, preference or individual can define what is compiled within its pages. This twenty-first annual edition captures the variety found in science-fiction, fantasy, horror, the surreal and in fine art created throughout 2013. Spectrum provides joy in premiering our newest stars as well as embracing our greatest contemporaries. Spectrum is a pursuit where predictability has no place. This book serves as a snapshot of where fantastic art stands today. It provides a glimpse into the future. This collection will further reveal that fantastic art can be mystifying, transcendent and enchanting.

Spectrum will always be for those who have an open mind and who appreciate, embrace and celebrate diversity. Spectrum is a community for those who do not wish to be labeled or told that they do not belong. We live in a time of transition in the arts marked by freedom of expression, growth, new ideas and tools that allow for alternative ways to tell stories—all of which are embraced by those here at Spectrum.

There was no shortage of discussion online in 2013 regarding the unfair treatment of women in the arts. Let me expand this dialogue to also include minorities and those with certain religious beliefs or sexual preferences. All have historically been discriminated against in the workplace. Even worse, when one's talents are stifled, society misses out on the next groundbreaking artist or editor, CEO or publisher who can offer us so much.

I feel it is a responsibility of anyone who gains a position in management (such as, in my case, as the new director of Spectrum) to create a welcome environment for all genders, age groups and races. This is what's right and what Spectrum stands for. This is how we can bring you the most diverse annual out there today.

Another item that makes Spectrum unique is the quality of art collected within its pages. Artists often discuss the key ingredients to a successful piece of art such as feeling and passion and the skill and ability to communicate. You will notice that I do not mention anything about technique here. This is a good topic worth exploring further.

We often look to the field with the one basic question: What is art? You can follow up this question by asking: What is good art? These are among the ongoing inquiries that have many answers but no single definition. Each of us has the right to interpret what art is for him or her. Therefore, by avoiding clear definitions—an attempt of which can prove to be in complete juxtaposition to the person next to you—and by keeping an open mind, a lively discussion can be had!

We can expand upon this discussion by asking if art has any more or less value based on the tools used in its creation. Does the technique used decide if it is art? Or is the viewer response what constitutes its ultimate judgment? Does its ability to communicate bear more or less relevance than the instruments used? These answers are for each of you to decide. You know best what art means to you. What we can do is provide an annual showcase that allows these questions to be asked and discussed, and allow for the works that are selected to be presented in an elegant format to serve as the best of the year. There is no doubt that within these pages you will find your answers. Is it execution or communication that triumphs? Or is it a combination of both? At Spectrum we set no boundaries. We want these questions asked. If the answers were simple, we would be left in a dull environment.

To me, art can be created with any tool; A piece of yarn, a sewing machine, a camera, oils, watercolor, charcoal, a brush, digital programs, pen or pencil—it doesn't matter. What matters is if the piece tells a story. Does it communicate to me, does it tug on my emotions? It's a personal connection based on my life experiences, beliefs, principles and philosophies. I can tell you what I like, but I cannot tell you what you should like. It is not up to me to say what is valid or not valid, since I can only speak my truth but not yours. Which is why I don't believe in defining art, nor do I believe that any one tool or process is invalid. What I can do instead is offer you some perspective, history, my thoughts, opinions and beliefs, and tell you what art means to me. Then we can continue that blissful never-ending journey of discovery to find an answer together. An answer that I hope never comes. For that unanswered question—now *that* is art!

And I believe, that just like art can't be defined, neither can the tools. I'll fight for traditional art and digital art equally. To restrict the tools would be to hinder the artists and their imagination. We embrace the variety of approaches, methods and forms of art. We want to see what artists are doing, using and experimenting with. That's important to see and to discuss. So, whether you use Super Sculpey or Pixar's RenderMan for your dimensional art, or oil paint or a digital brush for your painting, you can be assured that we judge all processes equally. I want each artist to know that when he or she submits a piece to Spectrum, it will be judged on the merits of the finished art, not the tools used. And our viewers will always know that we do not prescreen submissions or cast judgment on anyone's art. Each work is voted upon anonymously and fairly by our five jury members. A simple majority of three or more votes places the art in the book. There are no limits. Every piece selected gets in.

The artworks shown here all grabbed the attention of the jury and demanded to be in the book. The pieces captured the imagination of five highly creative individuals who cannot be fooled by technique or trickery and who are not easily impressed. They know what is real and what is not. The works communicated with the jury—a feat that is difficult, as it should be. To represent the best of the year, the artist must have made a statement.

Spectrum includes eight categories that showcase artwork created for a variety of purposes: Advertising, Book, Comic, Concept Art, Dimensional, Editorial, Institutional and Unpublished. After the book selection voting was completed, those pieces labeled for award considerations were laid out for the jury to discuss as a group. Not too surprisingly, many of the pieces were noted as possible award recipients by multiple jury members. The jury became fast friends, respected one another and took the time to consider each person's thoughts. This made the ultimate decisions to select the five nominees and the actual two award winners in each category a smooth process. New for this year, each recipient is featured on a dedicated two-page spread within this book. For those who could make the Spectrum 21 awards ceremony, we were fortunate to have the noted photographer Greg Preston take their portrait for inclusion within these pages as well. Congratulations to all sixteen of you!

Each category can be deemed a favorite. Each is well-represented in this book by top artists in the field. Also included are some insights into each section, followed by a list of notable art created within the category during 2013. Due to space limitations, far fewer artists are mentioned than I would prefer.

ADVERTISING

The advertising category includes art done for newspapers, magazines, film posters, television, DVD packaging, art for brochures and billboards. Kent Williams opens the section with his gold award for his Blu-ray cover art for The Criterion Collection's *Lord of the Flies*. Art director Eric Skillman explains at criterion.com, "...we brought in artist Kent Williams to create a new, iconic image focusing on the psychology of one archetypal boy." The end result is a dynamic work fitting this new remastering of the 1963 film. Victo Ngai follows with a silver award for her "Tiger Beer Chinese New Year" for Tiger Beer. Victo's art weaves a fanciful array of sublime moods through her use of narration and color. Anita Kunz, Gabriel Verdon and Shu Yan were also recognized by receiving nominations for an award in this category.

The year in advertising produced a great number of confident works: Gregory Manchess lent his narrative skills to the ad campaign for Jameson Whiskey and was filmed painting the bottle for a Patrón Tequila television commercial. (The art was also used in the print campaign.) Justin Metz powerfully captured a Kaiju facing off against a Jaeger in his advertising art for Guillermo del Toro's film *Pacific Rim*. Michael Koelsch produced a fun poster for a Las Vegas Halloween party, while Robert Rodriguez painted an elegant ad for the "Tales of the Cocktail" event in New Orleans. Yuko Shimizu created promotional art for Criterion's *Zatoichi: The Blind Swordsman* video; the package featured additional attractive art by Patrick Leger, Josh Cochran, Paul Pope, Sam Hiti, Greg Ruth and Benjamin Marra.

BOOK

The book category features art that appeared on the inside or the cover of a book. The book section is highlighted with the gold award for "The End of the Road" by Nicolas Delort, a masterwork of execution and design. This was one of the fastest decisions made by the jury, due to all five of them having had this piece earmarked for discussion. Delort proves his abilities have no limits, as is represented by his other fine works in this book. For the silver award, Scott Gustafson—a *Spectrum* favorite—follows with his playful rendition of "Little Sambha." Gustafson is one of only two artists who have been included in all twenty-one volumes of *Spectrum*. (The other artist is Brom. About as yin and yang as you can get.) Petar Meseldžija, Kirsti Wakelin and John Harris should be noted as submitting exceptional works that were highlighted by the jury as nominations for an award too.

The book category is one that is a personal favorite to many. Artists and fans are rabid book collectors. (Even now, with the digital age upon us, online book sales were flat for 2013.) The experience of holding, owning and viewing a real book has remained strong for all generations, resulting in steady and increased book sales, to the delight of art-book publishers like myself. You will find a better selection of art books at your local independent comic-book shop and book stores than anywhere else, and they report increased sales.

Individual artist collections, illustrated books and jacket covers have historically been among the premier echelon of notoriety for an artist within the fan culture. Few artists receive the assignment of a illustrating a cover, even fewer have an opportunity to fill its pages with their

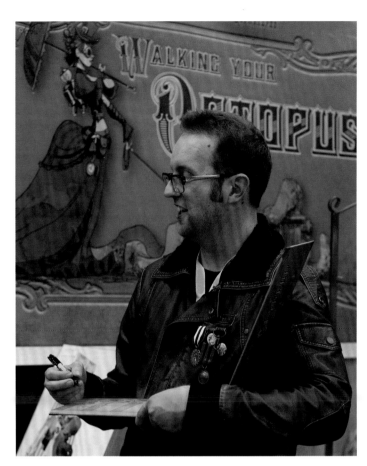
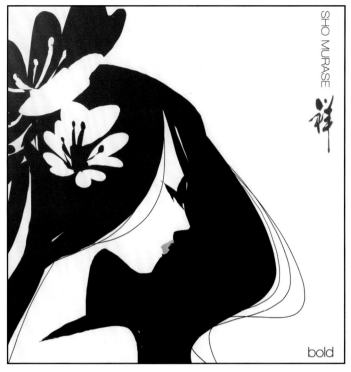
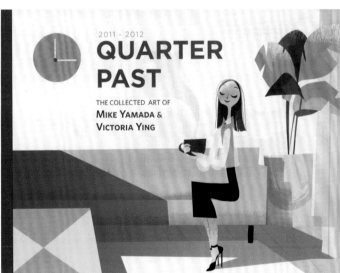
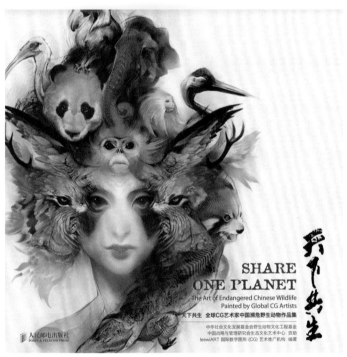

Clockwise from top left: Brian Kesinger signs a copy of his new book *Walking Your Octopus: A Guidebook to the Domesticated Cephalopod* at Comic-Con International San Diego at the Baby Tattoo booth, July 2013; Cover to *Bold,* the latest collection of art by Sho Murase; LeewiART's *Share One Planet* has a gorgeous cover by Android Jones and equally impressive interiors by over eighty artists; *Quarter Past* by Mike Yamada and Victoria Ying collects personal works by this gifted pair of visual development artists.

delineations, and fewer still are the subject of a book collecting their work. Those who receive this type of exposure tend to have a greater profile than those whose work is done for online purposes.

Artists themselves have taken advantage of the ability to produce small print runs through on-demand resources to create unique and rare collections and sketchbooks that are only found during their appearances at shows or direct from their website. The print runs can be anywhere from a few hundred copies to two thousand for the bigger-named artists. These mementos are a great way to capture a personal meeting with your favorite artist. These items can be difficult to find outside of the events where the artists appear. One of the best resources over the last forty years has been Bud Plant (budsartbooks.com), who specializes in carrying collections by our favorite artists.

Books that caught our eye in 2013 include *The Art of Jaime Hernandez* [Abrams ComicArts]; *The Art of Daniel Clowes* [Abrams]; *Re:Invent,* edited by Derick Tsai and Stephen Chang [A Magnus Rex Project]; *The Art of Petar Meseldžija* [Dark Dragon Books]; *White Cloud Worlds Volume Two* edited by Paul Tobin [Harper Design]; *The Art of Blizzard Entertainment,* edited by Nick Carpenter [Insight Editions]; *Diablo III: Book of Tyrael* [Insight Editions]; *Trajectory* by Stephan Martiniere [Design Studio Press]; *Aphorismyth: A Collection of Art and Design* by Ragnar [Baby Tattoo Books]; *Walking Your Octopus: A Guidebook to the Domesticated Cephalopod* by Brian Kesinger [Baby Tattoo Books]; *Tales: The Art of Christian Alzmann* by Christian Alzmann [Design Studio Press]; *Helmetgirls: The Art of Camilla d'Errico Volume 2* [Dark Horse]; *RASL* by Jeff Smith [Cartoon Books]; *Star Trek: The Art of*

Juan Ortiz [Titan Books]; *The Sky: The Art of Final Fantasy* by Yoshitaka Amano [Dark Horse] and; *Share One Planet* [LeewiArt]. Flesk titles released in 2013 include *The Art of Brom; Brom: Sketches, Drawings and Musings; Mark Schultz: Carbon* and a new printing of *Xenozoic* with a new cover; *Spectrum Fantastic Art Live 2; Naughty and Nice 2013 Teaser* by Bruce Timm; and *Wendy Pini Teaser* by Wendy Pini.

Self-published convention collections include the latest editions of the *Chris Sanders Sketchbook 5; Arthur Adams Sketchbook Volume XI; Koza: Selected Works* by Tuna Bora; *Half Past* and *Quarter Past: The collected Art of Mike Yamada and Victoria Ying; A Pure Isle Fantasy Sketchbook* by Bret Blevins; *Sorceress: The Enchanting Art of Dan Brereton; Bombshells 7* by Terry Dodson; *Justin Gerard Sketchbook; Scribblings 6* by Dean Yeagle; *Oil and Water: Spectrum 2013* by Dave Dorman; *Allen Williams Personal Demons; William Stout Monsters Sketchbook #4* [Terra Nova Press]; *William Stout 50 Convention Sketches #19* [Terra Nova Press]; *Paul Bonner: Scribbles and Sketches* [Stuart Ng Books]; *The Ravishing Red Collection* by J. Scott Campbell; *Savage Beauty* by Frank Cho; *Little Help?* by Adam Hughes; *A Year of Monsters* by Mike Mignola; and *Bold* by Sho Murase.

High-profile books, such as the revised Harry Potter editions with new covers by Kazu Kibuishi [Scholastic] and *The House of Hades* by Rick Riordan with cover art by John Rocco [Disney-Hyperion], continue to inform and bring in new readers using images that expand the awareness of the arts.

The "art of" film books continue to offer gorgeous collections highlighting the artists who conceptualize and design everything from the characters to the clothes, environment, moods and colors that tell stories onscreen. *The Art of Monsters University* [Chronicle Books] includes outstanding art by Shelly Wan, Dice Tsutsumi and many others. *The Art of Frozen* [Chronicle Books] is a stunner, as is the companion storybook *Frozen: A Sister More Like Me* with art by Brittney Lee [Disney Press]. *Frozen* was the latest film to gross over one billion dollars and is currently the fifth highest-grossing film of all time. (In fact, sixteen out of the eighteen films that have grossed over one billion are fantasy-related projects, including *The Dark Knight Rises, Marvel's The Avengers, Iron Man 3, Transformers: Dark of the Moon* and *Star Wars Episode 1: The Phantom Menace*.) Marvel's *Thor: The Dark World—The Art of the Movie* and Marvel's *Iron Man 3: The Art of the Movie* feature a wide range of visual development worth seeing. *Star Wars Storyboards: The Original Trilogy, Star Wars Storyboards: The Prequel Trilogy, Star Wars: Concept* and *Star Wars Blueprints* [Abrams] all offer insight into the process of storyboarding and filmmaking that is normally kept within the studio. *The Hobbit: The Desolation of Smaug, Chronicles: Art & Design by Weta* [Harper Design] is also worth exploring. The new book celebrating the women in fantastic art, *Women of Wonder* edited by Cathy Fenner, will be available in spring 2015.

COMICS

The output of new premium material in the comic arena was exceptional in 2013. Leading off the section this year is Thomas Campi's gold award for *The Red Door*. Mark A. Nelson was recognized by the jury with a silver award for his page 1 from *Seasons*. Both should be noted for their superior use of storytelling done through a graphic narrative. Comics are one of the greatest forms of the narrative language and have initiated the passions for art among many. The well-deserved recognition that comics and graphic novels have garnered in the U.S. over the last twenty years has been astounding and exciting to watch. It is coming closer to earning the respect and admiration that comics hold among the residents of Europe. It should be noted that we welcome line drawings and story pages for Spectrum submissions. It has been brought to our attention that a perception has formed that only cover

art is favored by the jury. Let this year prove that sequential pages can receive the top accolades as well. Runners-up for award considerations include Mona, Goni Montes and David Palumbo.

As is the case for all categories, it is impossible to reflect upon and note all of the great material that came out during the year. The

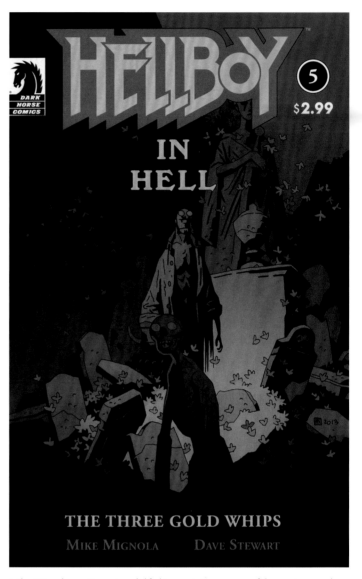

Mike Mignola continues to solidify his reputation as one of the most revered artist/writer/creators of his generation with *Hellboy in Hell*.

following list is just a sample of the stellar work you can find in modern-day comics. Our focus here is the art, not story lines, characters or the writing.

Hellboy in Hell [Dark Horse] by Mike Mignola is an easy first mention as Mignola focuses on his first love which is working in comics. The "Young Guns" at Marvel—Jim Cheung (*Infinity*), Olivier Coipel (*X-Men*), Adi Granov and Steve McNiven—continue to impress, as does Joe Quinones' work on *Black Canary* and *Zatanna* for DC. Thanks in part to Fiona Staples work on *Saga*, Image continues to grow its reputation as publishing some of the best stories in the comic field today. Terry and Rachel Dodson further grew their fan base through their regular cover assignments on *X-Men* and *Catwoman*. Jim Lee continues to dominate the industry with his new drawings for *Superman Unchained*. *March* by John Lewis with art by Nate Powell [Top Shelf] was met with critical fanfare and proved that superheroes do not rule comics.

Jae Lee's art on *Batman/Superman* and *Before Watchman: Ozymandias*, with his architectural panel designs and incorporations of shapes and tone to tell a story, makes me rank him among the best artists working in comics at the moment. I've never seen anyone else do

what Lee does and make it work so beautifully. Others deserving praise include Chris Bachalo on *Wolverine and the X-Men*, Alan Davis on *Wolverine*, Cliff Chiang on *Wonder Woman*, Ed McGuinness on *Nova* and *Guardians of the Galaxy* and Walter Simonson's new renaissance while working on the *Avengers* and *Hulk*. Arthur Adams continues his

Zander Cannon promoting his new graphic novel *Heck* at Comic-Con International in San Diego, July 2013.

great covers for Marvel, such as on *Original Sin*. Skottie Young's playful covers are sought after by a growing number of fans as are Michael Allred's *Batman '66* covers, Adam Hughes' *Fairest* and *Star Wars: Rebel Heist* covers, John Cassaday on *Uncanny Avengers* and *The Goon* by Eric Powell. Frank Cho's variant covers continue to impress, as did *Slayground* by Darwyn Cooke, *Heck* by Zander Cannon, *Trillium* by Jeff Lemire, *The Lost Boy* by Greg Ruth, Duncan Fegredo's work on *Hellboy: The Midnight Circus* and Yuko Shimizu's covers for *The Unwritten*.

Straight off of his *Punk Rock Jesus* comic, Sean Gordon Murphy began drawing *The Wake* in 2013. Murphy's raw yet controlled ability is one that engages the reader and offers a range of ability usually reserved for an artist with a lifetime of experience.

There is no greater time to be a comics fan with oversized editions, art companions, artist features and high-end collector editions. And the treatment of comic artists as stars by the general public is exciting to see. Comic conventions have become household names with fans flocking to them. Young men and women crowd the aisles with no worries of this genre becoming relegated only to an older demographic. It's an exciting shift from just ten to fifteen years ago.

Other news: In December of 2013, it was discovered that Shia LaBeouf had lifted whole sections of dialogue and visuals from Daniel Clowes' 2007 comic *Justin M. Damiano* in the actor's directorial debut with the short film *HowardCantour.com*. LaBeouf later addressed his plagiarism by posting apologies on his Twitter account that were often plagiarized from other sources. Clowes has since sued. And DC Entertainment made the announcement in October that its DC Comics operations would be moving from New York City to Burbank, California, by 2015 to improve operations.

CONCEPT ART

The concept-art category, which includes work created for films and video games, is a doorway into the rarely seen area of development. These artists shape and imagine the worlds that permeate some of

our greatest pop-culture entertainment. Starting this section off is Theo Prins who receives the gold award in this category for his moving art titled "Refugees," created for ArenaNet's massively popular game *Guild Wars 2*. Vance Kovacs' "Carter Punches a Thark," done for the film *John Carter*, stood out to the jury and received the silver award. Brian Matyas, Jaime Jones and Theo Prins (for a second piece) were recognized with nominations for awards in this category as well.

The concept artists are often the unsung heroes of the entertainment industry. They are tasked with turning a script or the director's ideas into something coherent. This art can then be shown to producers, actors, effects studios or game designers so that everyone will understand what is going on. And these artist's efforts are primarily done in anonymity with non-disclosure contracts. We "hear" murmurs that Allen Williams and Carlos Huante are working on "this" or that Stephan Martiniere and Iain McCaig were hired for "that." We are tantalized by hints at what the wizards at the Weta Workshop are up to, but we never know for sure until the film is released or an "art of" book is published. (Or they get permission to submit their work to Spectrum.)

Donato Giancola drawing his concept art for *Red Sonja, Archer* (page 147) at Comic-Con International in San Diego, July 2013.

We are fortunate indeed to have this category so well represented. Because concept art must remain internal during the development process, companies understandably require that the work not be shown until after the release of the film, game or product. Consequently, we allow for a two-year window after the product release for the artist to receive permission from the company to submit the art to Spectrum. We would like to thank the artists for submitting to this category, and the companies for providing reproduction permission.

DIMENSIONAL

We are quite proud to feature a dimensional category within these pages. That this category is relatively small is in direct correlation to the number of submissions received. We will continue to embrace and keep this category and hopefully can encourage its growth for an even better representation in future volumes.

Receiving top honors with a gold award are Brandon and Jarrod Shiflett, known as the Shiflett Bros. We had the good fortune to view their original work that stunned the jury, "Vertical Man-Tank, 1892," in person. Brandon explained that they know they are done when a piece looks to be about ninety-percent complete. This is in an effort to not overwork or polish a piece too much and thus lose the energy in their works. Colin and Kristine Poole made an impression with their work titled "Hot Diggety Dog," which received the silver award. And

congratulations must also be handed out to Shaun Tan, Forest Rogers and Jessica Dalva for being nominated. The esteemed makeup and effects artist Joel Harlow contributed his life-sized creations, which we hope will inspire more submissions for this type of work.

Scott Musgrove sculpted the "Walktopus" and made it available as a limited-edition bronze. For his own amusement, movie concept artist Simon Lee did a number of intricate sculptures on a self-imposed deadline. Daniel Horne divided his time between traditional painting and sculpting one-of-a-kind monster busts and masks. Clayburn Moore released the gorgeous hand-painted "Angelus Faux" bronze statue, which stands approximately 21 inches high. Tim Bruckner sculpted "Superman and Wonder Women: The Kiss" in addition to his masterful "Hush: Batman and Catwoman Kiss" statue, both of which were based on the art of Jim Lee. DC released its latest "Batman: Black and White" statues, one of which was designed by Sean Murphy.

EDITORIAL

The editorial category represents art done primarily for magazines or newspapers. Tran Nguyen took the top honors by receiving the gold award for "Insects of Love." Nguyen injects sincerity into her art, which is subtle, yet commanding. Her drive for creating great art is evident. Yuko Shimizu's "Hair Tree" took the silver. Shimizu's art takes a traditional approach and makes it contemporary and fresh. There is a timelessness to her art that reaches out and makes a statement. We must hand out special recognition to Nicolas Delort, Bill Mayer and Luo Xin for being nominated.

While newspapers have had a harrowing journey over the last decade as they attempt to reach their shrinking audiences, the magazines that focus on art and the number of magazines that utilize art remains strong. Let's start off with a few of the best out there. *ImagineFX* continues its excellent coverage of both top digital and traditional artists, many of whom appear in *Spectrum*. *International Artist* and *American Art Collector* both bring you some of the best fine artists from around the world and embrace the fantastic arts without prejudice.

Though the magazine industry continues to struggle there was no lack of titles scrambling for attention and many included some exceptional illustrations. Irene Gallo applied her enviable art directing abilities to turn *Tor.com* into the genre's most visually stunning publication. Anna and Elena Balbusso, Goni Montes, Sam Wolfe Connelly and Sam Burley were only a handful of the many artists who created memorable work for Gallo. *Playboy*, *Entertainment Weekly* and *Rolling Stone* all featured outstanding work in a variety of styles. Mark Fredrickson was *Mad* magazine's cover artist of choice for 2013. William Stout and James Gurney could be found in select issues of *Prehistoric Times*, Kinuko Y. Craft contributed a beautiful cover to *Asimov's Science Fiction Magazine*, while *National Geographic* called upon the skills of Jon Foster and Gregory Manchess. *Juxtapoz*, *Hi-Fructose*, *Communication Arts*, *Hogan's Alley* and *Illustration Magazine* are all worth grabbing subscriptions for. Look for a new *Spectrum* magazine to begin in 2015.

INSTITUTIONAL

The institutional category is one of the largest within *Spectrum*. Artwork here serves in connection with announcements, annual reports, calendars, greeting cards, prints, portfolios, posters, plates, website graphics, collectibles, promotional directories and self-promotion mailers, and any other venues not obviously covered by the other categories. Due to the nature of the category, it attracts a great variety. And if Bill Carman were to define "variety" through a painting, that's exactly what he submitted and what ultimately wowed the jury into giving him the gold award. Justin Sweet—a longtime favorite among his peers and a dynamic craftsman—received the silver. Those who

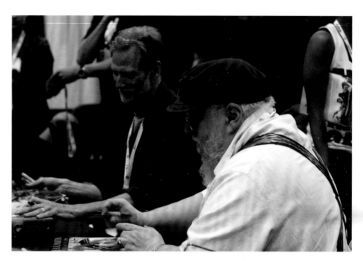

Left to right: Gary Gianni and George R.R. Martin sign copies of their *Game of Thrones: A Song of Ice and Fire* calendar at the Madefire booth at Comic-Con International, July 2013. Gianni was handpicked by Martin to paint twelve new works.

captured nominations include Ed Binkley and Donato Giancola, who both are no strangers to high praise and recognition within the field; and Rebecca Yanovskaya, a young artist with a big future who commands the ballpoint pen with a unique grace.

A number of art directors continued to stand out for their dedication to the arts. These are the people who assign projects that produce thousands of exceptional new works by our favorite artists each year. I would like to highlight Irene Gallo at Tor, Lauren Panepinto at Orbit Books, Dawn Murin and Jeremy Jarvis at Wizards of the Coast, Jeremy Cranford at Blizzard Entertainment, Marc Scheff and Jon Schindehette.

Exceptional calendars for the year include *Game of Thrones: A Song of Ice and Fire*, illustrated with twelve new paintings by Gary Gianni. John Picacio's calendar, published by his Lone Boy company, and the Boris Vallejo and Julie Bell fantasy calendar are also noteworthy.

Two significant documentaries were released: *Better Things: The Life and Choices of Jeffrey Catherine Jones*, directed by Maria Paz Cabardo; *Drew: The Man Behind the Poster*, a film about Drew Struzan directed by Erik Sharkey. Both are premium features worth viewing.

UNPUBLISHED

The unpublished category includes art created for portfolios, student work, gallery shows, experimental studies, speculative assignments and ongoing projects for work to be published at a future date. This section affords anyone the opportunity to submit an entry to Spectrum. Without question, this category represents the largest grouping of works. Likewise, it is the hardest section in which to receive an award, due to its sheer size and the amount of competing pieces. Right at the top is Omar Rayyan, whose brilliant use of color in "The Long Walk Home" received the gold award. Yukari Masuike's "Riding Horse on the Freezing Day," with its energetic composition and grand allure, captured the silver. And, as with the previous categories, we would like to point out the other three artists who were also nominated: Jean-Baptiste Monge, who is no stranger to accolades; Audrey Benjaminsen, whom we can't wait to see more work from; and Annie Stegg Gerard, an exceptional painter who we are pleased to announce will be a jury member for *Spectrum 22*.

EXHIBITS AND EVENTS

The growing popularity of pop-culture events that base their shows upon comics continues to attract massive crowds. The dominant event

remains Comic-Con International in San Diego, where the organizers' passion for promoting the comic arts continues to be their primary focus. This may appear otherwise, due to the media attention given to the movie stars at the show, but take a look at the panels, guests and program guides. The areas the organizers can control revolve wholeheartedly around comics.

The Illustration Master Class run by Rebecca Guay at Amherst College in Massachusetts continued for a week in June. The approximately one hundred attendees benefited from a full schedule of classes featuring an all-star group of working professionals. The 2013 faculty included Boris Vallejo, Julie Bell, Rebecca Guay, Donato Giancola, Gregory Manchess, Dan Dos Santos, Scott M. Fischer, Irene Gallo, Iain McCaig, Lauren Panepinto, Mike Mignola, James Gurney, Scott Allie, Mo Willems and Peter de Sève.

The exhibit "Illustrating Modern Life: The Golden Age of American Illustration from the Kelly Collection" was held at the Frederick R. Weisman Museum of Art at Pepperdine University in Malibu, California. The show ran from January 12 to March 31, 2013. Drawn from one of the country's premier collections of historic American illustration, this exhibition featured original paintings by legendary artists such as Howard Pyle, N.C. Wyeth, J.C. Leyendecker and Norman Rockwell. Working with the museum director, Michael Zakian, Flesk packaged the hardbound exhibit catalog.

Cathy and Arnie Fenner sponsored the exhibit "Gregory Manchess: A Life in Paint" at the Society of Illustrators' Museum of American Illustration in New York City from September 3 to October 26. Featuring work created throughout the course of his 25 year career, nearly sixty

Justin Sweet paints at his booth during Spectrum Fantastic Art Live, May 2013.

of Greg's commercial and explorative paintings were on display in the members' gallery of the museum. Cathy and Arnie hope to be able to sponsor similar exhibitions in the future.

The second "Spectrum Fantastic Art Live" event was held on May 17-19 in Kansas City, Missouri. Over 200 artists exhibited for this three day gathering that is open to the public. The special guests included Jon

Foster, Peter de Sève, Tara McPherson, Charles Vess, Michael Whelan and Terryl Whitlatch. Workshops with professionals in the industry and portfolio reviews by premier art directors were available. The Spectrum 20 Awards ceremony was held on the Saturday evening at the Midland Theatre.

There were two large one-man museum exhibitions focusing on James Gurney's *Dinotopia* originals. Each focused on two non-overlapping sets of artwork. The first was at the Lyman Allyn Art Museum in New London, Connecticut, and the second was at the Arkell Museum of Art in Canajoharie, New York. Gurney reported, "Both were record-setters in terms of attendance, helped by the especially strong family and school attendance. It's the small art museums, run by independent, community-spirited directors, that are likely to continue leading the way for bringing such awareness to fantastic art."

A third Spectrum exhibition began in September 2014 at the Society of Illustrators' Museum of American Illustration, curated by Irene Gallo and Gregory Manchess.

ABOUT 2013

Much of 2013 was consumed with the discussion of inequality between the few who have staggering wealth versus the majority who do not. According to the Bureau of Labor Statistics in May 2013, the majority of U.S. jobs paid less than $20.00 an hour, with 18 million jobs paying less than $10 an hour. Those making minimum wage demanded a livable wage while others insisted that an increase in minimum wage would create more unemployment. The fact remains that the minimum wage has crept up at a much slower pace than the respective costs of food, gas and housing—the basic fixed costs of what people need to pay to survive. For artists, this all ties into the amount of assignments that are available, the prices offered for their work and the free cash people have available to spend on art related material.

In original art sales news, Norman Rockwell's painting titled "Saying Grace" brought in $46 million at auction, the most paid for one of his works and certain to raise speculation among investors about future purchases of his paintings.

The strong sales of original comic art over the last five years have eliminated the prejudice that comic art dealt with up until fifteen years ago. I see the fantastic arts as being the next large area of growth for the original art market. The prices are still very reasonable in comparison to other genres.

Purchasing original art is fun, especially when it is direct from an artist. Only a small percentage of artists command prices that are far out of reach of the majority of people. Taking home a small painting or comic page will help to keep the artist creating more. There are a few types of people who buy art and each is important. One buys it based on an emotional response. Another may buy it as an investment to resell in a day or many years down the line. Some buy for both reasons. Whatever your reason, your being a patron advances the arts.

ADVICE AND WHAT IT'S WORTH

During each event where we exhibit, I make myself available to answer questions. I would like to cover a few of the most common topics that are discussed. Since I am not an artist, I cannot offer advice on how to draw. But where I can help is in the area of how to achieve your goals, regardless of the industry that you choose to enter.

I typically do not offer people advice unless I have been asked for it. This is because I want to know that someone is looking for advice first and that they will be receptive, followed by my wanting to discover specifically how I can help that person on an individual level.

I understand that some people may want advice but not know what questions to ask. Or they may be too intimidated. Let me offer some tips in this area.

My approach to formulating questions is to first identify the issue at hand, then to identify the individual who has the experience in the chosen area to ask. I run through this cycle by asking myself a lot of questions. (I talk to myself and challenge my ideas often.) Once my questions are ready, I contact one of my mentors.

I have a number of mentors whom I greatly respect. They serve as guides for personal and business issues. The majority of them are 15 to 40 years older than I am, are small business owners or achieved something in life that inspires me, or who are generally just all-around good people. I believe in surrounding myself with people whom I aspire to emulate, but most importantly they have to be good-natured and kind to others. (You do not have to be tough to be successful, but you can't let people walk all over you either.) To limit yourself to being surrounded by those who have less than you is to hold yourself back from ever being challenged and to create a false comfort zone. Comfort leads to being static and stale. Finding a mentor is imperative to being the best that you can be. They are not there to hold your hand or do the work for you. They are there to guide you when you stop and ask for directions. The driving is still up to you.

I choose carefully who I take advice from. Because when it gets down to it, there are plenty of people out there who like to give advice or offer criticism, but who have not achieved, have not created, have not made an effort to risk and place themselves into a position of being successful. They can also be the people who attempt to introduce negativity into your life, along with roadblocks. Let me give you an example.

When I first started Flesk Publications there were those who rallied behind me, who were excited for me and who offered their support. Conversely, there were those who were quite negative about my new venture. I do not think these people were malicious or realized what they were doing. In their own way, they were being protective of me by not wanting to see me fail or simply wanted more of my time, which I was not giving them any longer due to my new dedication toward the business. Or, in some cases, they would project their own failures and fears on what I was doing by questioning my goals. My desire to make books was (and remains) so strong that I let nothing get in my way. I blocked out the unnecessary noise around me and focused on my path, where I wanted to go and what I wanted to accomplish. I have always been fortunate that I let no one stop me from doing what I want to do,

and it only makes me stronger when someone makes an attempt to block my path. I am a strong believer in converting negative energy into positive energy. The point is, don't let anyone get in the way of your success. This leads to our next topic of ambition and drive.

AMBITION AND DRIVE

Why do some people have ambition while others do not? Why do some individuals have a burning drive, yet others have trouble igniting the flame? How do some achieve success while others struggle to reach their goals? How do some confront their fears and overcome them while others use fear to never begin?

I often ask these questions of myself and constructively of other people. There is no simple or singular answer. Terms like "success" and "fears" hold wide-ranging definitions to different people. To some, money and materialism is the definition of success. To others, their relationships, friends or achievement of certain personal goals determine success. Then, how a person feels about his or her own success can be viewed as a different type of success by someone looking from the outside.

To achieve a personal expression, it takes ambition and drive. How to fuel and channel it is something every person needs to discover for him or herself. It must be something close, personal and genuine. For instance, I am very aware of what pushes me hard each day. My work ethic and ambition are clearly defined in my head. I own it and know how to make it work for me.

The reason I bring this topic up is a result of being a book publisher for twelve years. I am in a position where I have taken a passion and turned it into a reality. I publish books by artists whom I admire. I feel what we are doing is important. I can express myself creatively and also make available a forum for an artist to express himself or herself fully through a book collection. We have a purpose and mission that we tackle and achieve. Passion and commitment drive us in all cases.

I will always respect someone who attempted to realize a dream yet failed. Failure is a gift to those who tried. Failure is something to embrace. You can hold your head up high knowing you gave it a shot, rather than living life continuing to only think about pursuing your passion.

I get excited for people when I hear their ideas and what they want to accomplish. Find your passion, click your gear into drive and express yourself. We are all waiting to see more people exercising their creativity and welcome all of the beautiful things that they will make.

Go be creative and have fun.

CORRECTION

Our apologies to Nils Hamm for inadvertently mislabeling his art in *Spectrum 20* to another artist. Here is his work again, this time labeled correctly.

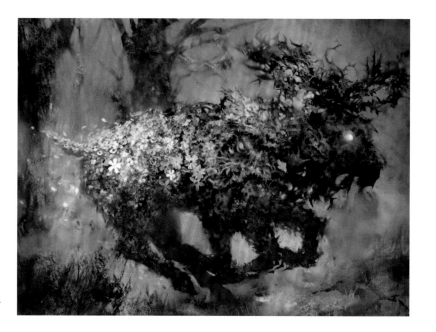

Nils Hamm
Title: Elderwood Scion *Medium:* Digital *Size:* 10 x 7.25 in.
Client: Wizards of the Coast *Art Director:* Dawn Murin

RAY HARRYHAUSEN REMEMBERED

BY WILLIAM STOUT

On a sleepy December 1958 morning, I awoke with a jolt to a vivid, four-color page in our Sunday comics section announcing a forthcoming movie packed with gigantic creatures. I could scarcely contain my excitement. A dragon! A cyclops—and *he's roasting guys*! A giant two-headed vulture! WOW!

During intermission, after catching the first Saturday matinée showing of *The 7th Voyage of Sinbad*, I called my mom, informing her that after the second feature my brothers and I were going to watch *Sinbad* again. Then I begged my parents to let us go back again on Sunday. The following weekend, the Stout kids rejected all the new features in favor of more Sinbad time, ultimately viewing that magical film seven times in two weeks. Although we delighted in its visual splendor and magnificent Bernard Herrmann score, we were particularly awestruck by the movie's unique monsters, created by someone named Ray Harryhausen. I read everything I could find about him in *Famous Monsters of Filmland*, edited by Ray's high school pal, Forrest J. Ackerman. (Ray's other teen friend was Ray Bradbury, whose short story "The Fog Horn" was brought to 1953 screens as *The Beast From 20,000 Fathoms*, with an animated monster by Harryhausen.)

The *7th Voyage* was not my first Harryhausen film. I recall being scared witless in the backseat of our Ford Fairlane as I watched *Earth vs. the Flying Saucers* at the Reseda drive-in in 1956. One by one, we Monster Kids eagerly consumed the entire Harryhausen canon, including such genre classics as *Mighty Joe Young* (1949), *20 Million Miles to Earth* (1957), *The 7th Voyage of Sinbad* (1958), *Mysterious Island* (1961), *Jason and the Argonauts* (1963), *The Valley of Gwangi* (1969), *The Golden Voyage of Sinbad* (1973), *Sinbad and The Eye of The Tiger* (1977) and *Clash of the Titans* (1981).

Today's best special effects are more realistic technically than Ray's stop-motion animation. Yet they all seem to lack something I never fail to find in the works of Harryhausen and his mentor, Willis O'Brien: humanity. Facets of their personalities can be observed in all of Ray's and O'Brien's creations.

Ray and I became fast friends upon meeting, both sharing a deep passion for O'Brien's *King Kong* (we met Fay Wray together at the 50th Anniversary of *Kong*'s premiere) and the work of that pioneer visualizer of prehistoric life, Charles R. Knight. Producer Richard Jones suggested I collaborate with Ray on a *7th Voyage* sequel. Richard and I intended the film to be a capper to Ray's career. Ray had retired, and we weren't expecting him to return to animating. Instead, he would function as the film's special effects supervisor. Our plan was to have each creature animated by a different accomplished acolyte of Ray's, allowing each to create a stirring homage to our fantasy godfather. (Ray has probably inspired more people to get into film than anyone else in the biz. Robert Rodriguez' *Spy Kids 2* is virtually a feature-length tribute to Harryhausen.)

I asked Ray for a list of all the creatures he had ever wanted to animate but for some reason (usually budgetary) never got a chance to bring to life. The *8th Voyage of Sinbad—Return to Colossa* incorporated all of these creatures (and a few more) into its story. Sadly, that film won't be made with Ray. We are left to content ourselves with Ray's rich cinematic legacy. Indulge yourself: Take ninety minutes off today to enjoy one of the imaginative worlds created by the late, great fantasy film legend, that Talos-sized giant of a moviemaker: Mr. Ray Harryhausen.

REQUIEM

In 2013 we also sadly remember the passing of these valued members of our community:

Dan Adkins [b 1937] Comic Artist
Eric Auld [b 1931] Artist
Frederic Back [b 1924] Animator
Sheilah Beckett [b 1913] Artist
Reed Cardwell [b 1955] Animator
Nick Cardy [b 1920] Comic Artist
Scott Clark [b 1970] Comic Artist
Bob Clarke [b 1926] Artist
Didier Comès [b 1958] Cartoonist
Ray Cusick [b 1928] Film Designer
Mike Dimayuga [b 1974] Artist
David Fairbrother-Roe [b ?] Artist
Stuart Freeborn [b 1914] Film Make-Up Artist
Louis S. Glanzman [b 1922] Artist
Charles Grigg [b 1916] Comic Artist
Ray Harryhausen [b 1920] SFX Artist
Mitchell Hooks [b 1923] Artist
Quentin Hoover [b 1964] Artist
Carmine Infantino [b 1925] Comic Artist
Hiro Isono [b 1945] Artist

Rune T. Kidd [b 1957] Artist
Leonard P. Leone Sr [b 1921] Art Director
Stan Lynde [b 1931] Cartoonist
Greg Martin [b ?] Artist
José Ortiz (Moya) [b 1932] Comic Artist
George Olesen [b 1924] Artist
Roy Peterson [b 1936] Cartoonist
Al Plastino [b 1921] Comic Artist
James Plumeri [b 1933] Art Director
Jesse Santos [b 1930] Comic Artist
Lou Scarborough [b 1953] Animator
Fred Scherer [b 1915] Muralist
J.C. Suares [b 1942] Artist
Gilbert Taylor [b 1914] Cinematographer
Storm Thorgerson [b 1944] Graphic Artist
Kurt Trampedach [1943] Artist
Janice Valleau Winkleman [b 1923] Artist
Delphyne Woods aka Joan Hanke-Woods [b 1945] Artist
Takashi Yanase [b 1919] Artist

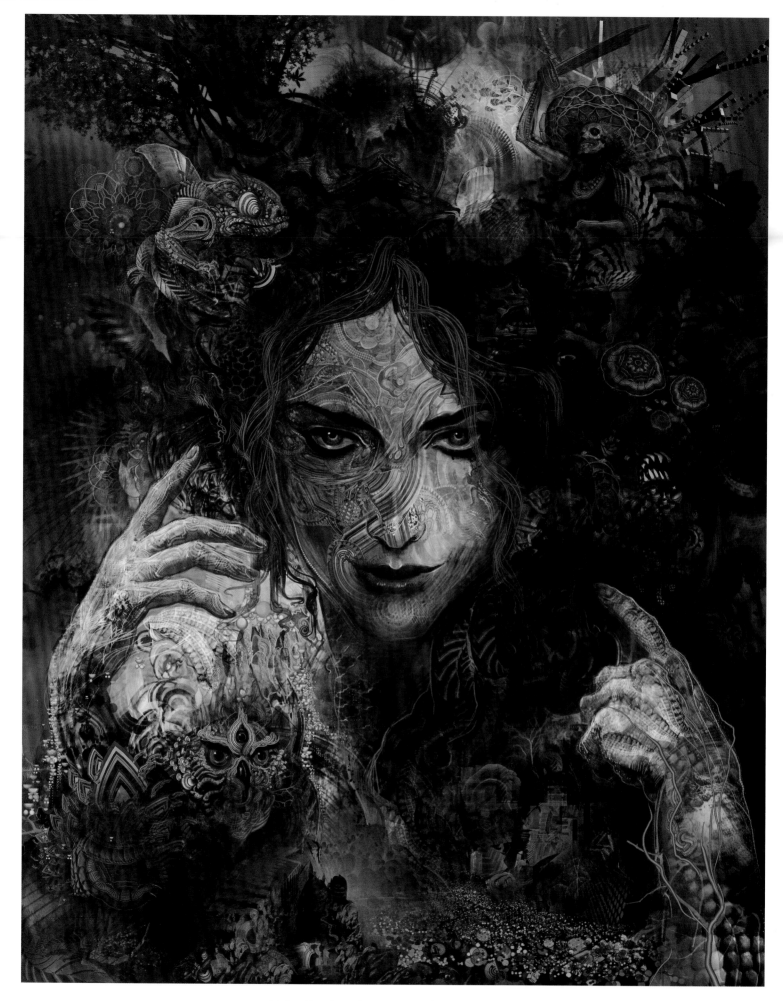

PAREIDOLIA
SPECTRUM 21 CALL FOR ENTRIES POSTER ART

Photo by Greg Preston for Spectrum Fantastic Art

ANDROID JONES

"It's the minds compulsive and involuntary acts of imagination when presented with chaos. The looseness of the rendering creates more shapes for the mind to explore."

—Android discussing "Pareidolia."

Android Jones is at the forefront of the Electro-Mineralist movement, a wave of artists whose medium is electricity and whose hardware and tools are forged from elements found deep inside the earth. Android's body of work aims to emphasize creativity as the foundation of consciousness and an agent of social change. As an Electro-Mineralist, he builds on the technical developments of past centuries in art history while pushing the boundaries of imagination with new technologies and media forms. Moving beyond the traditional organic vegetable and animal technologies of pencils, ink and brushes, Android develops latent possibilities within software programs such as Painter, Photoshop, ZBrush and Alchemy, discovering new combinations and uses for tools that exceed the original intentions of their programmers.

In Android's live-art performances—including the acclaimed PhaDroid dance performances with his wife, Phaedra Ana— he incorporates elements of chance and improvisation, inviting synchronicities that additionally exceed the individual artist's intentions and allow unscripted moments of beauty to shine through. As an experience designer, Android has contributed to films, games and to building communities in person and online. His interactive installations have enchanted tens of thousands of participants at events like Boom and Burning Man.

Viewing the digital domain as a medium of energy and light capable of expanding the nature of reality, Android's art encourages others to explore the potential interfaces of mind and machine in this time of accelerating change and increasing novelty. To this end, his art serves two related functions: It bears witness to realities accessible through heightened states of consciousness, and it also engenders heightened awareness.

"I have seen things in this life that I am incapable of translating into words. In my practice I have visited realms where the imagination ends and the terrifying beauty of infinity unfolds over and over again.

If I could distill into words exactly what motivates me to create the art that I make, then it would not be worth making it. Instead I have chosen the Pen. Honestly, I don't know why I make this art or what compels me to keep creating it; it's a mystery I intend to pursue for the rest of my life, and each image brings me closer to the Ultimate Truth."

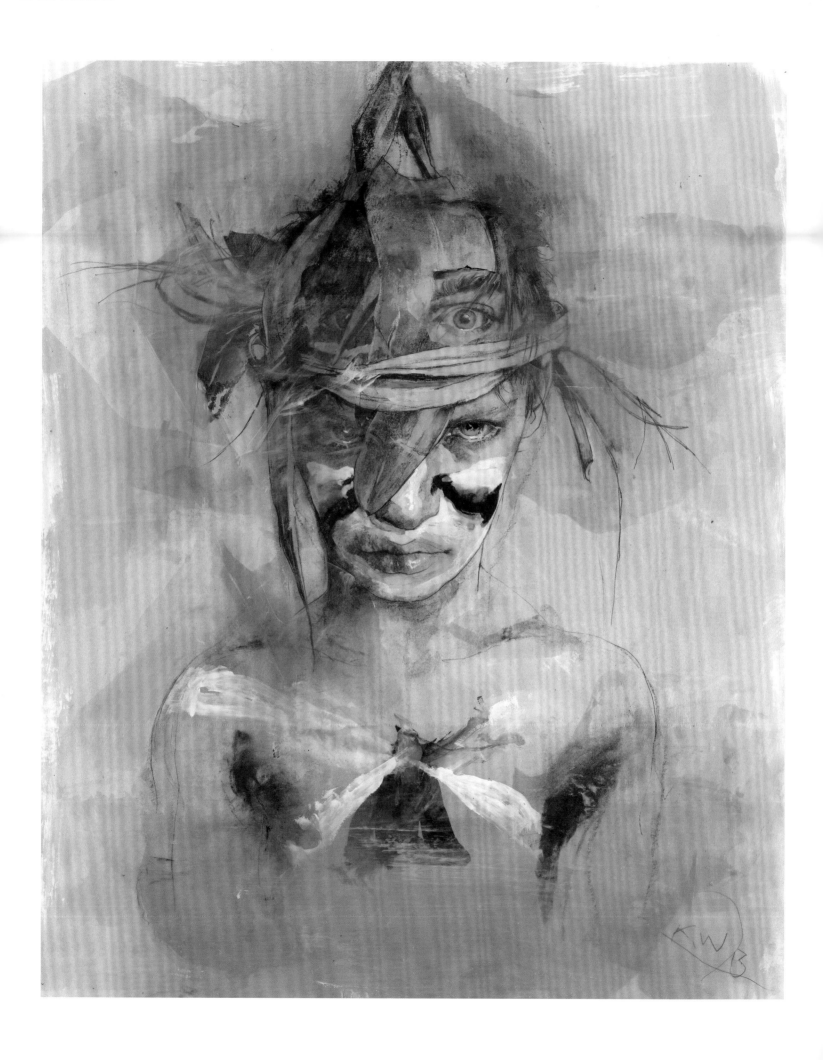

KENT
WILLIAMS

LORD OF THE FLIES

Medium: Mixed media
Size: 5.25 x 7.5 in.
Client: The Criterion Collection
Art Director: Eric Skillman

"This was a special opportunity presented to me by Eric Skillman for The Criterion Collection, which allowed me to follow in my teacher's footstep, Barron Storey and create a work based on *The Lord of the Flies*. To win this award for it makes it even more special indeed!"

—Acceptance speech written for the Spectrum 21 Awards Ceremony

Kent Williams has built up a formidable reputation as a powerful contemporary painter. His is a bold realism with combined attributes of abstraction and neo-expressionistic sensibilities. His work is characterized by strong gestural forms combined with areas of arresting detail, rendered with rich dynamic brushwork. Williams' approach to his subjects is often subjective and intense. Whether through multi-figured compositional complexity and suggestive narrative or with the straightforward lone human form, there is often autobiographical narrative at play. Favorite models, friends and the artist himself all play a role in the human story of his paintings. Williams lives in Los Angeles. He has two sons, Kerig Sun and Ian Kai.

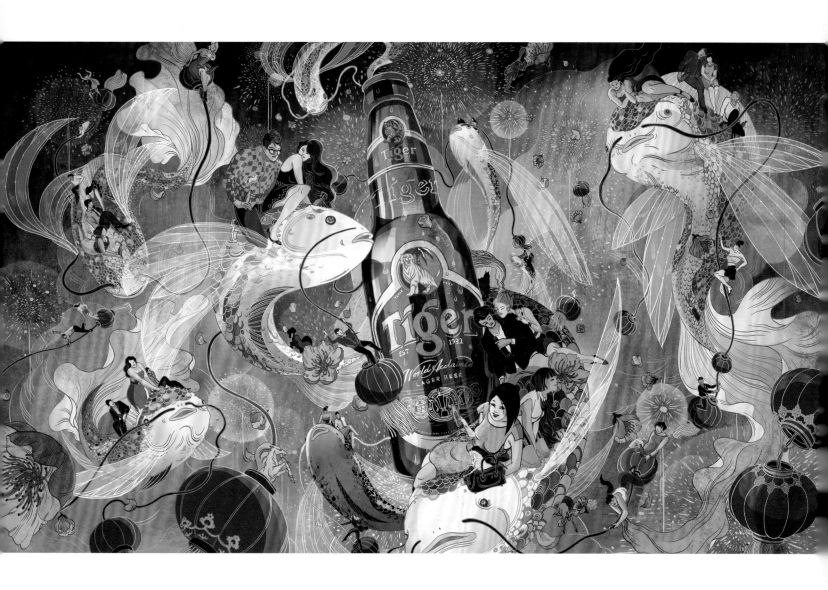

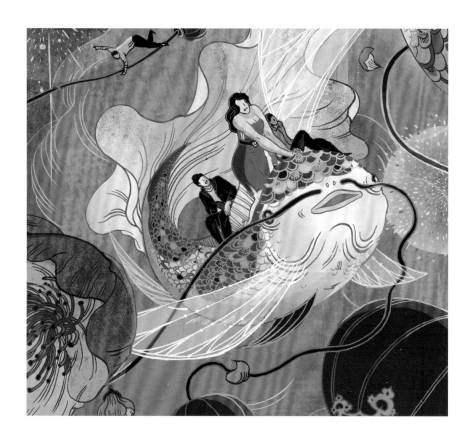

ADVERTISING SILVER AWARD

VICTO NGAI

TIGER BEER
CHINESE NEW YEAR
Medium: Mixed
Size: 42.5 x 24.8 in.
Client: Tiger Beer
Art Director: Dylan Davies

"I am deeply honored and surprised to have received the silver medal. Frankly, I didn't think I stood a chance when I saw the other nominated work. Being selected among such quality art made this award especially precious. I have always been a huge fan of sci-fi/fantasy books but couldn't see myself getting hired unless I started drawing a half-naked armored big-bosom lady riding a dragon into the sunset. However, thanks to Irene Gallo, who possesses unique eyes for new talents and the guts to be different, I got my foot in the door. Soon I realized my worry was nonsense. The sci-fi/fantasy community embraced me with the utmost warmth and encouraged me to keep doing what I do, for which I am very grateful. Over the past years, I have noticed more and more "unorthodox" looking art are being selected into Spectrum. As one of the most prestigious competitions in the industry, it's shaping the sci-fi/fantasy art landscape to be more and more diverse and accepting. So, thank you, Spectrum, the judges and all of you who have been so supportive!"

—Acceptance speech written for the Spectrum 21 Awards Ceremony

Victo Ngai is a New York based illustrator from Hong Kong who graduated from Rhode Island School of Design. "Victo" is not a boy or a typo, but a nickname derived from Victoria—a leftover from the British colonization. Apart from drawing, Victo's biggest passions are traveling and eating. She's hoping that one day she will save up enough to travel around the world and sample all kinds of cuisine. Her clients include *The New Yorker*, *The New York Times*, the Sundance Film Festival and many more. In 2014, she is one of the *Forbes* 30 Under 30 (Art & Culture). She also has been awarded two gold medals by the Society of Illustrators, among many other achievements.

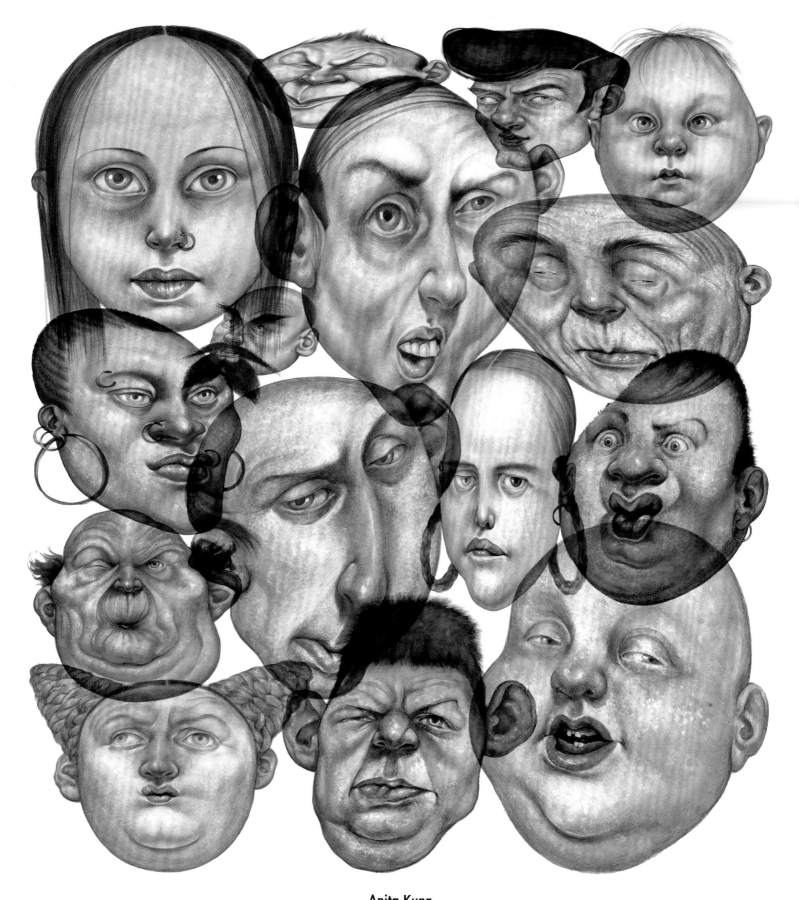

Anita Kunz
Title: Little Monsters *Medium:* Mixed
Size: 18 x20 in. *Client:* Polaroid *Art Director:* Lady Gaga

Shu Yan
Title: Go Into the Gate
Medium: Digital
Client: Spicy Horse
Size: 12 x 3.375 in.

Gabriel Verdon
Title: Hiversairies
Medium: Digital
Size: 7.25 x 10.25 in.
Client: Aliceffekt
Art Director: Devine Lu Linvega

Mark Fredrickson
Title: Robin Hood *Medium:* Digital *Size:* 22 x 15 in.
Client: High 5 Games *Art Director:* Joseph Masci

Matt Smith
Title: Zombie Harper *Medium:* Graphite
Size: 9 x 12 in. *Client:* Matt Draws Pets

Chris Rahn
Title: The Black Riders *Medium:* Oil on hardboard *Size:* 14 x 36 in. *Client:* Fantasy Flight Games *Art Director:* Zoe Robinson

Noah Bradley
Title: Our Dreadful Savior *Medium:* Digital *Size:* 36 x 21 in. *Client:* Reddit

Corinne Reid
Title: Ripple Effect *Medium:* Digital *Size:* 18 x 24 in. *Client:* Crystal Dynamics *Art Director:* Marc Scheff

Bruce Telopa
Title: Bride of Taos
Medium: Oil on panel, bronze, copper and wood frame *Size:* 32 x 48 in.

David Palumbo
Title: Unknowable *Medium:* Oil on panel *Size:* 36 x 48 in.
Client: Association of Fantastic Art *Art Director:* Pat and Jeannie Wilshire

Kari Christensen
Title: The Last Human *Medium:* Digital
Client: The Science Fiction Book Club *Art Director:* Matthew Kalamidas

With his back against the wall, one man has to dig deep within himself to solve the mystery—

WHO IS THE MANDARIN?

M1963
35c

MARVEL

M1963

35c

IRON MAN THREE

DREW PEARCE & SHANE BLACK

MARVEL

A NEW
TONY STARK
MYSTERY

IRON MAN THREE

A complete novel

SOON TO
BE A MAJOR
MOTION
PICTURE

MARVEL STUDIOS PRESENTS IN ASSOCIATION WITH PARAMOUNT PICTURES AND DMG ENTERTAINMENT A MARVEL STUDIOS PRODUCTION ROBERT DOWNEY JR. "IRON MAN 3" GWYNETH PALTROW DON CHEADLE GUY PEARCE REBECCA HALL STEPHANIE SZOSTAK JAMES BADGE DALE WITH JON FAVREAU AND BEN KINGSLEY
CASTING BY SARAH HALLEY FINN, C.S.A. MUSIC BY BRIAN TYLER MUSIC SUPERVISOR DAVE JORDAN VISUAL EFFECTS PRODUCER MARK SOPER VISUAL EFFECTS SUPERVISOR CHRISTOPHER TOWNSEND COSTUME DESIGNER LOUISE FROGLEY EDITED BY JEFFREY FORD, A.C.E. PETER S. ELLIOT PRODUCTION DESIGN BILL BRZESKI DIRECTOR OF PHOTOGRAPHY JOHN TOLL, ASC
EXECUTIVE PRODUCERS STAN LEE DAN MINTZ EXECUTIVE PRODUCER ALAN FINE EXECUTIVE PRODUCERS CHARLES NEWIRTH VICTORIA ALONSO STEPHEN BROUSSARD EXECUTIVE PRODUCER LOUIS D'ESPOSITO EXECUTIVE PRODUCER JON FAVREAU PRODUCED BY KEVIN FEIGE SCREENPLAY BY DREW PEARCE & SHANE BLACK DIRECTED BY SHANE BLACK

Paolo Rivera
Title: Iron Man 3 Cast & Crew Poster *Medium:* Gouache and acrylic, digital *Size:* 22 x 17 in.

Hui Tan
Title: Farmer's Market *Medium:* Acrylic *Size:* 12 x 6 in. *Client:* Guangzhou Daily Newspaper. Guangzhou. China *Art Director:* Li Qian

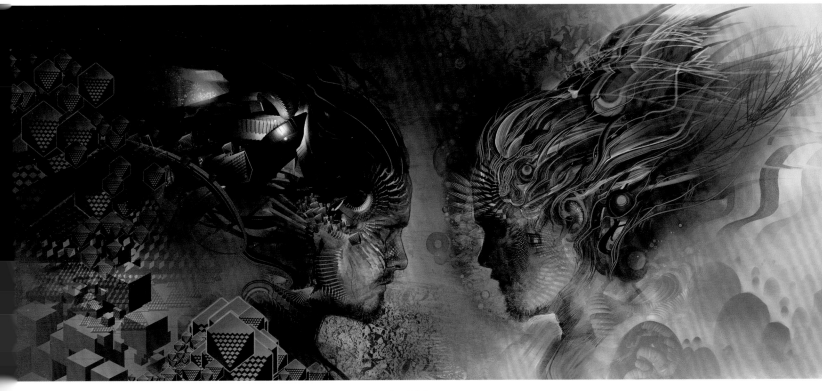

Android Jones
Title: Magnus *Medium:* Digital

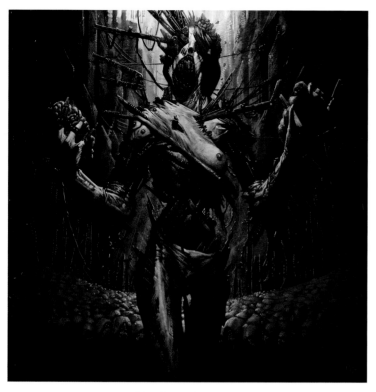

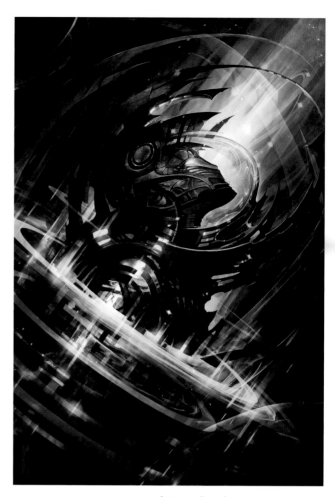

Matthew G. Lewis
Title: Abnormal Life Portrayed
Medium: Digital *Size:* 12 x 12 in. *Client:* Inbreeding Rednecks

Raymond Swanland
Title: Portals to Canaan
Medium: Digital *Client:* Deeds of Flesh

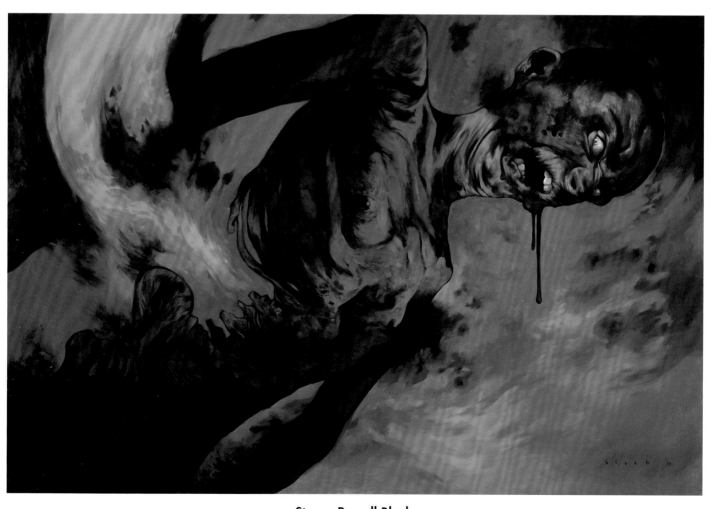

Steven Russell Black
Title: White Zombie *Medium:* Oil on masonite *Size:* 24 x 36 in. *Client:* Richard Evans

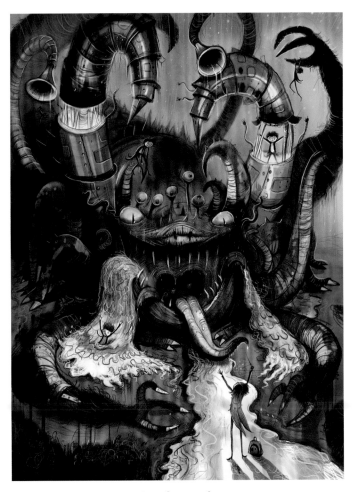

Timothy Banks
Title: Eukaria *Medium:* Digital *Size:* 9 x 12 in.
Client: Humans As Animals/True Music

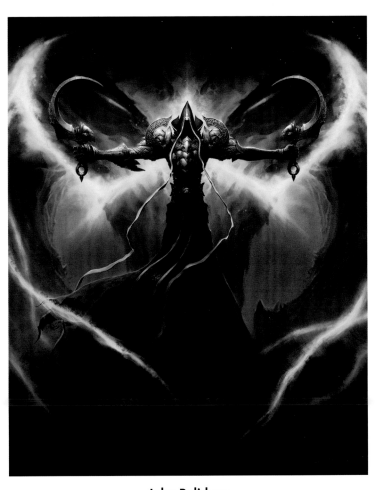

John Polidora
Title: Malthael, Angel of Death *Medium:* Photoshop *Size:* 37.75 x 46.75 in.
Client: Blizzard Entertainment *Art Director:* Glenn Rane

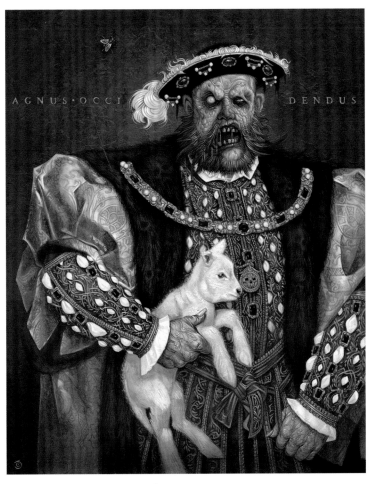

Chris Seaman
Title: Lamb to the Slaughter
Medium: Acrylic *Size:* 15 x 17.25 in. *Client:* Last Rites Gallery, NYC

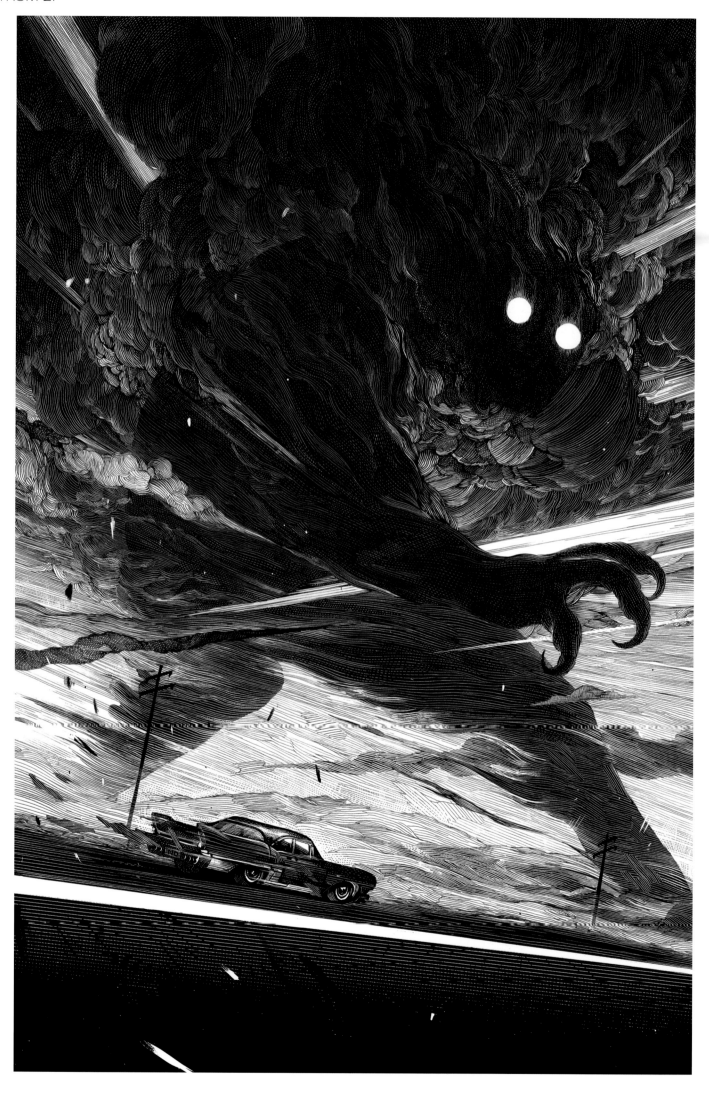

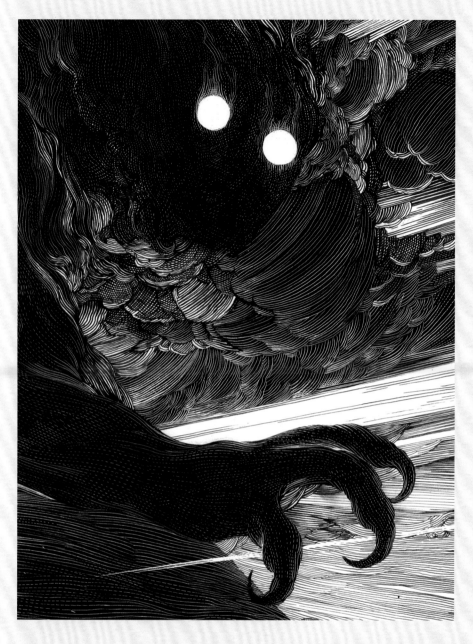

NICOLAS DELORT

THE END OF THE ROAD
Medium: Ink on clayboard
Size: 12 x 16 in.
Client: Solaris Books
Art Director: Simon Parr

"I'm extremely honored to be part of Spectrum this year, alongside many artists I've always considered inspirations, I will strive to be worthy of the honor by working even harder!"

—Delort's acceptance speech provided to Spectrum

Delort is a Canadian and French illustrator who grew up in the Ontario wilderness before moving to France. His teenage years were spent copying Akira Toriyama's art leaving him with a great passion for ink work, a fire that would only be fueled further by the discovery of artists like Bernie Wrightson, Franklin Booth and Gustave Doré. Now finding inspiration in everything from video-game art to architecture or symbolist art, Delort tries to put a refreshing spin on a rather traditional technique by working on modern and dramatic compositions. He lives and works in the gray, rainy suburbs of Paris, where Delort shares a house and studio space with his dog (who—on his good days—doubles as his assistant).

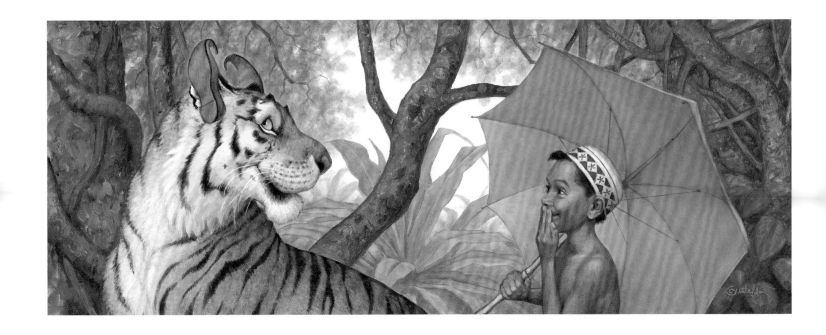

Photo by Greg Preston for Spectrum Fantastic Art

BOOK
SILVER AWARD

SCOTT
GUSTAFSON

LITTLE SAMBHA AND THE TIGER
WITH THE BEAUTIFUL PURPLE
SHOES WITH
CRIMSON SOLES
Medium: Oil
Size: 24 x 9 in.
Client: The Greenwich Workshop Press
Art Director: Wendy Wentworth

"Well, every year since the beginning I've watched this book get bigger and better, and the pool of talent just grow and deepen. And to be singled out among that group is a high honor indeed and I thank everybody."

—During Gustafson's acceptance speech at the Spectrum 21 Awards Ceremony

Scott Gustafson's earliest artistic ambition was to become an animator. But by the time he entered high school, he had become acquainted with artists from the "Golden Age of Illustration," opening a door onto a world of beautiful images that continue to inspire him to this day. Lingering dreams of making animated films, however, led Gustafson to major in animation at the Chicago Academy of Fine Arts. It wasn't until after leaving art school that the possibility of a career as a freelance illustrator began to truly appeal to him. Over the nearly thirty-five years that span his career, he has had the opportunity to fulfill commissions for a number of varied clients and publishers, such as Celestial Seasonings, *Playboy* magazine, *The Saturday Evening Post*, The Bradford Exchange, DreamWorks and The Greenwich Workshop. Gustafson's *Favorite Nursery Rhymes from Mother Goose*, was released as a companion book to the fairy-tale book by The Greenwich Workshop Press, featuring over forty-five color illustrations. It won a silver in the category of Best Children's Picture Book for 2008 at the Independent Publisher Book Awards.

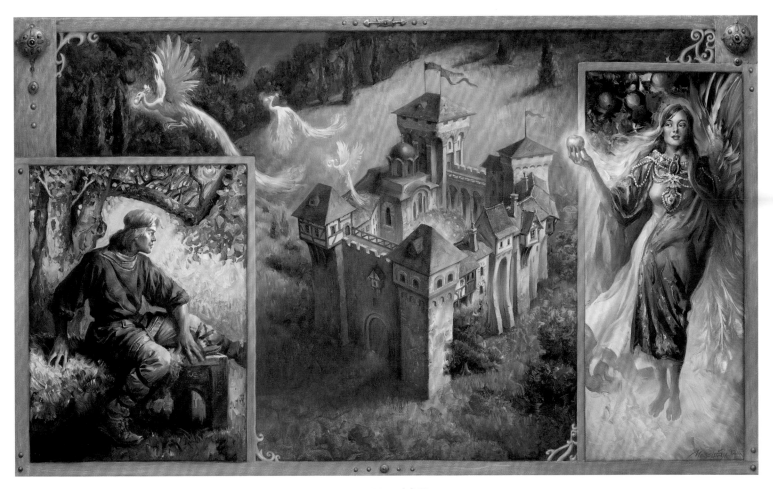

Petar Meseldžija
Title: The Golden Apple Tree 1 *Medium:* Oil *Size:* 48 x 72 cm. *Client:* Dark Dragon Books

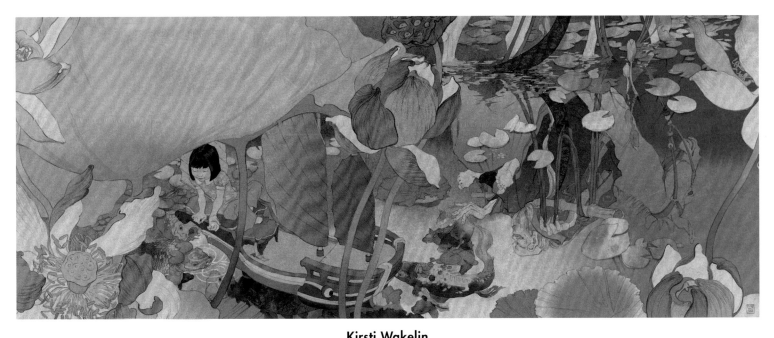

Kirsti Wakelin
Title: "Lilies, Koi and Chang Kuo-lao" from Dream Boats *Medium:* Pencil on Rives BFK, ink on rice paper, acrylic, watercolor, and digital
Size: 22 x 8.75 in. *Client:* Simply Read Books *Art Director:* Dimiter Savoff

John Harris
Title: Fire: the Road Beside the Wall *Medium:* Oils on canvas *Size:* 40 x 44 in.

Bill Mayer
Title: Lapin Noir *Medium:* Mixed media *Size:* 13 x 13 in.
Client: BlabWorld #3 *Art Director:* Monte Beauchamp

Bill Mayer
Title: The Industrialist *Medium:* Mixed media *Size:* 13 x 13 in.
Client: BlabWorld #3 *Art Director:* Monte Beauchamp

Adam S. Doyle
Title: The Dream Thieves *Medium:* Oil and digital *Size:* 11 x 9 in.
Client: Scholastic Books *Art Director:* Christopher Stengel

Anna and Elena Balbusso
Title: Ekaterina and the Firebird *Medium:* Acrylic and digital
Size: 8.25 x 11.75 in. *Client:* Tor.com *Art Director:* Irene Gallo

Anna and Elena Balbusso
Title: Beowulf *Medium:* Acrylic and digital *Size:* 6.5 x 8.75 in.
Client: Black Cat Publishing *Art Director:* Nadia Maestri

Chris Beatrice
Title: Swamp Things *Medium:* Digital *Size:* 13 x 10 in. *Client:* Tailwind

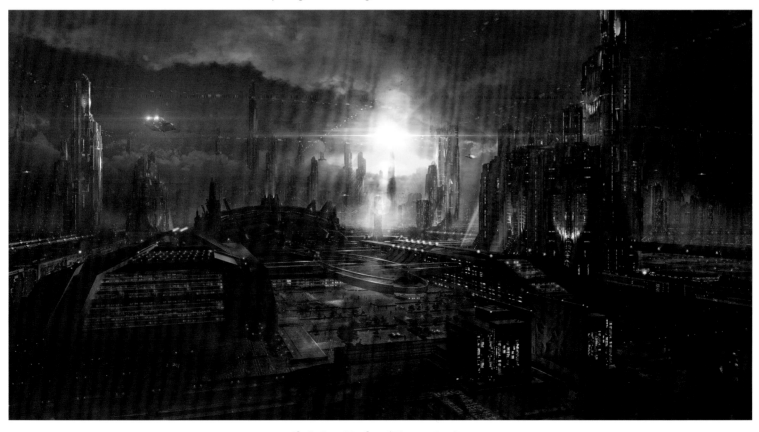

Christian Hecker/Tigaer Design
Title: The Curve of the Earth by Simon Morden *Medium:* Digital *Size:* 5.5 x 8.25 in. *Client:* Orbit Books *Art Director:* Lauren Panepinto

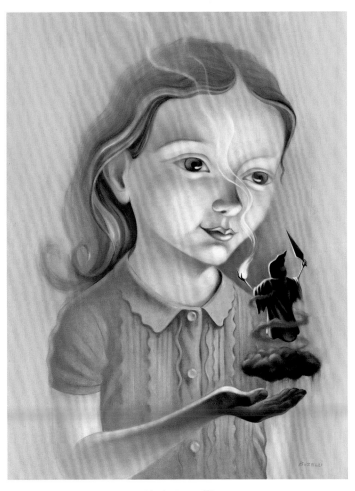

Chris Buzelli
Title: Brimstone and Marmalade *Medium:* Oil on panel
Size: 14 x 19 in. *Client:* Tor *Art Director:* Irene Gallo

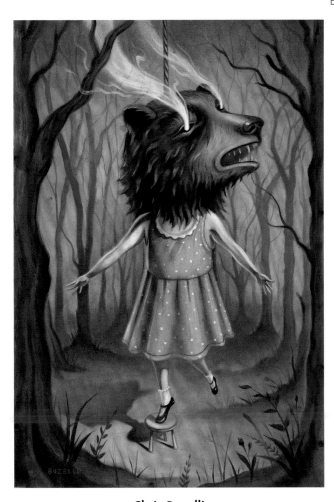

Chris Buzelli
Title: The Hanging Game *Medium:* Oil on panel
Size: 11 x 16 in. *Client:* Tor *Art Director:* Irene Gallo

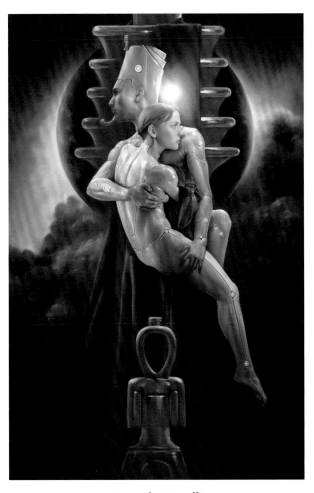

Corrado Vanelli
Title: Elektron *Medium:* Digital, Corel Painter *Size:* 14 x 21.5 in.
Client: Linee Infinite Edizioni *Book:* Elektron *Author:* Cinzia Baldini

Dan dos Santos
Title: Mercy Thompson: Night Broken *Client:* Ace Books
Art Director: Judith Murello

Dan dos Santos
Title: Shifting Shadows *Medium:* Oils on board *Client:* Ace Books *Art Director:* Judith Murello

Christian Alzmann
Title: The Florist and the Witch *Medium:* Digital *Size:* 11.25 x 9 in.
Client: Battlemilk 3, Design Studio Press

Dennis Dorrity
Title: Awakening the Banshee *Medium:* Digital *Size:* 12 x 16 in.
Photographer: Jason Morrison *Art Director/Designer:* Devon Dorrity

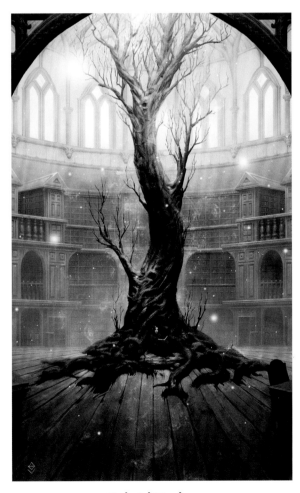

Gabriel Verdon
Title: Neverland's Library *Medium:* Digital *Size:* 7.75 x 12.5 in.
Client: Neverland Books *Art Director:* Roger Bellini & Rebecca Lovatt

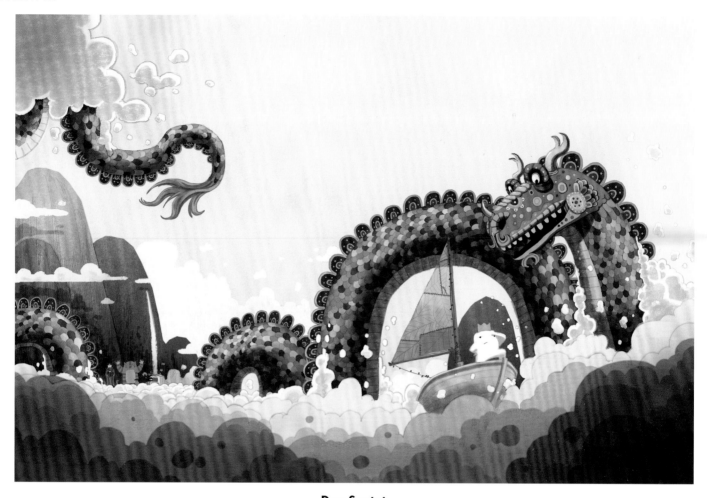

Dan Santat
Title: The Adventures of Beekle: The Unimaginary Friend/The Rainbow Dragon
Medium: Mixed media and digital *Size:* 18 x 12 in. *Client:* Little, Brown Books for Young Readers *Art Director:* David Caplan

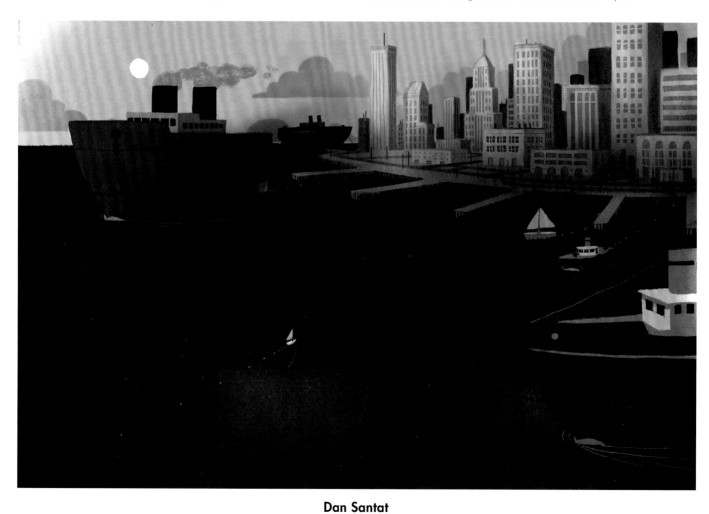

Dan Santat
Title: The Adventures of Beekle: The Unimaginary Friend/Arriving to the Real World
Medium: Mixed media and digital *Size:* 18 x 12 in. *Client:* Little, Brown Books for Young Readers *Art Director:* David Caplan

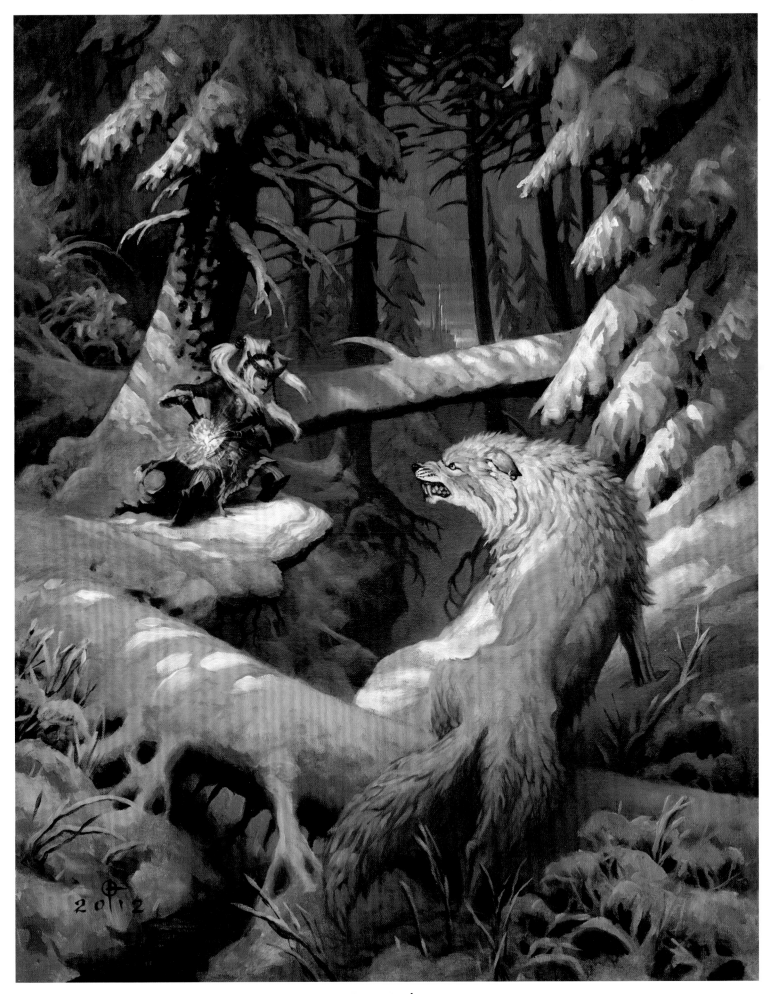

Daren Bader
Title: The White Witch *Medium:* Oil on canvas *Size:* 24 x 30 in.
Client: Paizo Publishing *Art Director:* Sarah Robinson

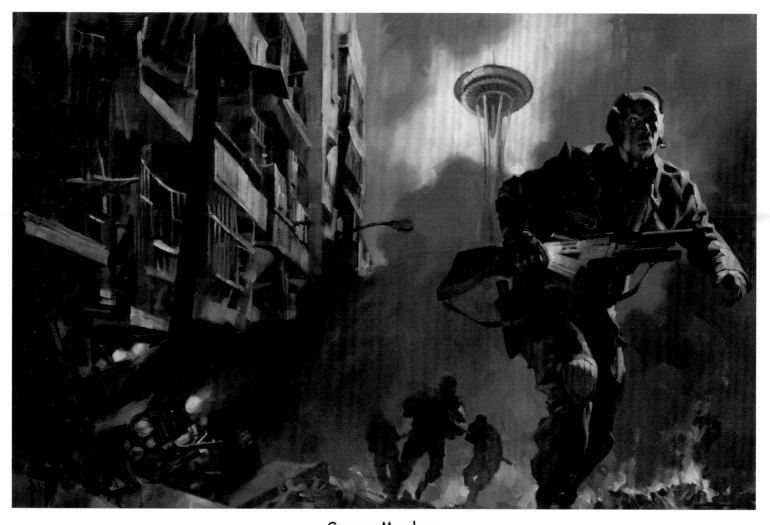

Gregory Manchess
Title: Vampire Earth vol. 2, Way of the Bear *Medium:* Oil on linen *Size:* 20 x 30 in.

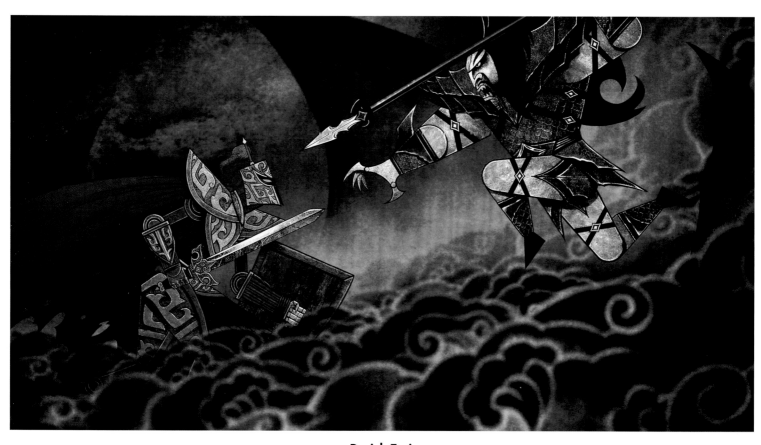

Derick Tsai
Title: Mythika: King of the Mountain *Medium:* Digital *Size:* 11 x 17 in. *Client:* Magnus Rex Studio

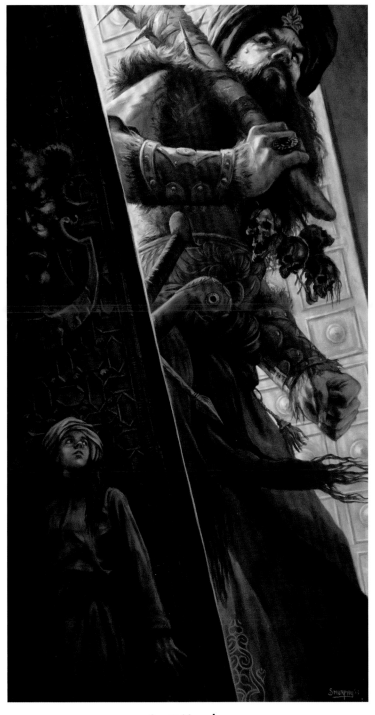

Scott Murphy
Title: Badru and the Giant *Medium:* Oil on masonite *Size:* 12 x 22.5 in.

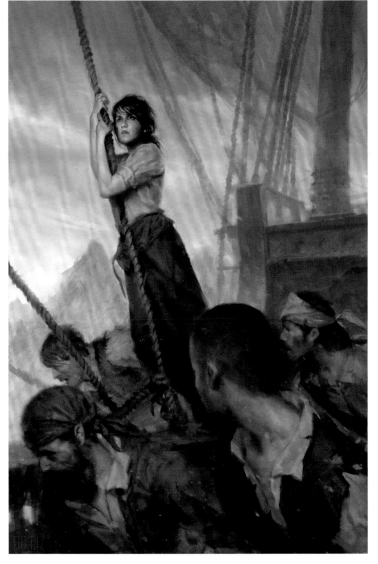

Karla Ortiz
Title: Homecoming *Medium:* Digital *Size:* 8 x 12 in.
Client: Tor Books *Art Director:* Irene Gallo

Jason Chan
Title: Lost Covenant *Medium:* Digital *Size:* 10 x 15 in.
Client: Pyr *Art Director:* Lou Anders

Michael Manomivibul
Title: Chupacabra *Medium:* Sumi Ink
Size: 9 x 14 in. *Client:* Scholastic

Jeffrey Alan Love
Title: Wolves *Medium:* Digital *Size:* 7.5 x 10.25 in.
Client: Gollancz *Art Director:* Nick May

Jason Chan
Title: Widdershins *Medium:* Digital *Size:* 10 x 15 in. *Client:* Pyr *Art Director:* Lou Anders

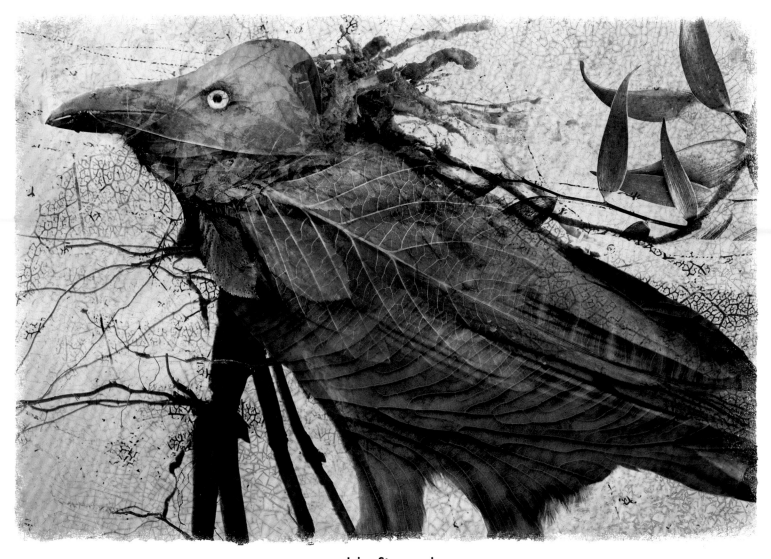

Ivica Stevanovic
Title: Bird Leaf: Wonderbook: The Illustrated Guide to Creating Imaginative Fiction
Medium: Digital painting *Client:* Abrams Image *Art Director:* Jeffrey Vandermeer

Ivica Stevanovic
Title: Messianic Rabbit: Wonderbook: The Illustrated Guide to Creating Imaginative Fiction
Medium: Digital painting *Client:* Abrams Image *Art Director:* Jeffrey Vandermeer

Kali Ciesemier
Title: It's Oh So Quiet *Medium:* Digital *Size:* 17 x 12 in. *Client:* Nobrow *Art Director:* Ben Newman

Scott Gustafson
Title: The Robber's Feast *Medium:* Oil *Size:* 24 x 8 in. *Client:* The Greenwich Workshop Press *Art Director:* Wendy Wentworth

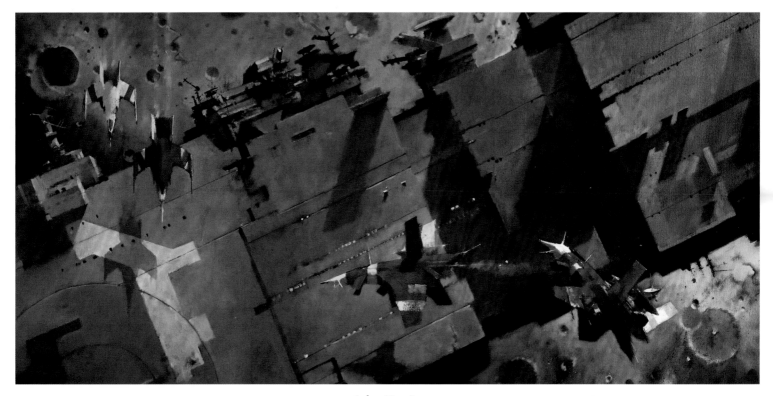

John Harris
Title: Ancillary Justice *Medium:* Oil on canvas *Size:* 42 x 24 in. *Client:* Orbit Books *Art Director:* Lauren Panepinto

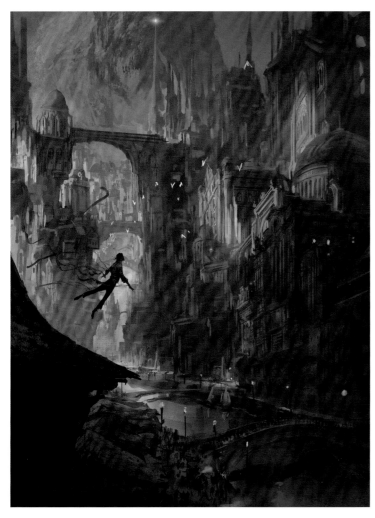

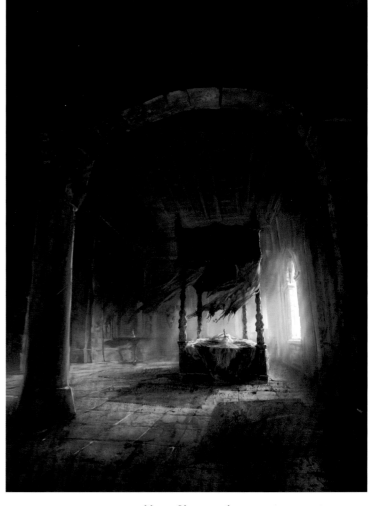

Marc Simonetti
Title: Thunderer *Medium:* Digital *Size:* 9 x 12 in.
Client: Panini Books France *Art Director:* Mathieu Saintout

Marc Simonetti
Title: Rules of Ascension *Medium:* Digital
Size: 9 x 12 in. *Client:* Editions J'ai Lu

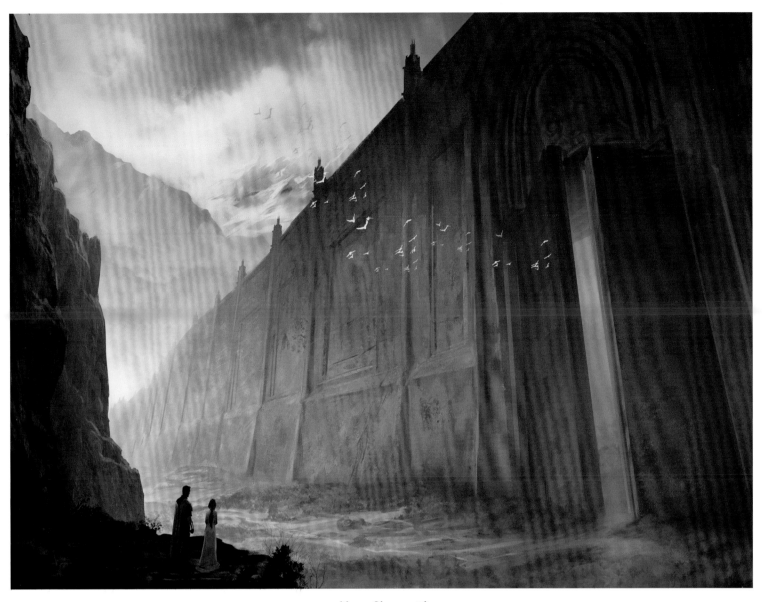

Marc Simonetti
Title: Third Kingdom *Medium:* Digital *Size:* 12x 9 in. *Client:* Editions Bragelonne *Art Director:* Fabrice Borio

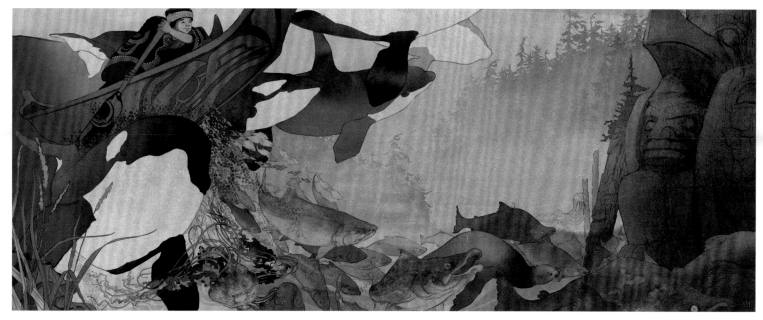

Kirsti Wakelin
Title: "Floating Towards the Shores of Haida Gwaii" from Dream Boats
Medium: Pencil on Rives BFK, ink on rice paper, acrylic, watercolor, and digital
Size: 22 x 8.75 in. *Client:* Simply Read Books *Art Director:* Dimiter Savoff

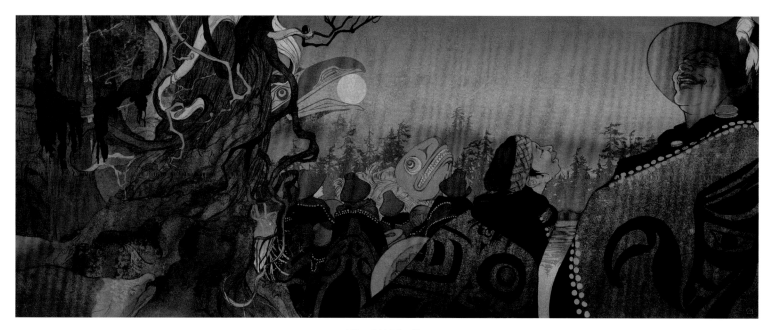

Kirsti Wakelin
Title: "Sun Turns to Fire" from Dream Boats
Medium: Pencil on Rives BFK, ink on rice paper, acrylic, watercolor, and digital
Size: 22 x 8.75 in. *Client:* Simply Read Books *Art Director:* Dimiter Savoff

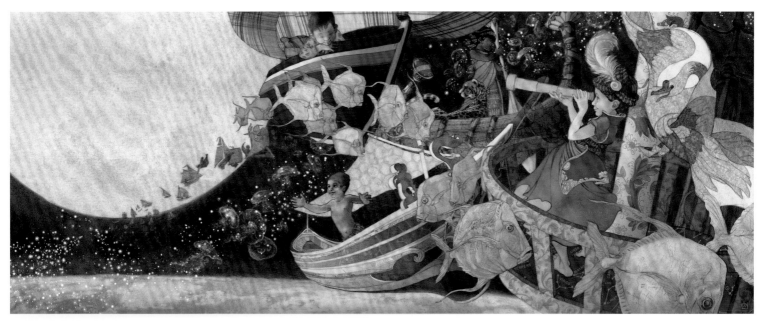

Kirsti Wakelin
Title: "Maps and Moon Jellies" from Dream Boats
Medium: Willow charcoal on vellum, ink, acrylic, watercolor, fabric, ephemera, and digital
Size: 22 x 8.75 in. *Client:* Simply Read Books *Art Director:* Dimiter Savoff

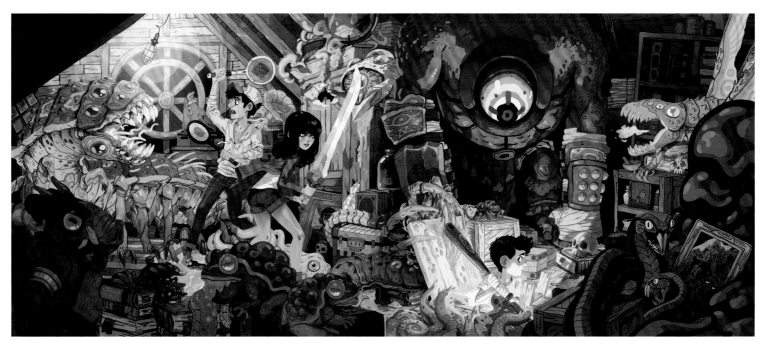

Sam Bosma
Title: Scare Scape *Medium:* Ink and digital *Client:* Scholastic Books *Art Director:* Phil Falco

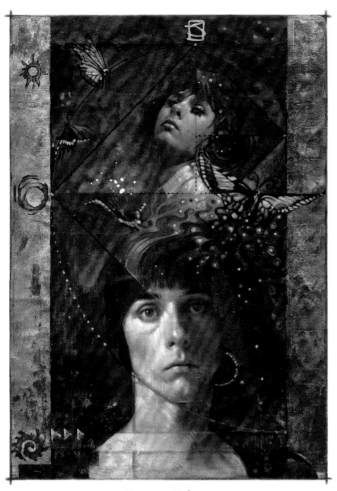

Terese Nielsen
Title: Jeffrey Catherine *Medium:* Acrylic, oil, colored pencil and gold leaf
Size: 6 x 8.75 in. *Designer:* Maria Carbado

Eric Deschamps
Title: The Fog Giant *Medium:* Digital *Size:* 12 x 19 in.
Client: Simon and Shuster *Art Director:* Jessica Handelman

Jon Lezinsky
Title: Boy of Bone *Medium:* Mixed media and digital
Size: 2269 x 3300 pixels *Client:* Siman Media Works *Art Director:* Jason Snyder

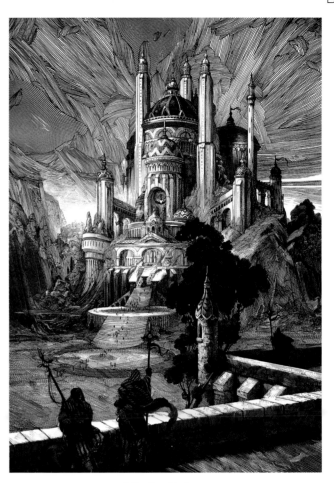

Nicolas Delort
Title: Book of Tyrael 3
Medium: Ink on clayboard *Size:* 10 x 14 in.
Client: Blizzard Entertainment *Art Director:* Doug A. Gregory

Nicolas Delort
Title: Book of Tyrael 1
Medium: Ink on clayboard *Size:* 10 x 14 in.
Client: Blizzard Entertainment *Art Director:* Doug A. Gregory

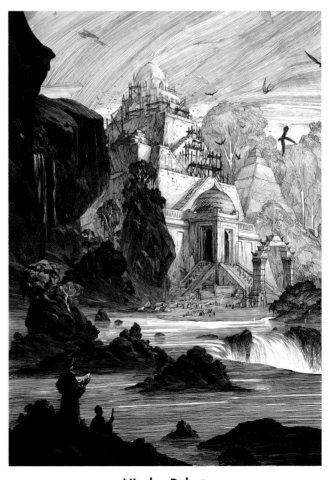

Nicolas Delort
Title: Book of Tyrael 2
Medium: Ink on clayboard *Size:* 10 x 14 in.
Client: Blizzard Entertainment *Art Director:* Doug A. Gregory

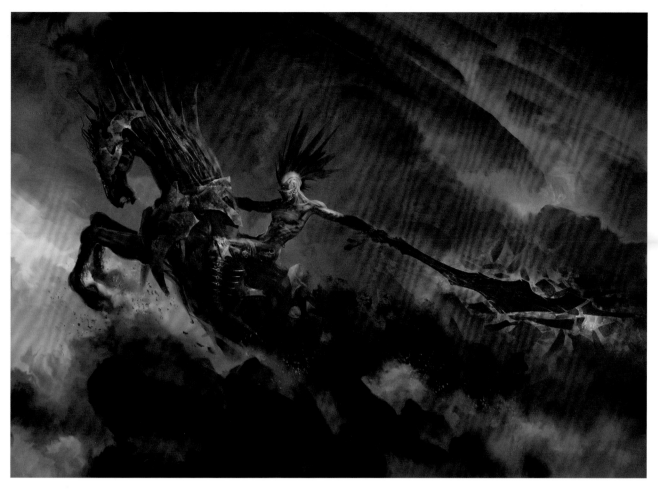

Paolo Barbieri
Title: Knight of War (From "Apocalypse" illustrated by Paolo Barbieri)
Medium: Digital *Size:* 19.5 x 27.75 in. *Client:* Arnoldo Mondadori Editore

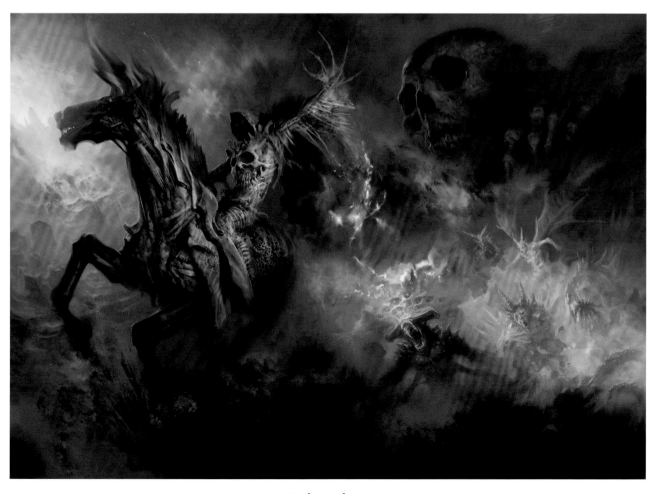

Paolo Barbieri
Title: Knight of Death (From "Apocalypse" illustrated by Paolo Barbieri)
Medium: Digital *Size:* 19.5 x 27.75 in. *Client:* Arnoldo Mondadori Editore

Scott Altmann
Title: Trail of Sword *Medium:* Digital
Client: Grey Griffins *Art Director:* Jon Lewis

Noah Bradley
Title: The Burdens of Triumph *Medium:* Digital
Size: 16 x 24 in. *Client:* The Sin of Man

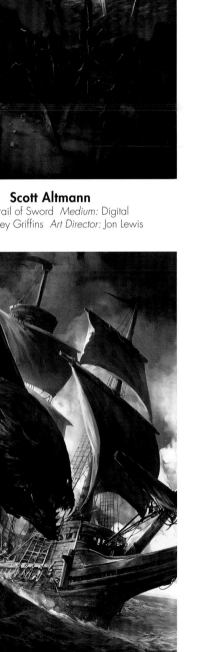

Nekro
Title: Nature, XIII: The Art of Nekro
Medium: Digital *Client:* Norma Editorial

Kekai Kotaki
Title: Quintessence *Medium:* Digital
Size: 11 x 16 in. *Client:* Tor Books *Art Director:* Irene Gallo

Sam Weber
Title: The Uninvited *Medium:* Oil and digital *Size:* 20 x 30 in. *Client:* Pyr Books *Art Director:* Lou Anders

Sean Andrew Murray
Title: Ambassador Quann *Medium:* Pencil, digital *Client:* Fishwizard Press

Sean Andrew Murray
Title: Illiandar the Mage Tree *Medium:* Digital *Client:* Fishwizard Press

Sean Andrew Murray
Title: Commorus Rex: The Grand Levitator
Medium: Pencil, digital *Client:* Fishwizard Press

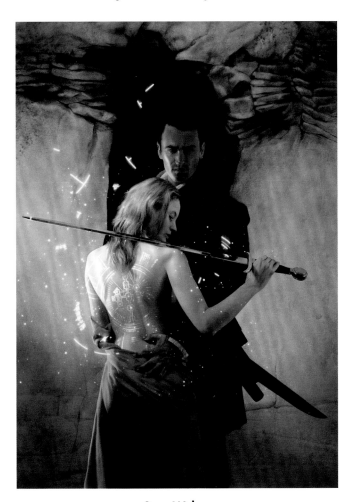

Sam Weber
Title: The Barrow *Medium:* Oil on board
Size: 20 x 30 in. *Client:* The Criterion Collection *Art Director:* Eric Skillman

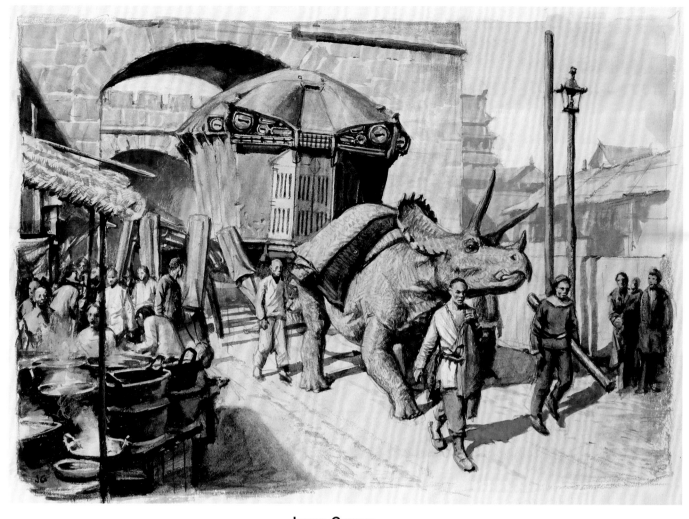

James Gurney
Title: Intruder *Medium:* Watercolor *Size:* 7 x 10 in.
Client: Dover Publications *Art Director:* Lorin Wood *Designer:* Jeff Menges

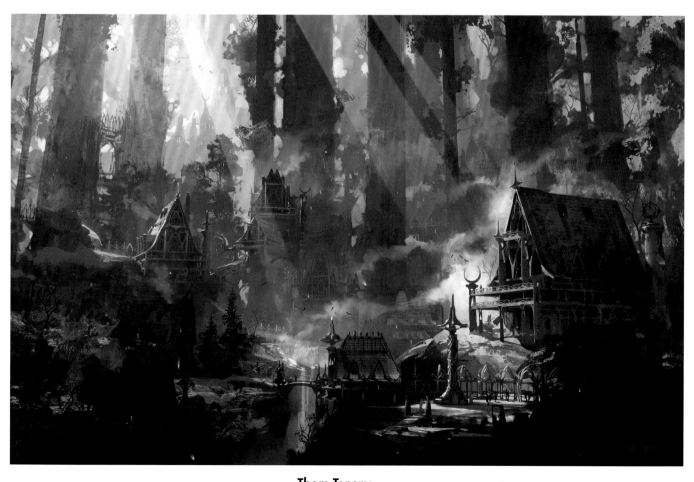

Thom Tenery
Title: Elven City *Client:* Wizards Of The Coast *Art Director:* Kate Irwin and Jon Schindehette

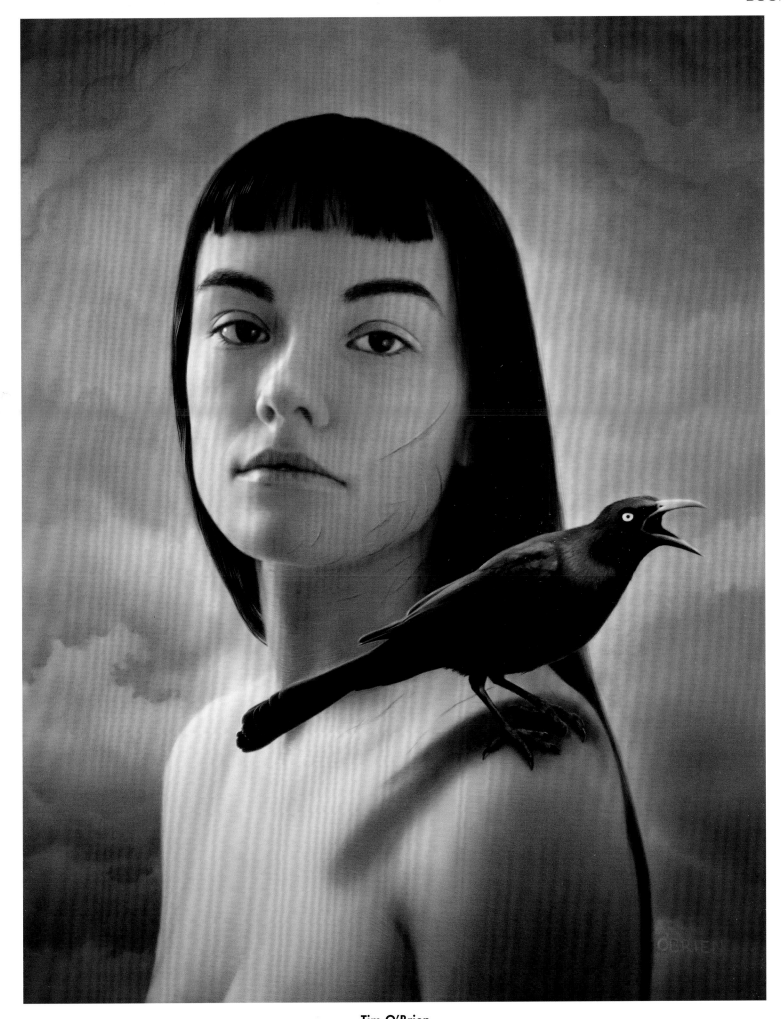

Tim O'Brien
Title: Anima by Wajdi Mouawad *Medium:* Oil and airbrush on panel *Size:* 16 x 22 in. *Client:* Grupo Planeta *Art Director:* Tim O'Brien

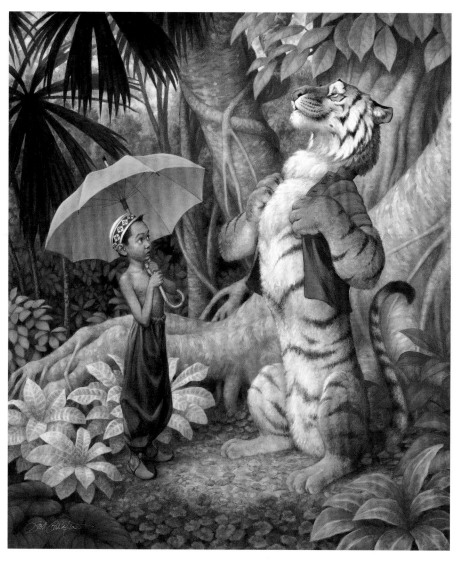

Scott Gustafson
Title: Little Sambha and the Tiger With the Beautiful Red Coat
Medium: Oil *Size:* 24 x 28 in.
Client: The Greenwich Workshop Press
Art Director: Wendy Wentworth

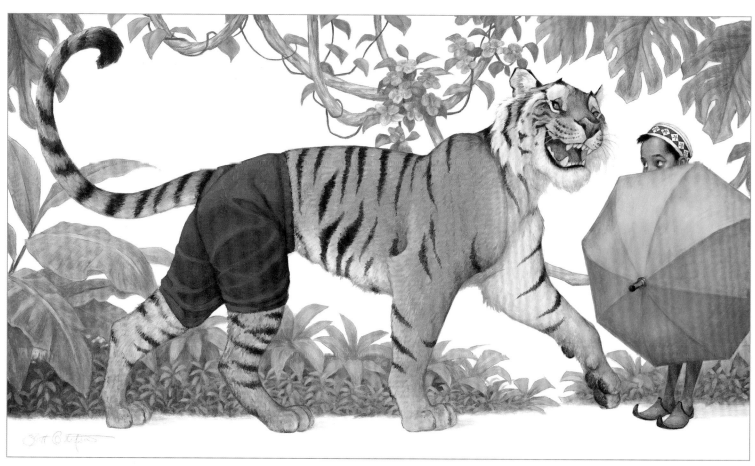

Scott Gustafson
Title: Little Sambha and the Tiger With the Beautiful Blue Trousers *Medium:* Oil *Size:* 24 x 14 in.
Client: The Greenwich Workshop Press *Art Director:* Wendy Wentworth

Tuna Bora
Title: Koza, Monkey King
Medium: Digital
Size: 12 x 10 in.

Tuna Bora
Title: Koza, Waning Light
Medium: Digital
Size: 12 x 10 in.

Vance Kovacs
Title: Queen Annes Revenge *Medium:* Ink and digital *Client:* Ubisoft/Insight Editions *Art Director:* Chrissy Kwasnik

Vance Kovacs
Title: Kraken Mermaids Skeleton *Medium:* Ink and digital
Client: Ubisoft/Insight Editions *Art Director:* Chrissy Kwasnik

Vance Kovacs
Title: Blackbeard *Medium:* Ink and digital
Client: Ubisoft/Insight Editions *Art Director:* Chrissy Kwasnik

Vance Kovacs
Title: Becoming Blackbeard *Medium:* Ink and digital
Client: Ubisoft/Insight Editions *Art Director:* Chrissy Kwasnik

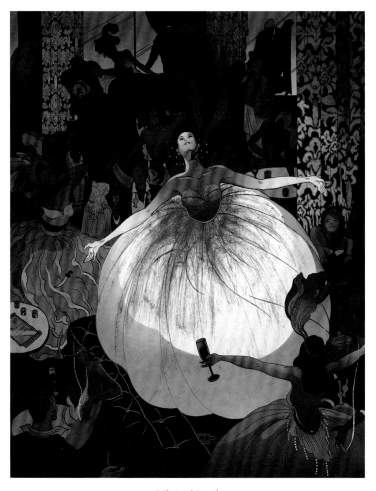

Victo Ngai
Title: End of the End of Everything *Medium:* Mixed
Size: 16 x 20.25 in. *Client:* Tor.com *Art Director:* Irene Gallo

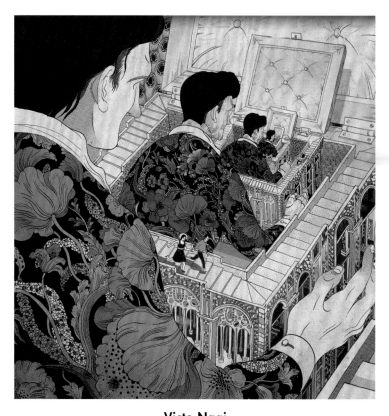

Victo Ngai
Title: Window or Small Box *Medium:* Mixed
Size: 13.5 x 14 in. *Client:* Tor.com *Art Director:* Irene Gallo

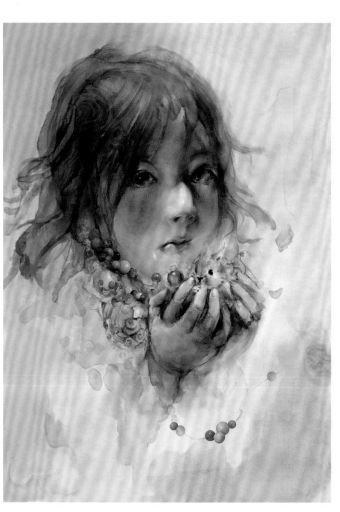

Shaun Tan
Title: Rules of Summer: Never Ruin a Perfect Plan
Medium: Oil on canvas *Size:* 34 x 30 in.
Client: Arthur A. Levine Books/Scholastic

Te Hu
Title: Hope *Medium:* Digital *Size:* 11.7 x 16.5 in. *Client:* EXPOSE 11

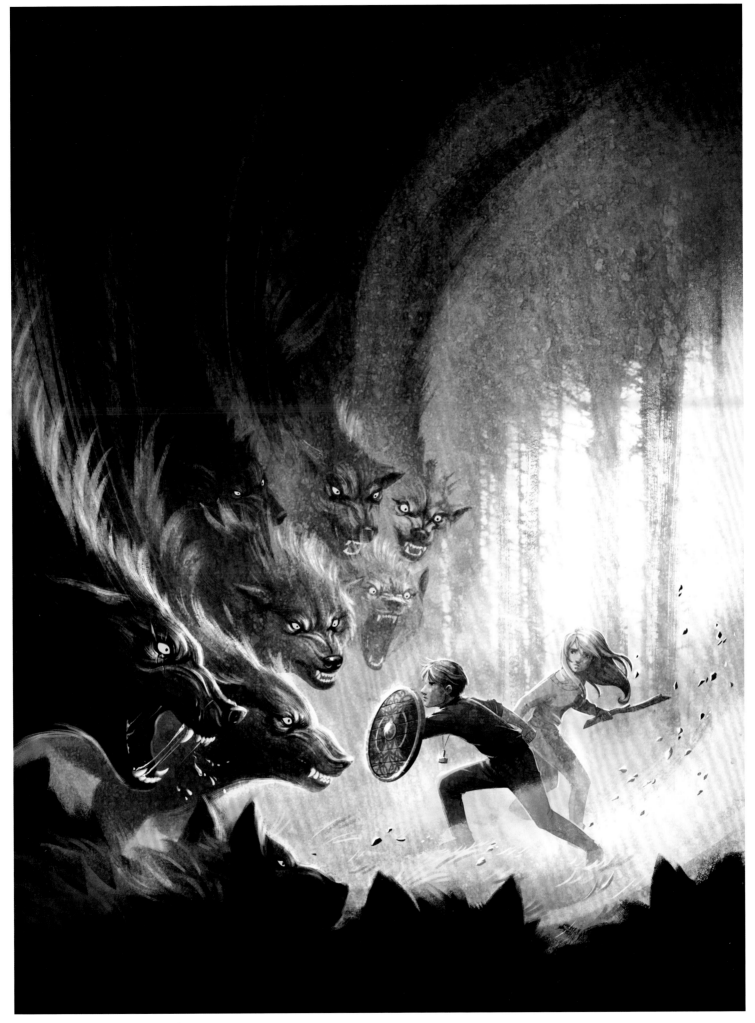

Vivienne To
Title: Loki's Wolves (The Blackwell Pages, Book 1) *Medium:* Ink and digital
Client: Little, Brown and Company *Art Director:* Sasha Illingworth

Wayne Haag
Title: Troll Mountain Book 1 *Medium:* Oil on paper
Size: 13.5 x 19 in. *Client:* Momentum Books

Wayne Reynolds
Title: Freeport 2 *Medium:* Acrylic *Size:* 11.5 x 15.25 in.
Client: Green Ronin *Art Director:* Hal Mangold

Didier Graffet
Title: Miss Octopus *Medium:* Digital
Client: Le Pre Aux Clercs ED *Art Director:* Didier Graffet

Stephen Hickman
Title: Sea Without a Shore *Medium:* Oil color
Size: 15 x 25 in. *Client:* Baen Books *Art Director:* Toni Weisskopf

Wayne Reynolds

Title: Pathfinder, Bestiary IIII *Medium:* Acrylic *Size:* 11.5 x 15.25 in. *Client:* Paizo Publishing *Art Director:* Sarah Robinson

Yuko Shimizu
Title: Melancholy of Mecha Girl
Medium: Ink drawing on paper with digital coloring
Client: Viz Media *Art Director:* Nick Mamatas

Yuko Shimizu
Title: Monstrous Affections
Medium: Ink drawing on paper with digital coloring
Size: 8 x 10 in. *Client:* Candlewick Press *Art Director:* Nathan Pyritz

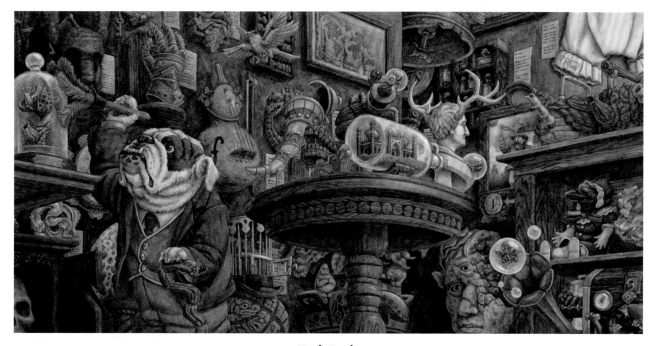

Zack Rock
Title: Homer Henry Hudson's Curio Museum
Medium: Watercolor *Size:* 16 x 8 in. *Client:* Creative Editions *Art Director:* Rita Marshall

Yuko Shimizu
Title: Three Scenarios in which Hana Sasaki Grows a Tail
Medium: Ink drawing on paper with digital coloring *Size:* 5 x 8 in. *Client:* A Strange Object *Art Director:* Callie Collins and Jill Meyers

Petar Meseldžija
Title: Frightened Monster *Medium:* Oil
Size: 13 x 17.5 cm. *Client:* Dark Dragon Books

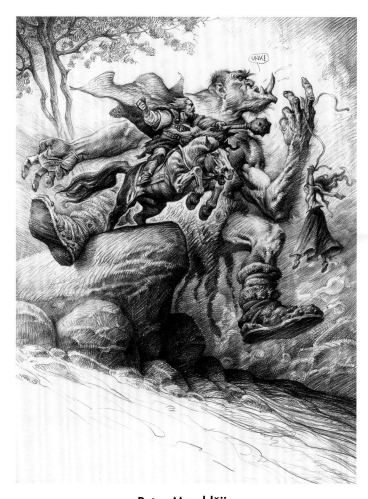

Petar Meseldžija
Title: Unk! *Medium:* Pencils *Size:* 30 x 42 cm.
Client: John Fleskes and Dark Dragon Books

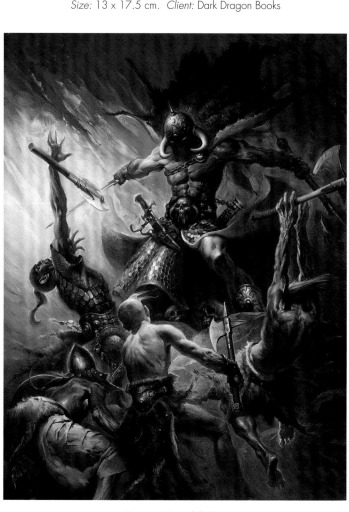

Petar Meseldžija
Title: Homage to Frazetta *Medium:* Oil
Size: 55 x 72 cm. *Client:* Gregg Spatz and Dark Dragon Books

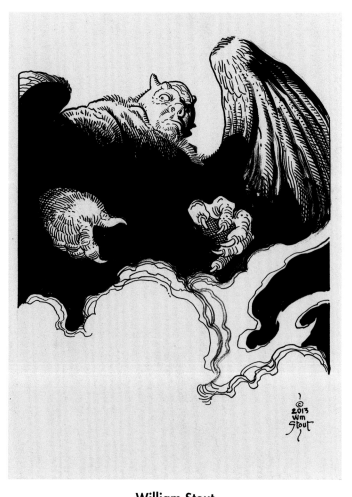

William Stout
Title: Faust's Devil *Medium:* Ink on paper
Size: 11 x 18.5 in. *Client:* Terra Nova Press

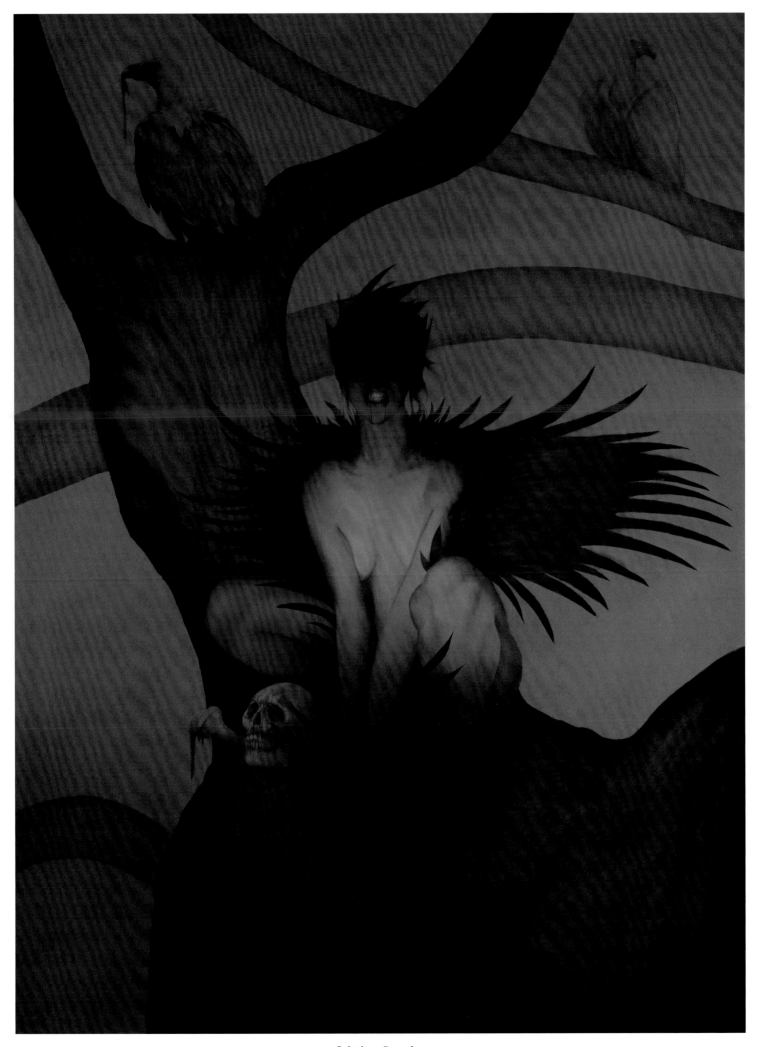

Cristina Bencina
Title: Roost *Medium:* Acrylic and digital *Client:* Art Order *Art Director:* Jon Schindehette

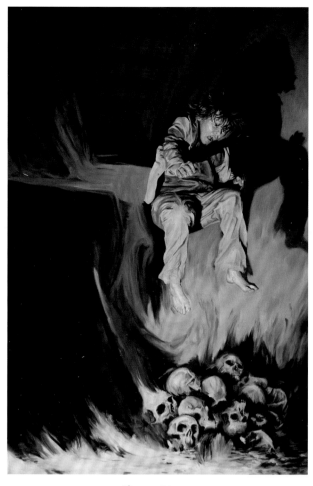

Shane Pierce
Title: Vampirism Son is Man *Medium:* Oil on canvas
Size: 24 x 36 in. *Client:* 44 Flood *Art Director:* Kasra Ghanbari

Todd Lockwood
Title: Grudgebearer *Medium:* Digital
Size: 14 x 24 in. *Client:* Pyr Books *Art Director:* Lou Anders

Todd Lockwood
Title: Witch Wraith *Medium:* Digital *Size:* 16 x 21 in.
Client: Random House *Art Director:* David Stevenson

Donato Giancola
Title: Eragon, Capter 1 *Medium:* Oil on board
Size: 18 x 27 in. *Client:* Random House *Art Director:* Isabel Warren-Lynch

John Jude Palencar
Title: The Last Dark *Medium:* Acrylic *Size:* 27 x 23 in. *Client:* Penguin Books *Art Director:* Lisa Amoroso

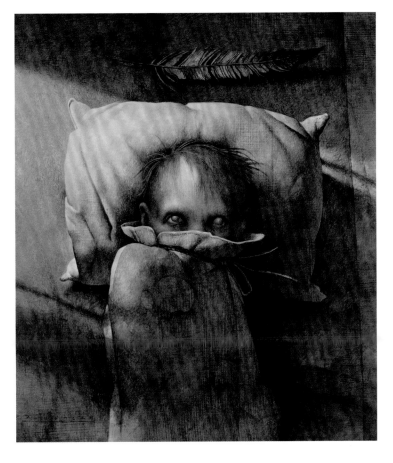

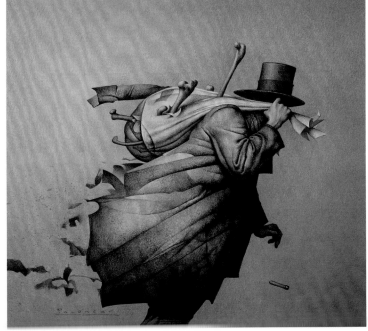

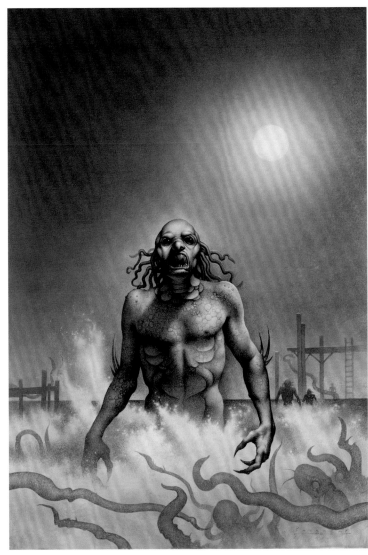

above:
John Jude Palencar
Title: A Terror *Medium:* Acrylic *Size:* 12 x 14 in.
Client: Tor Books *Art Director:* Irene Gallo

top right:
John Jude Palencar
Title: Rag and Bone *Medium:* Acrylic *Size:* 15.5 x 13.75 in.
Client: Tor Books *Art Director:* Irene Gallo

right:
John Jude Palencar
Title: Weird Shadows Over Innsmouth *Medium:* Acrylic *Size:* 29 x 17 in.
Client: Titan Books *Art Director:* Steve Saffel

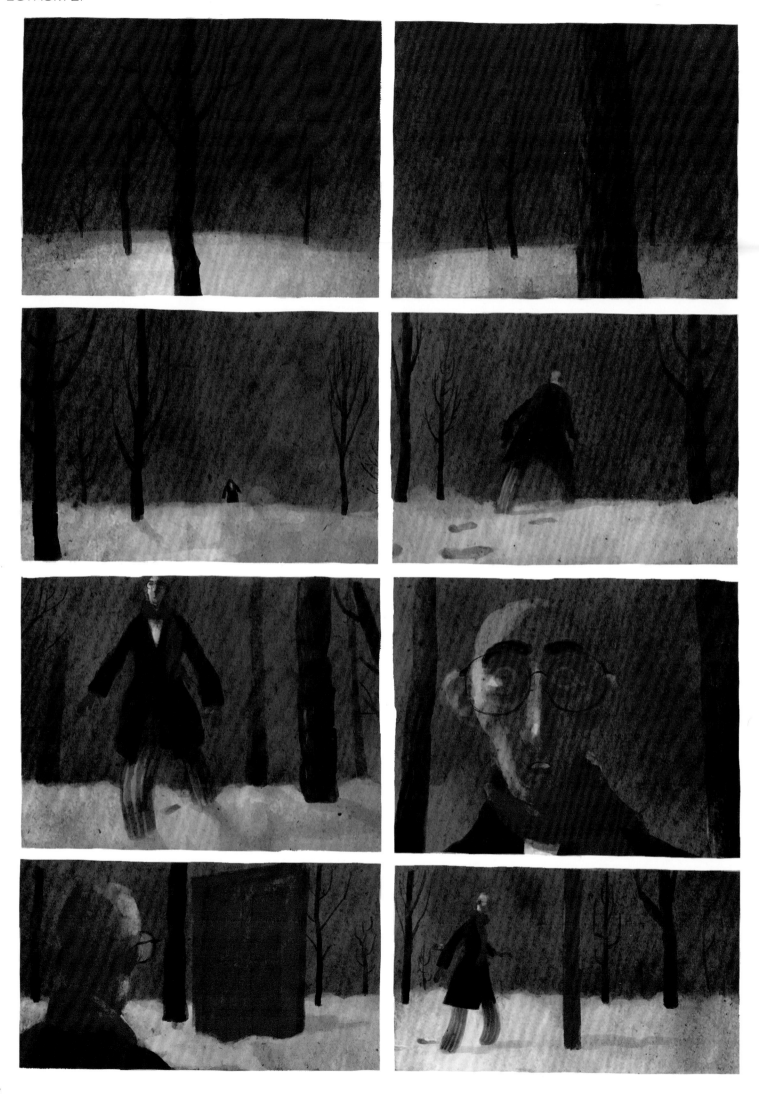

THOMAS CAMPI

THE RED DOOR
Medium: Digital
Size: 10 x 14 in.

"I've been drawing since I can remember, it's always been the place where I could feel in peace with everything and everyone. All the lines, the colors, shadows and forms are probably the most inner expression of myself. Creating comics is like a journey in a world that I imagine and draw, but not control, and all the characters in it are my journey friends, it's sort of living more lives even if it's fictional. On the other hand this award is very real and very important to me. It means that people can relate with my art, and feel something when looking at it, even if it is for just a second. Thank you for that second."

—Campi's acceptance speech provided to Spectrum

Campi is based in Sydney, Australia. He has been drawing comics for over fourteen years. His work has been published in Italy, France, Belgium, Switzerland, Canada, Brazil and Korea by several publishers, such as: Sergio Bonelli Editore, Coniglio Editore, Adonis/Glénat, LeLombard, Dupuis, Munhakdongne, among others. His latest book is *Les Petites Gens* published in October 2012 by LeLombard [Brussels, Belgium]. He is currently drawing a graphic novel for Dupuis Editions, written by the Belgian reporter Pascale Bourgaoux [RTBF Television] in collaboration with the writer Vincent Zabus. Campi is also illustrating a picture book for ELI Editions [Italy]. His last solo exhibition was "Les Petites Gens" in December 2012 at the Comic Strip Center in Brussels, Belgium.

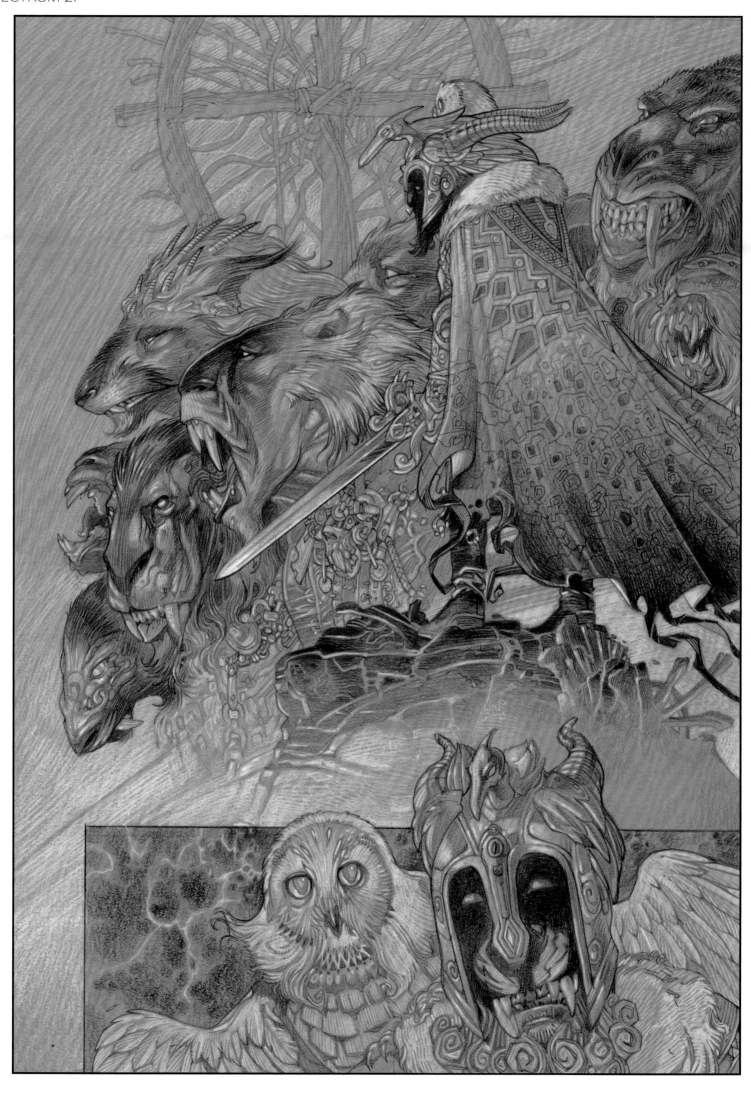

COMIC SILVER AWARD

MARK A. NELSON

SEASONS, PAGE 1

Medium: Black and white pencil on grey paper
Size: 10 x 14 in.
Client: Monster Massacre
Art Director: Dave Elliot

"If it wasn't for all you artists out there, I wouldn't be where I am today. You guys have raised the standards and the bars and created the incredible universe that does nothing but enhance creativity so thank you very much for being out there to help me do what I do."

—During Nelson's acceptance speech at the Spectrum 21 Awards Ceremony

Nelson's artistic journey has allowed him to research everything from the prehistoric to contemporary symbols and images from cultures around the world. It has also focused on our relationships with animals, their stories and fables and how they differ from culture to culture. His personal images are a collection of strokes and marks, made by various tools, to create a believable world linking these symbols and visuals together. The visual story can be simple or complex, humorous or mysterious, full of fantastic creatures or just one object, and in color or black-and-white. All of these elements become the basis for his visual images. Sometimes they are a series of drawings and sometimes the statement is complete in one image. Nelson cannot expect the viewer to know all of the symbols and their meaning in his work. Part of that is up to their personal interpretations and reactions to his images. We all know that, as time moves on, words and images change their meaning to each generation. But he hopes that his love of the natural world, its mystery, its shapes and forms, its textures and its beauty comes across in his work.

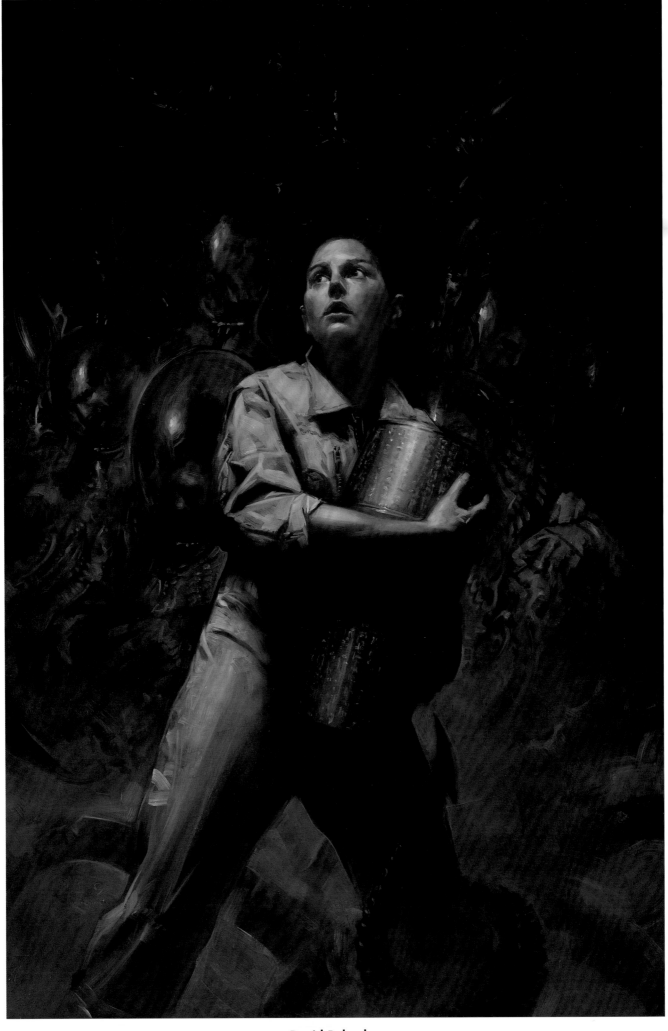

David Palumbo
Title: No Good Deed *Medium:* Oil on panel *Size:* 16 x 24 in. *Client:* Dark Horse Comics *Art Director:* Scott Allie

Mona
Title: All Corners of the Country, The Lost Buildings 4
Medium: Digital *Size:* 7.5 x 11.5 in.

Goni Montes
Title: Clive Barker Next Testament 6 *Medium:* Digital
Size: 7 x 10.5 in. *Client:* Boom! Studios *Art Director:* Chris Rosa

Alex Garner
Title: Batgirl #30 *Medium:* Digital *Size:* 10.5 x 15.75 in.
Client: DC Comics *Art Director:* Katie Kubert and Mike Marts

Alex Garner
Title: Batgirl #25 *Medium:* Digital *Size:* 10.5 x 15.75 in.
Client: DC Comics *Art Director:* Katie Kubert and Mike Marts

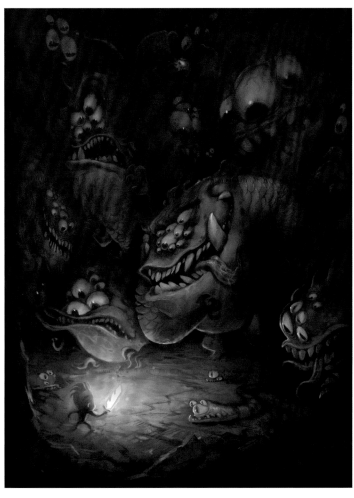

Ryan Wood
Title: The Eyes Have It *Medium:* Digital *Art Director:* Bobby Chiu

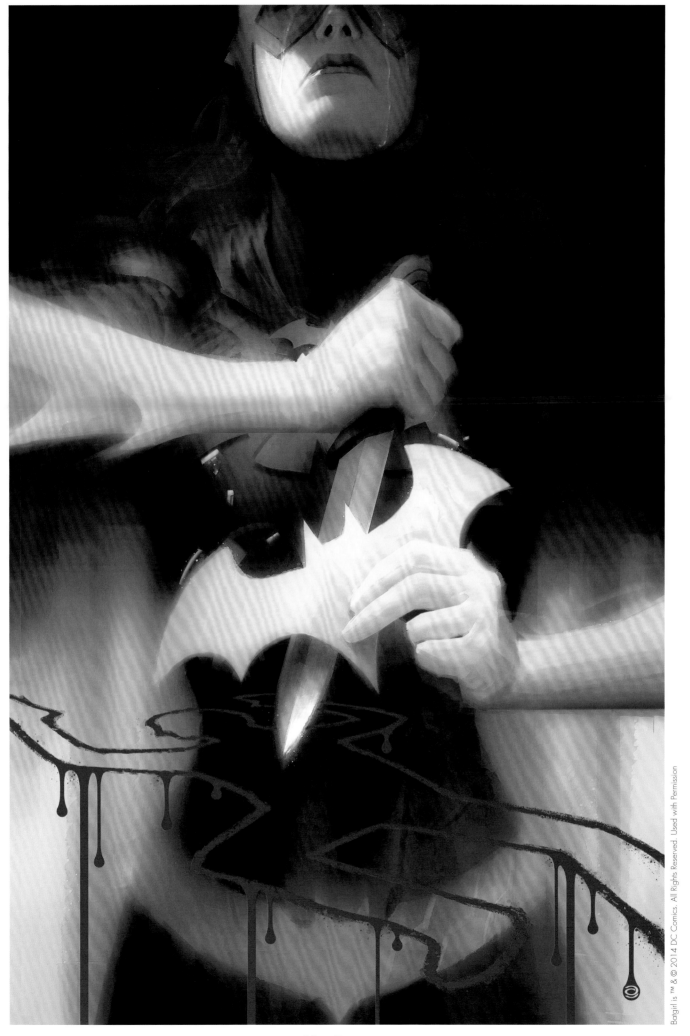

Alex Garner
Title: Batgirl #22 *Medium:* Digital *Size:* 10.5 x 15.75 in. *Client:* DC Comics *Art Director:* Katie Kubert and Mike Marts

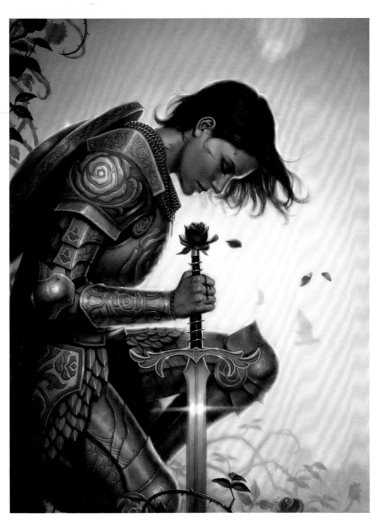

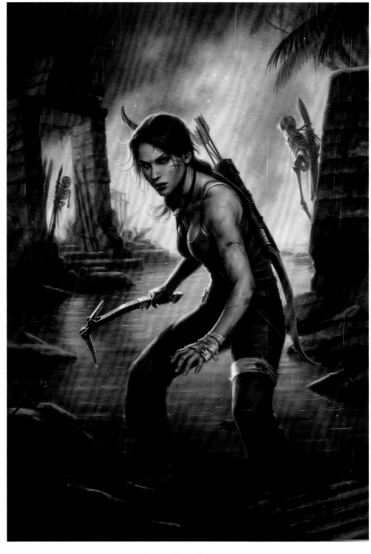

Dan dos Santos
Title: Rose Red: Fables #136 *Medium:* Oils on board *Client:* DC/Vertigo
Art Director: Shelly Bond Image © DC/Vertigo Comics

Dan dos Santos
Title: Tomb Raider: Reborn *Medium:* Oils on board *Client:* Dark Horse Comics
Art Director: Scott Allie Image © Dark Horse Comics

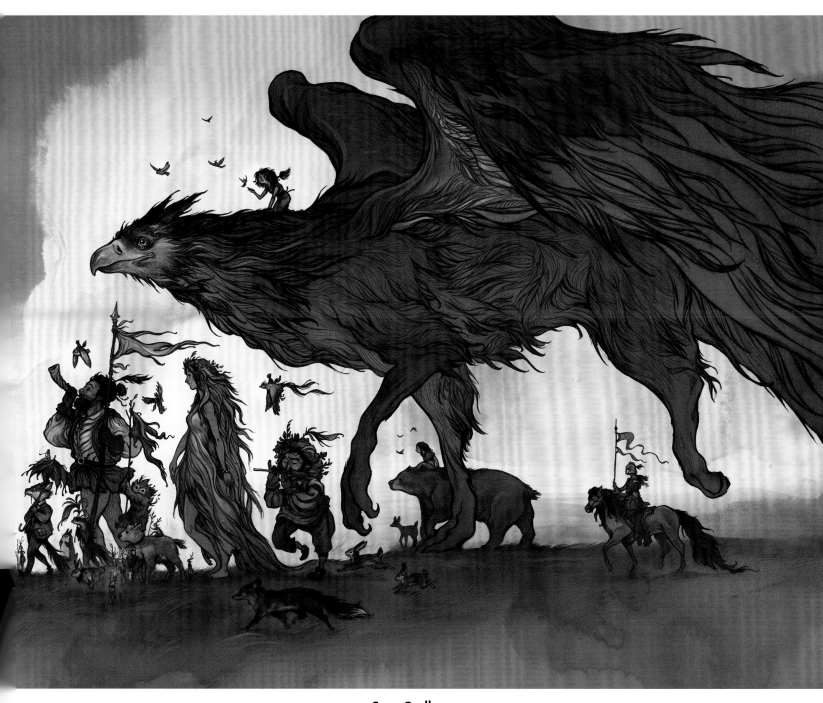

Cory Godbey
Title: The Gryphon March *Medium:* Watercolor and digital *Size:* 20 x 24 in.

David Peterson
Title: Legends of the Guard Volume 2 Issue 2 *Medium:* Ink on bristol and digital color *Size:* 8 x 16 in.

David Peterson
Title: Legends of the Guard Volume 2 Issue 3 *Medium:* Ink on bristol and digital color *Size:* 8 x 16 in.

David Peterson
Title: Legends of the Guard Volume 2 Issue 4 *Medium:* Ink on bristol and digital color *Size:* 8 x 16 in.

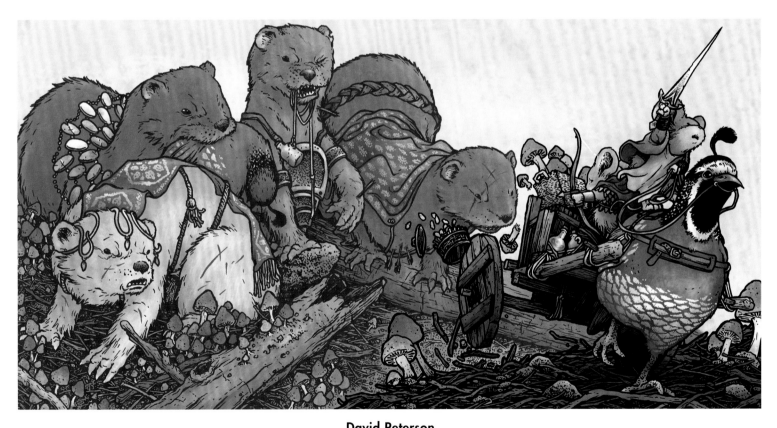

David Peterson
Title: Legends of the Guard Volume 2 Hardcover Cover *Medium:* Ink on bristol and digital color *Size:* 8 x 16 in.

Mona
Title: All Corners of the Country, The Lost Buildings 3
Size: 7.5 x 11.25 in. *Medium:* Digital

Mona
Title: All Corners of the Country, The Lost Buildings 5
Size: 7.5 x 11.25 in. *Medium:* Digital

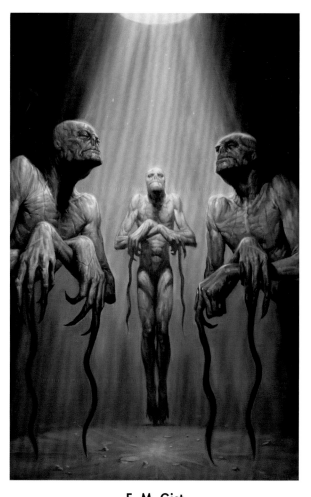

E. M. Gist
Title: Savage Vampire *Medium:* Oil on panel *Size:* 14 x 22 in.
Client: Dark Horse Comics *Art Director:* Sierra Hahn

E. M. Gist
Title: The Ancients *Medium:* Oil on Panel *Size:* 14 x 22 in.
Client: Dark Horse Comics *Art Director:* Sierra Hahn

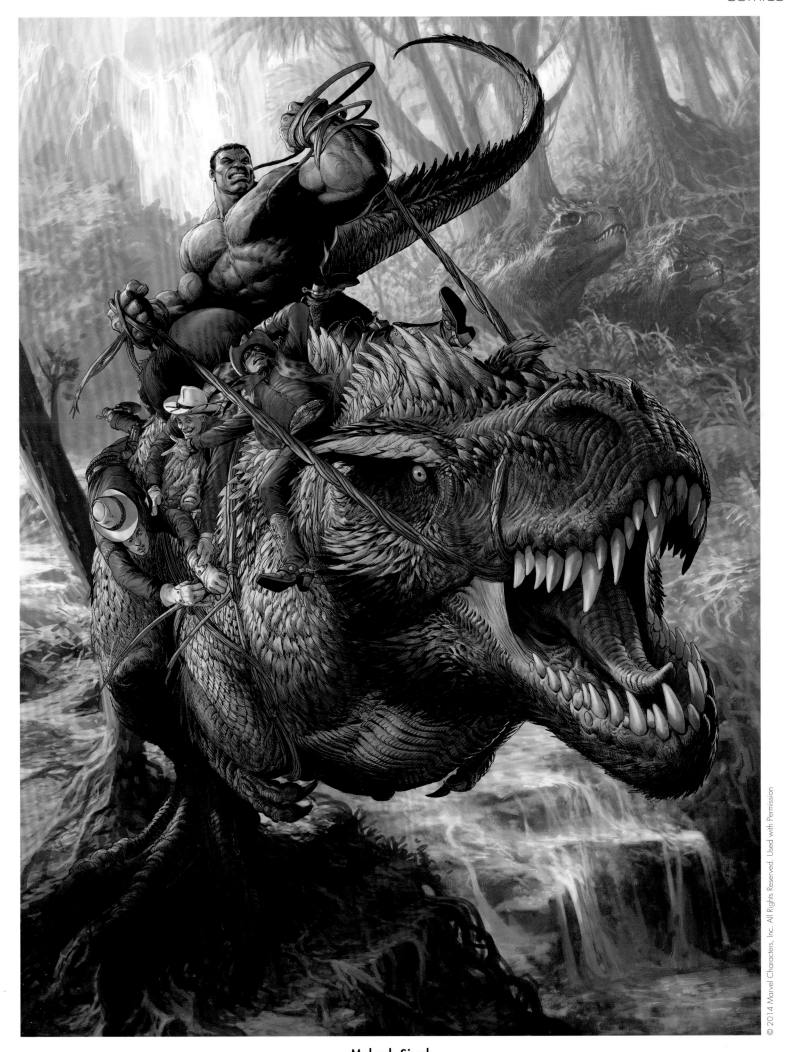

Mukesh Singh
Title: Indestructible Hulk book 12 cover *Medium:* Digital *Size:* 7 x 10.25 in. *Client:* Marvel Comics Copyright © Marvel Comics

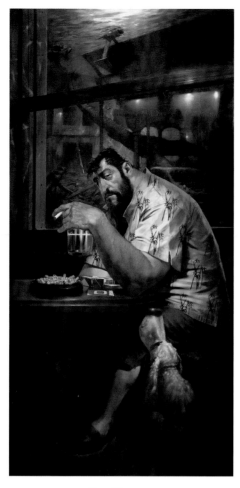

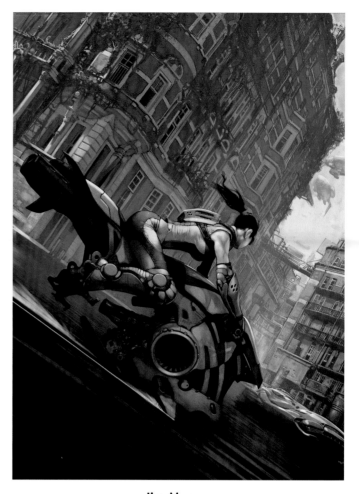

Jim Murray
Title: Drowntown: Noiret Portrait
Medium: Oil and digital *Size:* 22 x 44 in. *Client:* Jonathan Cape

Jim Murray
Title: Drowntown, page 13
Medium: Acrylic and digital *Size:* 11 x 15 in. *Client:* Jonathan Cape

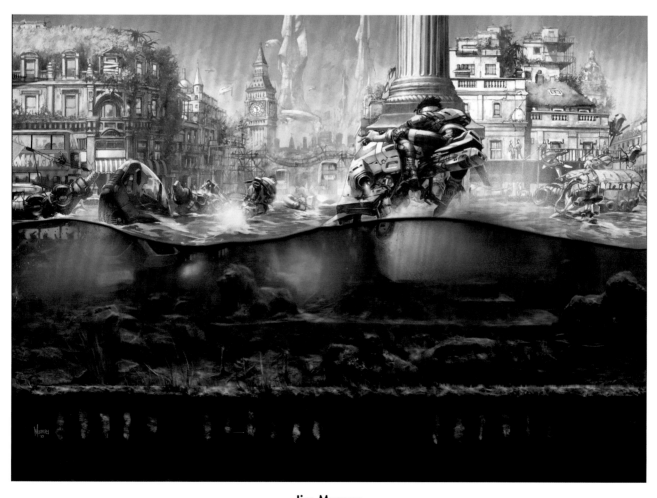

Jim Murray
Title: Drowntown: Trafalgar Square
Medium: Acrylic and digital *Size:* 24 x 16 in. *Client:* Jonathan Cape

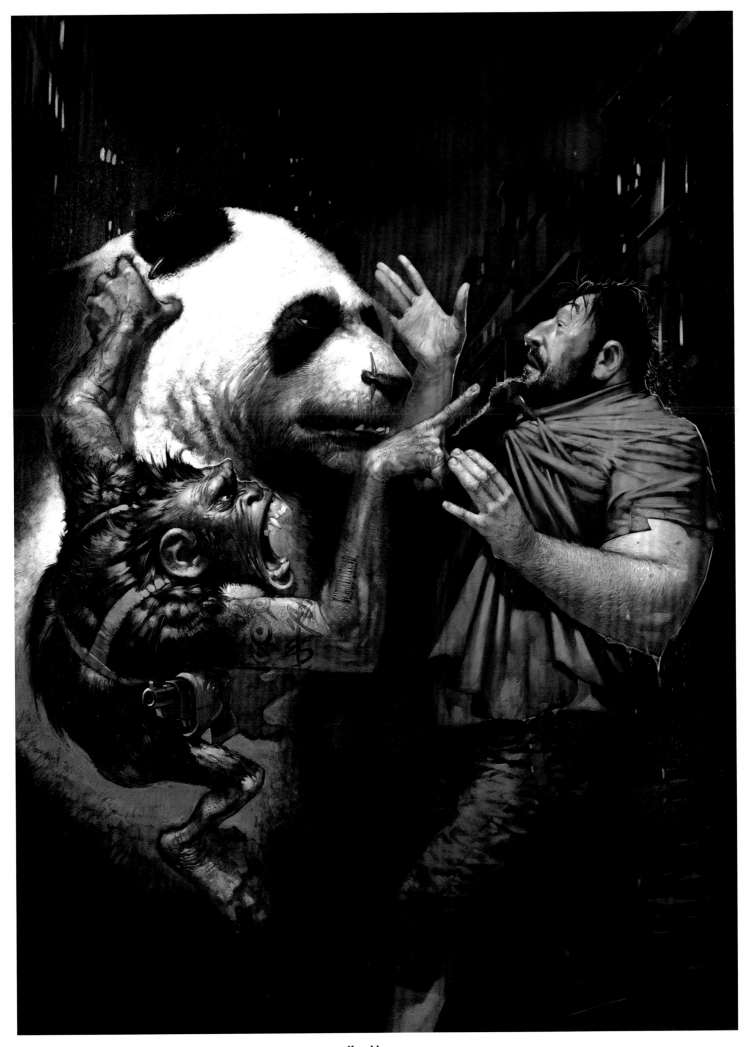

Jim Murray
Title: Drowntown, page 45 *Medium:* Acrylic and digital *Size:* 11 x 15 in. *Client:* Jonathan Cape

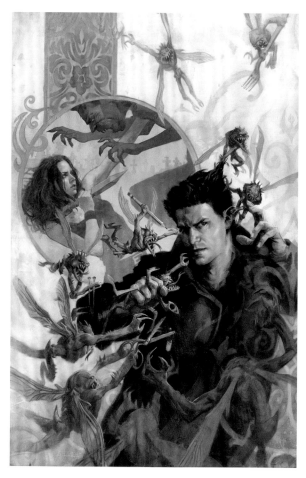

Scott M. Fischer
Title: Angel and Faith 1
Medium: Acrylic, gouache and oil *Size:* 12 x 18 in.
Client: Dark Horse Comics *Art Director:* Scott Allie

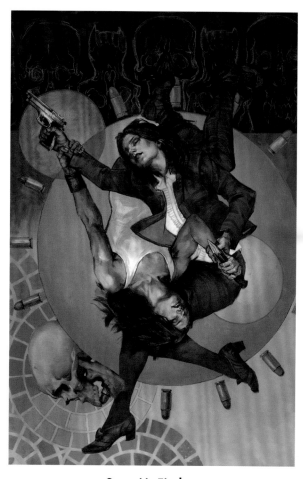

Scott M. Fischer
Title: Angel and Faith 4
Medium: Acrylic, gouache and oil *Size:* 12 x 18 in.
Client: Dark Horse Comics *Art Director:* Scott Allie

Zach Montoya
Title: Harbinger 16
Medium: Digital *Size:* 7 x 11 in.
Client: Valiant Entertainment *Art Director:* Warren Simons

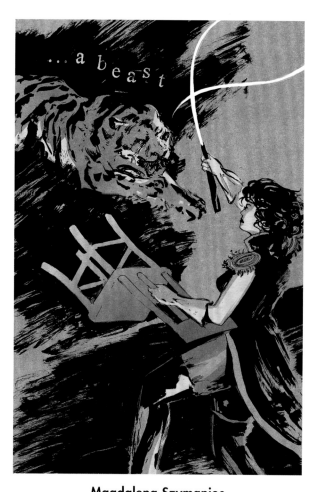

Magdalena Szymaniec
Title: Beast *Medium:* Ink with digital finish *Size:* 12 x 18 in.
Client: Ringling College of Art and Design
Art Director: Octavio Perez, Joseph Thiel and George Pratt

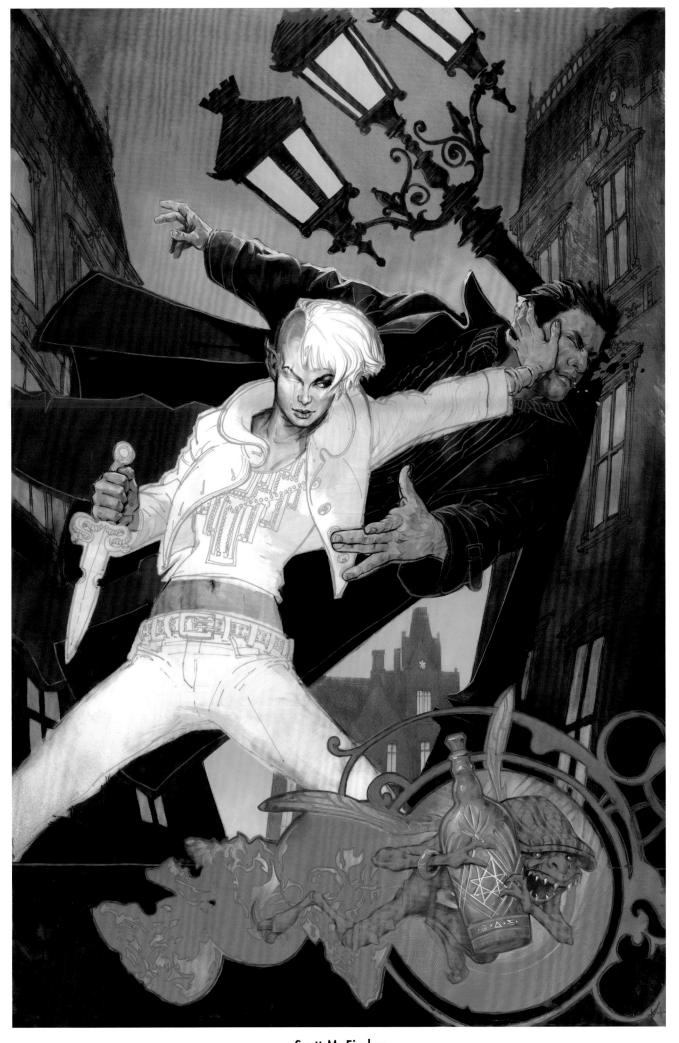

Scott M. Fischer
Title: Angel and Faith 3 *Medium:* Acrylic, gouache and oil *Size:* 12 x 18 in. *Client:* Dark Horse Comics *Art Director:* Scott Allie

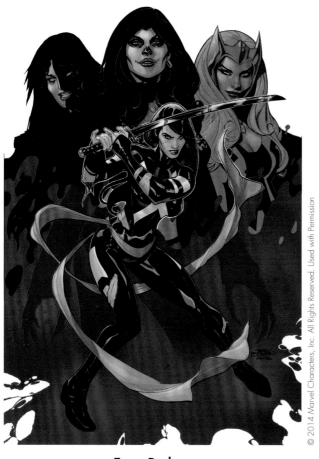

Terry Dodson
Title: X-Men #9 cover *Inker:* Rachel Dodson *Medium:* Pen and ink/digital
Size: 12 x 18 in. *Client:* Marvel Entertainment *Art Director:* Jeanine Schaefer

Steve Morris
Title: The Occultist, issue 2 *Medium:* Photoshop *Size:* 8 x 11.5 in.
The Occultist® © 2014 Dark Horse Comics, Inc. All rights reserved.

Mark A. Nelson
Title: The Garden, page 1 *Medium:* Ink and digital color
Size: 10 x 15 in. *Client:* Heavy Metal *Art Director:* Dave Elliot

Yuko Shimizu
Title: Unwritten #50 *Medium:* Ink drawing on paper with digital color
Size: 14.5 x 22 in. *Client:* DC Comics/Vertigo
Art Director: Shelly Bond and Gregory Lockard Image © DC/Vertigo Comics

Steve Morris
Title: The Occultist, issue 3 *Medium:* Photoshop *Size:* 8 x 12.5 in. The Occultist® © 2014 Dark Horse Comics, Inc. All rights reserved.

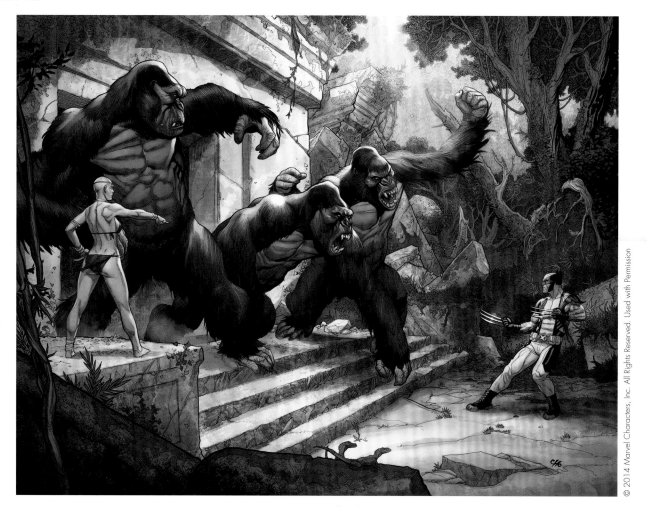

Frank Cho
Title: Savage Wolverine #4, pages 12-13 *Medium:* Pen and ink and digital color *Size:* 21 x 28 in. *Client:* Marvel Comics *Colorist:* Jason Keith

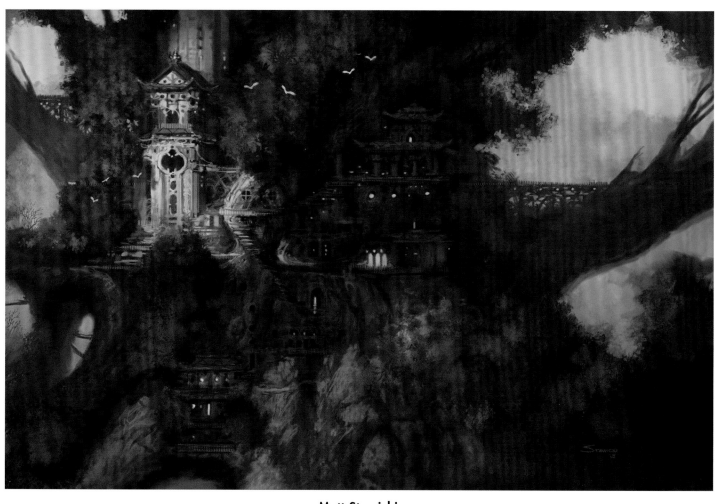

Matt Stawicki
Title: Ardeyn Tree City *Medium:* Digital *Client:* Monte Cook Games, LLC *Art Director:* Shanna Germain

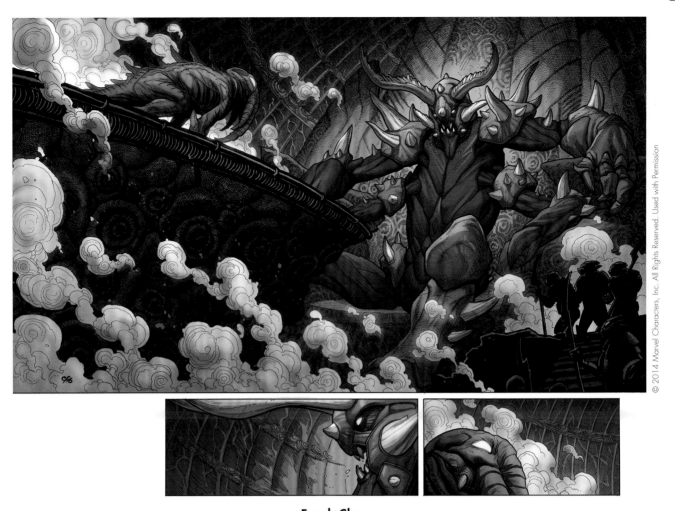

Frank Cho
Title: Savage Wolverine #5, pages 18-19 *Medium:* Pen and ink and digital color *Size:* 21 x 28 in. *Client:* Marvel Comics *Colorist:* Jason Keith

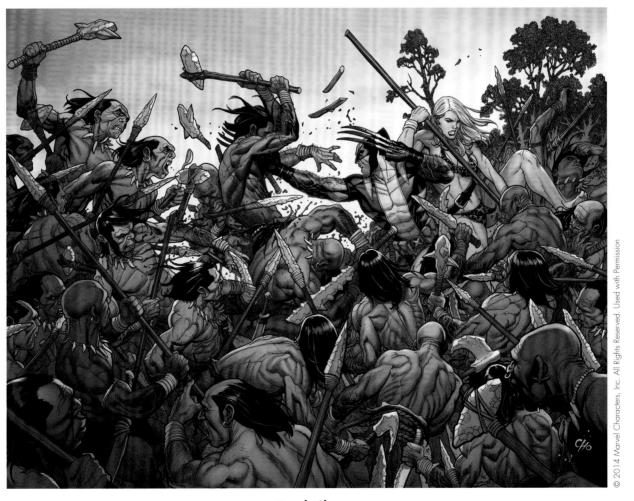

Frank Cho
Title: Savage Wolverine #3, pages 14-15 *Medium:* Pen and ink and digital color *Size:* 14 x 21 in. *Client:* Marvel Comics *Colorist:* Jason Keith

Frank Cho
Title: Battle of the Atom *Medium:* Ballpoint pen and digital color *Size:* 22 x 28 in. *Client:* Marvel Comics *Colorist:* Marte Gracia

Greg Ruth
Title: The Lost Boy: The Final Recording of Walter Pidgin, page 73
Medium: Brush and Sumi Ink *Size:* 5 x 9 in.
Client: Scholastic/Graphix *Art Director:* David Saylor *Designer:* Phil Falco

Steve Rude
Title: Captain Midnight #2 cover
Medium: Watercolor *Size:* 20 x 30 in.
Client: Dark Horse Comics *Art Director:* Mike Richardson

Greg Ruth
Title: The Lost Boy: The Ten Men, page 133
Medium: Brush and Sumi Ink *Size:* 5 x 9 in. *Client:* Scholastic/Graphix *Art Director:* David Saylor *Designer:* Phil Falco

Aaron McBride
Title: Dead Trees *Medium:* Digital

Aaron McBride
Title: In the Blindspot of a Crown *Medium:* Digital

Grim Wilkins
Title: Little Nemo and the Opalescent Prisms of Toppizia *Medium:* Ink and acrylic *Size:* 20 x 26 in. *Client:* Locust Moon Comics

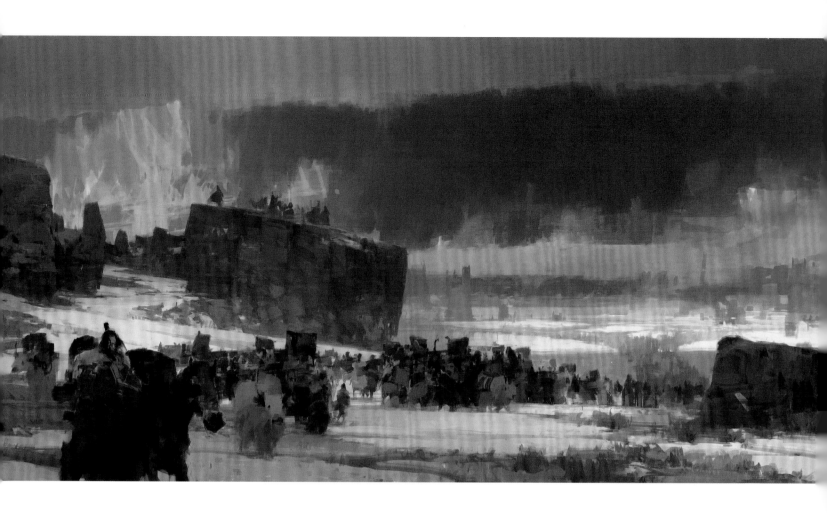

CONCEPT ART GOLD AWARD

THEO PRINS

REFUGEES

Medium: Digital
Client: ArenaNet/Guild Wars 2
Art Director: Daniel Dociu

"It's a huge honor that my artwork has received recognition here. I'm very grateful to be part of this community of artists. I'd like to thank Daniel Dociu and everyone at ArenaNet who've created an inspiring and supportive environment to work in that allows me the freedom to express my imagination. Thank you very much."

—Acceptance speech written for the Spectrum 21 Awards Ceremony

Theo Prins is a concept artist working at ArenaNet on "Guild Wars 2." He grew up in the Pacific Northwest and the Netherlands and spent most of his childhood drawing airplanes, cities and dinosaurs. As a teenager, he financed flying lessons with aviation art commissions but dropped his idea of becoming a pilot when he discovered his passion for digital art.

Since 2007 he's been working as a concept artist in the video-game industry. This opened the doors to a somewhat nomadic existence. First he worked for CCP games in Iceland, then Reloaded Studios in South Korea and eventually began traveling and living in different cities throughout Asia while freelancing on the go. He's had a temporary studio space aboard a container ship crossing the Pacific Ocean, telecommuted from the Himalayan foothills, lived on a small island off Hong Kong, visited ship breaking yards in India and extensively explored street markets and alleyways around Asia.

Photo by Greg Preston for Spectrum Fantastic Art

CONCEPT ART
SILVER AWARD

VANCE KOVACS

CARTER PUNCHES A THARK
Medium: Digital
Client: Disney

"It is an extreme privilege to be given this award. Truly, thank you."
—During Kovac's acceptance speech at the Spectrum 21 Awards Ceremony

Kovac's an artist, illustrator and designer for games, film, publishing and theme parks. He worked for ten years in game studios and has worked freelance for the past ten. His clients have included Disney, Disney Imagineering, Warner Bros., Epic Games, Paramount, Universal, Blizzard, Trion Worlds, Wizards of the Coast, Sony and many more. He lives in California with his wife, two beautiful daughters and their dog, Ozzie.

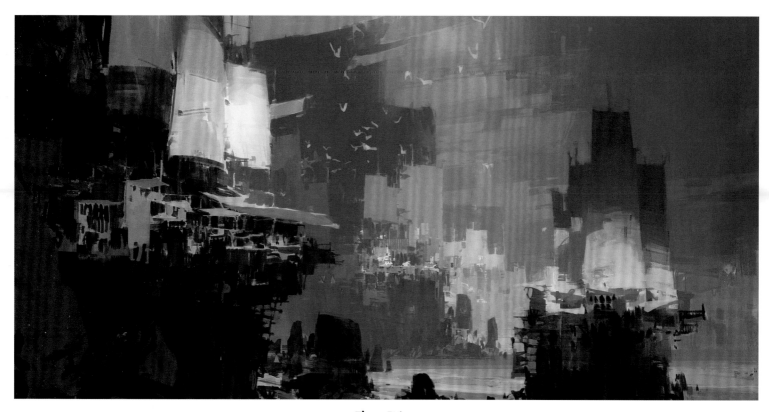

Theo Prins
Title: Kite City 2 *Medium:* Digital *Client:* ArenaNet/Guild Wars 2 *Art Director:* Daniel Dociu

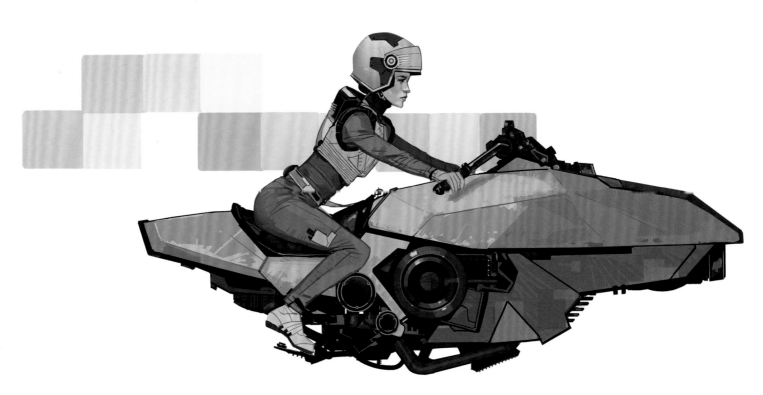

Brian Matyas
Title: Messenger Girl *Medium:* Digital *Client:* Kabam *Art Director:* Aron Lusen

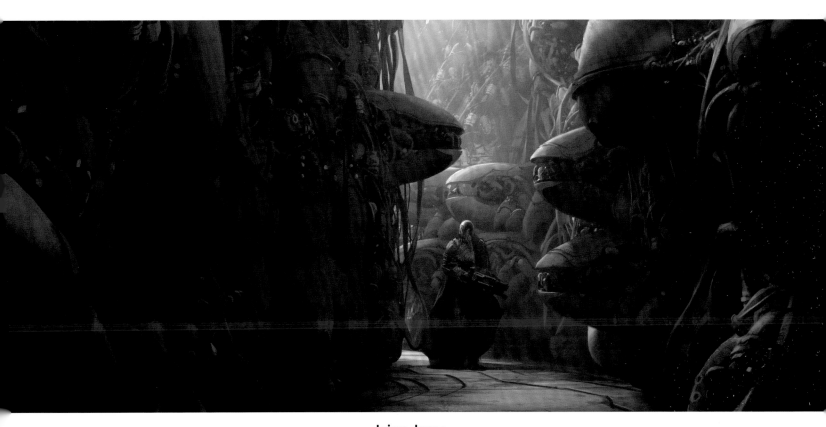

Jaime Jones
Title: Black Zero Interior *Medium:* Digital *Client:* Warner Bros. *Art Director:* Alex Mcdowell

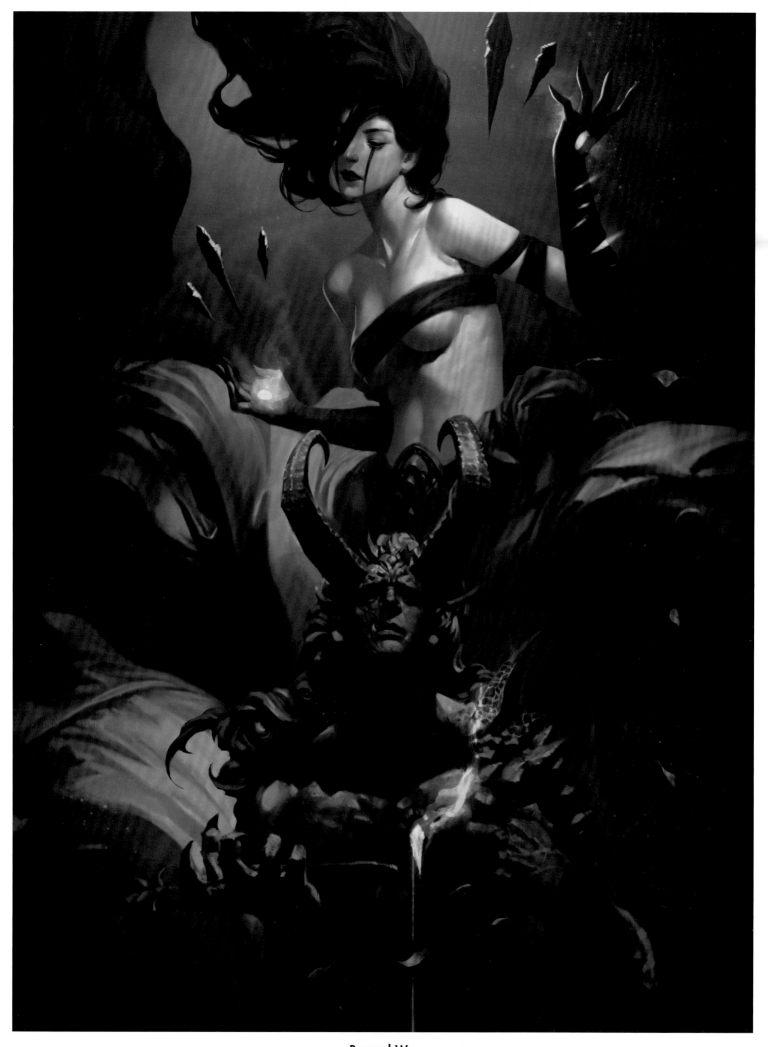

Bayard Wu
Title: Ally and Demon *Medium:* Digital *Size:* 20.75 x 27.75 in. *Client:* Applibot, Inc.

Ben Mauro
Title: Scythian *Medium:* Digital

Bayard Wu
Title: Gardien *Medium:* Digital *Size:* 20.75 x 27.75 in. *Client:* Applibot,Inc.

Ben Mauro
Title: Formicidae *Medium:* Digital

Brian Matyas
Title: Exus Alienus
Medium: Digital *Client:* Kabam *Art Director:* Thomas Denmark

Brian Matyas
Title: Captain Fulton
Medium: Digital *Client:* Kabam *Art Director:* Aron Lusen

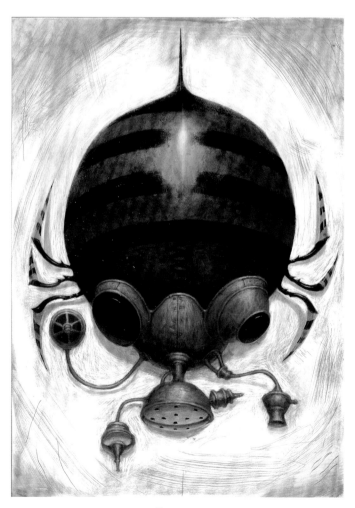

Bill Carman
Title: Be Prepared *Medium:* Mixed *Size:* 5 x 7 in.

Brian Matyas
Title: Ragnarok Rising *Medium:* Digital *Client:* Kabam *Art Director:* Aron Lusen

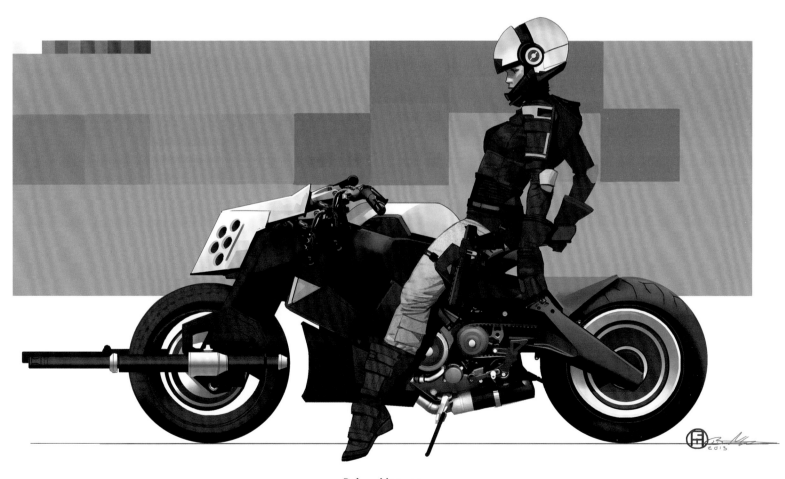

Brian Matyas
Title: Courier *Medium:* Digital *Client:* Kabam *Art Director:* Thomas Denmark

Chuan Zhong
Title: Contemplator *Medium:* Digital *Size:* 12 x 5.25 in.

Chuan Zhong
Title: House of Good Deals *Medium:* Digital *Size:* 12 x 5 in.

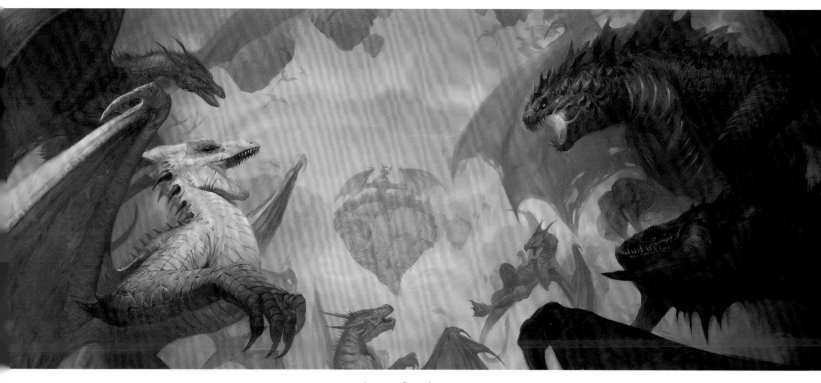

Lucas Graciano
Title: EverQuest II: Tears of Veeshan *Medium:* Oil on masonite
Client: Sony Online Entertainment EverQuest II © Sony Online Entertainment, LLC

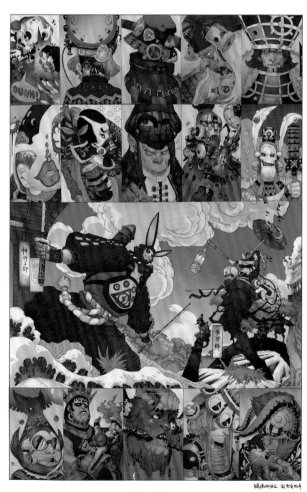

Dredant
Title: Poster Style Artwork Series 03
Medium: Pen and ink with digital color *Size:* 9 x 12 in.

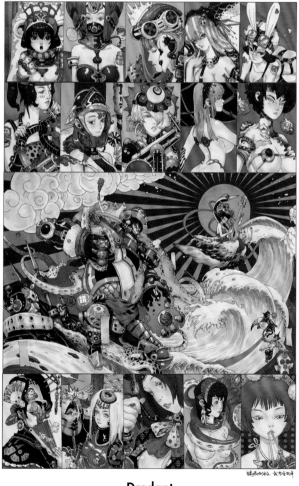

Dredant
Title: Poster Style Artwork Series 04
Medium: Pen and ink with digital color *Size:* 9 x 12 in.

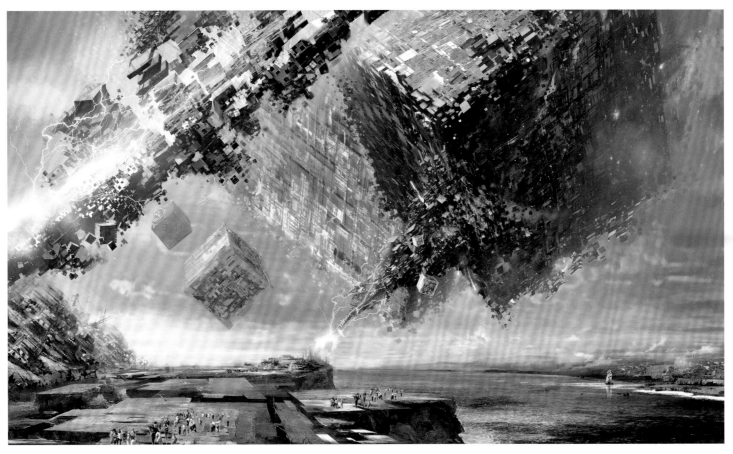

Daniel Dociu
Title: Building Rata Sum *Medium:* Digital *Client:* Arenanet/Guild Wars 2 Live Content
Guild Wars images are property of Arenanet/Ncsoft and are used with permission

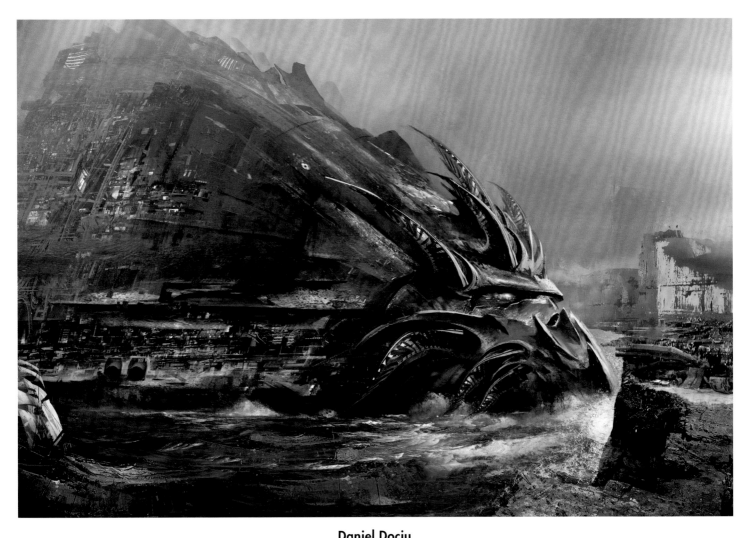

Daniel Dociu
Title: Norn Ironclad War Ship *Medium:* Digital *Client:* Arenanet/Guild Wars 2 Live Content
Guild Wars images are property of Arenanet/Ncsoft and are used with permission

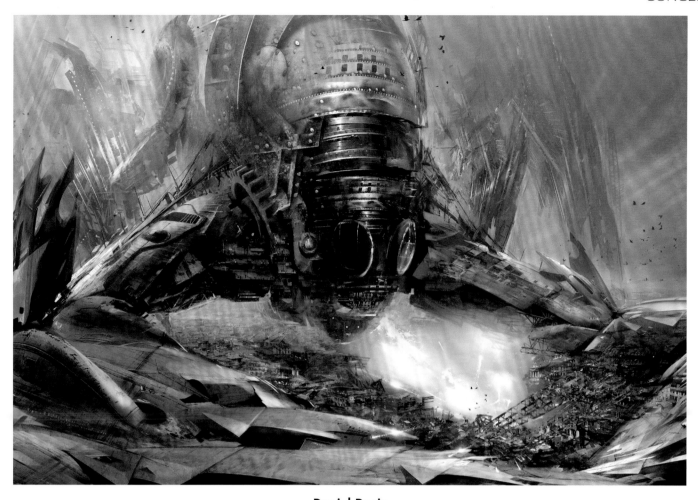

Daniel Dociu
Title: Devourer *Medium:* Digital *Client:* Arenanet/Guild Wars 2 Live Content
Guild Wars images are property of Arenanet/Ncsoft and are used with permission

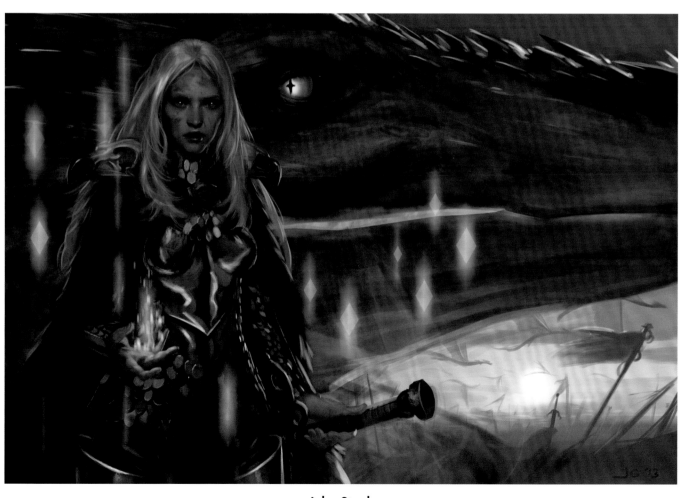

John Staub
Title: Legends at War *Client:* GREE international *Art Director:* Armand Dacuba

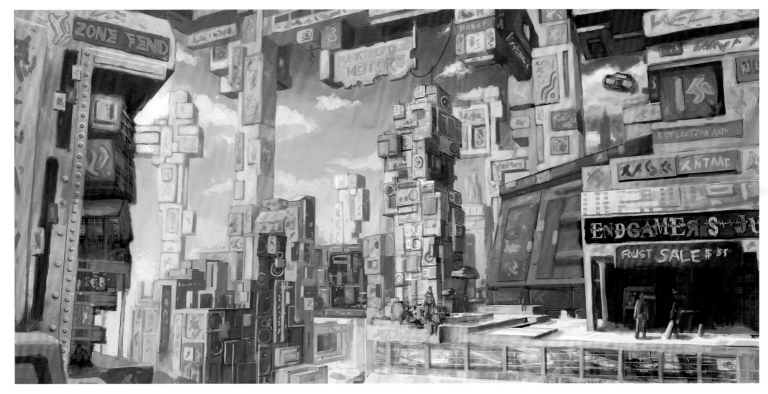

Derek Weselake
Title: Funktropolis *Medium:* Digital *Size:* 17 x 8.25 in.

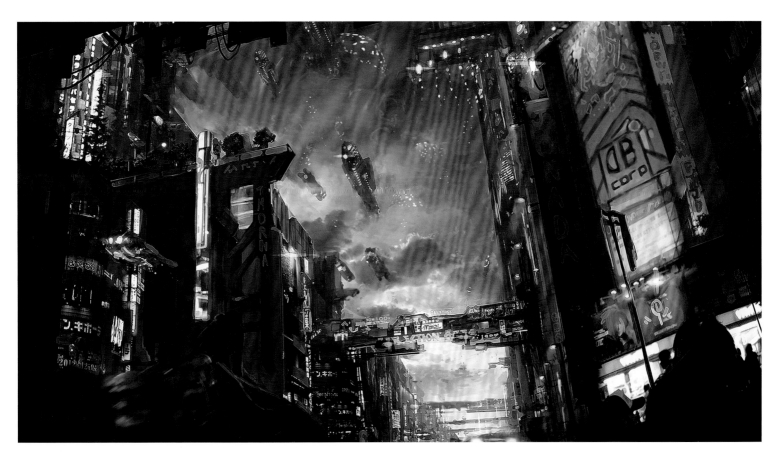

Derek Weselake
Title: The Line of Jonada *Medium:* Digital *Size:* 17 x 9.25 in.

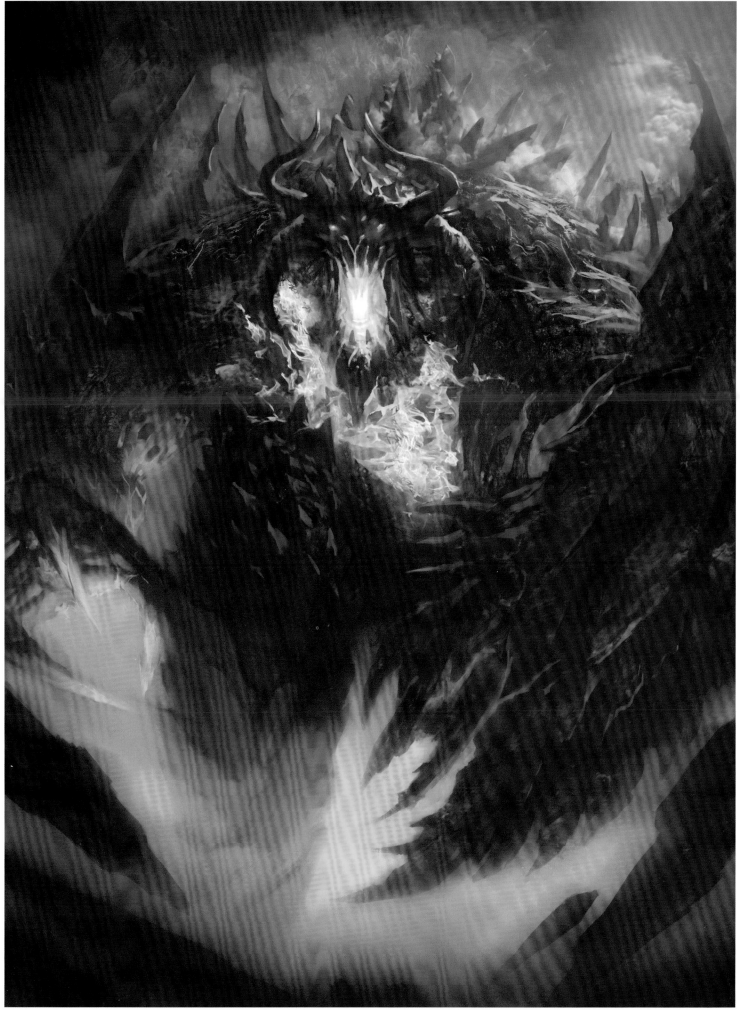

Kan Muftic
Title: Molten Giant *Medium:* Digital *Client:* Sheng
Copyright 2013 ShengDong. Inc./Impact of Gods

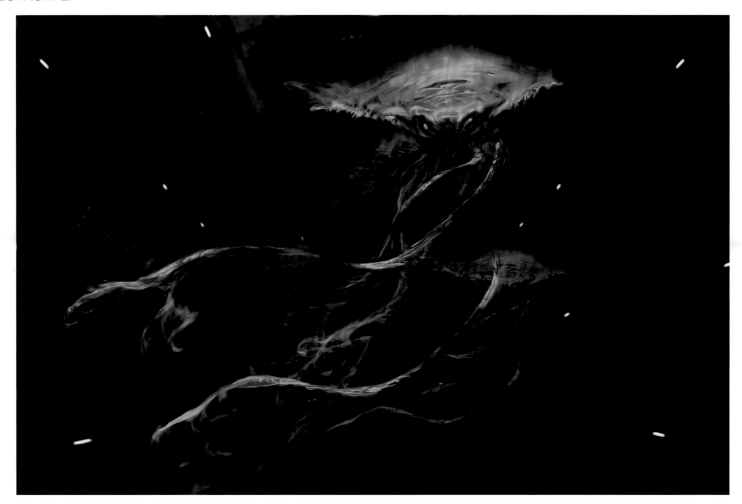

Iain McCaig
Title: Cerberons

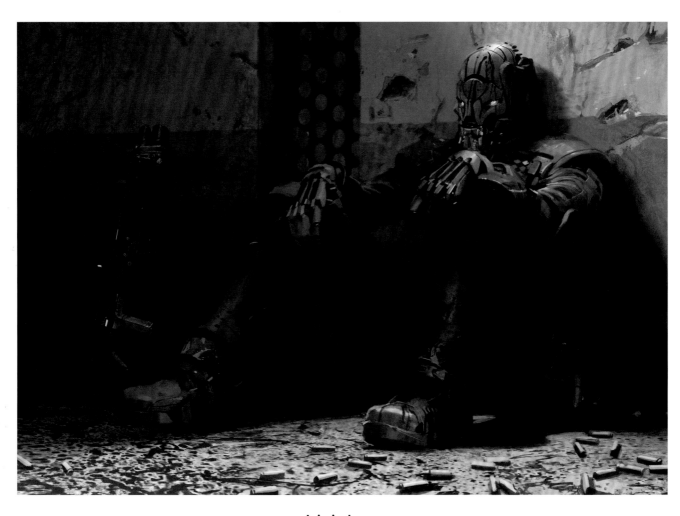

Jaimie Jones
Title: Back from the Wild *Medium:* Digital *Client:* Bungie *Art Director:* Christopher Barrett

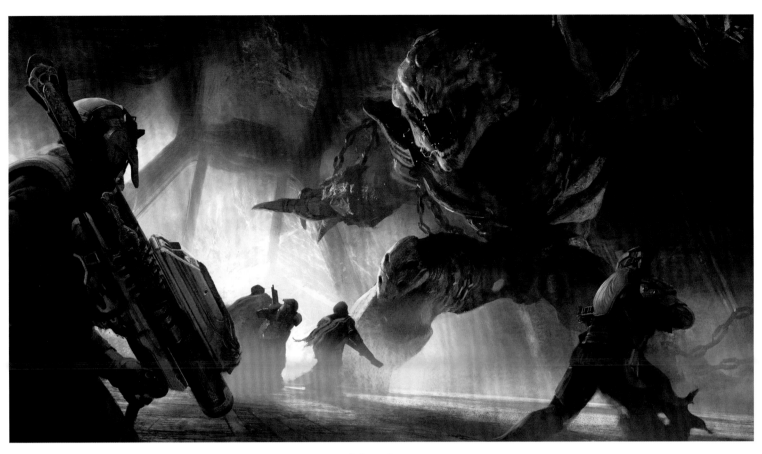

Jaime Jones
Title: Hive Ultra *Medium:* Digital *Client:* Bungie *Art Director:* Christopher Barrett

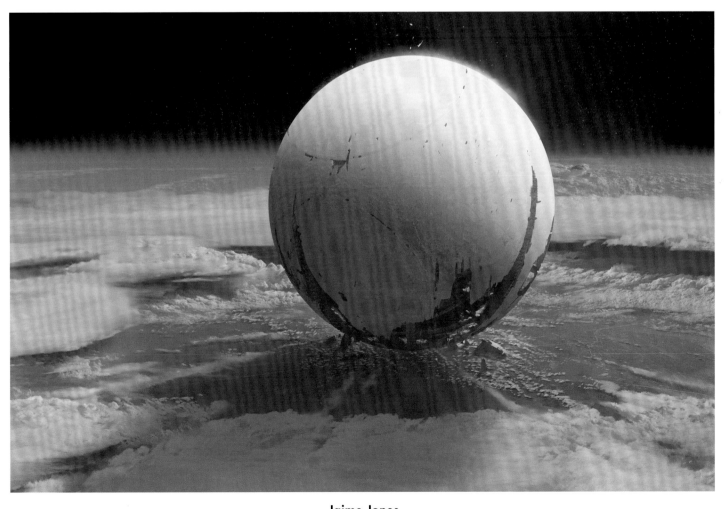

Jaime Jones
Title: The Traveler *Medium:* Digital *Client:* Bungie *Art Director:* Christopher Barrett

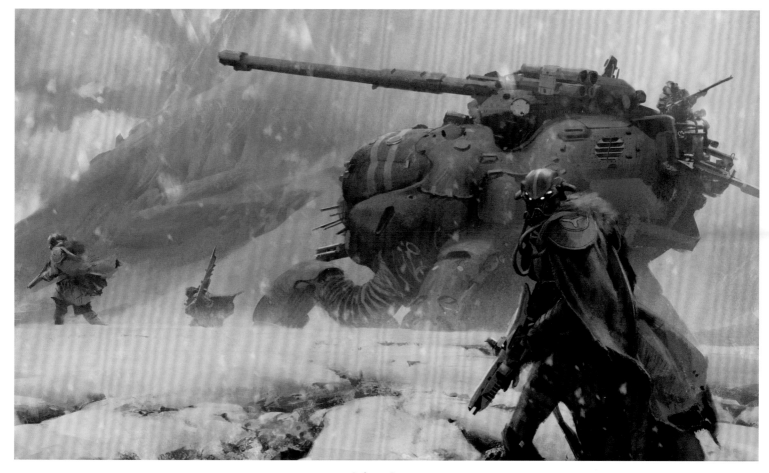

Jaime Jones
Title: Fallen Troops *Medium:* Digital *Client:* Bungie *Art Director:* Christopher Barrett

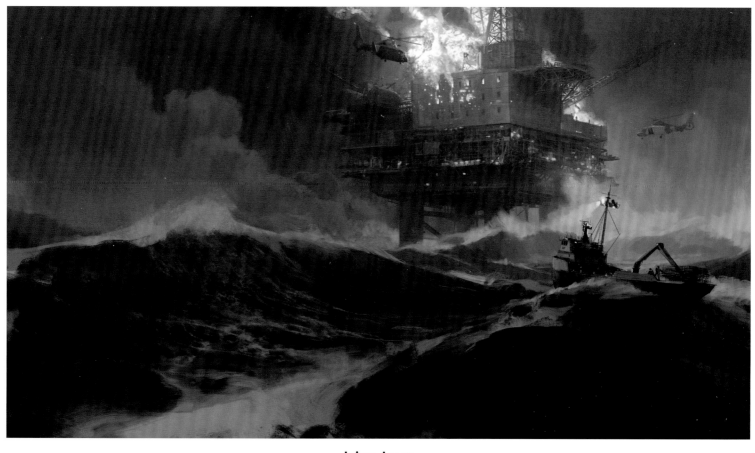

Jaime Jones
Title: Trawler and Platform *Medium:* Digital *Client:* Warner Bros. *Art Director:* Alex Mcdowell

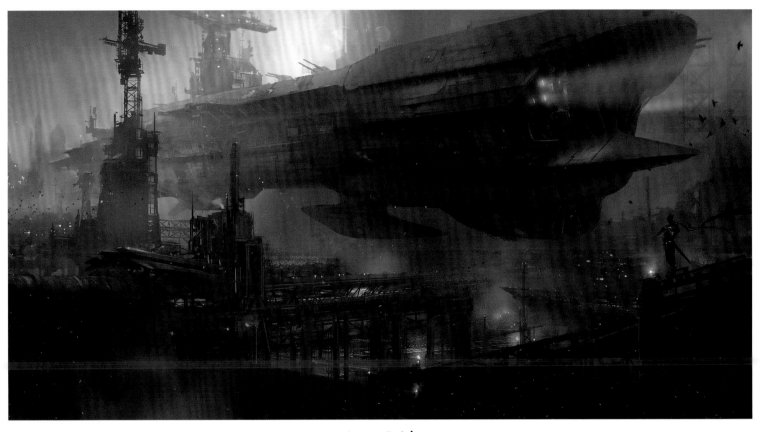

James Paick
Title: Balrog *Artists:* James Paick, Joy Lee and Shawn Kim *Medium:* Digital *Client:* Double-Helix Games *Art Director:* James Paick

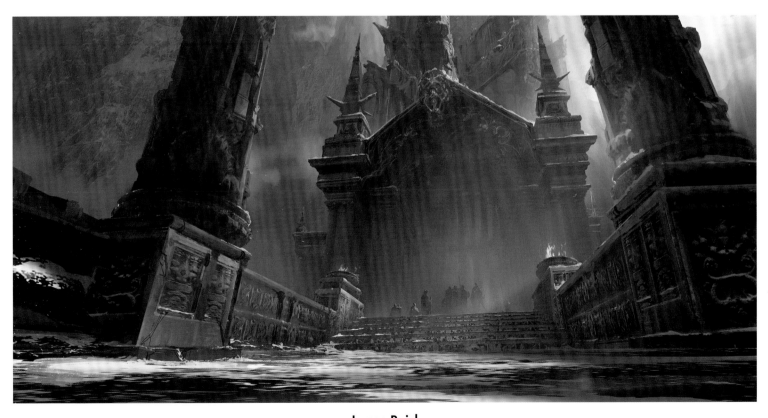

James Paick
Title: Freljord Tower *Medium:* Digital *Client:* Riot Games: League of Legends *Art Director:* Eduardo Gonzalez

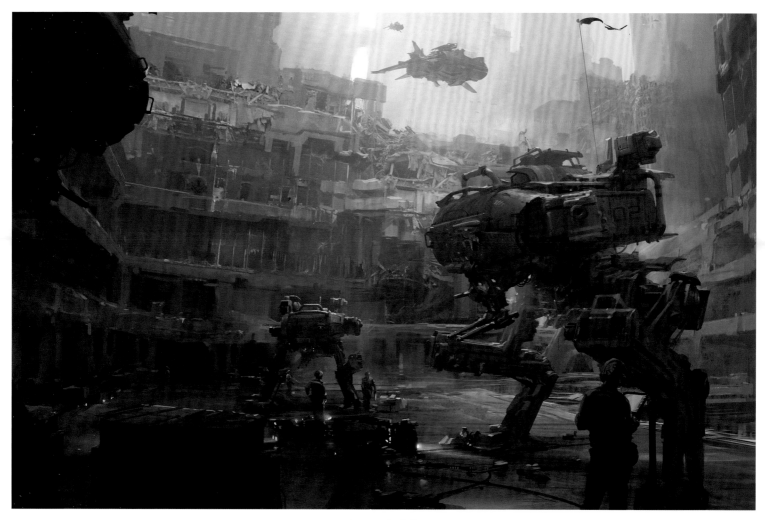

James Paick
Title: Prep Zone *Medium:* Digital *Client:* Scribble Pad Studios

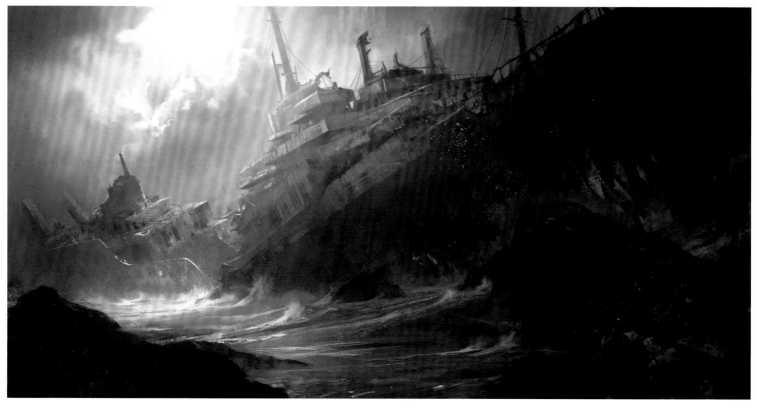

James Paick
Title: Shipwreck Beach *Medium:* Digital *Client:* Crystal Dynamics: Tomb Raider *Art Director:* Brian Horton

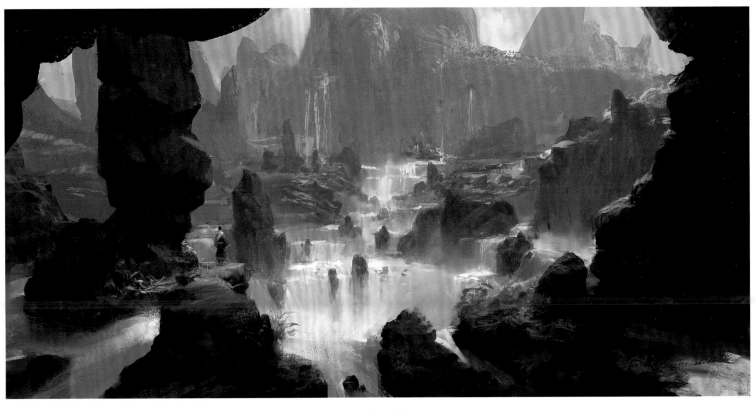

Juanzhu Zhao
Title: Ocean of Stone *Medium:* Digital *Size:* 12 x 9 in.

Juanzhu Zhao
Title: Tranquility *Medium:* Digital *Size:* 12 x 9 in.

Justin Sweet
Title: Drax Armor *Medium:* Digital *Client:* Marvel Entertainment for Guardians of the Galaxy *Art Director:* Charlie Wen Artwork © Marvel

Justin Sweet
Title: Drax 1 *Medium:* Digital
Client: Marvel Entertainment for Guardians of the Galaxy
Art Director: Charlie Wen
Artwork © Marvel

Justin Sweet
Title: Spartoid *Medium:* Digital
Client: Marvel Entertainment for Guardians of the Galaxy
Art Director: Charlie Wen
Artwork © Marvel

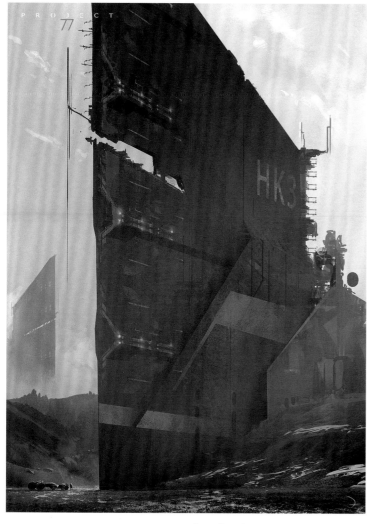

Martin Deschambault
Title: Project 77 The Blade *Medium:* Photoshop

Nick Keller
Title: Misery *Medium:* Oil on canvas *Size:* 30 x 30 in. *Client:* Disentomb

Max.Qin
Title: The Age of Great Depression The Last of Us
Medium: Digital *Size:* 32.75 x 11.75 in.

Sparth
Title: Assemblage *Medium:* Photoshop *Size:* 52 x 70 in.

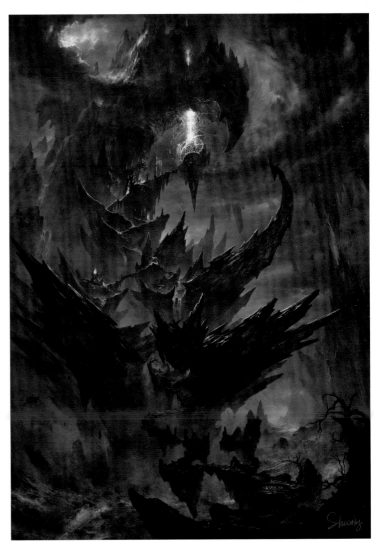

Shuxing Li
Title: Top of the Amber *Medium:* Digital *Size:* 19.75 x 27.75 in.

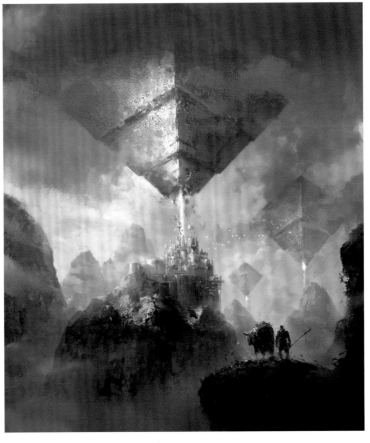

Park Jong Wong
Title: Beginning of the Civilization

Theo Prins
Title: Kite City 3 *Medium:* Digital *Client:* ArenaNet/Guild Wars 2 *Art Director:* Daniel Dociu

Theo Prins
Title: Kite City *Medium:* Digital *Client:* ArenaNet/Guild Wars 2 *Art Director:* Daniel Dociu

Theo Prins
Title: Krait Tower Ruins *Medium:* Digital *Client:* ArenaNet/Guild Wars 2 *Art Director:* Daniel Dociu

Thom Tenery
Title: Temple of Umberlee *Client:* Wizards Of The Coast *Art Director:* Jon Schindehette © Wizards of the Coast

Tyler Edlin
Title: World of Tinia *Medium:* Digital *Client:* Lucky Squid Studios *Art Director:* Nancy Frey

Vance Kovacs
Title: Thark Chieftain *Medium:* Digital *Client:* Disney © Disney

Yan-Wen Tang
Title: Kylin *Medium:* Photoshop *Size:* 11 x 17 in.

Donato Giancola
Title: Red Sonja, Archer *Medium:* Pencil and chalk on paper
Size: 11 x 14 in. *Client:* Burgundy Arts

Yip Lee
Title: Refinery Arch088 *Medium:* Digital

James Gurney
Title: Blake Terrapin *Medium:* Oil *Size:* 3 x 7 in. *Client:* The Beanstalk Group *Art Director:* Michael Stone *Designer:* Oliver Herzfeld

Devon Cady-Lee
Title: Captain of the Guard *Medium:* Photoshop
Size: 3900 x 5300 pixels *Client:* ImagineFX

Te Hu
Title: Judith *Medium:* Digital *Size:* 11.75 x 16.5 in.

Jaemin Kim
Title: Divider/Insect Creature *Medium:* Digital *Size:* 8 x 14.5 in.

Steve Firchow
Title: Hall of Justice *Medium:* Digital *Size:* 9 x 14 in.
Client: Monolith Productions *Art Director:* Philip Straub

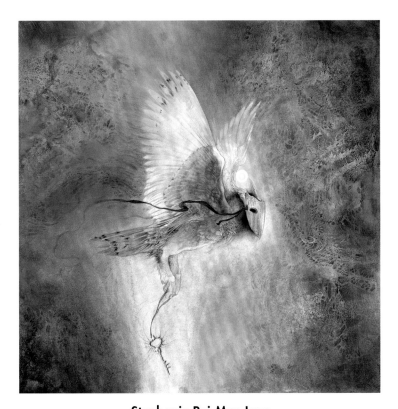

Stephanie Pui-Mun Law
Title: Dreamsign *Medium:* Watercolor and ink *Size:* 14 x 14 in.

Bruno Gore
Title: Lighthouse Keeper *Medium:* Digital
Size: 9 x 10 in. *Client:* Big Fish Games *Art Director:* Ted Galaday

149

Photo by Greg Preston for Spectrum Fantastic Art

SHIFLETT BROS.

VERTICAL MAN-TANK
Medium: Epoxy Putty, Super Sculpey
Size: 14 in.
Photo: Joe Winston

"This situation you see right here is exactly like our creative partnership, in that I do all the work and he basks in the glory...

 "We're two kids from Beaumont, Texas and we're gonna go back and we're gonna tell everyone about this and they're not gonna give a damn, because their not gonna know who any of you people are. But from the bottom of our hearts, I want to thank everyone in this room. We really, really appreciate this." —Brandon

—During the Shiflett Bros. acceptance speech at the Spectrum 21 Awards Ceremony

Brandon and Jarrod Shiflett are comic-book sculpting nerds who sculpt nerdy stuff. The brothers live in Texas with herds of pirate dogs, listening to Kate Bush, and pondering their chances of taking over the world, one fantasy sculpture at a time.

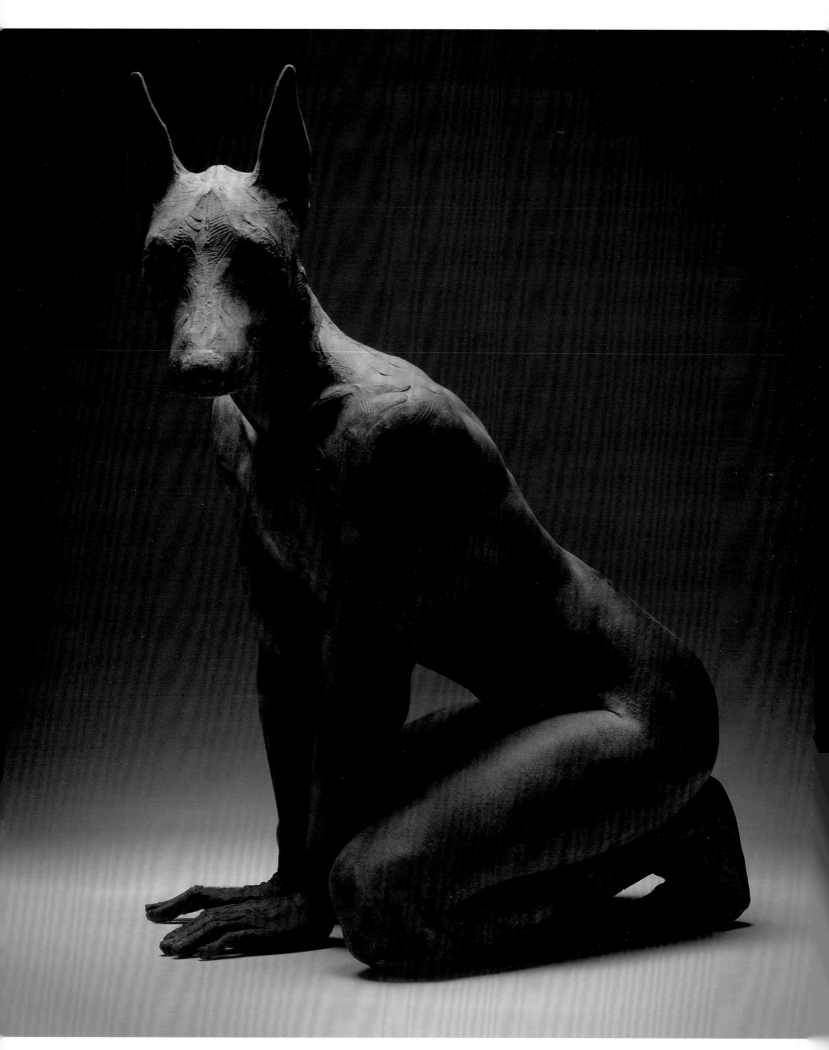

Photo by Greg Preston for Spectrum Fantastic Art

COLIN &
KRISTINE
POOLE

HOT DIGGETY DOG

Medium: Fired ceramic
Size: 28 x 21 x 21 in.

"What started as a tango has turned into a lifelong creative adventure."
—During the Poole's acceptance speech at the Spectrum 21 Awards Ceremony

Upon first encountering the collaborative anthropomorphic creations of Colin and Kristine Poole, one almost believes they've stepped into a reality where such creatures might actually exist. Each of their life-sized ceramic sculptures is based on a particular world myth and also tells its own story through the viewer's imagination. Colin's enduring fascination with mythology began in early childhood, having been introduced to the Greek mythological pantheon while working in the studio of his mentor, Christosomos Chakos, a master of Greek icon painting at the time. Colin shared his love of myth with Kristine, and together they have broadened their influences to include mythological stories from cultures around the globe. Their retelling of world myths inspires viewers to revisit the wonder of storytelling and emphasizes the unity of our cultural roots—how, since ancient times, people have told stories of creatures combining human and animal attributes, with magical results.

Regarding their working methodology, Colin says, "It really is a complete collaboration from the beginning. There isn't any part that we don't both have our hands in, literally and figuratively." Kristine adds, "We both bring specialized backgrounds to the table. My extensive background in ceramic sculpture and anatomical study is the perfect complement to Colin's twenty-five years of experience as a professional painter and sculptor. His work has been exhibited in museums and galleries throughout the United States and Europe, and his corporate client list reads as a "who's who" of *Fortune* 500 companies."

Colin and Kristine both moved to Santa Fe at the same time twenty years ago, but their paths did not cross until 2008, when he asked her to dance a tango. They were married in Greece the following summer and began combining their artistic talents the same year.

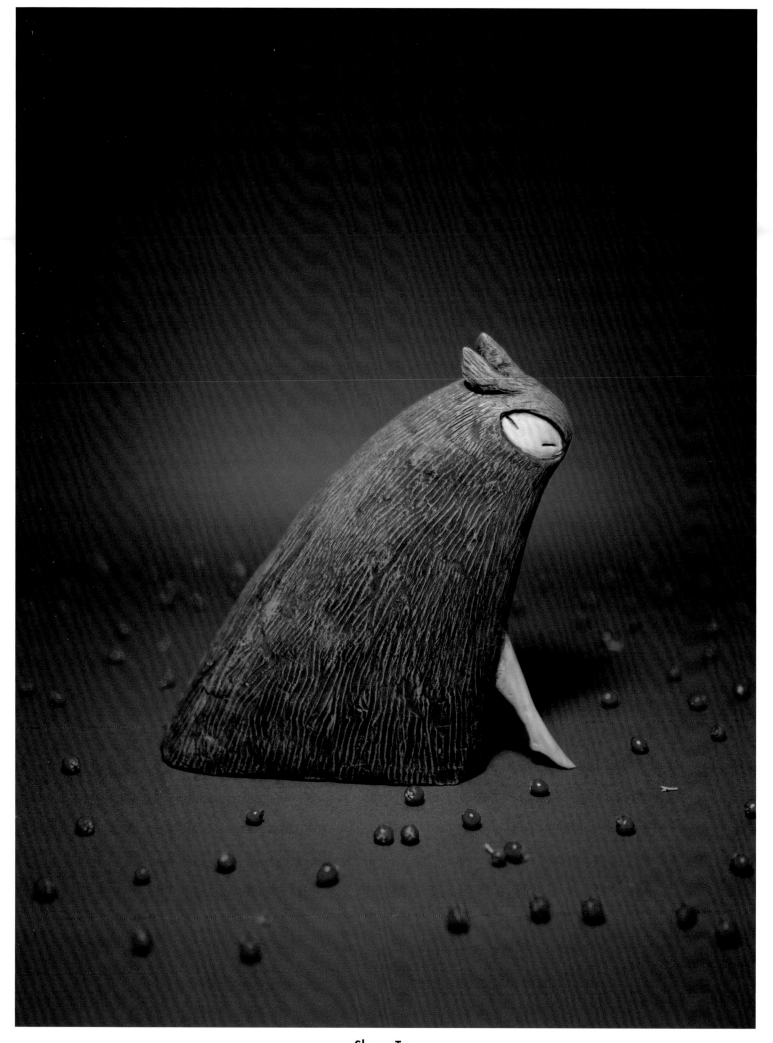

Shaun Tan
Title: Grimm Tales: Thousandfurs *Medium:* Paper, clay, paint and berries *Size:* 9 in. tall *Client:* Aladin Verlag *Art Director:* Nina Horn

Forest Rogers
Title: Goblin Spider
Medium: Kato Polyclay, garnets and wood *Size:* 6 x 15 in.

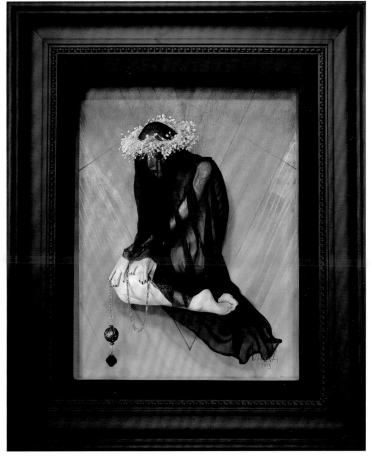

Jessica Dalva
Title: Don't Mind Me
Medium: Polymer clay, fabric, acrylic paint, mohair and various accoutrement's
Size: 14 x 17 in.

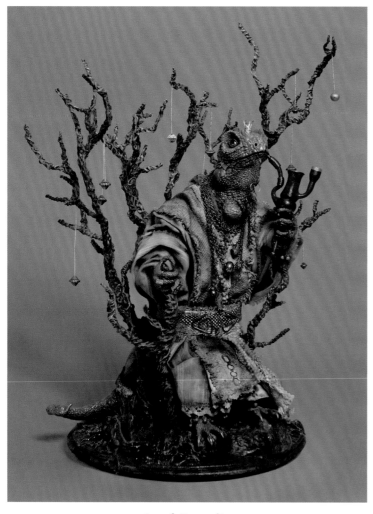

Assaf Carmeli
Title: Zikith *Medium:* Mixed *Size:* 11.75 x 19.75 in.
Photographer: Scott Gallagher

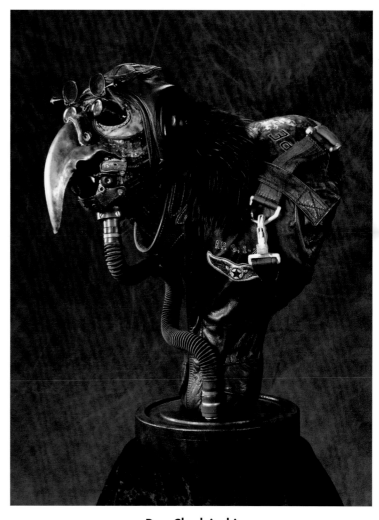

Dan Chudzinski
Title: Pestilenza: The Four Horsemen Series *Medium:* Fiberglass, mixed media
Dimensions: 28 x 25 x 18 in. *Photographer:* Dave Casperson

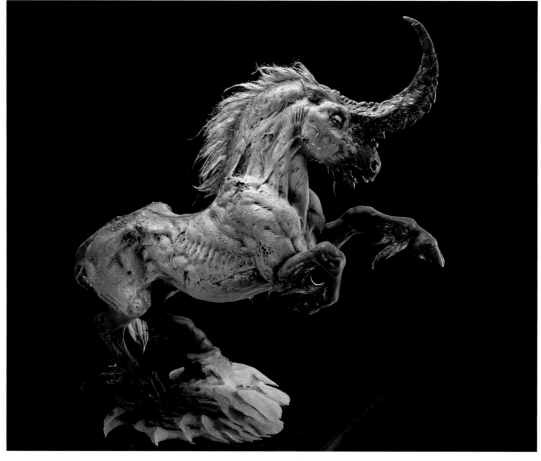

L.D. Austin
Title: Zombie Unicorn *Medium:* Polymer Clay *Size:* 8 x 12 in.

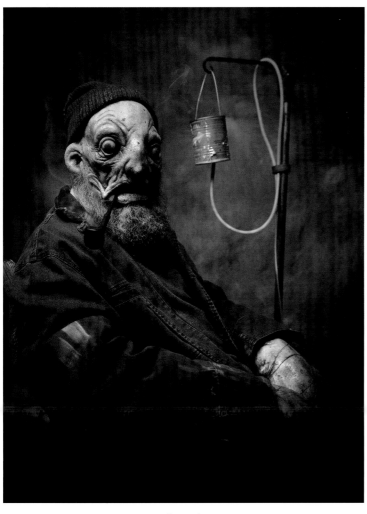

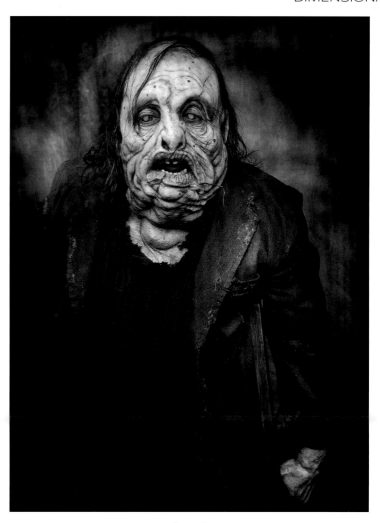

Joel Harlow
Title: Innsmouth Elder *Medium:* Silicone, acrylic, flesh, blood and bone
Size: Lifesize *Designer:* Joel Harlow *Photographer:* Ivan Sharudo

Joel Harlow
Title: Innsmouth Vagrant *Medium:* Silicone, acrylic, flesh, blood and bone
Size: Lifesize *Designer:* Joel Harlow *Photographer:* Michael Spatola

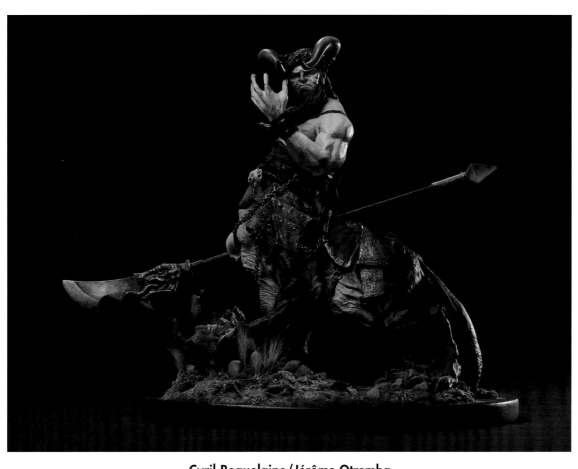

Cyril Roquelaine/Jérôme Otremba
Title: Grimlaw *Medium:* Sculpey, resin, leather, brass, feather
Size: 37 x 40 cm. *Designer:* Cristophe Grau *Photographer:* Greg Cervall

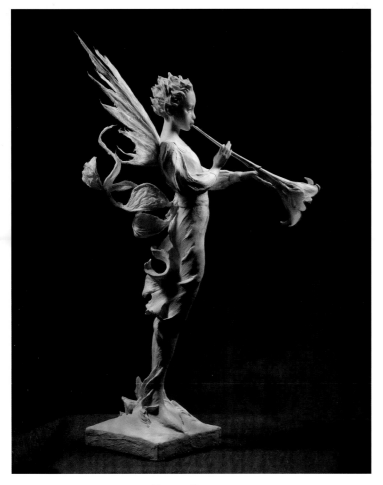

Forest Rogers
Title: Fairy Herald
Medium: Premier air-dry clay, polymer, washi paper and wood
Size: 10 x 15.5 in.

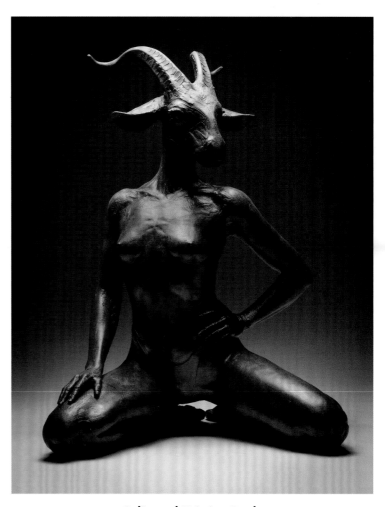

Colin and Kristine Poole
Title: Fauna *Medium:* Fired ceramic *Size:* 30 x 29 x 20 in.

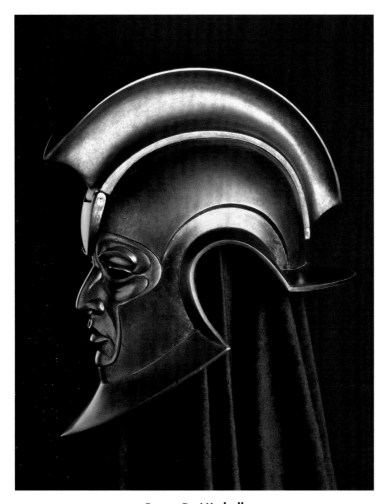

Bruce D. Mitchell
Title: Crucible *Medium:* Epoxy *Size:* 14 x 15 in.

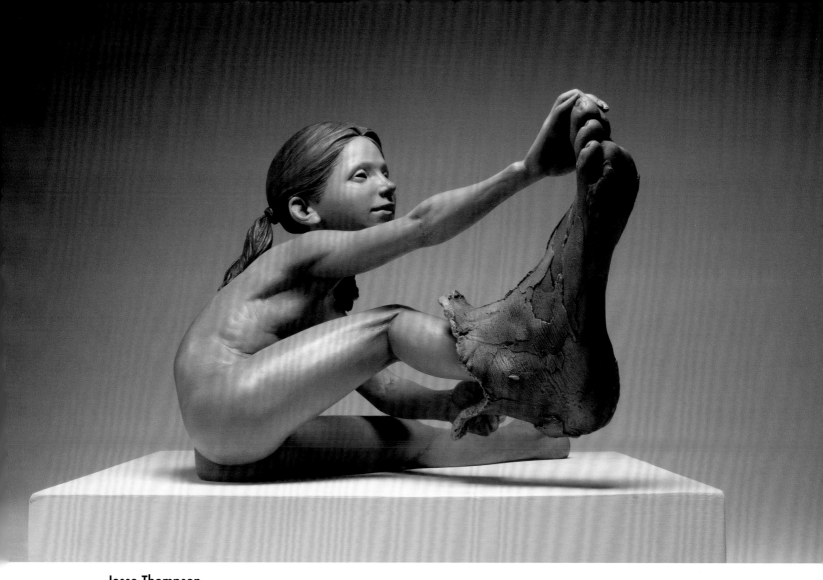

Jesse Thompson
Title: Dress up Bigfoot *Medium:* Cast resin
Size: 18 x 18 x 18 in. *Designer:* Matthew Clowney

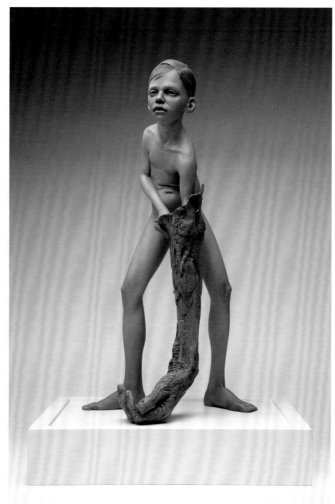

Jesse Thompson
Title: Dress up Long Arm *Medium:* Cast resin
Size: 18 x 18 x 18 in. *Designer:* Matthew Clowney

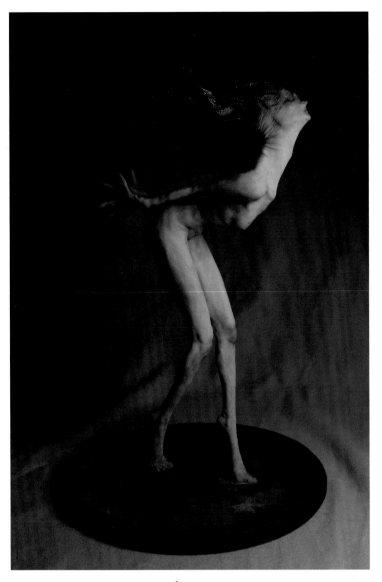

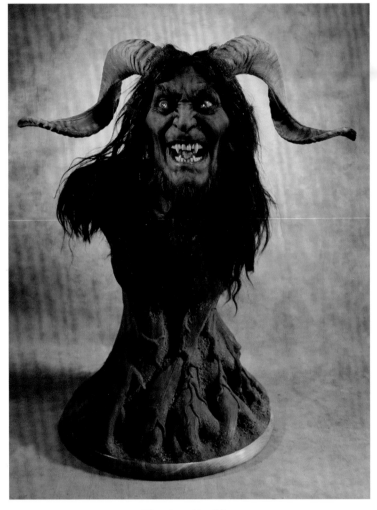

Matthew Levin
Title: Dryad *Medium:* Polymer Clay *Size:* 8 x 15 x 10 in.

Thomas Kuebler
Title: Krampus *Medium:* Silicone, mixed media
Size: 27 x 31 in. *Designer:* Brom

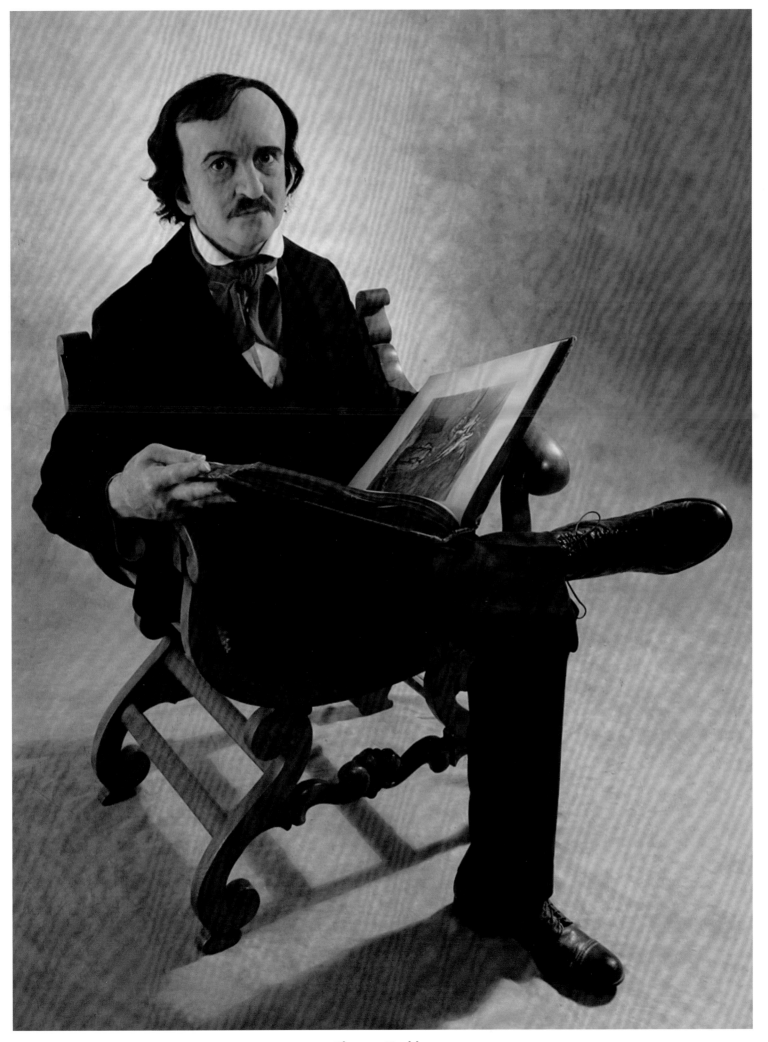

Thomas Kuebler
Title: Once Upon a Midnight Dreary *Medium:* Silicone, mixed media *Size:* Life-sized *Client:* Guillermo Del Toro

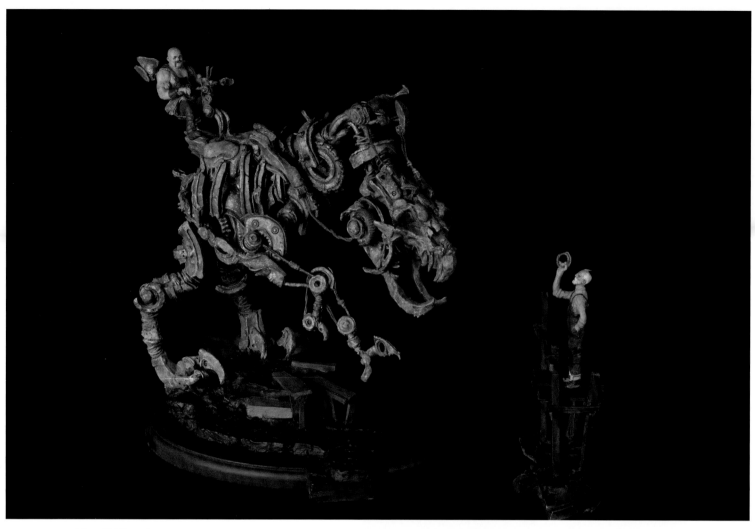

The Shiflett Bros.
Title: The Dragon Crane, 1893
Medium: Epoxy Putty, Super Sculpey
Size: 14 in.

Nathan Mansfield
Title: Captain Bonekurse *Medium:* Mixed
Painter: Richard T. Mayberry *Photo:* Ginny Guzman

Virginie Ropars
Title: Acanthophis IV *Medium:* Mixed media, Polymer Clay *Size:* 68 cm.

Photo by Greg Preston for Spectrum Fantastic Art

TRAN
NGUYEN

THE INSECTS OF LOVE

Client: Tor.com
Art Director: Irene Gallo

"I want to dedicate this to all the people that help us become the artist we are today. Thank you."

—During Nguyen's acceptance speech at the Spectrum 21 Awards Ceremony

Tran Nguyen is a Georgia-based gallery artist and freelance illustrator. Born in Vietnam and raised in the States, she is fascinated with creating visuals that can be used as a psycho-therapeutic support vehicle, exploring the mind's landscape. Her paintings are created with a soft, delicate quality using colored pencils and acrylics on paper. Nguyen has worked for clients such as *Playboy*, Tor, McDonald's and Chateau St. Michelle Winery and has been showcased in galleries in California, New York, Spain and Italy. She is currently represented by Richard Solomon and the Thinkspace Art gallery in Culver City, California.

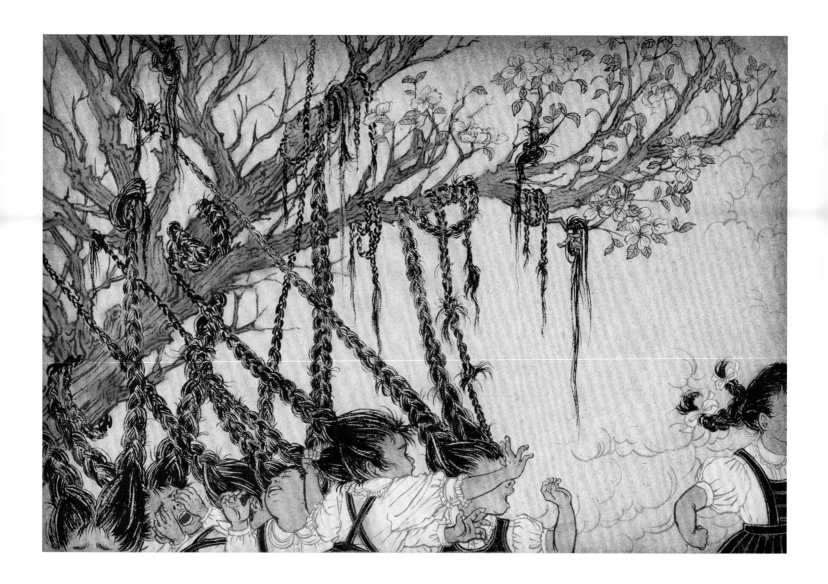

YUKO SHIMIZU

HAIR TREE
Medium: Ink drawing on paper with digital drawing
Client: Asset International
Art Director: SooJin Buzelli

"When I moved to New York as a child in the late 70s, I didn't speak any English. My parents and teachers thought it was a good idea if I read a lot of English books to get better at my second language and soon, I found myself spending every weekend for many hours in the sci-fi fantasy section of the bookstore, just because covers were so beautiful. I picked up many paperbacks with covers illustrated by Frank Frazetta and Boris Vallejo, among other artists who's work I loved. My English was terrible, so I couldn't read most of them, I bought them for the covers, and most of them are still in my parents home in Tokyo.

I tried to imitate their wok with my very limited ability to draw and paint. My dream was to be on the covers of those books one day. I even wrote a fan letter to Boris, when I was around13, with a xeroxed copy of one of my drawings folded into half and tacked into a small envelope.
It is a HUGE honor to receive an award from Spectrum. I wish I can go back to 1977 and tell that kid in the Fantasy isle of a bookstore in suburban New York. Though I don't think she would ever believe it.
Thank you SO much."

—Acceptance speech written for the Spectrum 21 Awards Ceremony

Yuko Shimizu is a Japanese illustrator based in New York City and an instructor at the School of Visual Arts (SVA). *Newsweek Japan* chose her as one of "100 Japanese People the World Respects" in 2009. You may have seen her work on Gap T-shirts, Pepsi cans, Visa billboards, Microsoft and Target ads, as well as on the covers of Penguin and Scholastic books and DC Comics. Her work also has graced the pages of *The New York Times, Time, Rolling Stone, The New Yorker* and many other publications over the last ten years. But illustration is actually Shimizu's second career. Although art has always been her passion, she initially chose a more practical path of studying advertising and marketing at Waseda University and took a job in corporate PR in Tokyo. It never quite made her happy. At age 22, she was in a mid-life crisis. Shimizu ended up working in the corporate job for eleven years, so she could figure out what she really wanted in life as well as to save up just enough to play the biggest gamble of her life: She moved to New York City in 1999, where she briefly spent her childhood, to study art for the first time. She graduated with an MFA from SVA's Illustration as Visual Essay program in 2003 and has been illustrating ever since.

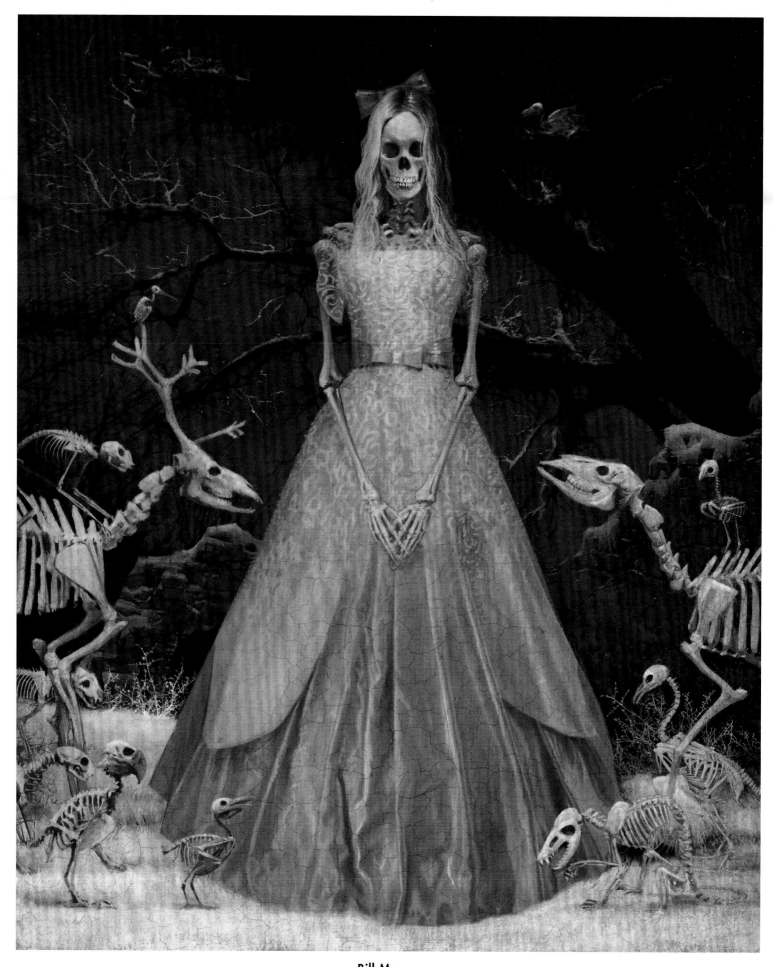

Bill Mayer
Title: Fragile Planet *Medium:* Mixed media *Size:* 10 x 12 in. *Client:* 3x3 *Art Director:* Charles Hively

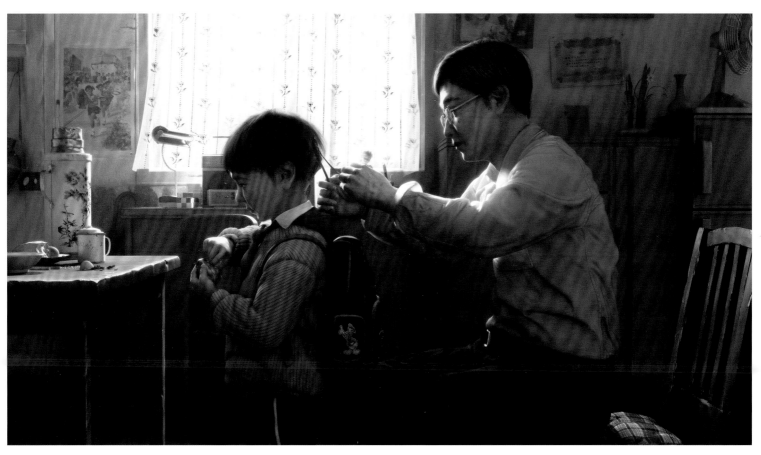

Luo Xin
Title: Recall *Artist:* Barnet *Medium:* Digital *Size:* 26.75 x 15 in.

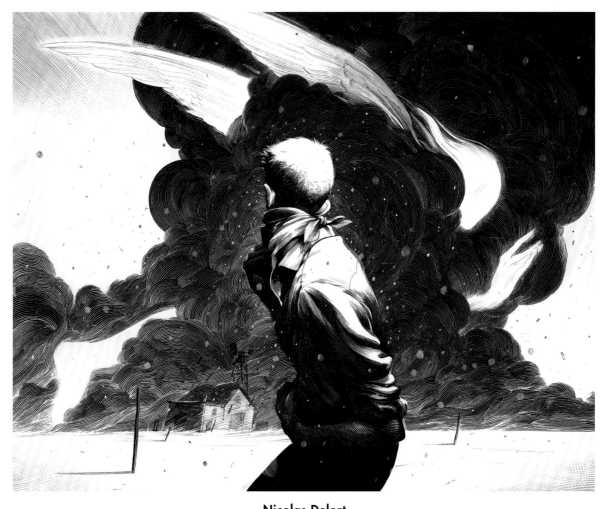

Nicolas Delort
Title: Rumor of Angels *Medium:* Ink on clayboard *Size:* 11 x 14 in. *Client:* Tor.com *Art Director:* Irene Gallo

Anna and Elena Balbusso
Title: Too-Clever Fox *Medium:* Acrylic and digital
Size: 8.25 x 11.75 in. *Client:* Tor.com *Art Director:* Irene Gallo

Anna and Elena Balbusso
Title: Burning Girls *Medium:* Acrylic and digital
Size: 8.25 x 11.75 in. *Client:* Tor.com *Art Director:* Irene Gallo

Bill Mayer
Title: Searching for Safe Harbor *Medium:* Mixed media
Size: 9 x 12 in. *Client:* Asset International *Art Director:* SooJin Buzelli

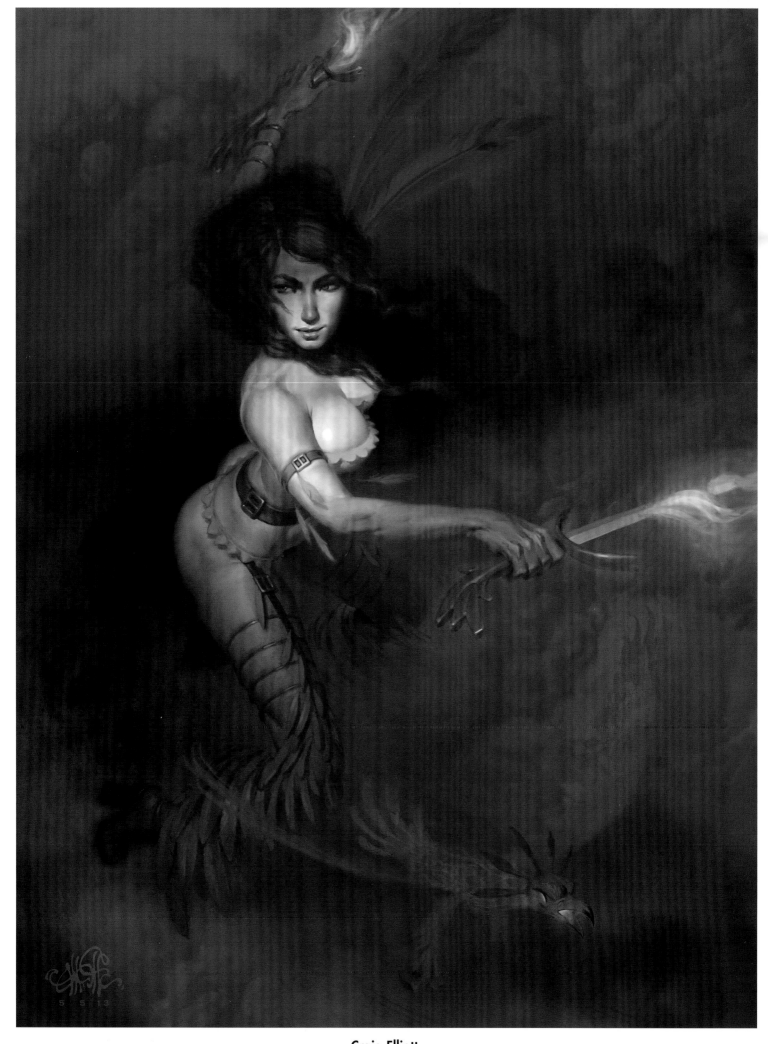

Craig Elliott
Title: Fire Goddess *Medium:* Digital *Size:* 10 x 13.25 in. *Client:* Applibot *Art Director:* Pierre Maneval

Chris Buzelli
Title: Nabokov's Butterfly *Medium:* Oil on panel
Size: 15 x 20 in. *Client:* Nautilus magazine *Art Director:* Len Small

Chris Buzelli
Title: Entropy *Medium:* Oil on panel *Size:* 16 x 20 in.
Client: Playboy magazine *Art Director:* Justin Page

Brom
Title: Succubus *Medium:* Oil *Client:* Carlos Simoes

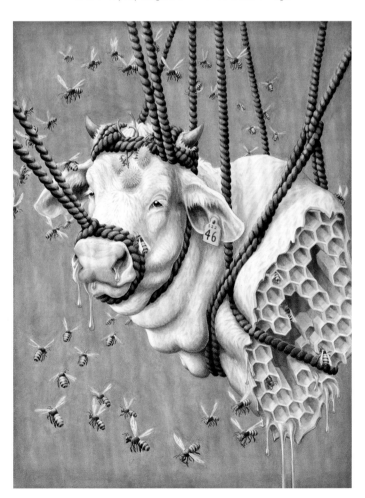

Brian Britigan
Title: Golden *Medium:* Pencil and acrylic on illustration board
Size: 18 x 24 in. *Client:* The Stranger *Art Director:* Aaron Huffman

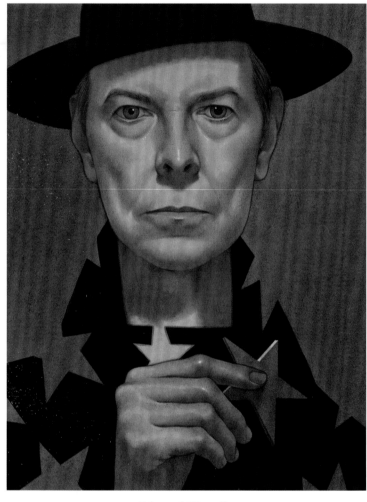

Edward Kinsella
Title: David Bowie, The Stars (Are Out Tonight)
Medium: Ink and gouache *Size:* 6 x 8 in.
Client: Entertainment Weekly *Art Director:* Kory Kennedy

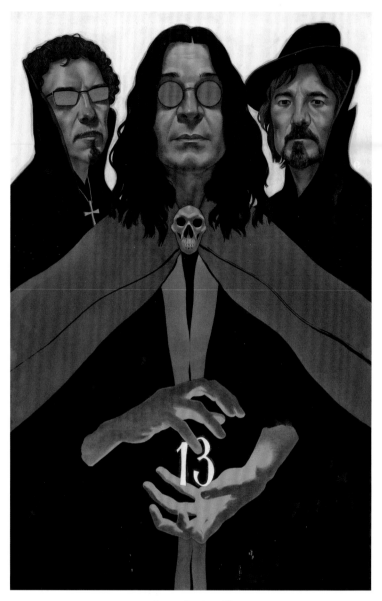

Edward Kinsella
Title: Black Sabbath 13 *Medium:* Ink, gouache and watercolor
Size: 13 x 20 in. *Client:* Rolling Stone Magazine *Art Director:* Mark Maltais

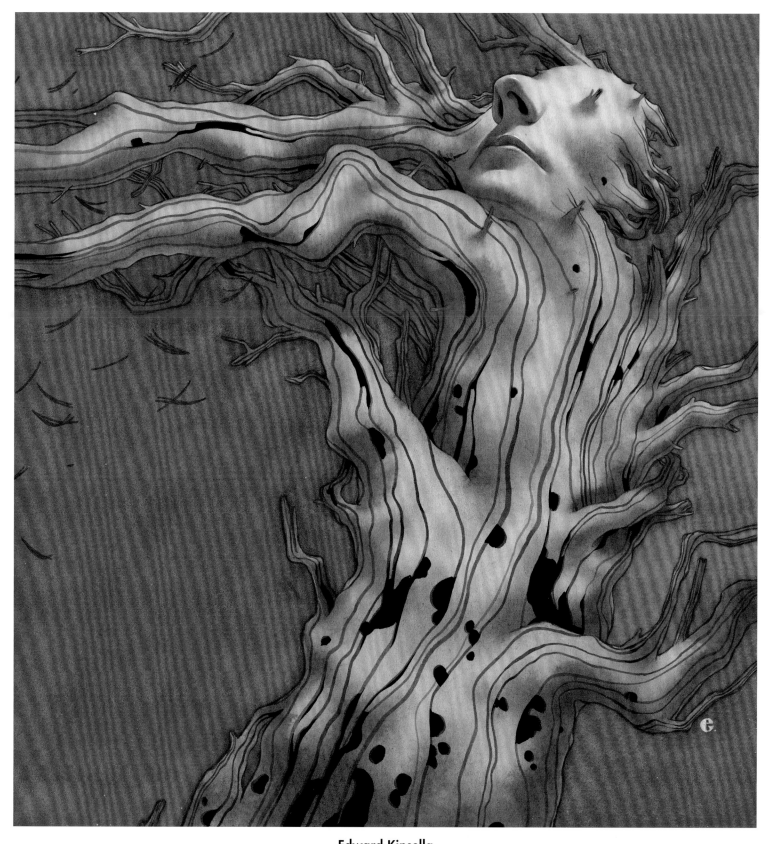

Edward Kinsella
Title: The Corpse Tree *Medium:* Ink and gouache *Size:* 12.5 x 13 in. *Client:* UU World Magazine *Art Director:* Robert Delboy

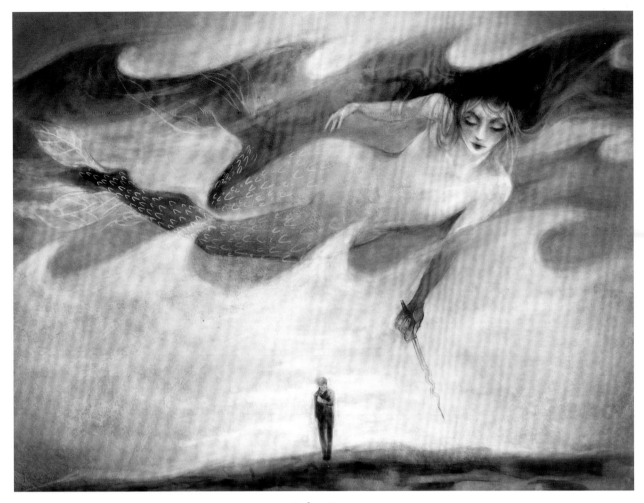

Galen Dara
Title: Abyssus Abyssum Invocat *Medium:* Digital *Size:* 9 x 12 in. *Client:* Lightspeed Magazine

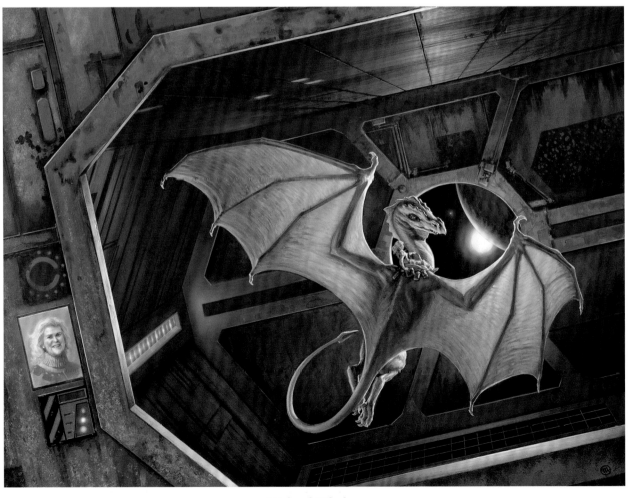

Michael Whelan
Title: Dragon Aboard

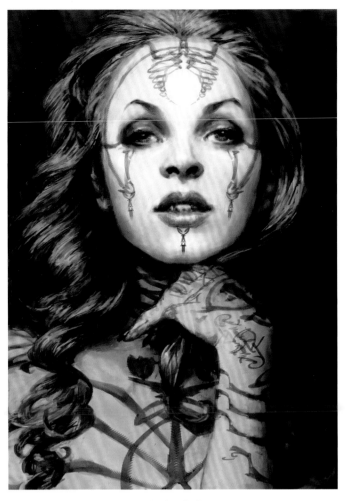

Iain McCaig
Title: Mad Maudlin *Client:* Tor.com *Art Director:* Irene Gallo

Jeffrey Alan Love
Title: Prince Igor *Medium:* Acrylic, oil and digital
Size: 9 x 10 in. *Client:* The New Yorker *Art Director:* Jordan Awan

Gary Gianni
Title: A Song of Ice and Fire *Medium:* Oil *Size:* 20 x 30 in. *Client:* Random House *Art Director:* Dave Stevenson

Morgan Schweitzer
Title: Into the Night *Medium:* Digital *Size:* 8 x 5 in. *Client:* Cycle World Magazine *Art Director:* Laura Milton

Vivienne To
Title: Edwena the Wise *Medium:* Digital *Client:* The School Magazine

Peter Diamond
Title: Godless Believers *Medium:* India ink and digital
Client: Hohe Luft *Picture Editor:* Maja Metz

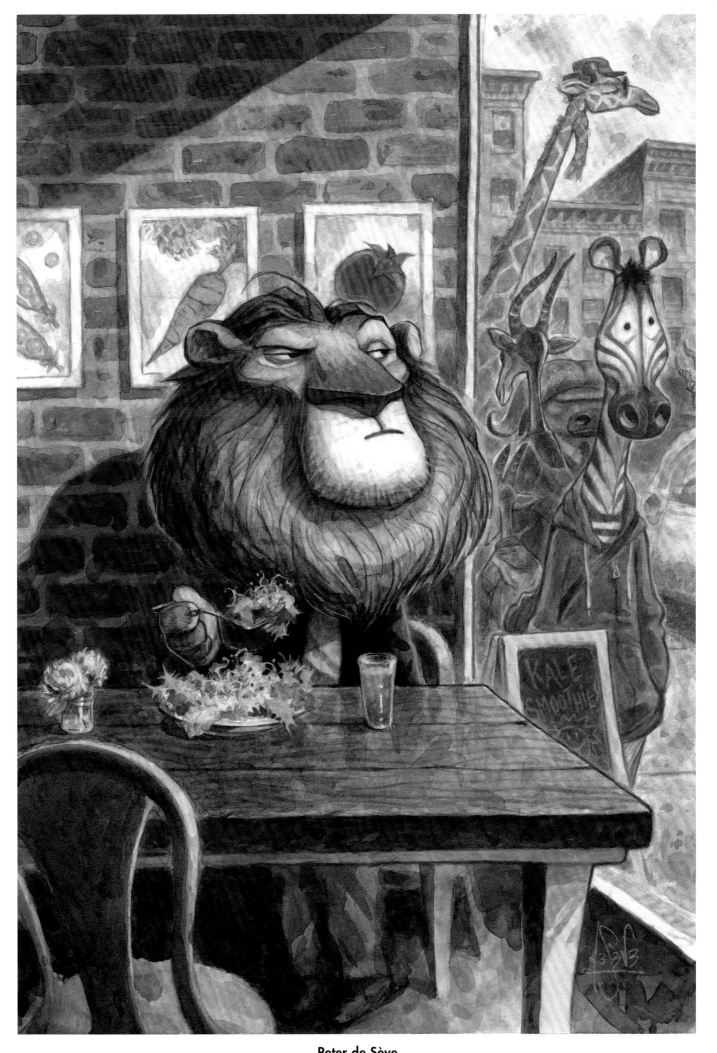

Peter de Sève
Title: A New Leaf *Medium:* Ink and watercolor *Size:* 13 x 17 in. *Client:* The New Yorker *Art Director:* Françoise Mouly

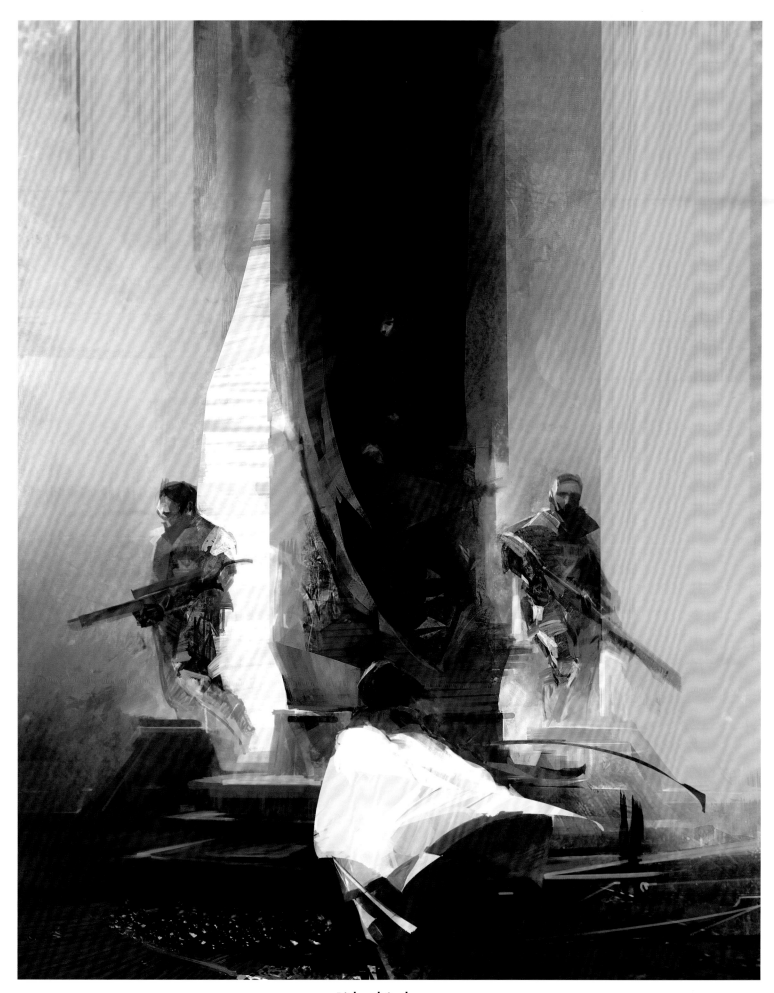

Richard Anderson
Title: Cartography of Sudden Death *Client:* Tor.com *Art Director:* Irene Gallo

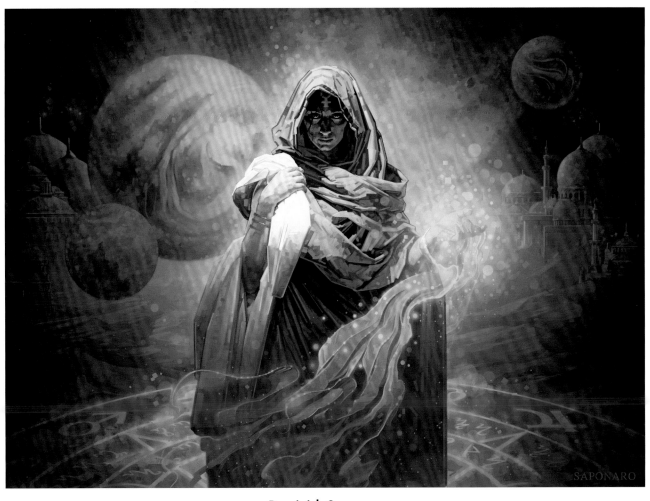

Dominick Saponaro
Title: Thief of War *Medium:* Mixed digital *Size:* 22 x 16 in. *Client:* Tor.com *Art Director:* Irene Gallo

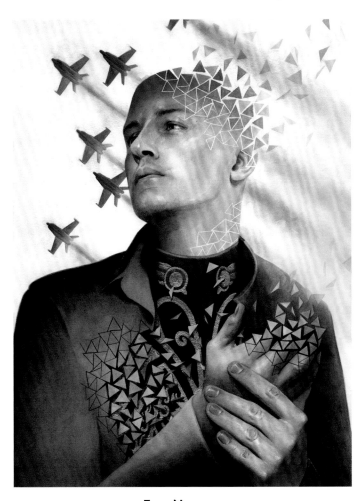

Tran Nguyen
Title: Vile Rat *Medium:* Acrylic, color pencil and digital
Size: 12 x 16 in. *Client:* Playboy *Art Director:* Justin Page

Richie Pope
Title: The Devil in America *Client:* Tor.com *Art Director:* Irene Gallo

Victo Ngai
Title: Leap *Medium:* Mixed *Size:* 16 x 20.5 in. *Client:* Plansponsor *Art Director:* SooJin Buzelli

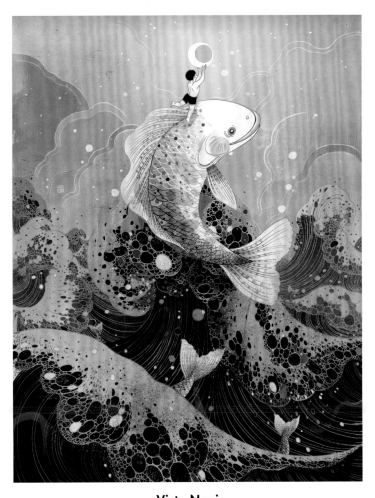

Victo Ngai
Title: Moon Catcher *Medium:* Mixed
Size: 12 x 15.5 in. *Client:* Plansponsor *Art Director:* SooJin Buzelli

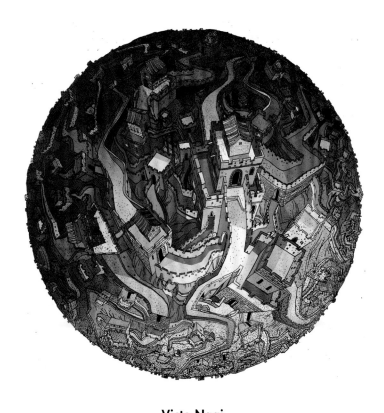

Victo Ngai
Title: China's Global Domination *Medium:* Mixed
Size: 20 x 20 in. *Client:* The New York Times *Art Director:* Aviva Michaelov

Victo Ngai
Title: Deep Thinkers *Medium:* Mixed *Size:* 18.5 x 25.25 in.
Client: Computer World Magazine *Art Director:* April Montgomery

Victo Ngai
Title: Wadjda *Medium:* Mixed *Size:* 12 x 17.25 in.
Client: The New Yorker *Art Director:* Jordan Awan

Yuko Shimizu
Title: Goose with Golden Eggs *Medium:* Ink drawing on paper with digital drawing *Client:* Asset International *Art Director:* SooJin Buzelli

Yuko Shimizu
Title: Igloo and a Big Kid *Medium:* Ink drawing on paper with digital drawing *Client:* Asset International *Art Director:* SooJin Buzelli

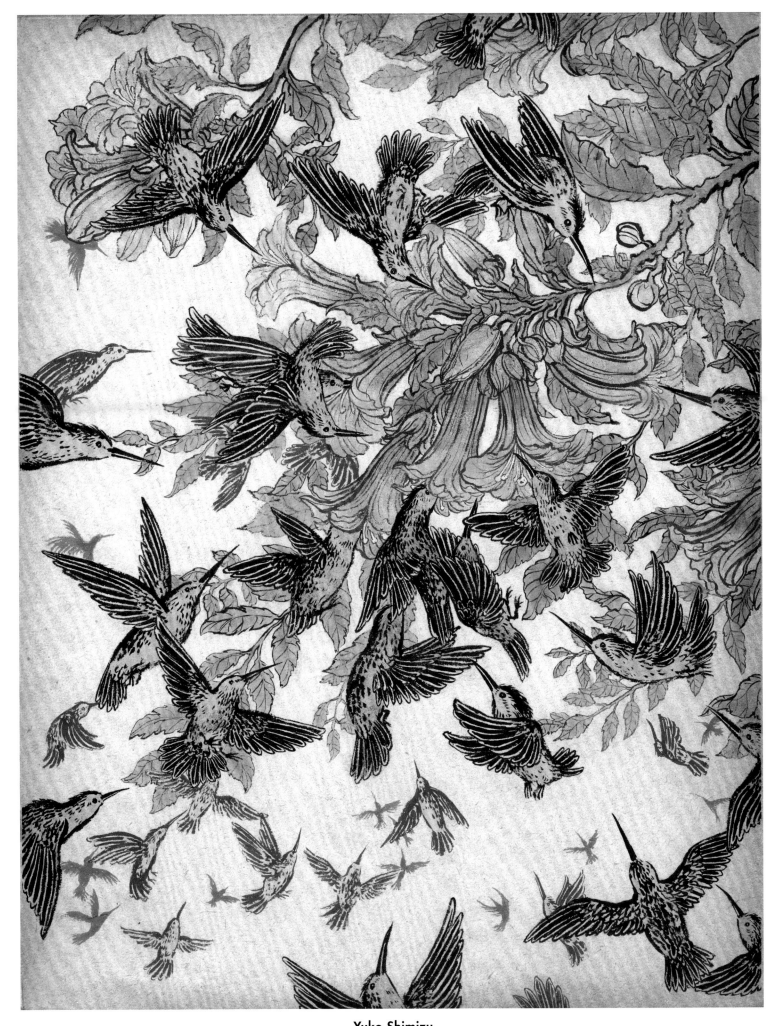

Yuko Shimizu
Title: Hummingbirds *Medium:* Ink drawing on paper with digital drawing *Client:* Asset International *Art Director:* SooJin Buzelli

INSTITUTIONAL GOLD AWARD

BILL CARMAN

SHARED EYEWEAR
Medium: Acrylic on panel
Size: 11 x 14 in.
Client: AFANYC Gallery

"People look at my work and go, what the !@%$ is that! Cool, but what do you do with it?"
—During Carman's acceptance speech at the Spectrum 21 Awards Ceremony

Bill Carman, according to Carman: "I entered a local Stinker convenience store. Upon taking my purchases to the counter, a young clerk remarked: 'Dude, your head is perfectly round.' Pause. My reply, 'Uh, thank you?' One would think that in such a perfectly round dome ideas and images might be orbiting neatly. But if my head were opened, it would be quite messy. A lot goes in, and if I did not let some out, an eye might pop. Though my work can be meticulous in its execution, my mind scribbles, jumps, spins and spits. Surface speaks to me, and things emerge as unknown yet familiar characters and unbalancing juxtapositions. Some pieces divulge narratives as I paint, and some stare back and challenge that mad place that lies deep in our brains. I've worked as a designer, illustrator, teacher and art director at universities, ad agencies, publishers and large corporations. Since graduating with a BFA in visual communication/illustration and an MFA in painting, I have always freelanced and exhibited and have been included in annuals like the *Society of Illustrators, Spectrum, 3x3, American Illustration* and have even finagled some medals. I have a decent client list which includes a children's book with Random House."

Photo by Greg Preston for Spectrum Fantastic Art

INSTITUTIONAL SILVER AWARD

JUSTIN SWEET

BLACKSEA
Medium: Oil on canvas
Size: 23 x 45 in.

"At an early age I started making pictures and just got caught up in this wave and here I am and to have an award is sort of a landmark, I think, of all the times and the blood, sweat and all we do to make an image and to do our thing. We come here and we get reminded that there are others of us and I just want to say thank you very much…"

—During Sweet's acceptance speech at the Spectrum 21 Awards Ceremony

Justin Sweet has worked as an illustrator on films, books and games for the last twenty years. He started his career at Interplay productions as a concept artist for projects such as Dragon Dice, Icewind Dale, and Fallout 1 and 2. Since then, he has worked on many feature films, including *The Avengers*, all the *Narnia* movies, *Thor 2*, *Snow White and The Huntsman* and many others. Some of Sweet's illustrated work for books includes *Kull: Exile of Atlantis*, *Game of Thrones* and others for Del Rey and Tor. Recently, he and his friend Vance Kovacs launched a successful Kickstarter art-book campaign called *Eclipse: The Well and the Black Sea*. Sweet Lives in Southern California with his wife, three children and dog Buster.

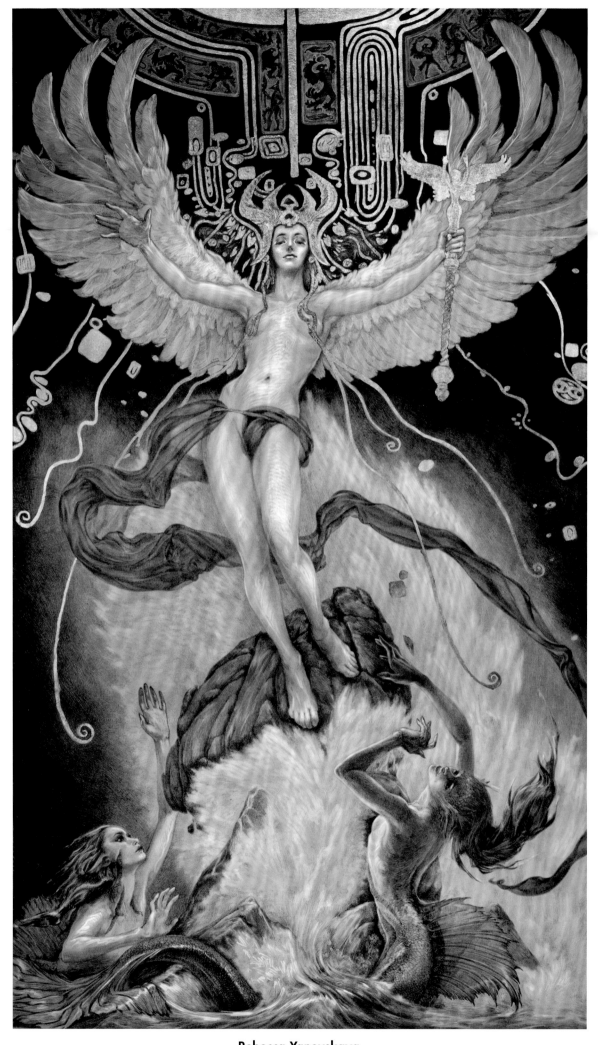

Rebecca Yanovskaya
Title: Ascent of Man *Medium:* Ballppoint pen *Size:* 17.5 x 10.5 in. *Art Director:* Peter Mohrbacher

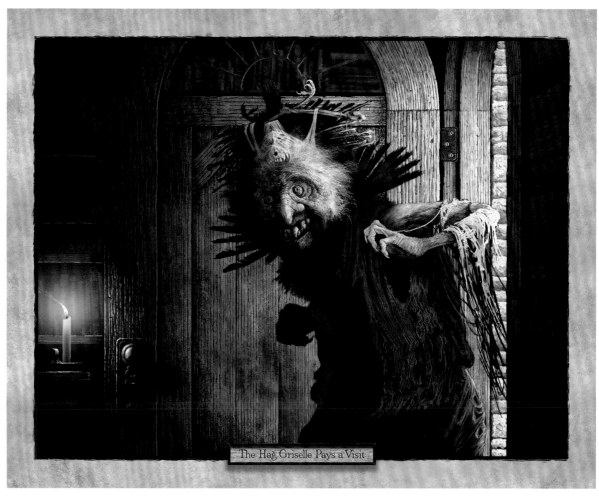

The Hag Griselle Pays a Visit

Ed Binkley
Title: The Hag Griselle Pays a Visit Medium: Digital *Size:* 12 x 15 in.

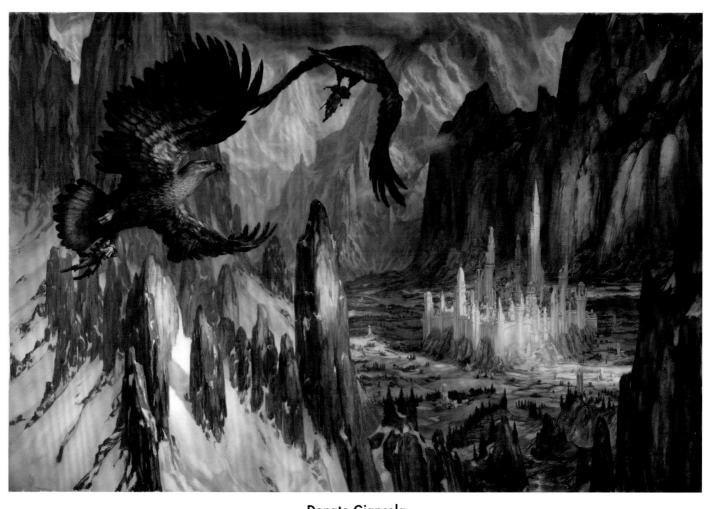

Donato Giancola
Title: Huor and Hurin Approaching Gondolin *Medium:* Oil on linen Size: 112 x 73 in. *Client:* Christopher Redligh

Adam Tan
Title: Natmada the Exiled *Medium:* Digital
Size: 10 x 18 in. *Client:* Light Grey Art Lab's Rolemodels exhibition

Jenna Kass
Title: The Long Path *Medium:* Oil
Size: 11 x 19.5 in. *Client:* Light Grey Art Lab

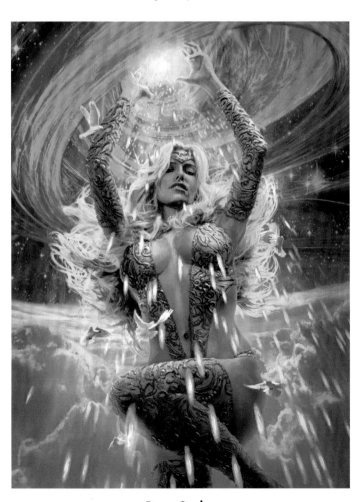

Dave Seeley
Title: Elf of Requiem Advanced *Medium:* Digital and oil *Size:* 25 x 36 in.
Client: Applibot *Art Director:* Pierre Maneval and Nicole Fang

Chrystal Chan
Title: Joan of Arc *Medium:* Digital
Size: 8.75 x 11.75 in. *Client:* Ngmoco,LLC *Art Director:* Gary Laib

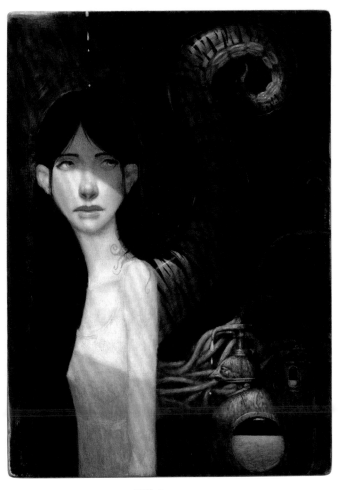

Bill Carman
Title: Microvisions: A Bit of Calamine?
Medium: Acrylic on copper *Size:* 5 x 7 in. *Client:* Society of Illustrators

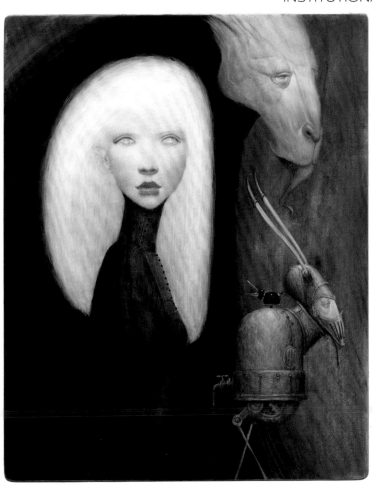

Bill Carman
Title: Family Ties *Medium:* Acrylic on copper
Size: 6 x 8 in. *Client:* AFANYC Gallery

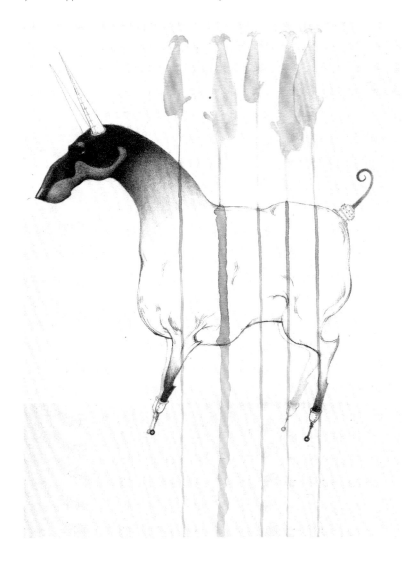

Bill Carman
Title: Protect Your Pets from Narbursts
Medium: Mixed *Size:* 8 x 10 in.

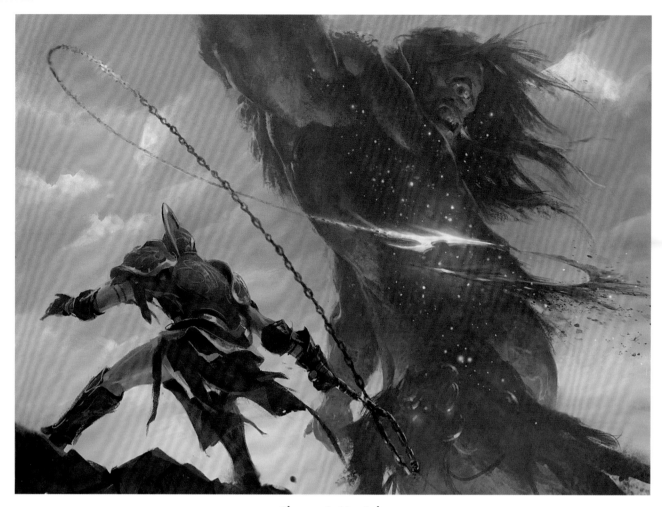

Slawomir Maniak
Title: Mortal Obstinacy *Medium:* Digital *Client:* Wizards of the Coast *Art Director:* Jeremy Jarvis

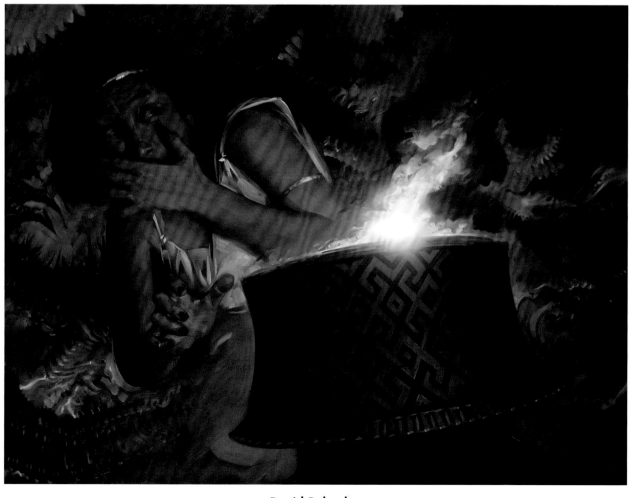

David Palumbo
Title: Pyxis of Pandemonium *Medium:* Oil *Client:* Wizards of the Coast *Art Director:* Jeremy Jarvis

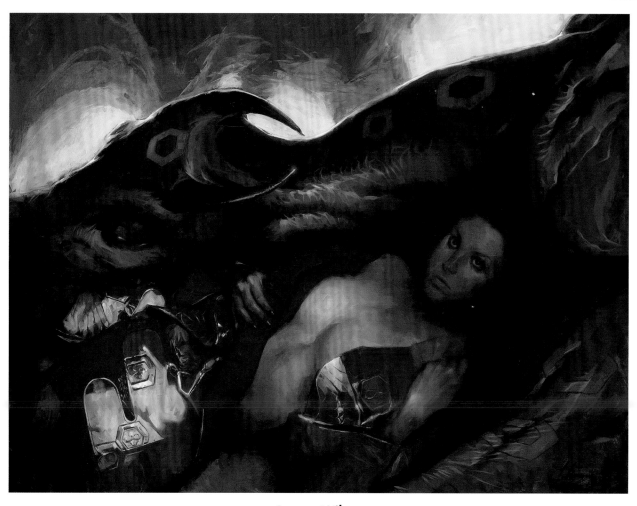

Jeremy Wilson
Title: The Keeper *Medium:* Oil on linen *Size:* 24 x 30 in. *Client:* One Thousand Words

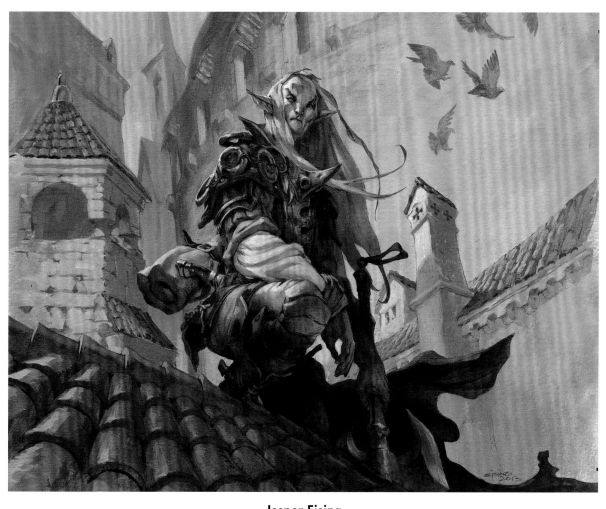

Jesper Ejsing
Title: Scout of Selvala *Medium:* Acrylics on paper *Size:* 12 x 10 in. *Client:* Magic the Gathering *Art Director:* Jeremy Jarvis

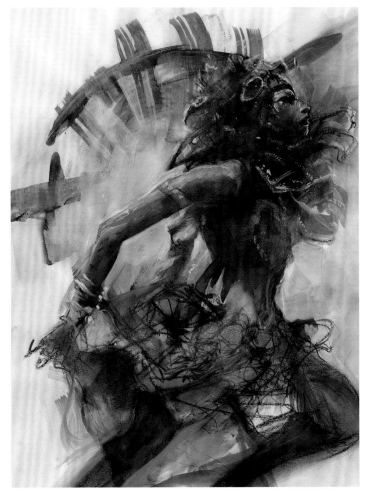

Jonathan Vair Duncan
Title: Legacy II *Medium:* Mixed *Size:* 10 x 16 in.

Lauren Saint-Onge
Title: Nautical Kings *Medium:* Digital *Size:* 10 x 14.5 in.

Angela Rizza
Title: The Owl Princess and Her Night Terrors
Medium: Ink, watercolor and digital *Size:* 8 x 10 in.

Scott M. Fischer
Title: Kiora the Crashing Wave *Medium:* Mixed *Client:* Wizards of the Coast
Art Director: Jeremy Jarvis *Other:* Magic: the Gathering

Karla Ortiz
Title: Ashiok, Nightmare Weaver *Medium:* Digital *Client:* Wizards of the Coast *Art Director:* Jeremy Jarvis

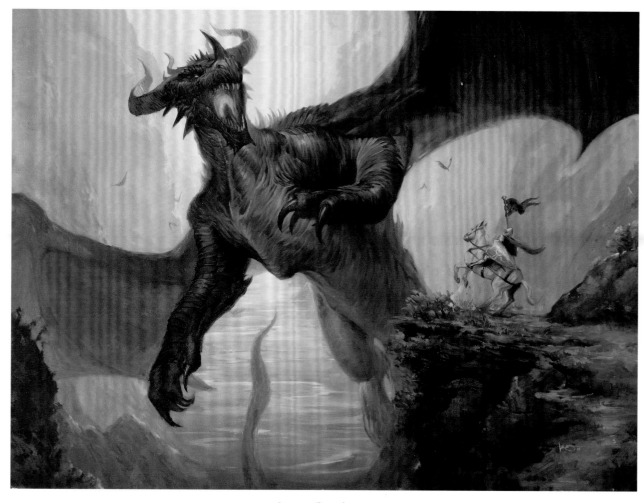

Lucas Graciano
Title: Scourge of Valkas *Medium:* Oil *Size:* 20 x 16 in. *Client:* Wizards of the Coast *Art Director:* Jeremy Jarvis

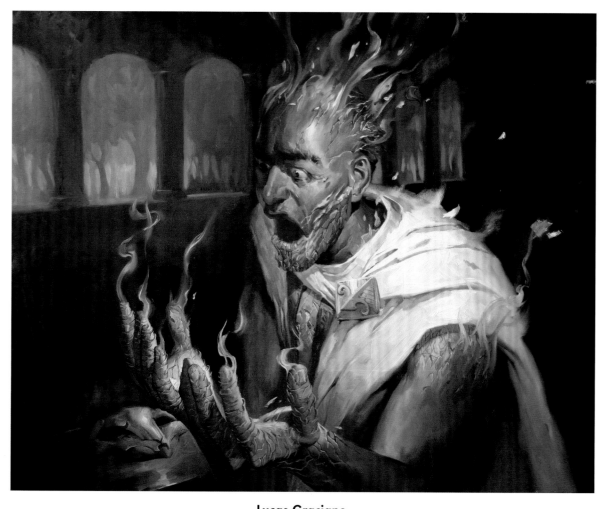

Lucas Graciano
Title: Thoughtseize *Medium:* Oil *Size:* 20 x 16 in. *Client:* Wizards of the Coast *Art Director:* Jeremy Jarvis

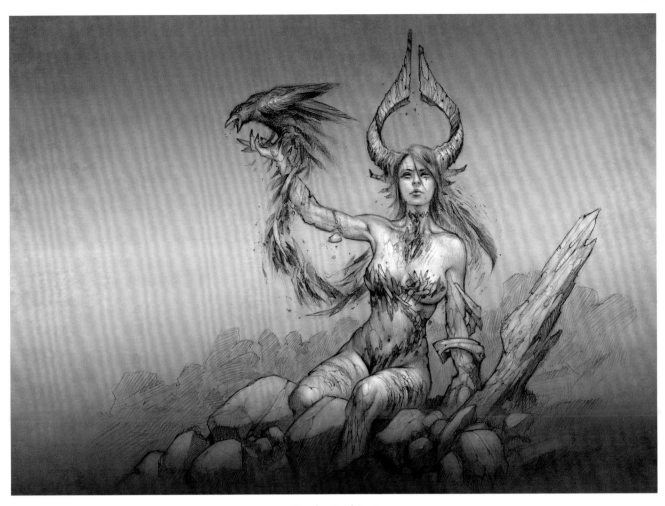

Paolo Barbieri
Title: Lady of Darkness *Medium:* Pencil and digital *Size:* 21.5 x 27.75 in. *Client:* Arnoldo Mondadori Editore

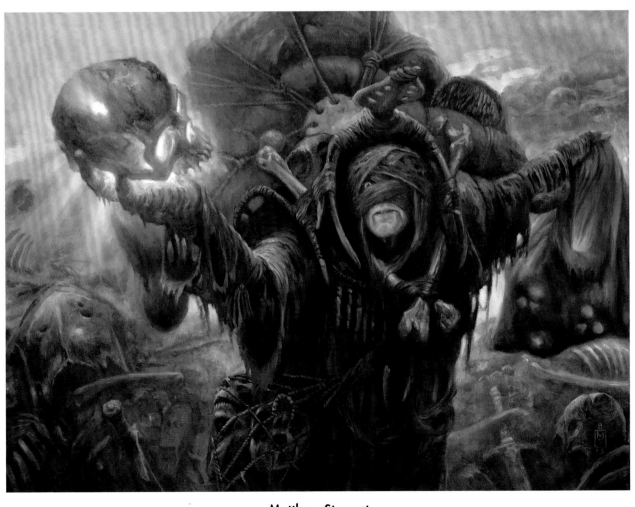

Matthew Stewart
Title: Waste Not *Medium:* Oil *Size:* 12 x 16 in. *Client:* Wizards of the Coast *Art Director:* Jeremy Jarvis

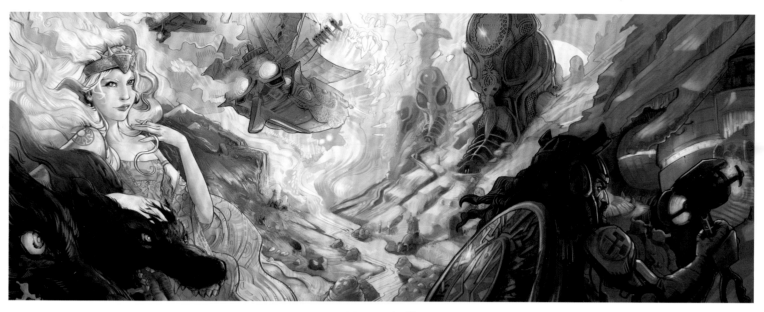

Marc Scheff
Title: Winter *Medium:* Digital *Size:* 26 x 13 in. *Client:* The Science Fiction Book Club
Art Director: Matthew Kalamidas Winter © The Science Fiction Book Club and Marc Scheff

Raoul Vitale
Title: The Hunt *Medium:* Oil on masonite *Size:* 36 x 26 in.

Raoul Vitale
Title: Second Breakfast *Medium:* Oil on masonite *Size:* 18 x 24 in.

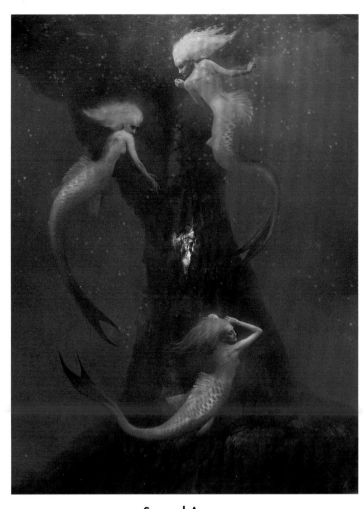

Samuel Araya
Title: Das Rheingold *Medium:* Digital *Client:* Seattle Opera House

Rebecca Yanovskaya
Title: Black Magic *Medium:* Ballpoint pen, digital
Size: 13.5 x 9 in. *Art Director:* Peter Mohrbacher

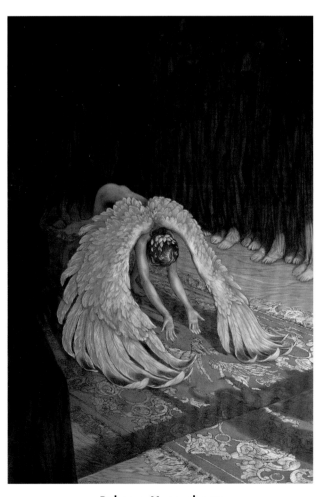

Rebecca Yanovskaya
Title: Descent of Man *Medium:* Ballpoint pen
Size: 15.5 x 10.5 in. *Art Director:* Pete Mohrbacher

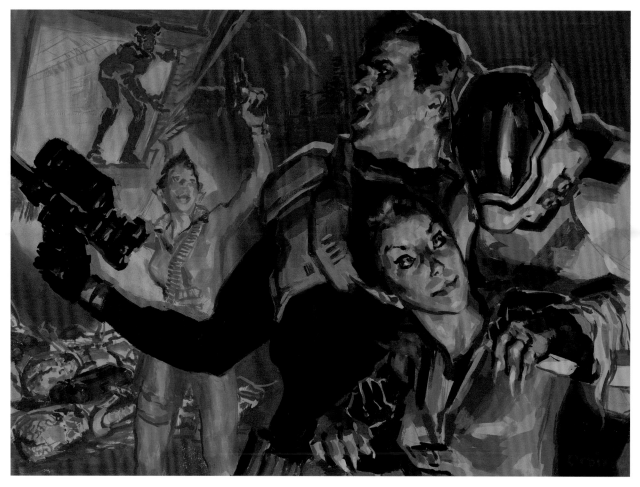

Glen Orbik
Title: Mars Attacks #24: Renegade Rescue *Medium:* Gouache *Size:* 13 x 18 in. *Client:* Topps
Art Director: Adam Levine *Designer:* Laurel Blechman and Glen Orbik

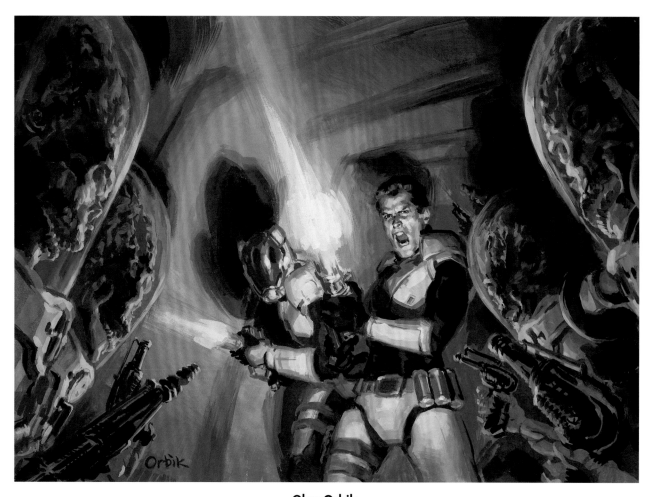

Glen Orbik
Title: Mars Attacks #25: Hide and Seek *Medium:* Gouache *Size:* 13 x 18 in.
Art Director: Adam Levine *Designer:* Laurel Blechman and Glen Orbik

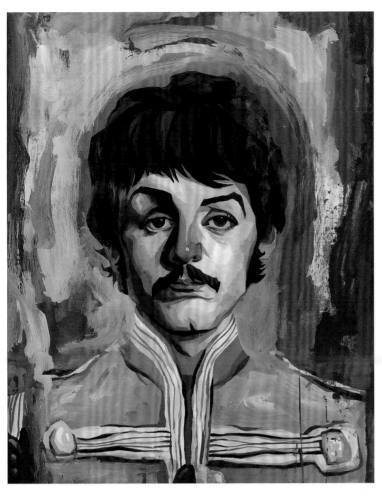
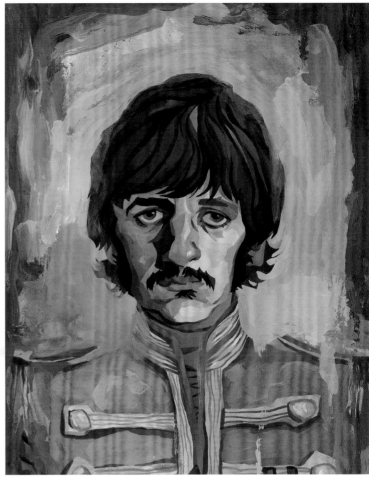
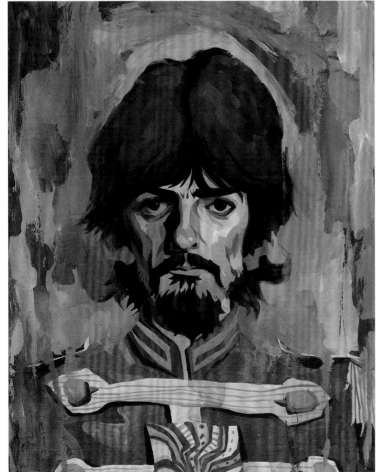
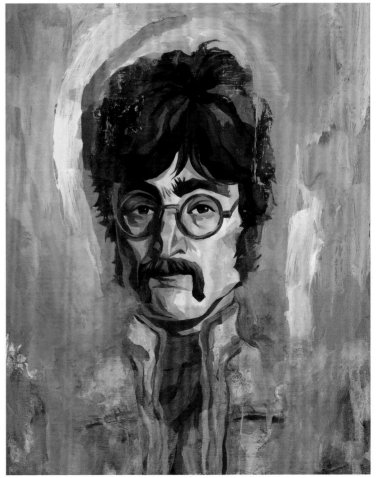

Rich Pellegrino
Title: Lonely Hearts *Medium:* Acrylic, gouache on panel *Size:* 16 x 20 in.

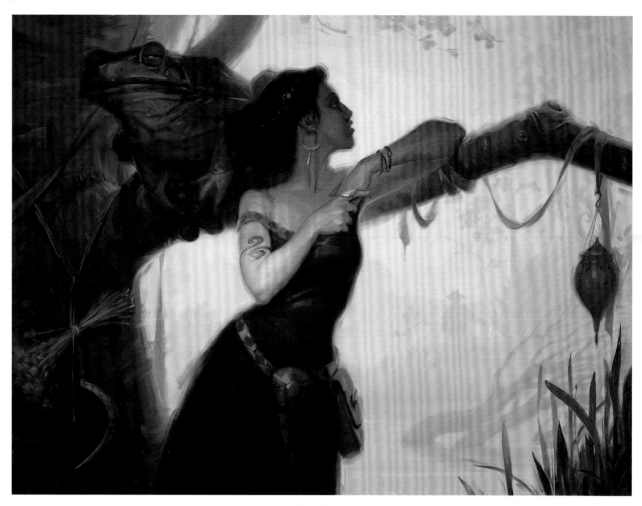

Rob Rey
Title: A Bargain Kept *Medium:* Oil *Size:* 24 x 18 in.

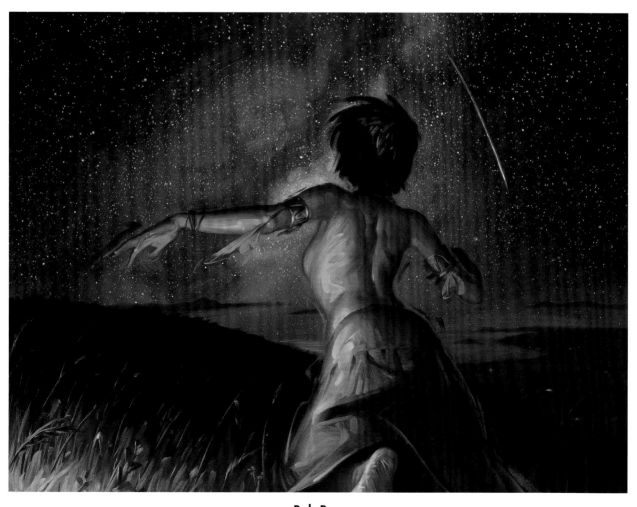

Rob Rey
Title: Falling Fire *Medium:* Oil *Size:* 24 x 18

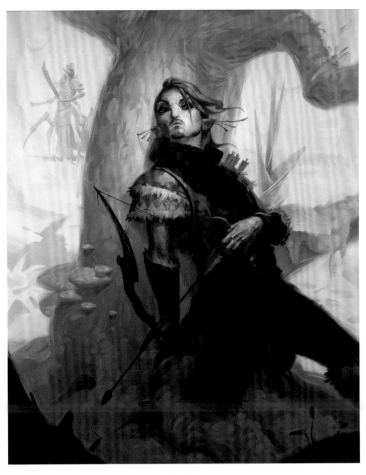

Rob Rey
Title: Nelebrin Skirmisher *Medium:* Oil *Size:* 16 x 20 in.
Client: Cryptozoic Entertainment *Art Director:* William Brinkman
© 2012 Square Enix, Inc. All rights reserved. Used with permission

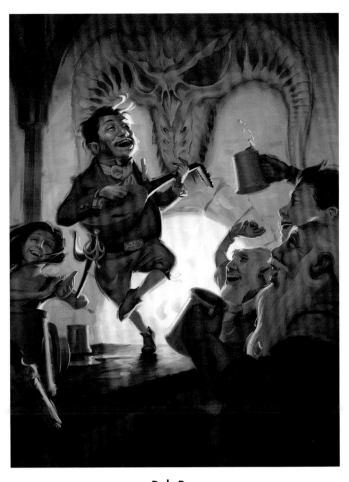

Rob Rey
Title: Lively Lute Player *Medium:* Oil *Size:* 12 x 16 in.
Client: Wizards of the Coast *Art Director:* Kate Irwin
© Wizard of the Coast LLC. Used with permission

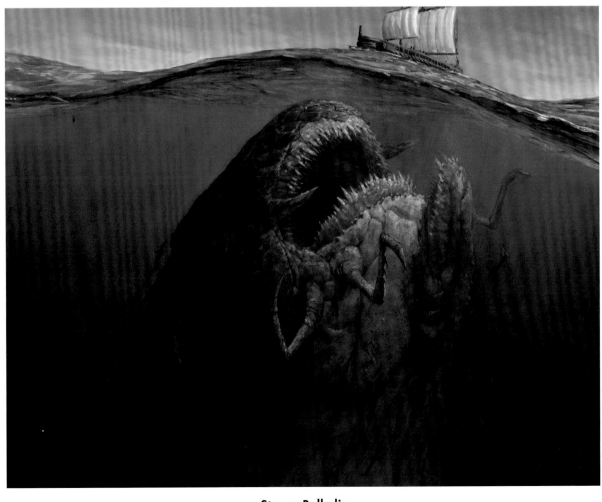

Steven Belledin
Title: Deluge Kraken *Medium:* Oil *Size:* 14 x 11 in. *Client:* Wizards of the Coast *Art Director:* Jeremy Jarvis

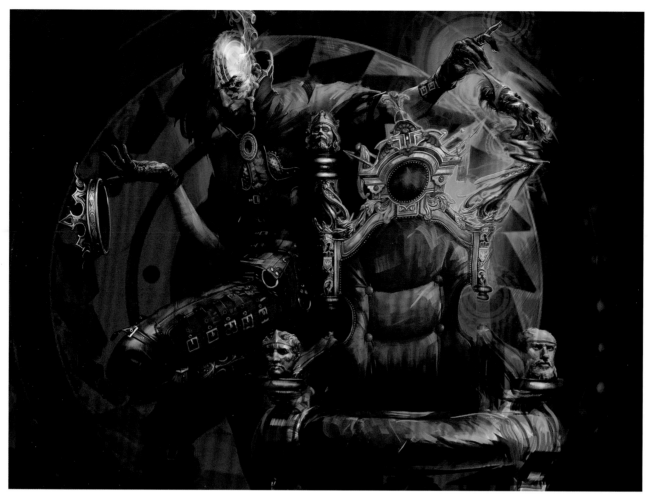

Scott M. Fischer
Title: Dark Confidant *Medium:* Mixed *Client:* Wizards of the Coast *Art Director:* Jeremy Jarvis

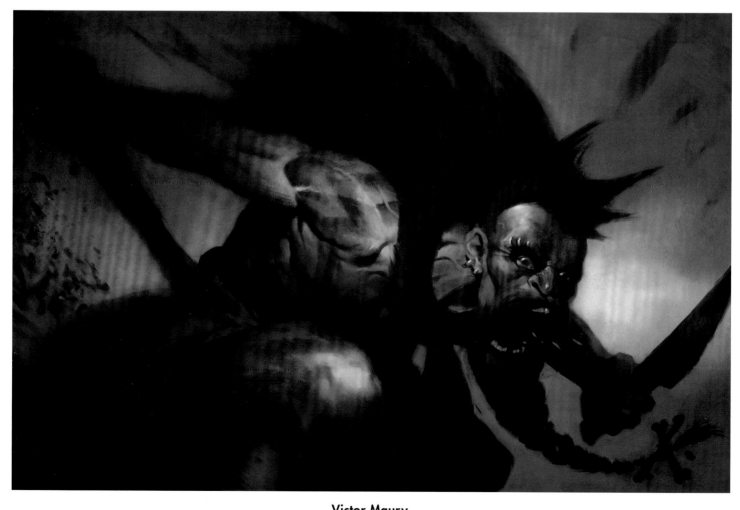

Victor Maury
Title: Rage *Medium:* Digital *Size:* 14 x 9 in. *Client:* Merlino Entertainment *Art Director:* Christopher Merlino © Merlino Entertainment. Used with permission

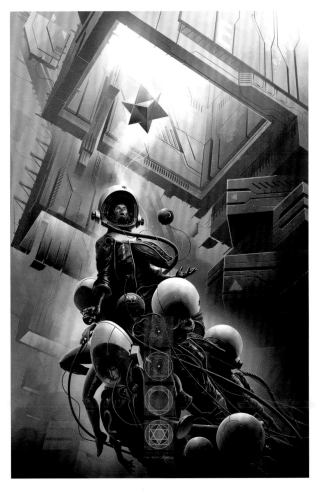

Derek Stenning
Title: The Great Geometer *Medium:* Digital
Size: 23 x 35 in. *Client:* Born in Concrete

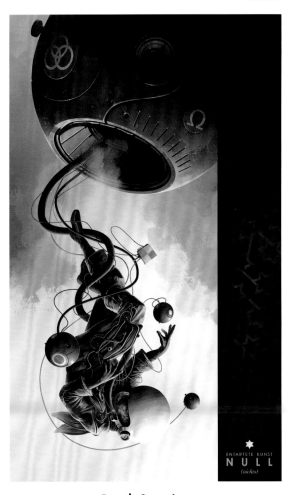

Derek Stenning
Title: Zero (Nothingness)
Medium: Digital *Client:* Born in Concrete

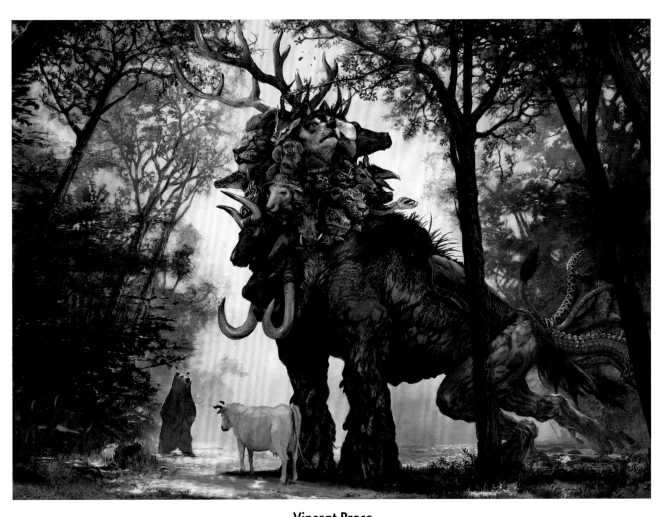

Vincent Proce
Title: Nessian Game Warden *Medium:* Digital *Size:* 5004 x 3643 pixels *Client:* Wizards of the Coast *Art Director:* Jeremy Jarvis

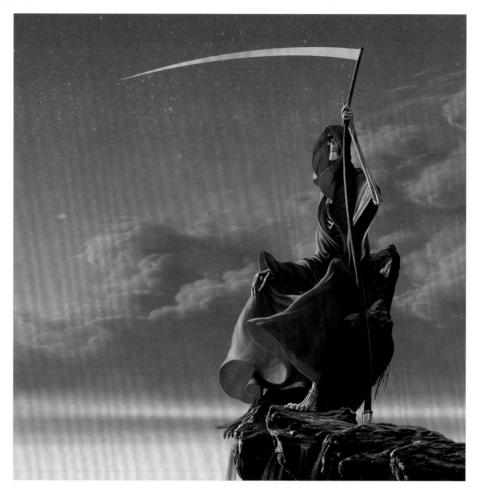

Stephen Player
Title: The Discworld Calendar 2015 *Medium:* Digital
Size: 14 x 14 in. *Client:* Orion Books *Art Director:* Nick May

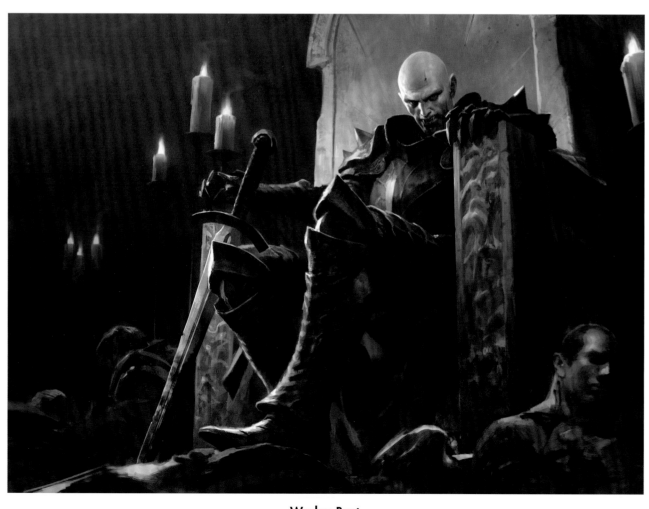

Wesley Burt
Title: Vampire Warlord *Medium:* Digital *Size:* 9 x 6.5 in. *Client:* Wizards of the Coast *Art Director:* Jeremy Jarvis

Ed Binkley
Title: Couturier *Size:* 14 x 18 in.
Medium: Digital *Client:* Stark-Raving Studios

Jeremy Wilson
Title: Lost in the Woods *Medium:* Oil on panel
Size: 12 x 16 in. *Client:* One Thousand Words

Clint Cearley
Title: Aurora *Medium:* Digital
Client: Applibot Inc. *Art Director:* Misako Urayama

Clint Cearley
Title: Aurora Advanced *Medium:* Digital
Client: Applibot Inc. *Art Director:* Misako Urayama

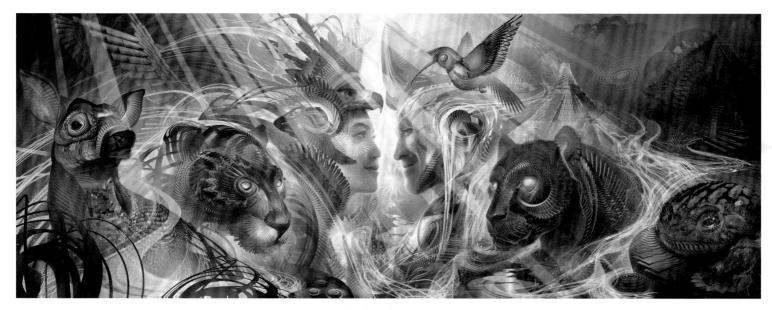

Android Jones
Title: I-Believe *Medium:* Digital *Art director:* Blue Mayans

Terry Dodson
Title: Rose City *Medium:* Pen and ink and digital color *Size:* 12 x 18 in. *Inker:* Rachel Dodson

Jennifer L. Meyer
Title: Three Musketeers *Medium:* Pencil and digital *Size:* 10.75 x 8 in. *Client:* Shannon Associates

Terry Dodson
Title: Down Under *Medium:* Pen and ink and digital colors
Size: 18 x 12 in. *Inker:* Rachel Dodson

Jean-Baptiste Monge
Title: Ode to the Moon
Medium: Digital *Size:* 14.75 x 19 in.

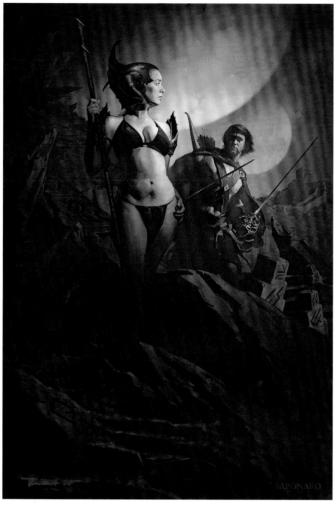

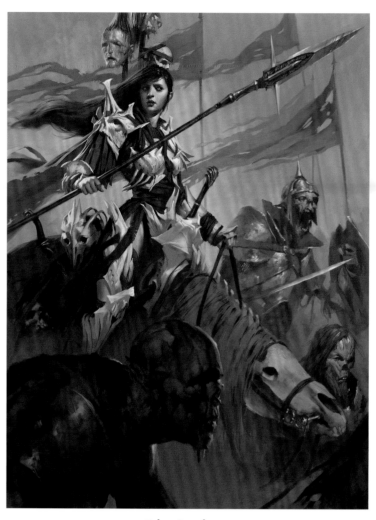

Dominick Saponaro
Title: A Princess of Mars *Medium:* Mixed and digital
Size: 13 x 19 in. *Client:* Self promotion mailer and Expose

Tyler Jacobson
Title: The Military Undead *Medium:* Digital
Client: Applibot Inc. *Art Director:* Pierre Maneval

Dominick Saponaro
Title: Swashbuckle Dom *Medium:* Mixed and digital
Size: 13 x 13 in. *Client:* Self promotion mailer and Expose

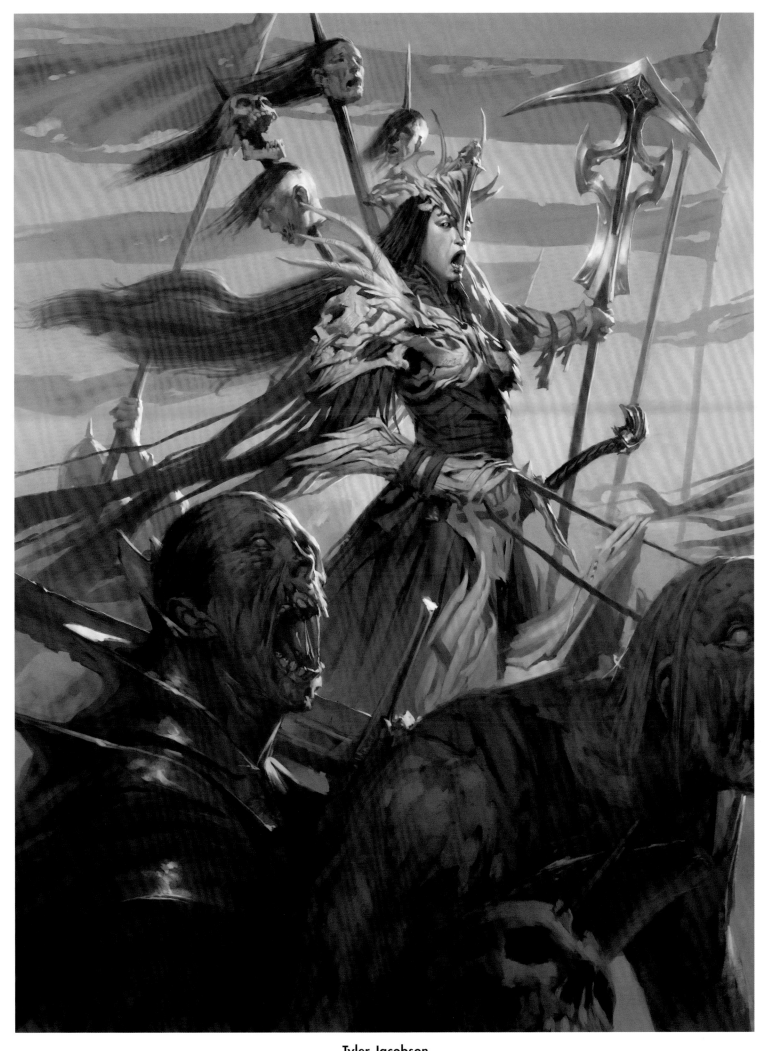

Tyler Jacobson
Title: The Military Undead Advanced *Medium:* Digital *Client:* Applibot Inc. *Art Director:* Pierre Maneval

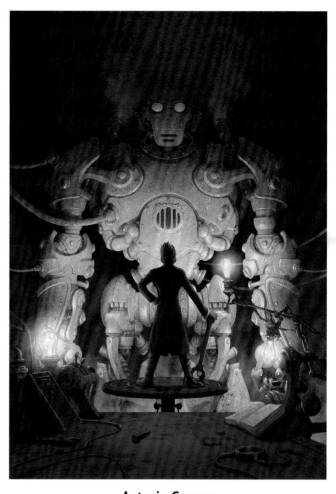

Justin Sweet
Title: Flints

Antonio Caparo
Title: Create, Full Steam Ahead *Medium:* Digital
Size: 13.75 x 19.75 in. *Client:* Upstart *Art Director:* Heidi Green

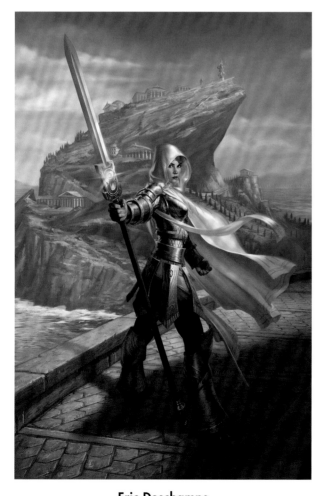

Eric Deschamps
Title: Elspeth, Sun's Campion *Medium:* Digital *Size:* 13 x 20 in.
Client: Wizards of the Coast *Art Director:* Jeremy Jarvis

Tyler Jacobson
Title: Theros *Medium:* Digital
Client: Wizards of the Coast *Art Director:* Matt Cavotta and Jeremy Jarvis

William Stout
Title: King Kong *Medium:* Ink and watercolor on board *Size:* 36 x 24 in. *Client:* Mondo *Art Director:* Justin Ishmael

Wesley Burt
Title: Ephara's Enlightenment *Client:* Wizards of the Coast *Art Director:* Jeremy Jarvis

Chris Rahn
Title: Ajani, the Steadfast
Medium: Oil
Client: Wizards of the Coast
Art Director: Dawn Murin

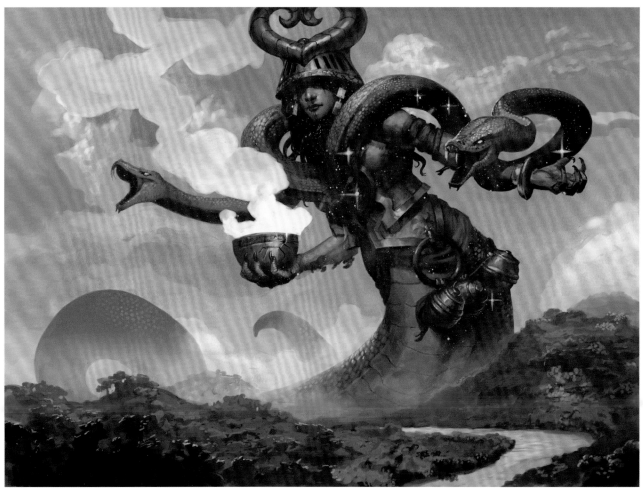

Peter Mohrbacher
Title: Pharika, God of Affliction *Medium:* Digital *Client:* Wizards of the Coast *Art Director:* Jeremy Jarvis

Adam Paquette
Title: Clockwork Defender *Medium:* Digital *Client:* Wizards of the Coast *Art Director:* Jeremy Jarvis

Karla Ortiz
Title: Ashiok's Adept *Medium:* Digital *Client:* Wizards of the Coast *Art Director:* Jeremy Jarvis

Tyler Jacobson
Title: The Sundering *Medium:* Digital *Client:* Wizards of the Coast *Art Director:* Melissa Rapier

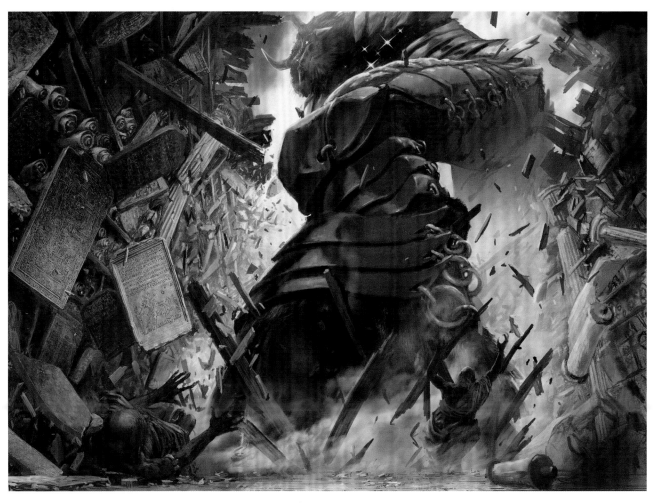

Vincent Proce
Title: Spit of Mogis *Medium:* Digital *Size:* 5004 x 3643 pixels *Client:* Wizards of the Coast *Art Director:* Jeremy Jarvis

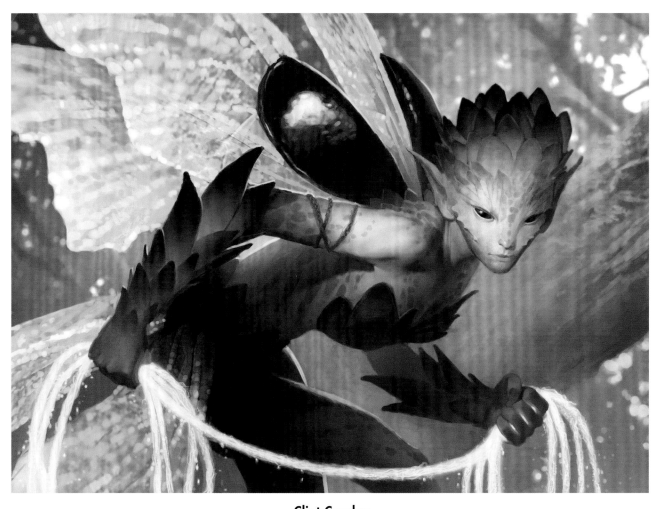

Clint Cearley
Title: Faerie Tangler *Medium:* Digital *Client:* Wizards of the Coast *Art Director:* Dawn Murin

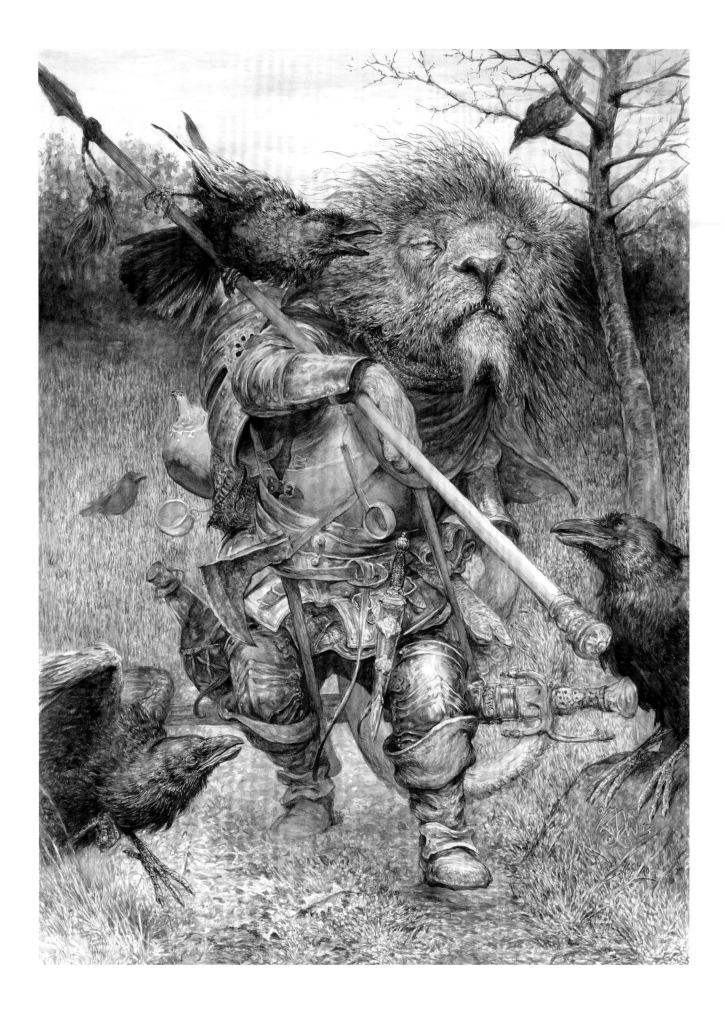

UNPUBLISHED GOLD AWARD

OMAR RAYYAN

THE LONG WALK HOME

Medium: Watercolor
Size: 12.5 x 17 in.

"The long walk to the stage wasn't long enough for me to come up with a speech. I'm literally speechless. There's a lot of great paintings out there. I'm very honored that mine was picked."

—During Rayyan's acceptance speech at the Spectrum 21 Awards Ceremony

Upon graduating from the Rhode Island School of Design, Omar Rayyan settled on the island of Martha's Vineyard with his wife, Sheila. The bucolic surroundings complement and help inspire his "old world" aesthetic toward painting. Although looking to the past for inspiration and guidance from the great oil painters of the Northern Renaissance and the romantic and symbolist painters of the nineteenth century, he has picked watercolor as his medium of choice. Having created illustrations for many publishers, including Simon & Schuster, Random House and Hyperion/Disney, Rayyan's primary market is geared toward children's and young adult's magazines and books, doing cover and interior illustrations. He has also illustrated several children's picture books. Other genres he has worked in include the gaming market, most notably for "Magic: The Gathering," where he has done card art and concept work. Rayyan was also among the talented artists who contributed concept art and created the look for the motion picture *The Chronicles of Narnia: The Lion, the Witch, and the Wardrobe*. His favorite body of work is not created for clients, however, but just for show. Paintings of whim and fantasy are made to indulge his own personal tastes and humors—and hopefully to entertain and please the viewing public as well.

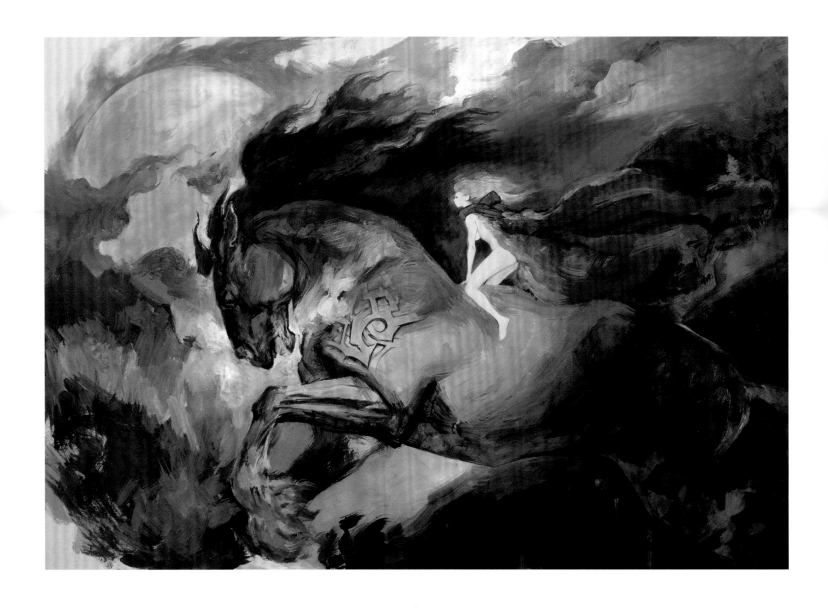

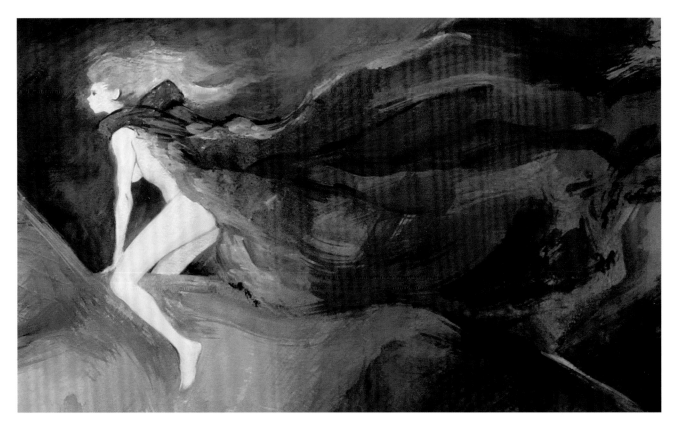

UNPUBLISHED
SILVER AWARD

YUKARI
MASUIKE

RIDING HORSE ON FREEZING DAY
Medium: Acrylic gouache, India ink and Photoshop
Size: 16.5 x 11.5 in.

Masuike is a freelance illustrator and designer in Japan. She learned oil painting at the Musashino Art University. Her recent work is the background art for Square Enix's *Bravely Default*. She also works on game character designs and concept art. She usually works in digital, but her personal work is often completed using a mixture of traditional and digital methods. Masuike wants to continue searching her expression through her art.

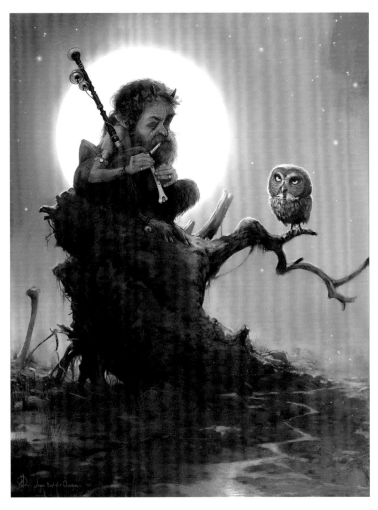

Jean-Baptiste Monge
Title: Ode to the Moon *Medium:* Digital *Size:* 14.75 x 19 in.

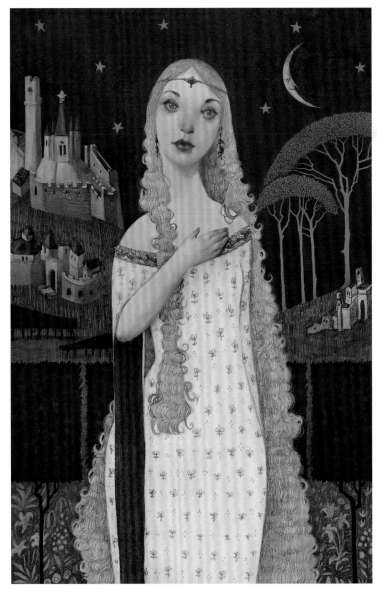

Audrey Benjaminsen
Title: Lady of Light *Medium:* Graphite and digital media *Size:* 22 x 17 in.

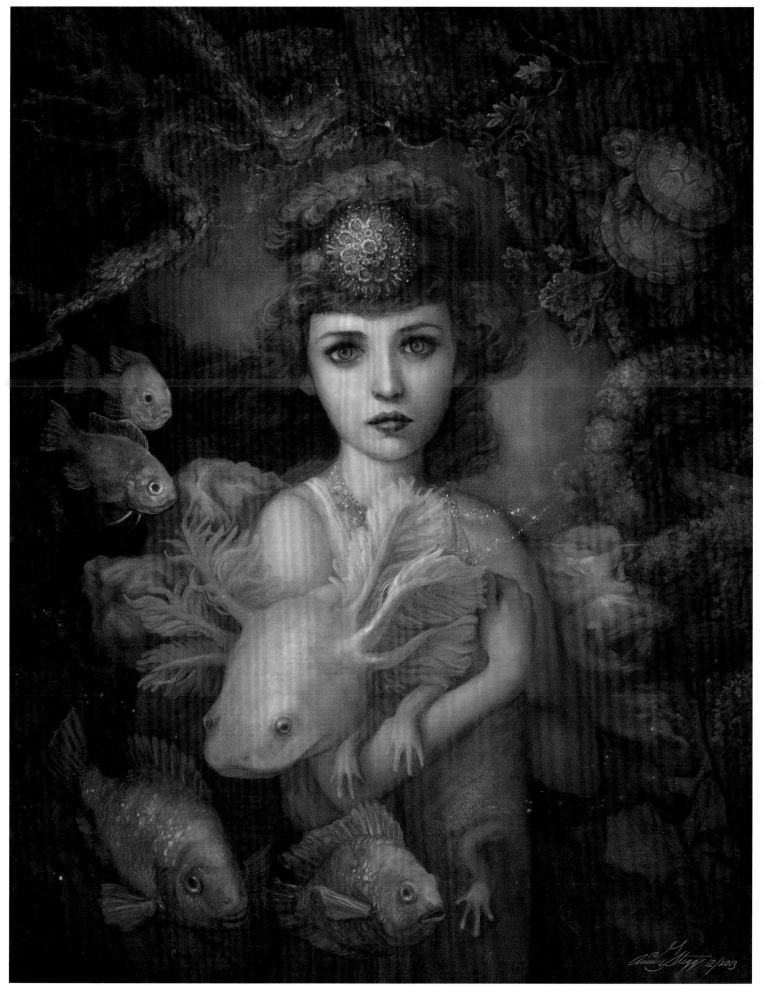

Annie Stegg-Gerard
Title: Lilaia the Naiad *Medium:* Oil on paper *Size:* 11 x 14 in.

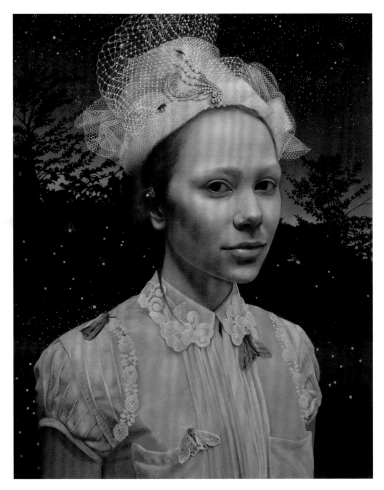

Andrea Kowch
Title: Nocturne *Medium:* Acrylic on canvas *Size:* 24 x 30 in.

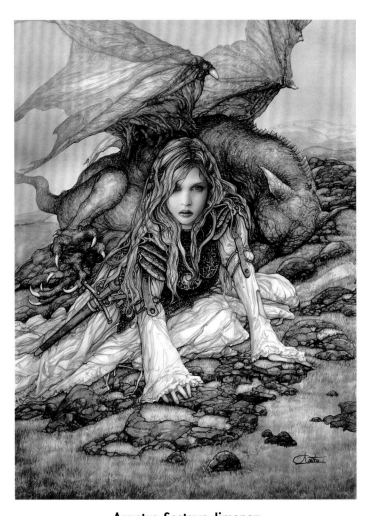

Arantza Sestayo Jimenez
Title: Rhabindranhaya *Medium:* Watercolor *Size:* 15.5 x 23.5 in.

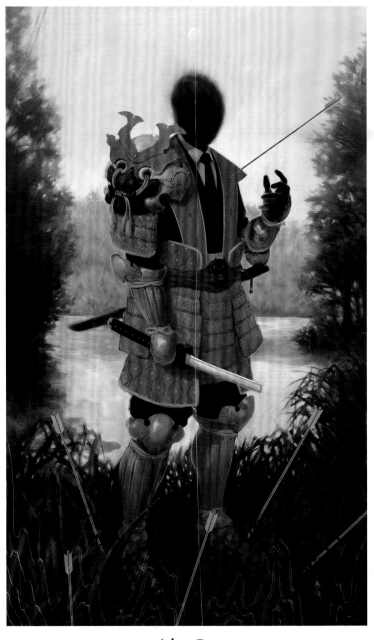

Adam Tan
Title: Gaudy *Medium:* Digital *Size:* 11.75 x 19.75 in.

Pierre Droal
Title: Onction *Medium:* Digital

Andrew Theophilopoulos
Title: The Abitbol Triplets *Medium:* Photoshop *Size:* 30 x 40 in.

Anna Dittmann
Title: Adorn *Medium:* Digital

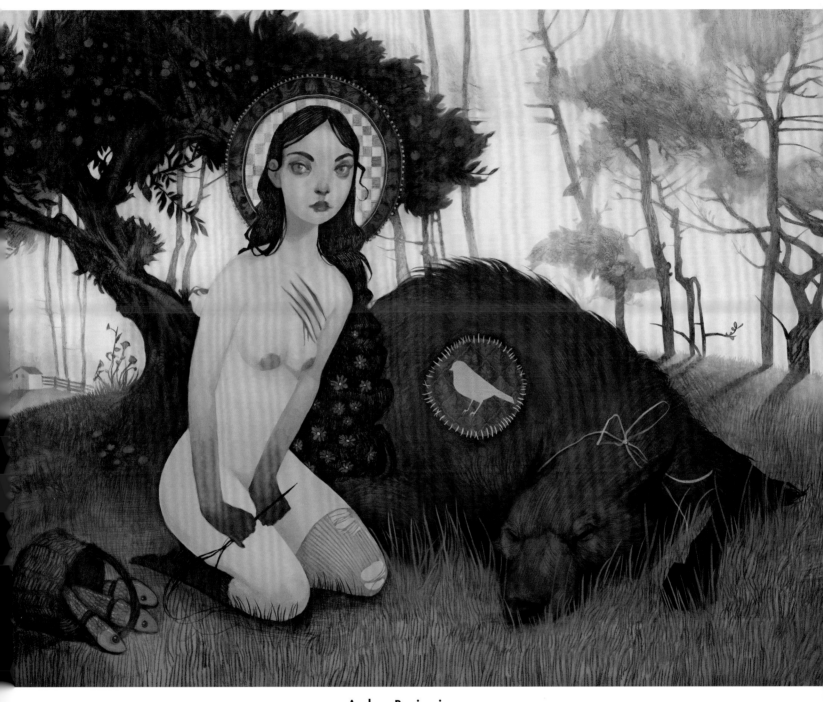

Audrey Benjaminsen
Title: Little Red Cap *Medium:* Graphite and digital media *Size:* 22 x 17 in.

Britton Snyder
Title: Box *Medium:* Oil on panel *Size:* 24 x 27 in.

Ashley Mackenzie
Title: Universal Understanding *Medium:* Graphite and Photoshop

Ashley Mackenzie
Title: Seeking Substance *Medium:* Graphite and Photoshop

Ashley Mackenzie
Title: Filling in the Gaps *Medium:* Graphite and Photoshop

Nicolas Delort
Title: The Path of Faith *Medium:* Ink on clayboard *Size:* 24 x 12 in. *Other:* LTD. Gallery – A Song of Ice and Fire themed Show

Nicolas Delort
Title: Wicked *Medium:* Ink on clayboard
Size: 12 x 16 in. *Other:* Gallery Nucleus, Wizard of Oz themed show

Jeff Delierre
Title: Feral Bandit *Medium:* Pen and ink *Size:* 11 x 14 in.

Bill Carman
Title: Bananabel *Medium:* Acrylic *Size:* 8 x 10 in.

Bill Carman
Title: Fredusa *Medium:* Mixed on claybord *Size:* 8 x 10 in.

Bill Carman
Title: Dehydration *Medium:* Acrylic on wood *Size:* 9 x 12 in.

Bill Carman
Title: I Prefer a Tophat *Medium:* Mixed *Size:* 8 x 10 in.

Bill Carman
Title: Proscenium Hill *Medium:* Acrylic *Size:* 8 x 10 in.
Client: David Anthony and Natalia Smith

Bill Carman
Title: Snake Eyes *Medium:* Acrylic on copper *Size:* 3 x 3 in.

Bill Carman
Title: There's a Bird in My Hole: There's a Hole in My Bird
Medium: Acrylic on copper *Size:* 6 x 8 in.

Bill Carman
Title: Narbombs *Medium:* Acrylic on copper *Size:* 6 x 8 in.

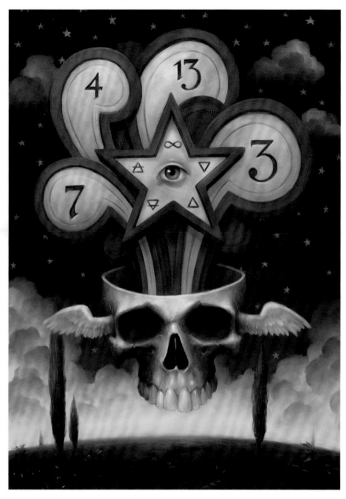

Brian Despain
Title: The Oracle *Medium:* Digital *Size:* 5 x 7 in.

Brom
Title: Worm *Medium:* Oil *Size:* 15 x 21 in.
Client: Centipede Press *Art Director:* Jerad Walters

Kim Kincaid
Title: Barcoded *Medium:* Colored pencil and oil
Size: 12 x 14.5 in. *Art Director:* Rebecca Guay, SmART School Assignment

Brian Despain
Title: The Future King *Medium:* Oil on wood panel *Size:* 11 x 14 *Client:* Kilgore Trout, Jr.

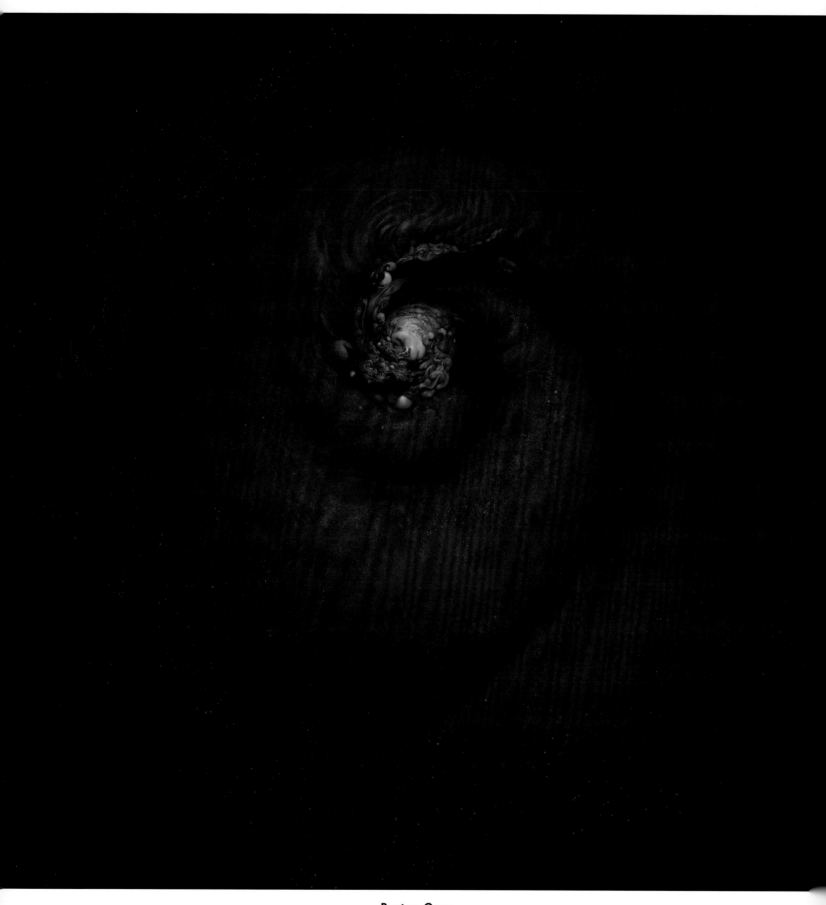

Burton Gray
Title: Gray Space Spiral *Medium:* Digital *Size:* 60 x 60 in.

Camilla d'Errico
Title: The Paint Catcher
Medium: Oil on wood panel
Size: 11 x 14 in.

Camilla d'Errico
Title: Fukurou
Medium: Oil on wood panel
Size: 11 x 14 in.

Corinne Reid
Title: Devour
Medium: Digital
Size: 19.5 x 20 in.

Cory Godbey
Title: The Lyrebird

Cory Godbey
Title: The Princess and the Dragon

Diane Dillon
Title: Spirit of the Reef *Medium:* Acrylic *Size:* 14 x 19 in.

Eli Minaya
Title: Moon Shadow

Bruce Holwerda
Title: Wild Fire *Medium:* Acrylic painting *Size:* 30 x 48 in.

Daren Bader
Title: Waterfall
Medium: Oil on canvas
Size: 40 x 30 in.

Dominique Fung
Title: Unusual Veneer
Medium: Oil on canvas
Size: 48 x 64 in.

Eric Fortune
Title: Comfort in Dying *Medium:* Acrylic *Size:* 15 x 20.5 in.

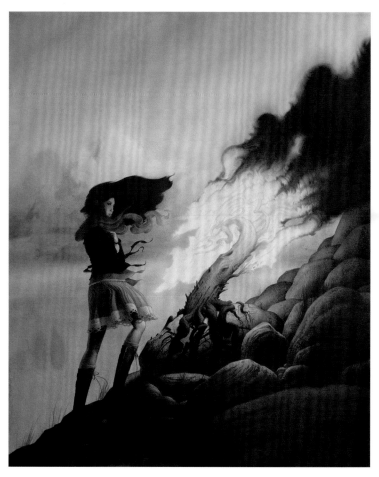

Eric Fortune
Title: Day of Dissonance *Medium:* Acrylic *Size:* 18 x 22 in.

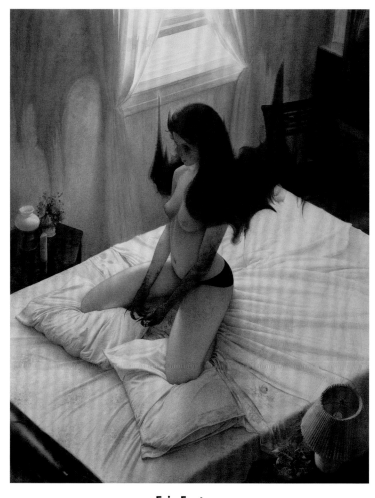

Eric Fortune
Title: The Demon Haunted World *Medium:* Acrylic *Size:* 16.5 x 22 in.

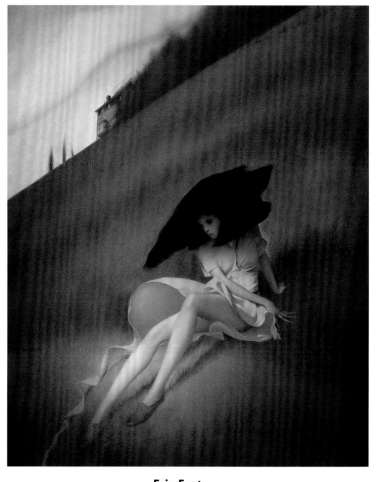

Eric Fortune
Title: World's Collapse *Medium:* Acrylic *Size:* 22 x 28.5 in.

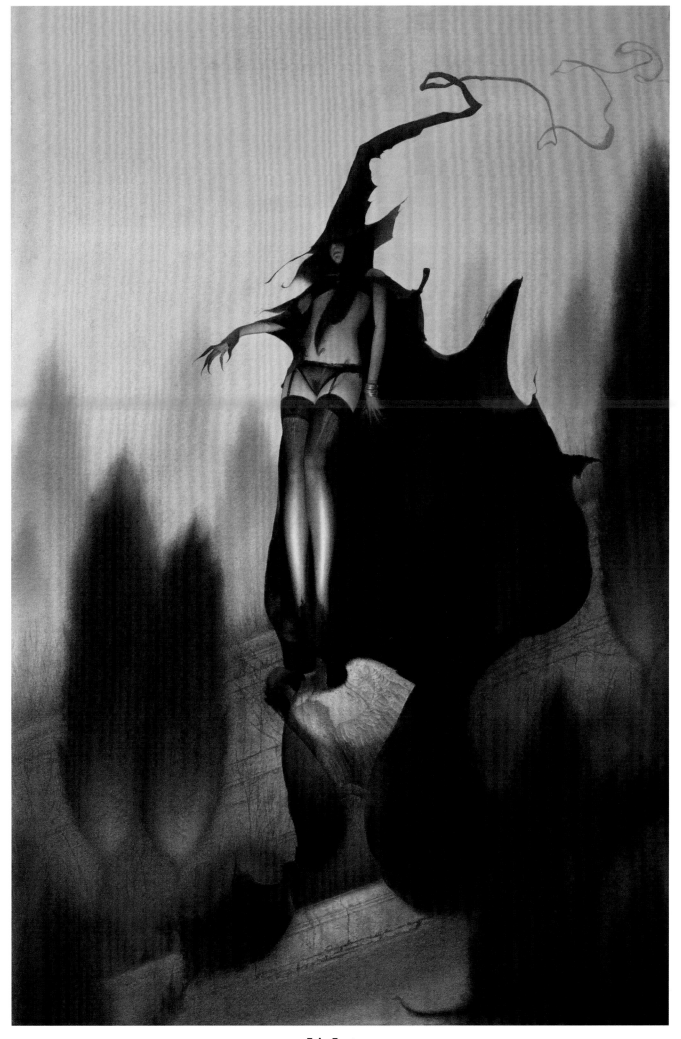

Eric Fortune
Title: The Secret of Oz *Medium:* Acrylic *Size:* 12 x 18 in.

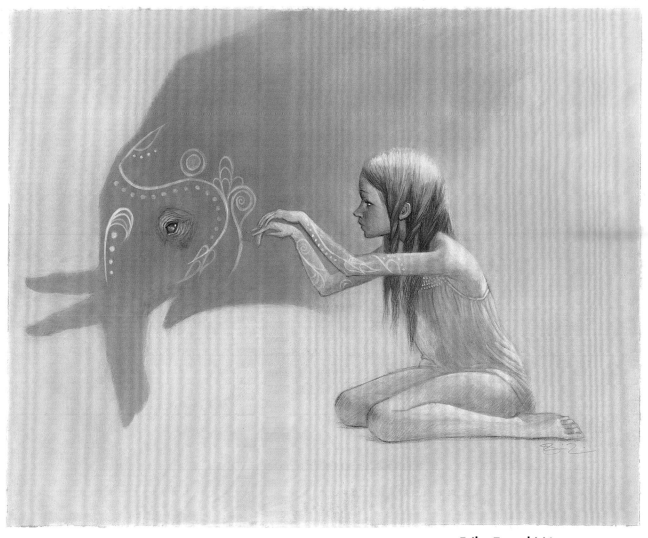

Erika Taguchi-Newton
Title: Shadowplay: Elephant
Medium: Acrylic
Size: 8 x 10 in.

Esther Lui
Title: Those Hazardous Flying Birds
Medium: Mixed media
Size: 11 x 12 in.

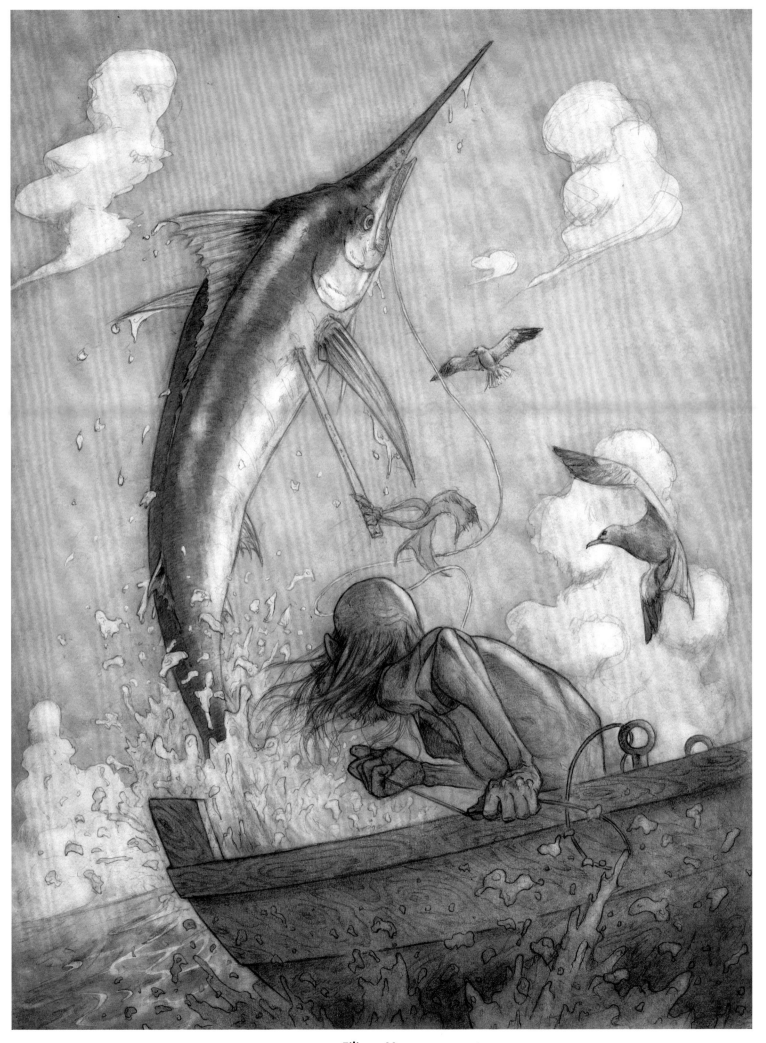

Filippo Vanzo
Title: The Old Man and the Sea

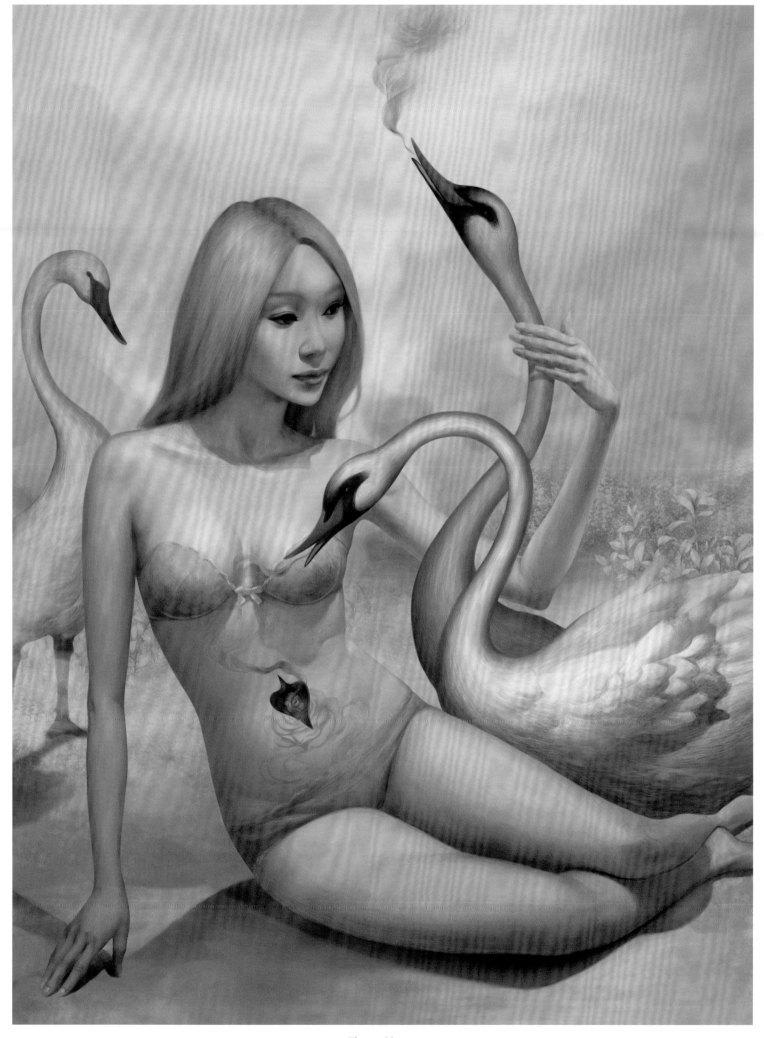

Fiona Meng
Title: Swans *Medium:* Photoshop *Size:* 8.5 x 11 in.

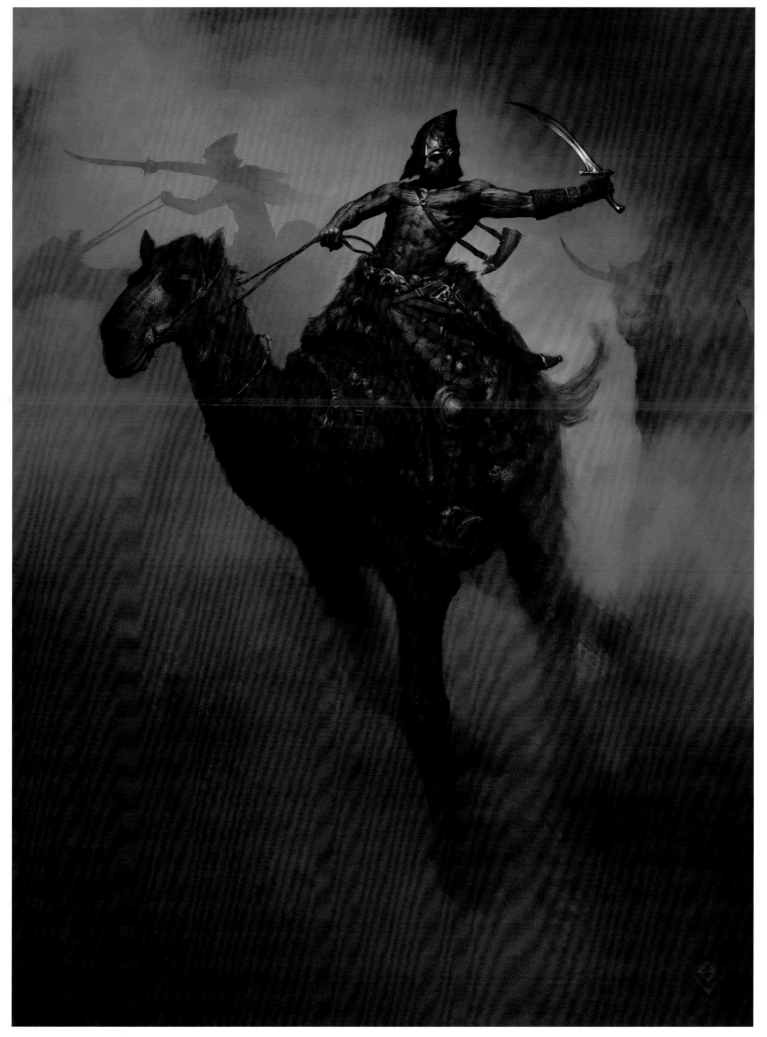

Gabriel Verdon
Title: Crusaders of Iram *Medium:* Digital *Size:* 6 x 8 in. *Client:* Inanimate

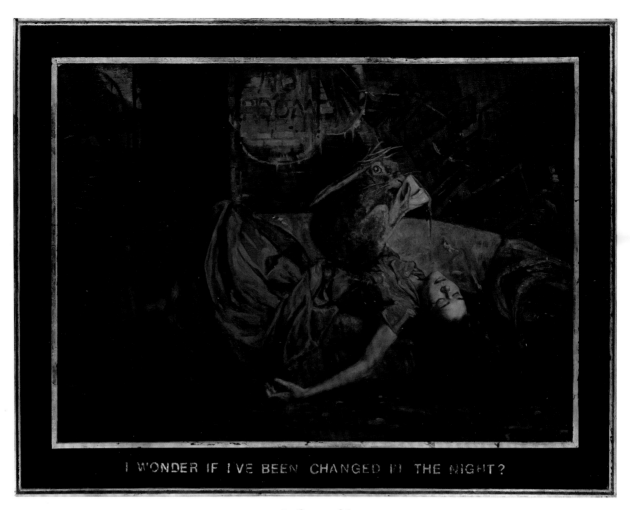

I WONDER IF I'VE BEEN CHANGED IN THE NIGHT?

Gail Potocki
Title: I Wonder if I've Been Changed in the Night?

George Pratt
Title: Cannibal *Medium:* Black and white acrylic, putty knives and paint rollers
Size: 18 x 24 in. *Client:* Black.Light - Germany *Art Director:* Christoph Ermisch

George Pratt
Title: Bucket Bath *Medium:* Black and white acrylic, putty knives and paint rollers
Size: 18 x 24 in. *Client:* Black.Light - Germany *Art Director:* Christoph Ermisch

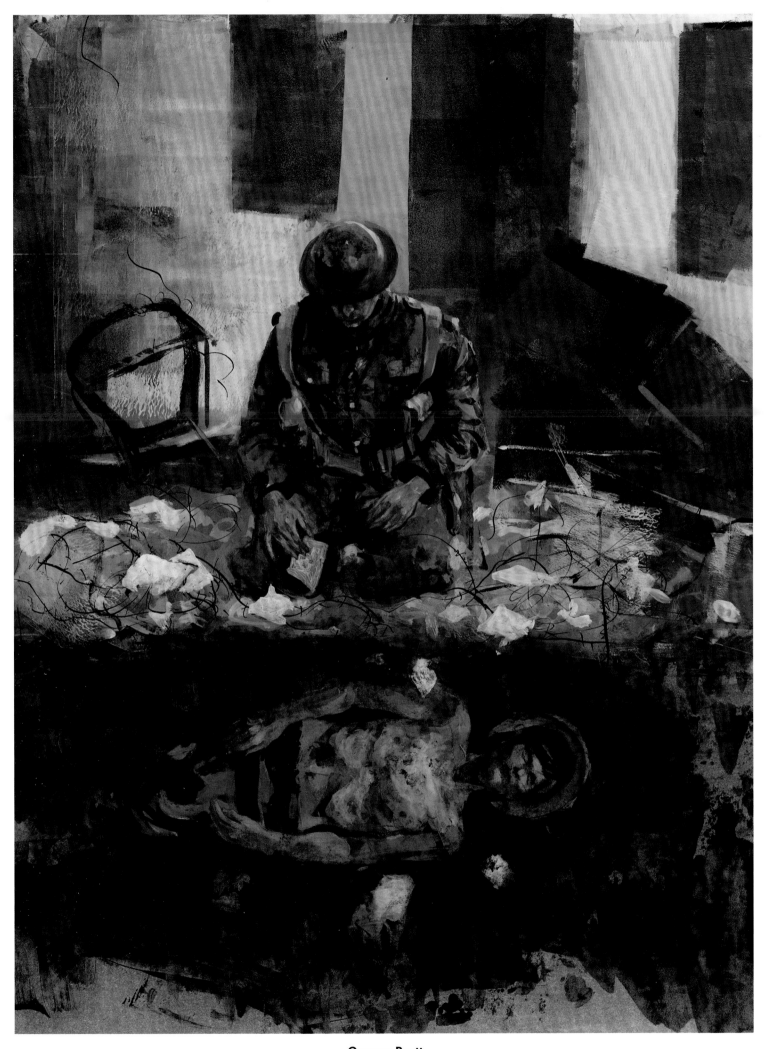

George Pratt
Title: Above the Dreamless Dead (cover) *Medium:* Mixed media *Size:* 18.75 x 23 in. *Client:* First Second Books *Art Director:* Colleen Venable

Gregory Manchess
Title: Deep Diver *Medium:* Oil on gessobord *Size:* 5 x 5 in.

Gregory Manchess
Title: Faery Portrait *Medium:* Oil on gessobord *Size:* 11 x 14 in.

Gregory Manchess
Title: Knight High Collar *Medium:* Oil on gessobord *Size:* 5 x 5 in.

Gregory Manchess
Title: Gladiator *Medium:* Oil on gessobord *Size:* 5 x 5 in.

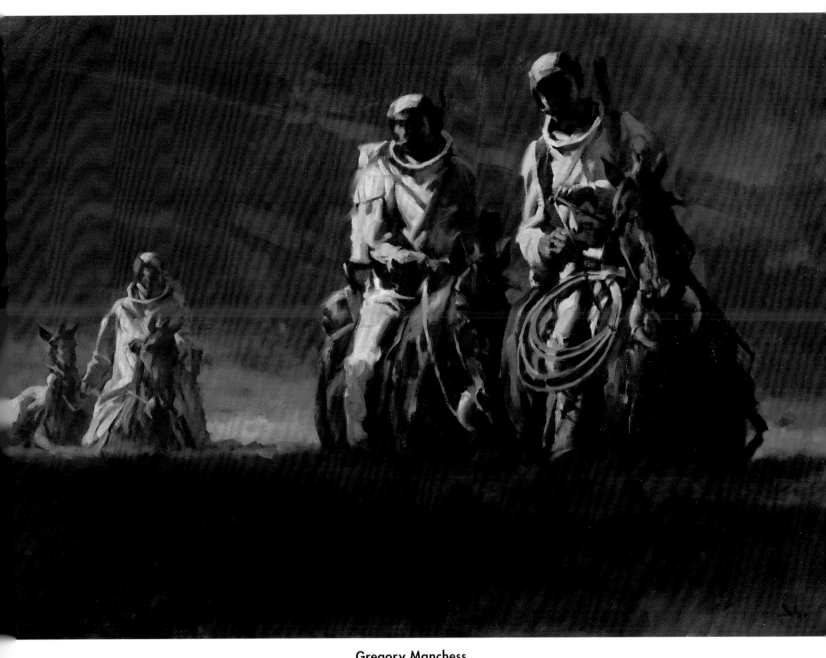

Gregory Manchess
Title: Perimeter Check *Medium:* Oil on linen *Size:* 17 x 20 in.

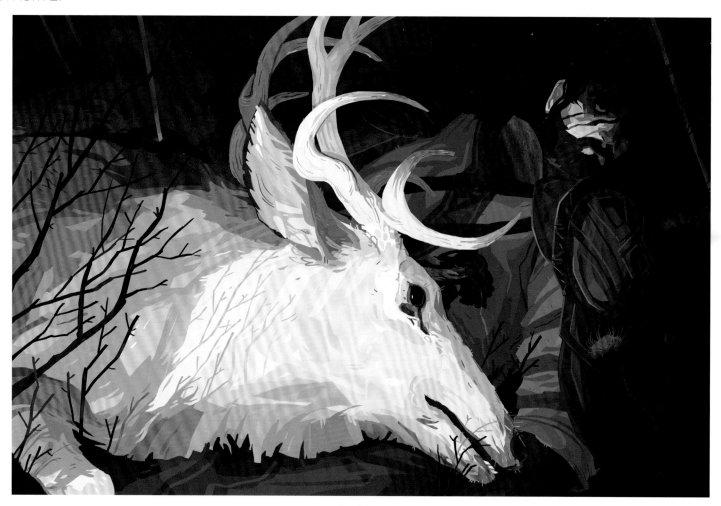

Hannah Christenson
Title: The King and the Stag

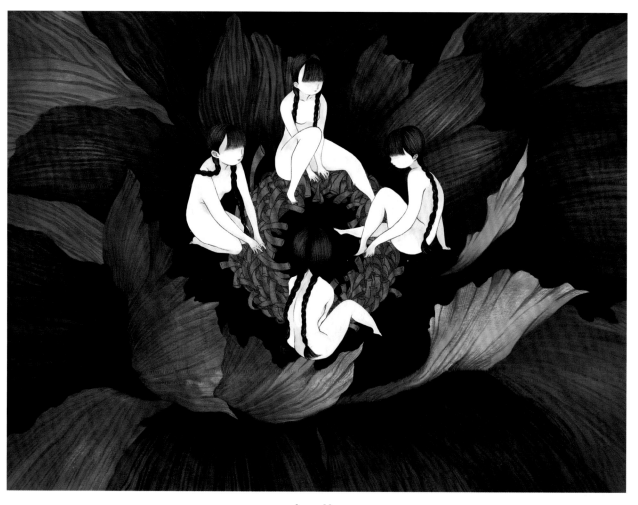

Jasu Hu
Title: Lady's Death *Medium:* Pencil and digital *Size:* 14 x 10 in.

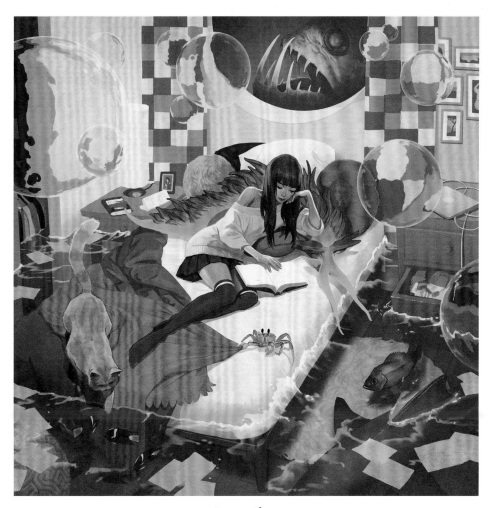

Jason Chan
Title: Fish Bowl *Medium:* Digital *Size:* 20 x 20 in.

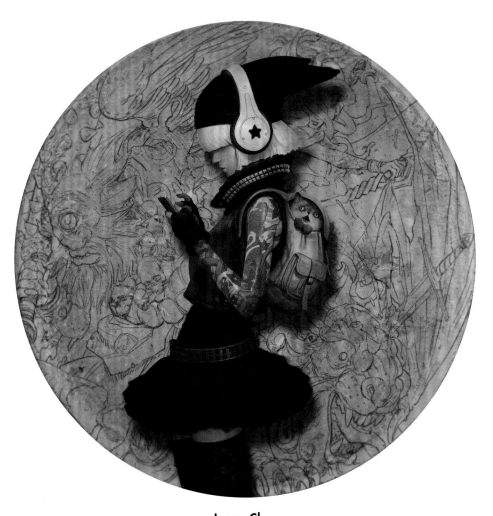

Jason Chan
Title: Mix *Medium:* Digital *Size:* 20 x 20 in.

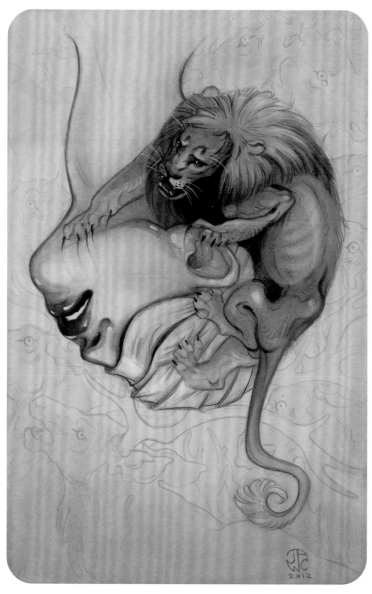

J.A.W. Cooper
Title: Gasp *Medium:* India ink and gouache

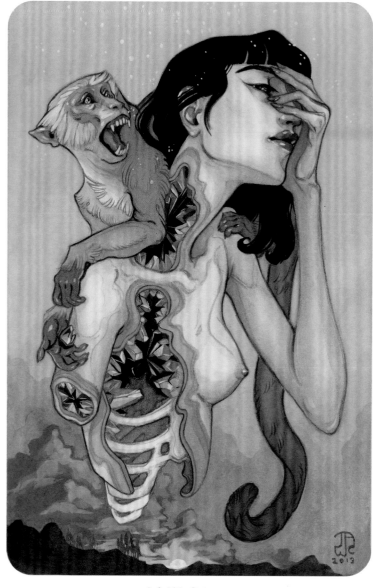

J.A.W. Cooper
Title: Rattle *Medium:* India ink and gouache

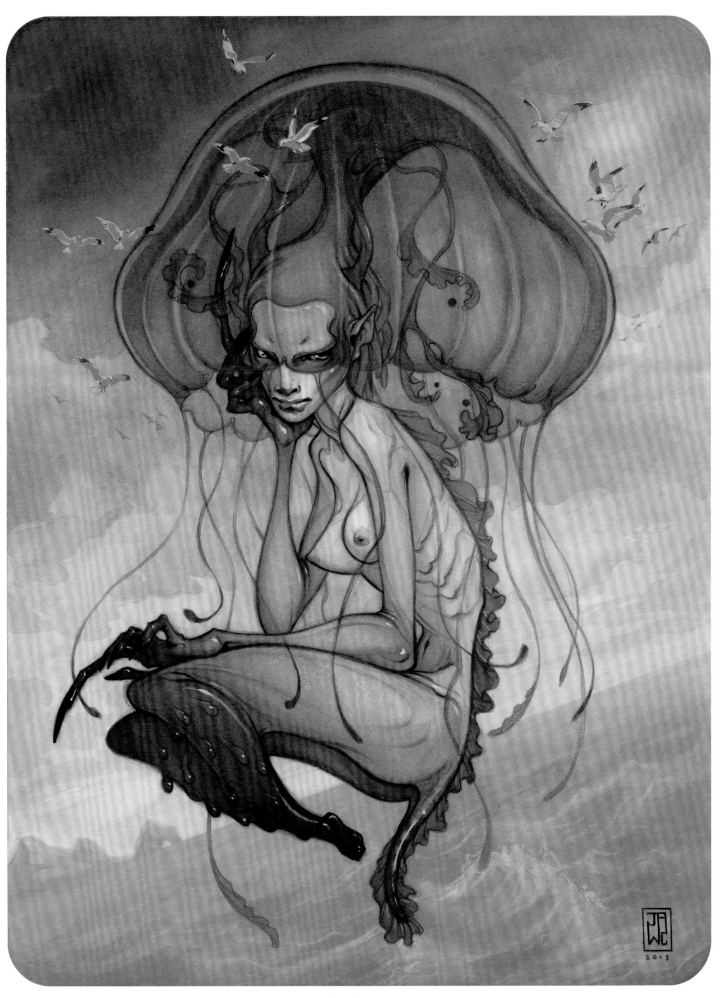

J.A.W. Cooper
Title: Shapeshifter *Medium:* India ink and gouache

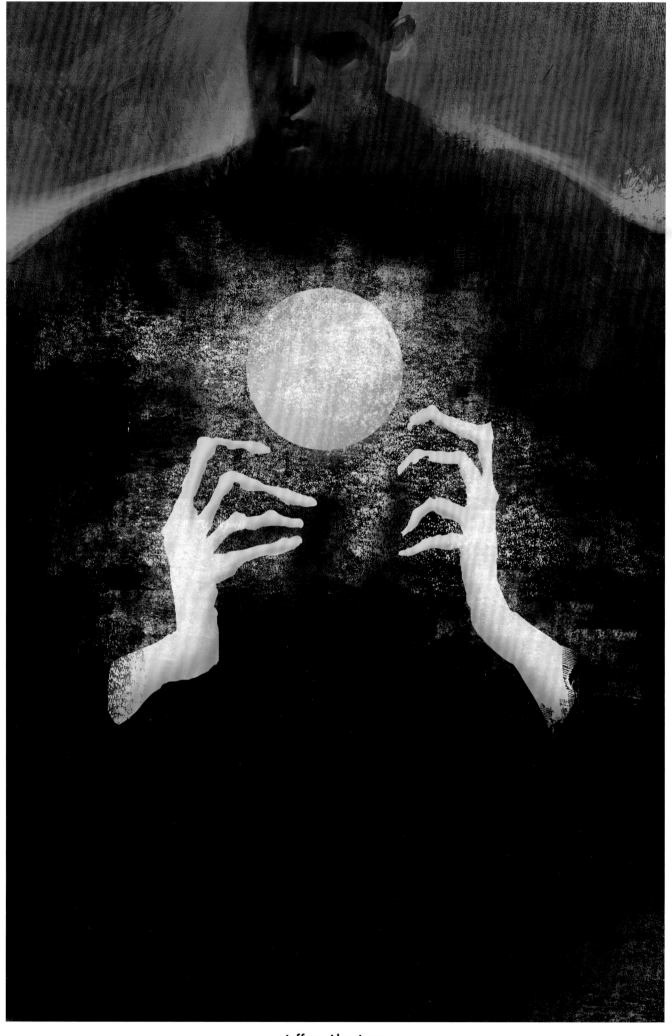

Jeffrey Alan Love
Title: The Dying Earth *Medium:* Digital *Size:* 8 x 12 in.

John Larriva
Title: Astronomer *Medium:* Oil on hardboard *Size:* 10 x 8 in.

Jenna Kass
Title: Devotional *Medium:* Oil *Size:* 20 x 30 in.
Client: Art Order Inspiration Challenge

Jokubas Uogintas
Title: Botanist *Medium:* Photoshop *Size:* 7.5 x 12 in.

Kelly Miller
Title: The Path *Medium:* Digital and ink *Size:* 10 x 14 in.

Gawki
Title: Unbirth *Medium:* Digital *Size:* 33 x 46.75 in.

Gawki
Title: Wandering *Medium:* Digital *Size:* 21.5 x 16.5 in.

Jokubas Uogintas
Title: Hide and Seek *Medium:* Photoshop *Size:* 12 x 6.75 in.

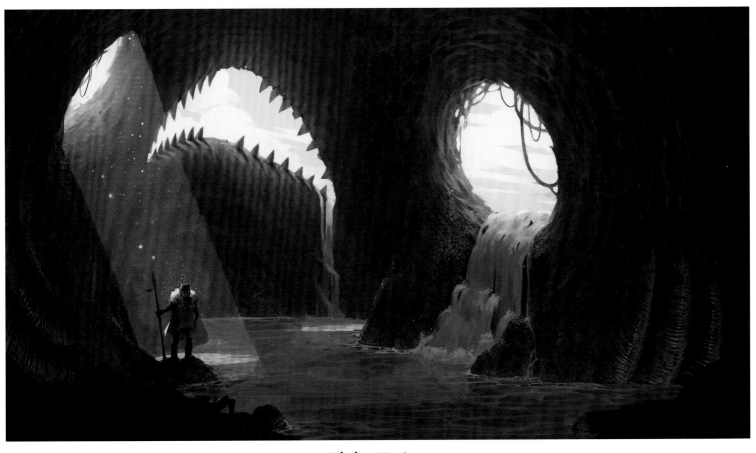

Jokubas Uogintas
Title: Cavern *Medium:* Photoshop *Size:* 12 x 6.75 in.

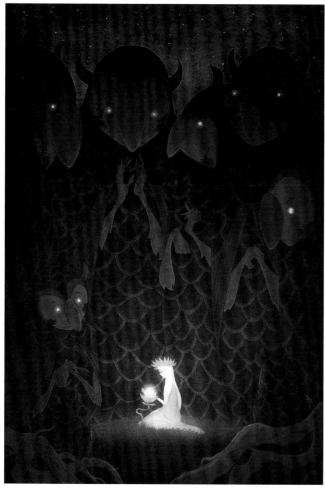

Justin Hernandez
Title: Lady and Trolls *Medium:* Pencil and digital *Size:* 11 x 17 in.

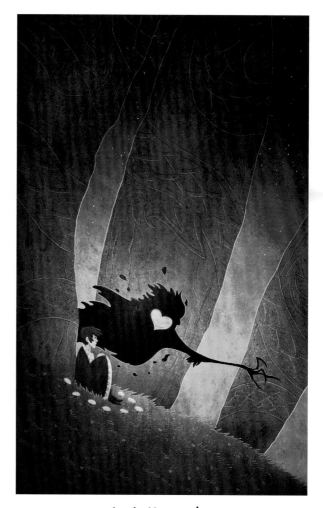

Justin Hernandez
Title: The Circle *Medium:* Pencil and digital *Size:* 10 x 16 in.

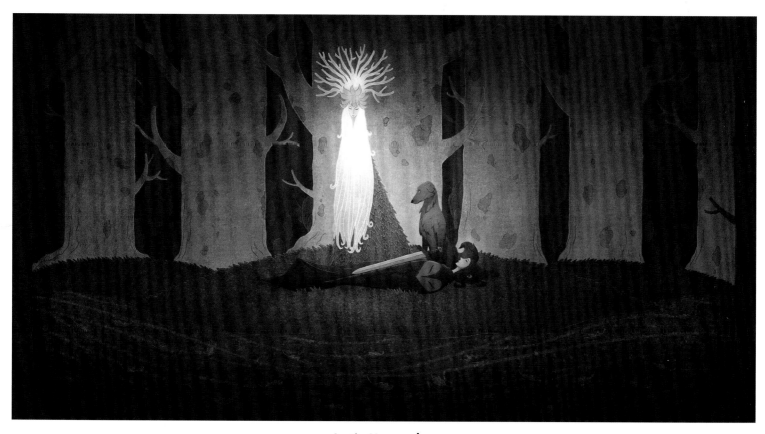

Justin Hernandez
Title: Lady, Fallen *Medium:* Pencil and digital *Size:* 9 x 17 in.

Justin Hernandez
Title: Valkyrie *Medium:* Pencil and digital *Size:* 9 x 16 in.

Justin Gerard
Title: The Ents Marching *Medium:* Oil on panel *Size:* 30 x 50 in.

Justin Gerard
Title: The Gryphon Hunters *Medium:* Oil over acrylic on canvas *Size:* 48 x 72 in.

Justin Gerard
Title: Morzog: Lord of Destruction *Medium:* Watercolor and digital *Size:* 12 x 18 in.

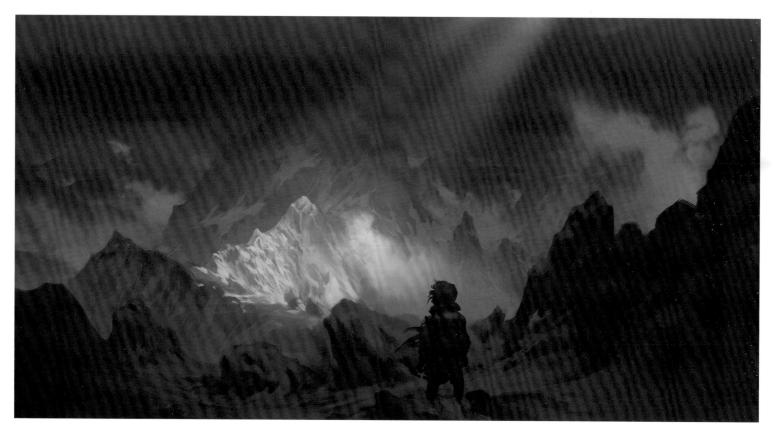

Justin Oaksford
Title: Over the Wind and Snow *Medium:* Digital *Size:* 9 x 17 in.

Keita Morimoto
Title: Bathers *Medium:* Oil

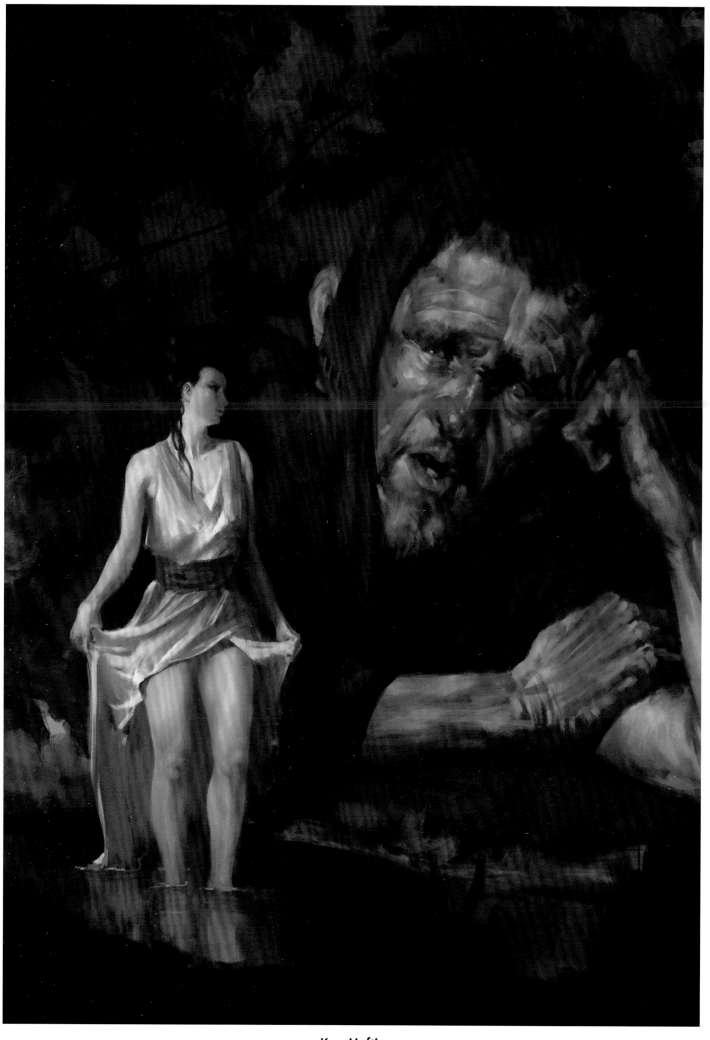

Kan Muftic
Title: Seduction *Medium:* Digital

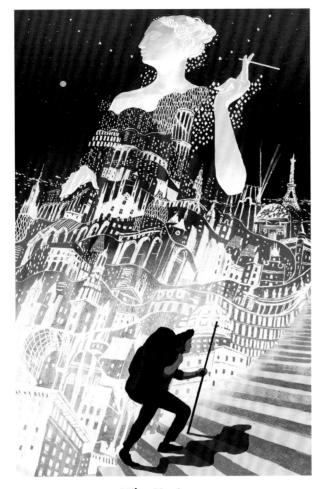

Miko Maciasze
Title: Europa & The Traveler
Medium: Graphite and digital *Size:* 8 x 12 in.

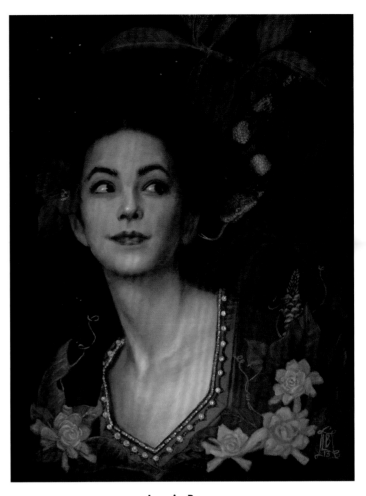

Laurie Brom
Title: Snake Whisper
Medium: Oil *Size:* 12 x 16 in. *Client:* Roq La Rue Gallery

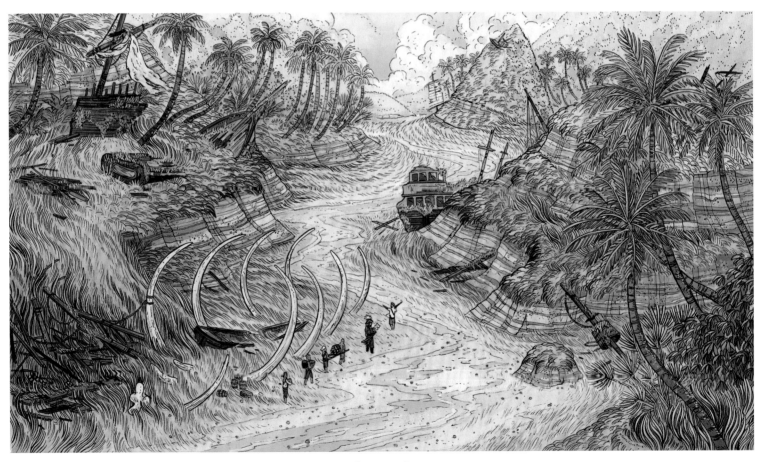

Nicole Gustafsson
Title: Isle of the Luckless *Medium:* Gouache and ink *Size:* 14 x 8 in.

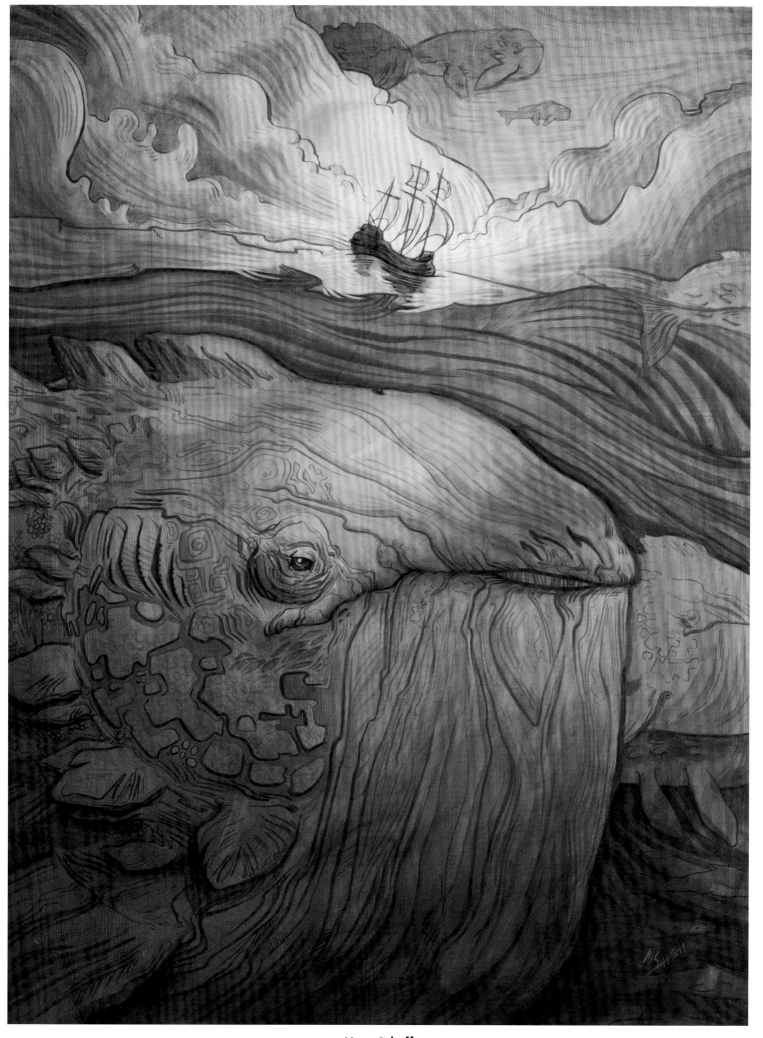

Marc Scheff
Title: The Deepness *Medium:* Acrylic and ink on board *Size:* 18 x 24 in.

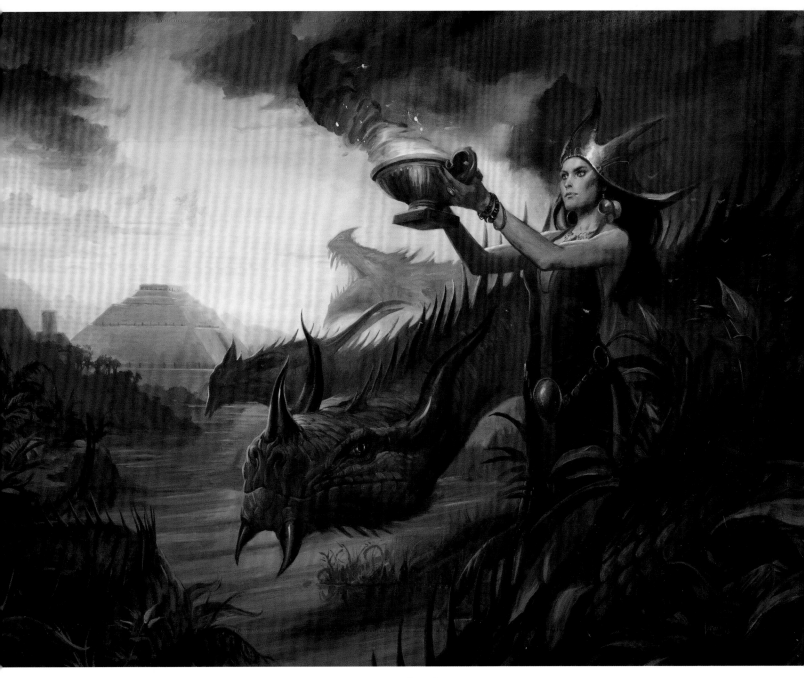

Lucas Graciano
Title: Dragon Queen *Medium:* Oil *Size:* 24 x 18 in.

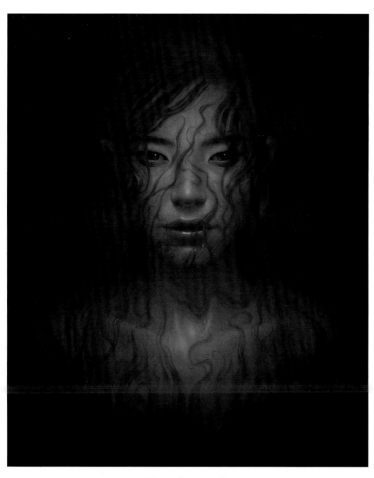

Miranda Meeks
Title: Siren *Medium:* Digital

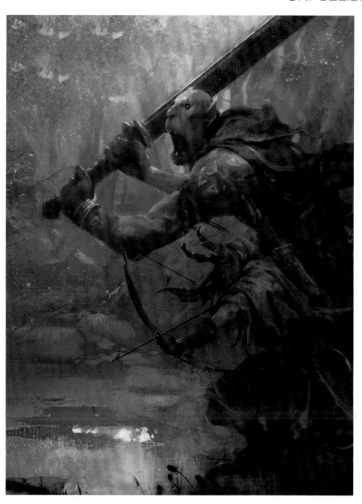

Martin Bergstrom
Title: Companions *Size:* 10 x 13 in.

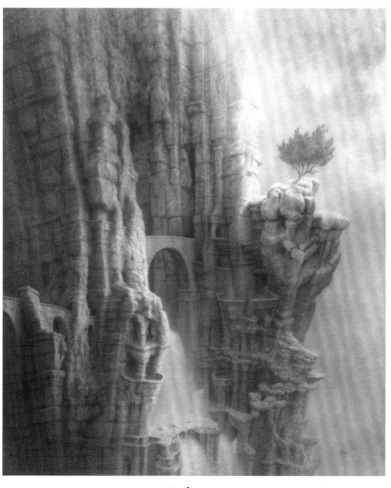

Mark Reep
Title: The Gift Within
Medium: Charcoal and graphite pencil drawing *Size:* 10.5 x 12.5 in.

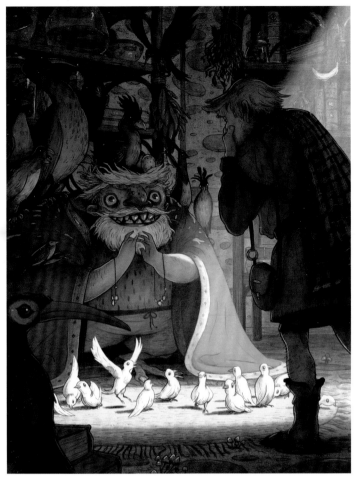

Matt Rockefeller
Title: The Fisherman and the Gruagach of Tricks
Medium: Graphite and digital *Size:* 8 x 10.5 in.

Matt Rockefeller
Title: The Firebird and the Horse of Power
Medium: Graphite and Digital *Size:* 8 x 10.5 in.

Matt Rockefeller
Title: Sinbad in the Land of Giants
Medium: Graphite and digital *Size:* 8 x 10.5 in.

Matt Rockefeller
Title: Urashima Taro *Medium:* Graphite and digital *Size:* 8 x 10.5 in.

Oliver Flores
Title: Dispersion *Medium:* Graphite *Size:* 10.5 x 15.5

Pavol Martinicki
Title: The Cathedral Dream
Medium: Pen and ink, serigraphy *Size:* 11.75 x 19.75 in.

Oliver Flores
Title: The Flight *Medium:* Graphite *Size:* 15.5 x 12.5

Patrick J. Jones
Title: The Gathering Storm
Medium: Oil on board
Size: 28 x 22 in.
Art Director: Catherine K. Gyllerstrom

Rick Berry
Title: Injury Prone

Paul Bonner
Title: Goblin *Medium:* Watercolor *Size:* 40 x 28 cm.

Paul Bonner
Title: Dwarf *Medium:* Watercolor *Size:* 40 x 28 cm.

Paul Bonner
Title: Vildhjarta *Medium:* Watercolor *Size:* 67 x 47 cm. *Client:* Riotminds *Art Director:* Theodore Bergquist

Zach Montoya
Title: Zeal *Medium:* Acrylic, oil and digital *Size:* 13 x 18 in.

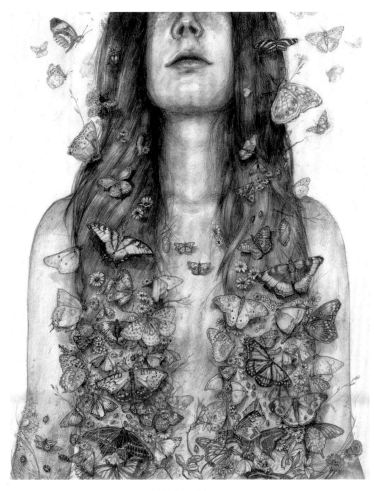

T. Dylan Moore
Title: Butterflies *Medium:* Graphite *Size:* 16 x 20 in.

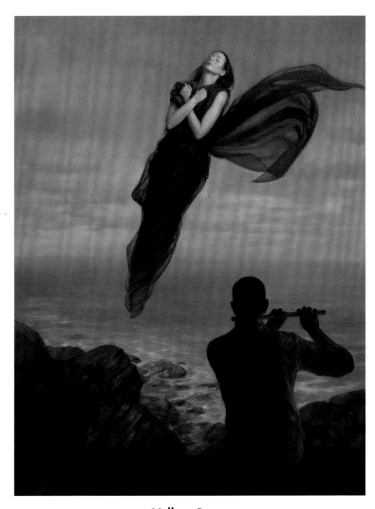

Volkan Baga
Title: Zweite Melodie *Medium:* Oil on panel *Size:* 23.5 x 31.5 in.

275

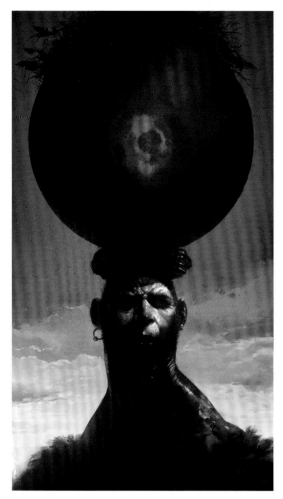

Pierre Droal
Title: Nia Red Eye *Medium:* Digital

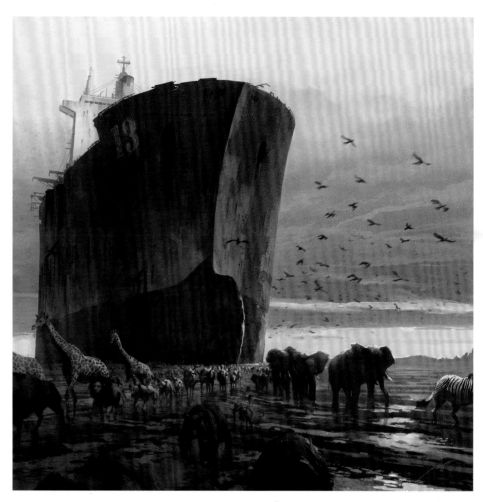

Pierre Droal
Title: Noah's Ark *Medium:* Digital

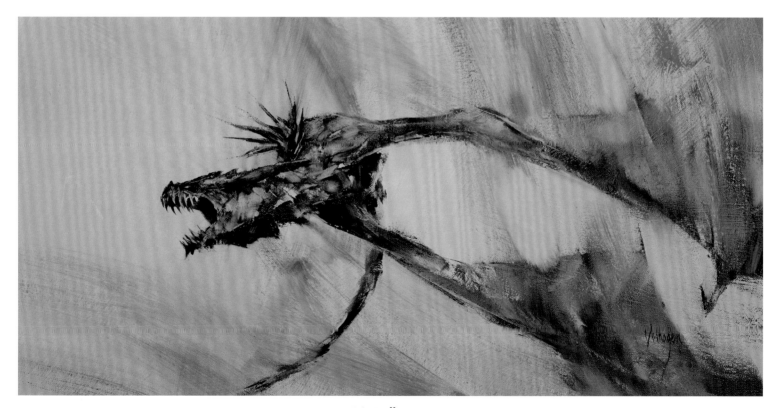

Eric Velhagen
Title: Dragon Flight *Medium:* Oil on linen *Size:* 11 x 22 in.

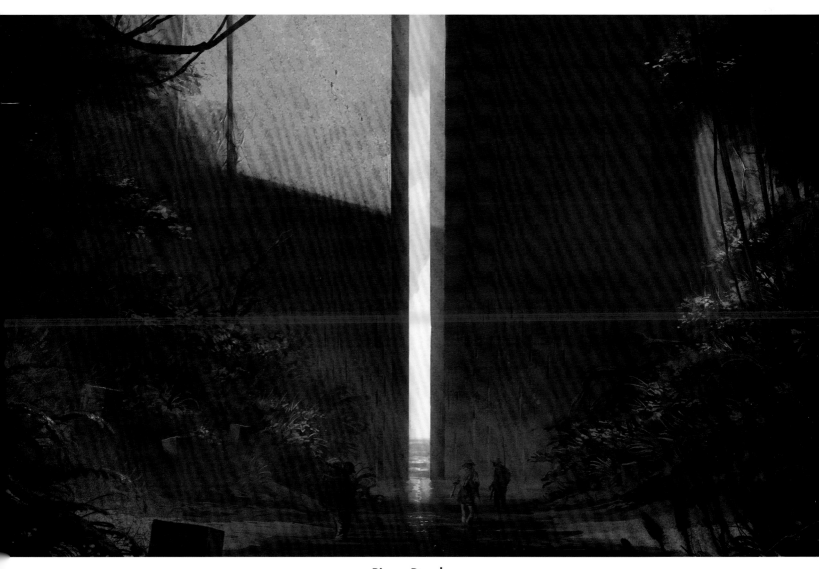

Pierre Droal
Title: Hidden Doors *Medium:* Digital

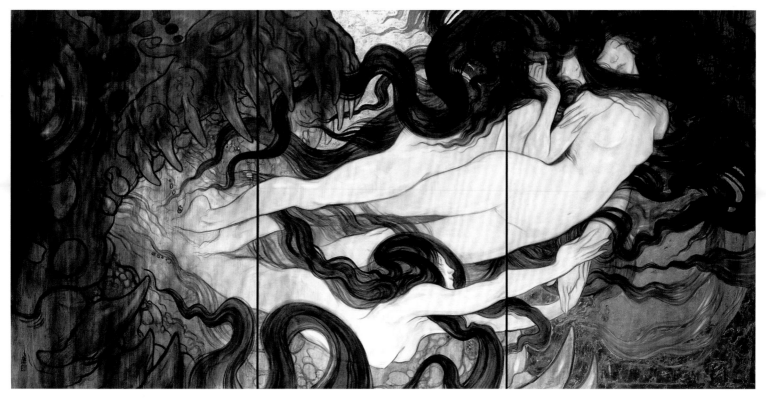

Rebecca Léveillé-Guay
Title: Little Fish *Medium:* Oil on canvas *Size:* 60 x 120 in.

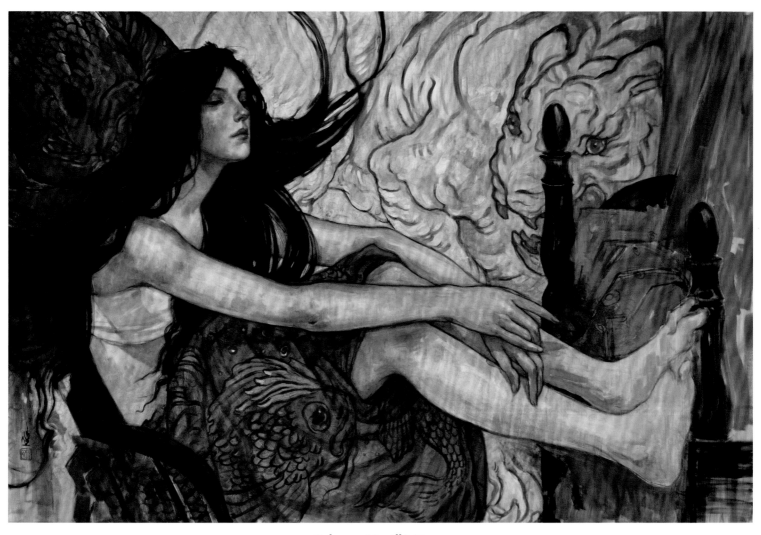

Rebecca Léveillé-Guay
Title: Tiger Tiger *Medium:* Oil *Size:* 40 x 60 in.

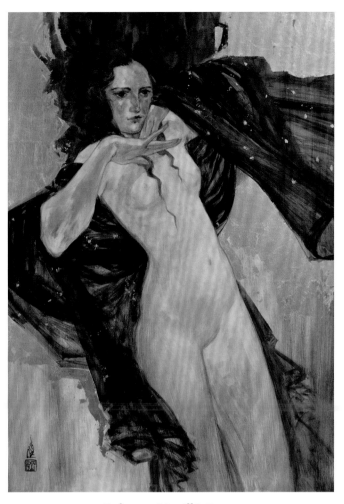

Rebecca Léveillé-Guay
Title: Salome *Medium:* Oil *Size:* 28 x 38 in.

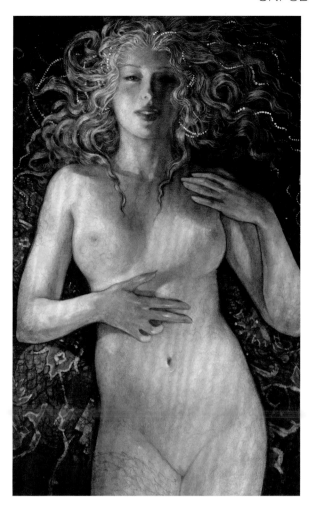

Rebecca Léveillé-Guay
Title: Medusa *Medium:* Oil *Size:* 11 x 14 in.

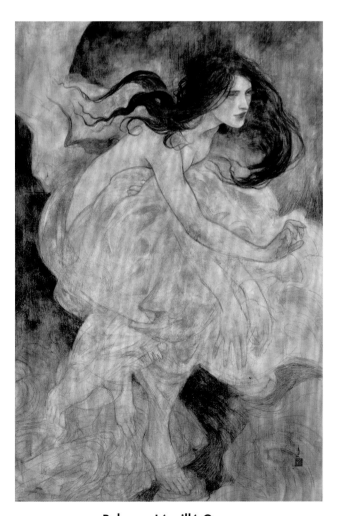

Rebecca Léveillé-Guay
Title: Wonder *Medium:* Oil and graphite *Size:* 40 x 60 in.

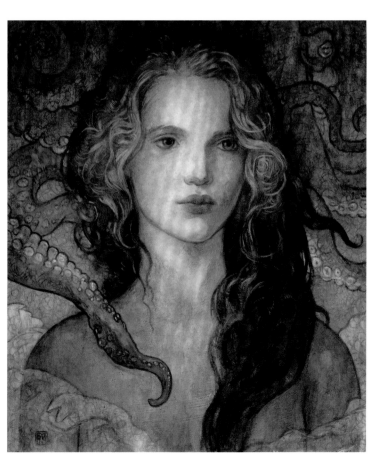

Rebecca Léveillé-Guay
Title: The Visitor *Medium:* Oil *Size:* 8 x 10 in.

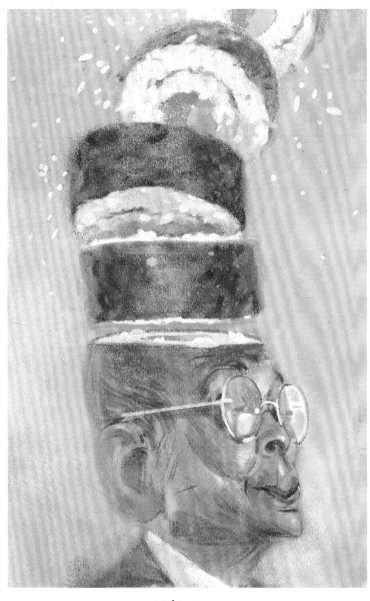

Richie Pope
Title: How Cats Find Their Way Home
Medium: Digital, gouache and graphite *Size:* 8.5 x 11 in.

Richie Pope
Title: Jiro Dreams of Sushi *Medium:* Digital and graphite *Size:* 9 x 14 in.

Rebecca Sorge
Title: Against These Things *Medium:* Digital *Size:* 24 x 36 in.

Robh Ruppel
Title: Office *Medium:* Photoshop *Client:* Don Hahn/Stone Circle Productions

Patricia Raubo
Title: Reversal of Fortune *Medium:* Digital *Size:* 12 x 18 in.

Robert Grafstrom
Title: A Portrait *Medium:* Digital

Rovina Cai
Title: Fig Tree *Medium:* Digital *Size:* 13 x 18 in.

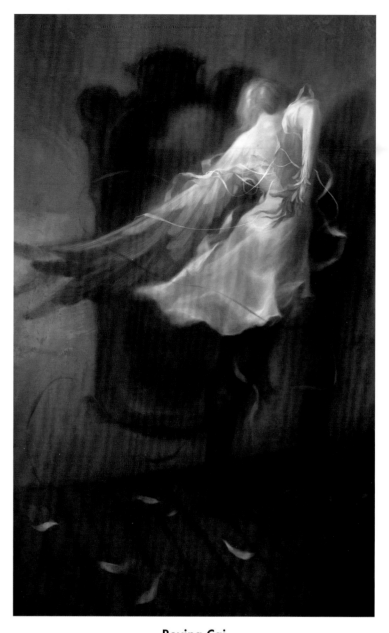

Rovina Cai
Title: Changes *Medium:* Digital *Size:* 16 x 26 in.

Rovina Cai
Title: The Six Swans: 3 *Medium:* Digital *Size:* 10 x 23 in.

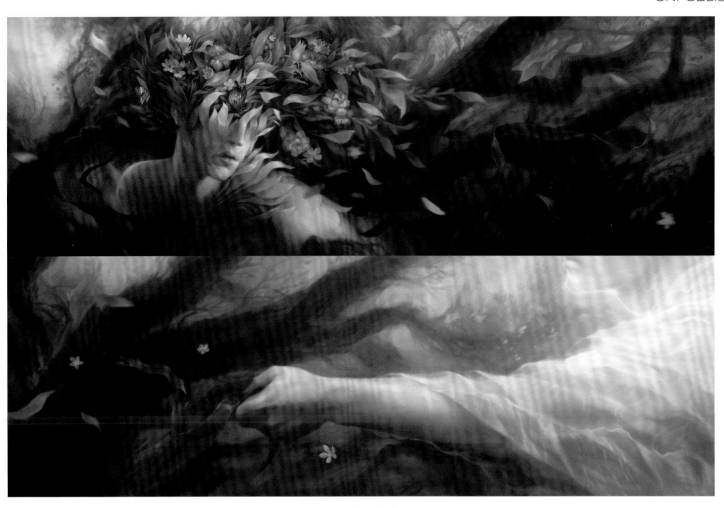

Rovina Cai
Title: Daphne & Apollo *Medium:* Digital *Size:* 27 x 18 in.

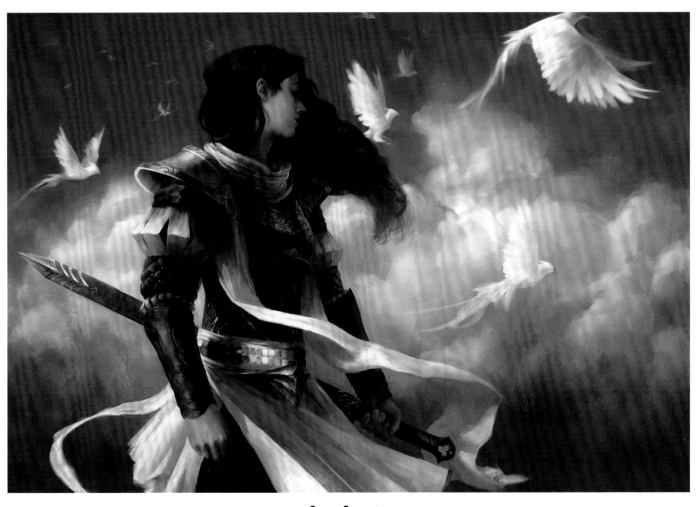

Sean Sevestre
Title: Birds *Medium:* Digital *Size:* 27 x 18.5 in.

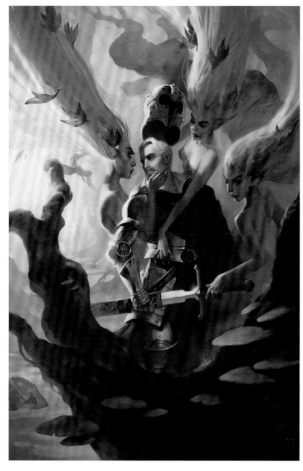

Victor Maury
Title: The Unfortunate But Not Altogether Unpleasant
End of Sir Francis de la Torre, Knight Errant
Medium: Digital *Size:* 12 x 18 in. *Client:* The Art Order

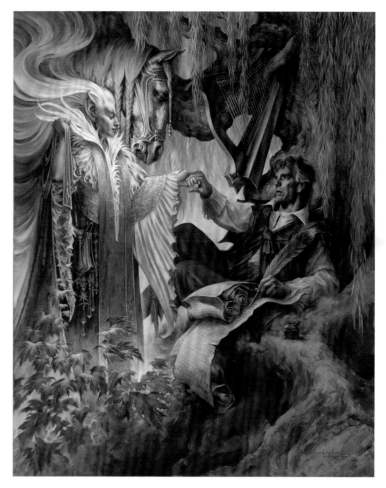

Stephen Hickman
Title: Thomas The Rhymer *Medium:* Oil color *Size:* 24 x 30 in.

Theo Prins
Title: Orange Palace *Medium:* Digital

Sam Bosma
Title: Space Paladin *Medium:* Digital

Serena Malyon
Title: Frieze *Medium:* Mixed media *Size:* 16.5 x 22.5 in.

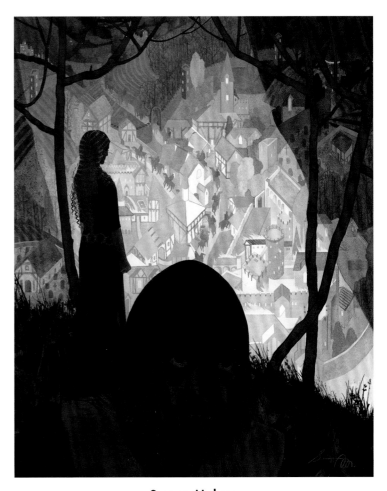

Serena Malyon
Title: The Plundering of Airlie *Medium:* Watercolor *Size:* 12.5 x 15.5 in.

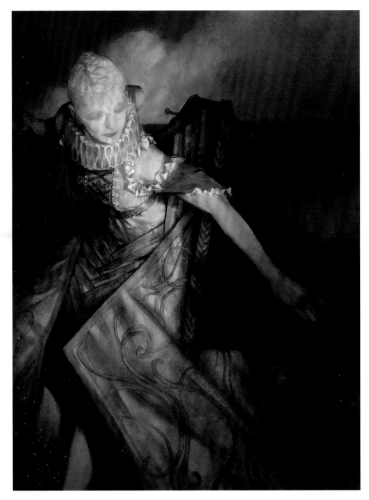

Tobias Kwan
Title: Motherland Chronicles: Braid *Medium:* Digital *Size:* 9 x 12 in.

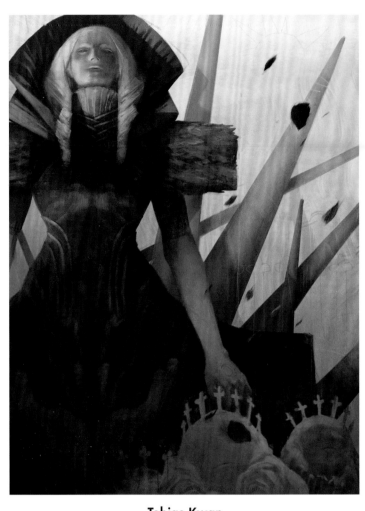

Tobias Kwan
Title: Motherlands Chronicles: Stomper II *Medium:* Digital *Size:* 9 x 12 in.

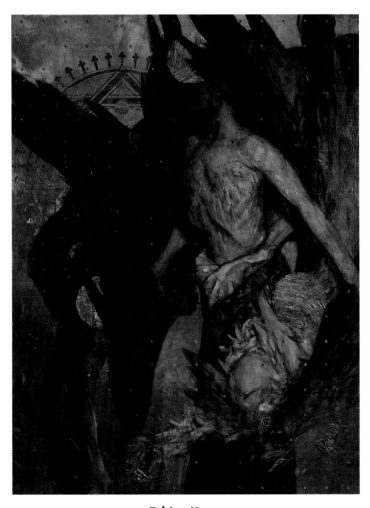

Tobias Kwan
Title: Motherlands Chronicles: Child *Medium:* Digital *Size:* 9 x 12 in.

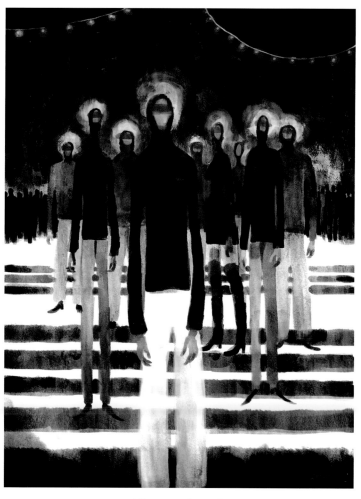

Thomas Campi
Title: Nocturne 3, The Cult *Medium:* Digital *Size:* 10 x 14 in.

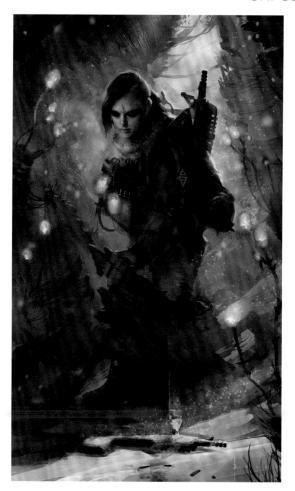

Bram "Boco" Sels
Title: Serves me Right *Medium:* Digital *Size:* 5000 x 2990 pixels
Art Directors: Vanessa Lemen and Jon Foster

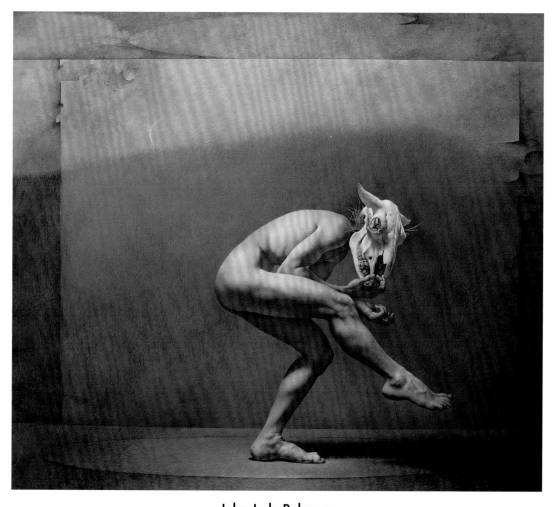

John Jude Palencar
Title: Pagan *Medium:* Acrylic *Size:* 37 x 33 in. *Client:* The Butler Institute of American Art

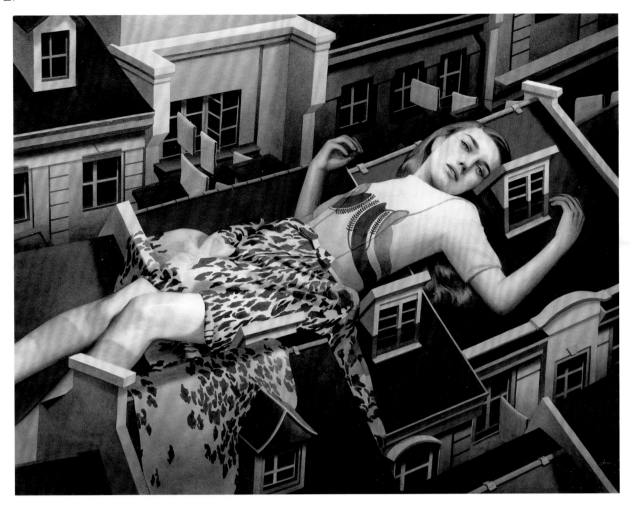

Tran Nguyen
Title: Sleeping with Nostalgia *Medium:* Acrylic and colored pencil *Size:* 20 x 24 in.

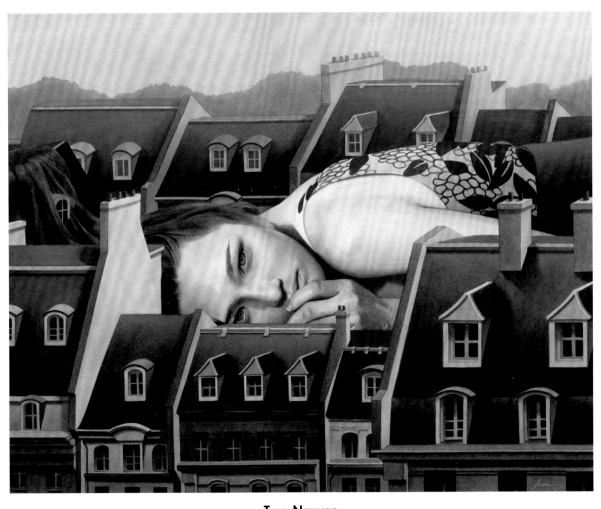

Tran Nguyen
Title: Taste for Bittersweet Beds *Medium:* Acrylic and colored pencil *Size:* 12 x 16 in.

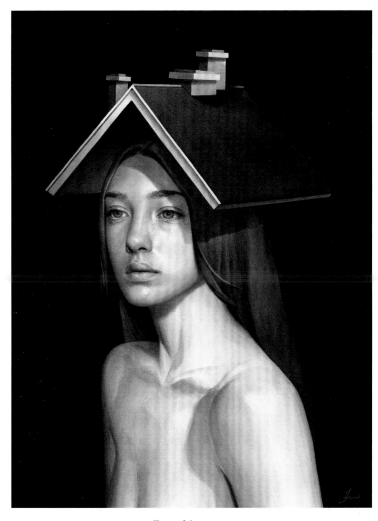

Tran Nguyen
Title: A Place I Once Homed
Medium: Acrylic and colored pencil *Size:* 12 x 16 in.

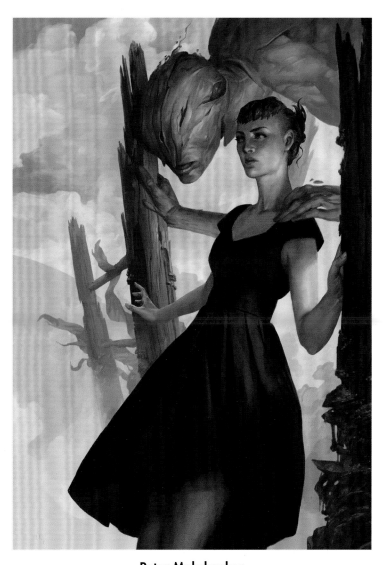

Peter Mohrbacher
Title: Wake *Medium:* Photoshop *Size:* 12 x 18 in.

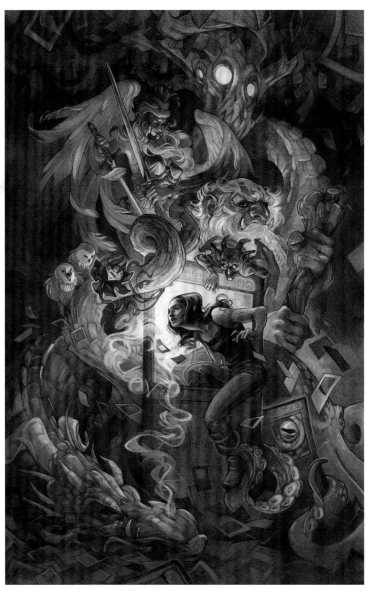

Wylie Beckert
Title: Hunt for the Black Lotus *Medium:* Digital *Size:* 11 x 17 in.

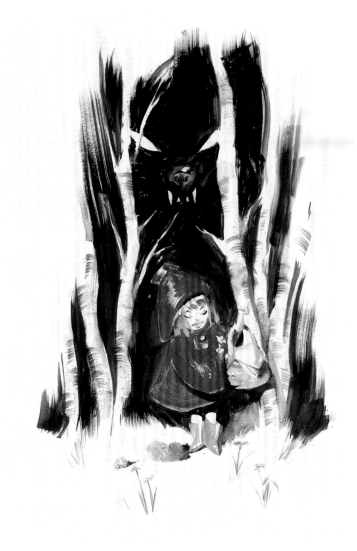

Tuna Bora
Title: Little Red Riding Hood *Medium:* Gouache and digital *Size:* 9 x 13 in.

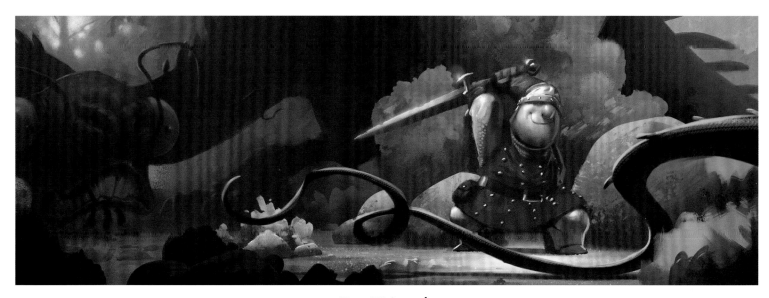

Tony Weinstock
Title: Not My Tail! *Medium:* Photoshop *Size:* 9 x 3 in.

Wesley Burt
Title: Entanglement *Medium:* Graphite *Size:* 11 x 14 in.

Wesley Burt
Title: Dervish *Medium:* Graphite *Size:* 9 x 12 in.

Wesley Burt
Title: Soothsayer *Medium:* Graphite *Size:* 9 x 12 in.

Kei Acedera
Title: Finder's Keepers *Medium:* Acrylic
Size: 48 x 62.5 cm. *Client:* Galerie Arludik

Kei Acedera
Title: Little Reader *Medium:* Acrylic
Size: 50 x 35.5 cm. *Client:* Galerie Arludik

Bobby Chiu
Title: Walk This Way *Medium:* Acrylic *Size:* 50 x 34.5 cm. *Client:* Imaginism Studios

Bobby Chiu
Title: Shelter *Medium:* Acrylic and watercolor *Size:* 28 x 22 cm. *Client:* Galerie Arludik

Kei Acedera
Title: Turtle Dove *Medium:* Digital *Size:* 11 x 14 in. *Client:* Imaginism Studios

Trevor Denham
Title: Something Caught my Eye *Medium:* Pencil *Size:* 8.75 x 16 in.

Allen Williams
Title: Nemette *Medium:* Graphite *Size:* 12 x 14 in.

Allen Williams
Title: If Beauty Were a Book *Medium:* Graphite *Size:* 12 x 12 in.

Omar Rayyan
Title: Titania's Bottom *Medium:* Watercolor *Size:* 11.5 x 15 in.

Omar Rayyan
Title: The God of Peter Cottontail *Medium:* Watercolor *Size:* 13 x 17.5 in.

Omar Rayyan
Title: Gin and Tonic *Medium:* Watercolor *Size:* 10.5 x 15.5 in.

Yoann Lossel
Title: La Morrigan
Medium: Oil and gold leaf on wooden board *Size:* 21.5 x 17.75 in.

Yoann Lossel
Title: Eros and Thanatos
Medium: Graphite and gold Leaf on Arches paper *Size:* 23 x 17 in.

Bastien Lecouffe-Deharme
Title: Hecate *Medium:* Digital

Peter Mohrbacher
Title: Flower *Medium:* Photoshop *Size:* 12 x 18 in.

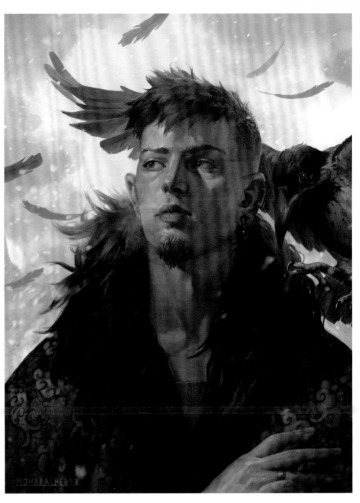

Peter Mohrbacher
Title: Cold Air *Medium:* Photoshop *Size:* 12 x 18 in.

Shane Pierce
Title: Priming the Creative *Medium:* Oil on canvas *Size:* 18 x 24 in.

Donato Giancola
Title: Red Sonja Unchained *Medium:* Oil on panel *Size:* 24 x 30 in.

Donato Giancola
Title: Mermaid : Jewel Collector *Medium:* Oil on Panel *Size:* 24 x 30 in.

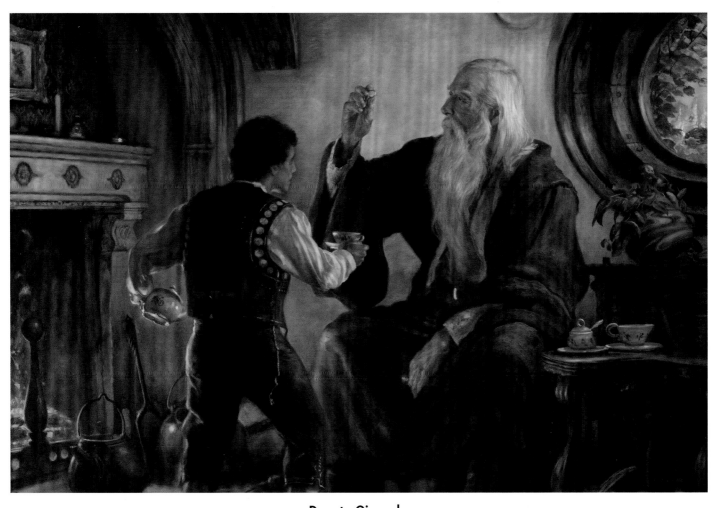

Donato Giancola
Title: Shadow of the Past *Medium:* Oil on panel *Size:* 36 x 24 in.

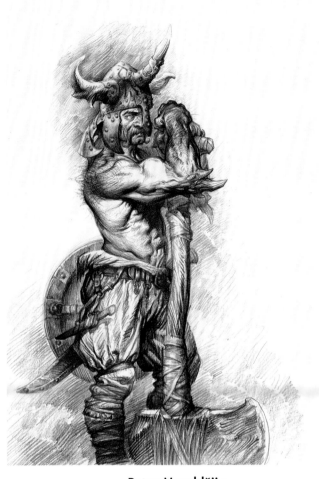

Petar Meseldžija
Title: The Book of Giants *Medium:* Pencils
Size: 30 x 42 cm. *Client:* Flesk Publications

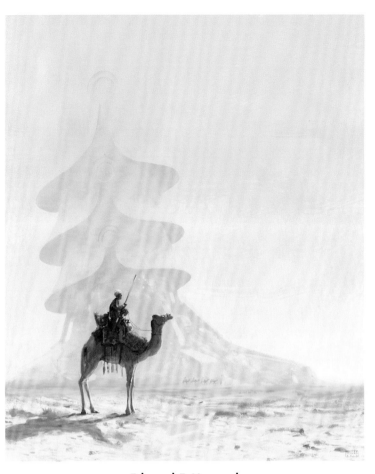

Edward F. Howard
Title: The Desert Sentinel *Medium:* Digital

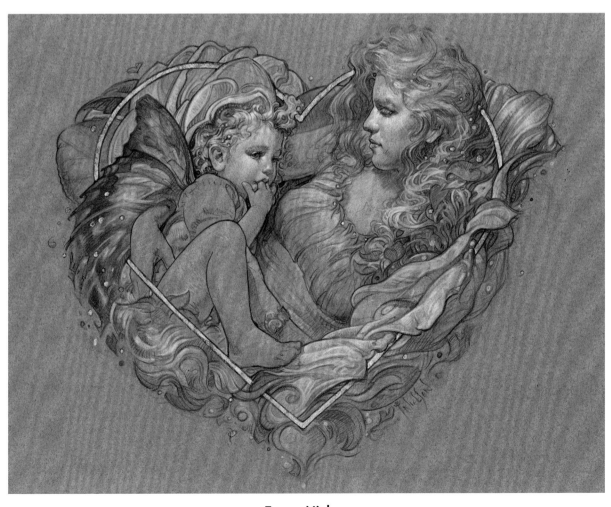

Terese Nielsen
Title: Love is Elemental *Medium:* Colored pencil, gold leaf *Size:* 13.5 x 10.5 in.

Mark A. Nelson
Title: Jeff's Deamon *Medium:* Ink and digital colour
Size: 10 x 15 in. *Client:* Grazing Dinosaur Press

Olivier Villoingt
Title: The Soul of War
Medium: Graphite and oil on Arches paper *Size:* 10.25 x 18.5 in.

Samuel Araya
Title: Capricorn and Mars *Medium:* Mixed *Client:* Gregg Spatz

Allen Douglas
Title: Baba Yaga *Medium:* Oil on panel *Size:* 14 x 20 in.

Julie Dillon
Title: Ariadne *Medium:* Digital

Lucas Graciano
Title: The Last Stand of Thorin Oakenshield
Medium: Oil *Size:* 40 x 30 in. *Client:* Ares Games

ARTIST INDEX

For twenty-one years the *Spectrum* annual has been a showcase for the best and brightest creators of fantastic art from around the globe: it serves as an invaluable resource book for art directors, art buyers, publishers, and agents world-wide. Hundreds of copies are sent out gratis with the intent of generating additional work and exposure for the artists selected for inclusion in the annual. The circulation of *Spectrum* far exceeds those of other annuals and resource books; we deliberately maintain a price that makes it affordable for every budget. Our purpose and singular agenda is the promotion of the art and artists. We believe that *Spectrum* functions as a cost-efficient promotional forum and provides a bridge between creator, client, and aficionado as well. Spectrum is all about facilitating opportunities for creators, about growing the audience for imaginative work in all its forms, without pretension and without prejudice.

Spectrum 22 jury members include Justin Gerard, Virginie Ropars, Greg Ruth and Annie Stegg-Gerard with an additional member to be announced. To learn more about Spectrum and for information about the Call for Entries, please visit our website at spectrumfantasticart.com.

Painting: "Keto" by Annie Stegg-Gerard.

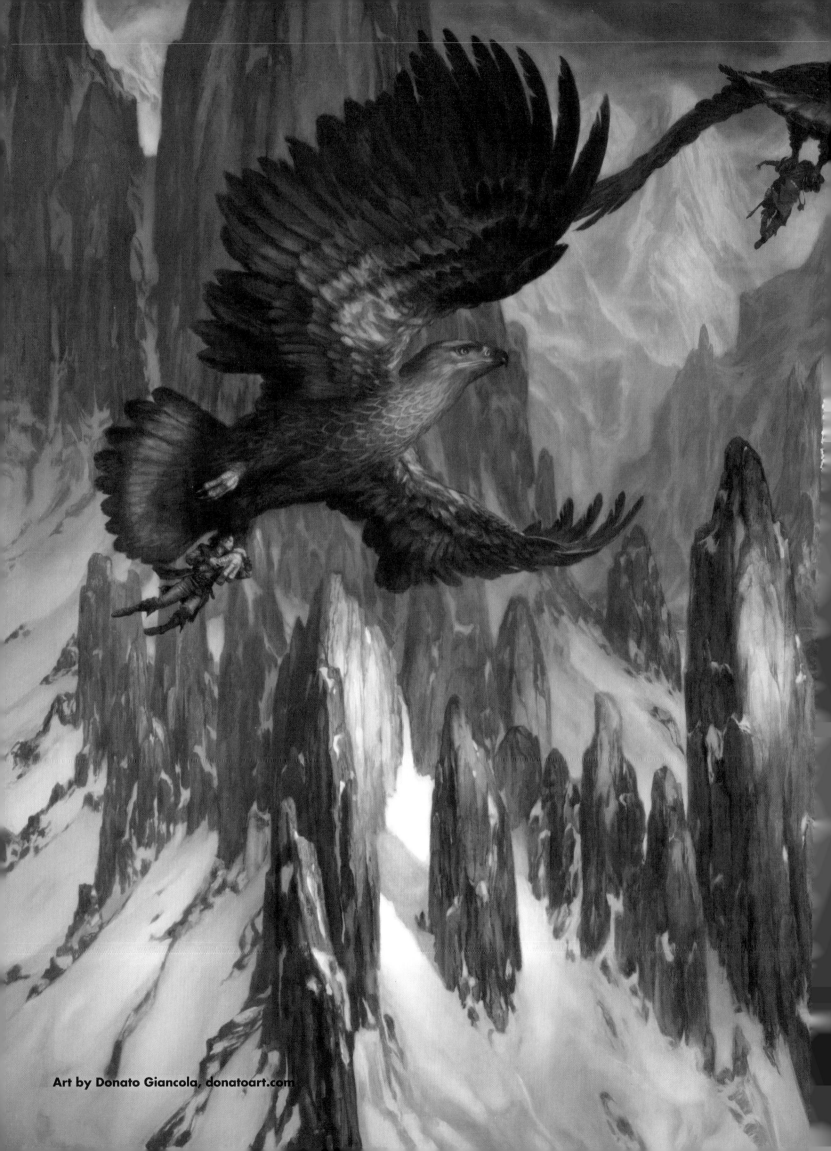

Art by Donato Giancola, donatoart.com